Katrin Davidson

PABLO
Picasso
1881-1973

Picasso 1881—1973

PABLO
Picasso
1881-1973

Edited by Sir Roland Penrose
and Dr. John Golding

Wordsworth Editions

First published 1973 by Paul Elek Ltd
under the title *Picasso 1881-1973*.

Reissued by Granada Publishing 1981.

This edition published 1988 by Wordsworth Editions Ltd,
8b East Street, Ware, Hertfordshire, under licence
from the proprietor.

ISBN 1-85326-905-0

Printed and bound in Hong Kong by South China Printing Co.

Contents

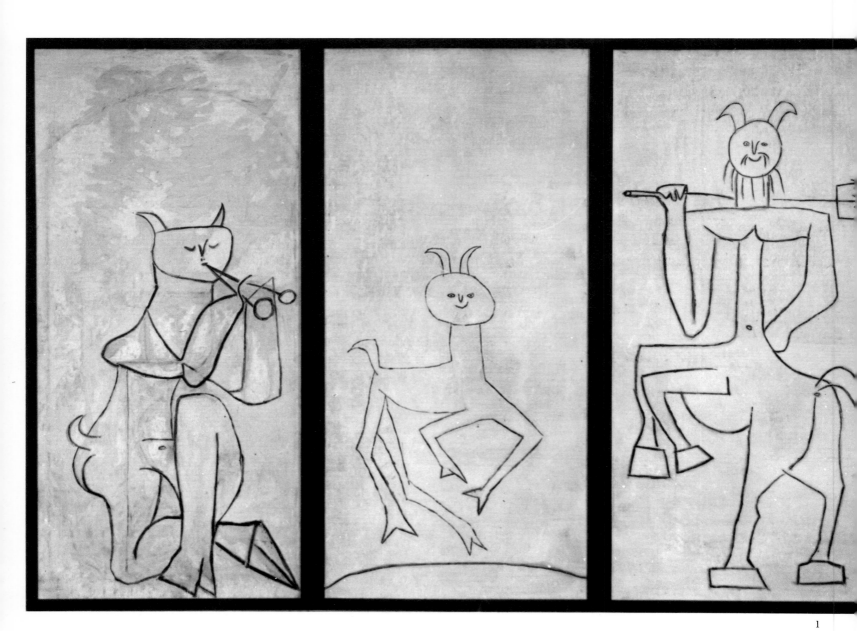

Introduction: A Free Man

Daniel-Henry Kahnweiler

The genius of Pablo Picasso has illuminated our century like a comet. I first met him in the spring of 1907 when he had just finished painting the *Demoiselles d'Avignon*, that milestone of modern art. I was privileged to remain close to him until his death, and my admiration of his work has grown unceasingly. If I had to pick out the one quality in it that has struck me the most forcibly, I would say that it was its *freedom*. It is true that I have described his oeuvre as 'fanatically autobiographical'. This is the same as saying that he depended only on himself, on his own *Erlebnis*. He was always at liberty, owing nothing to anyone but himself.

There are some great painters who move towards a single objective. They gradually realize an artistic end which has been their cherished goal from the beginning. I would cite in particular, among my contemporaries, my very dear friend Juan Gris, whose development followed a perfectly straight course, corresponding to his conception of the nature of painting. He was a classical painter in the purest sense, and the complete antithesis of Picasso, a romantic painter if ever there was one. 'When you start a painting', he confided to me once, 'you need to have an idea, but it should be a vague one.' This is the explanation of what I believe to be a unique phenomenon, paintings that changed completely during the course of their execution. Several different pictures sometimes appeared and disappeared before a painting arrived at its definitive form. Picasso rarely made sketches with a future work in view; each picture was an end, a universe in itself. He gave his creative urge free rein, and lived only in the present. His observation 'Painting makes me do what it wants' is well known. A work was finished when it seemed to him that there was nothing more to add to it. In this way one was always confronted with new solutions when one looked at his pictures. And yet these new solutions carried on the tradition, by virtue of inventing it afresh each time.

I was reminded of this recently when I visited the Picasso Museum in Barcelona, which has reopened after having an extension added. What struck me at the sight of the hundreds of drawings dating from Picasso's early youth—of which I had previously known only a very small part—was the profound fundamental unity of his work, in spite of its astounding diversity. The narrative approach in his work prior to 1906 was taken up again in the evening of his life. He said to me, indeed, some years ago: 'It's not such a bad thing, a picture which tells a story.' Even earlier, he had assured me that paintings ought to express 'great feelings'.

Something equally remarkable is the recurrence of certain themes. The theme of *L'homme à l'agneau* is enough to illustrate this. As early as 1895

1 *Triptych (Satyr, faun and centaur)*, 1946.

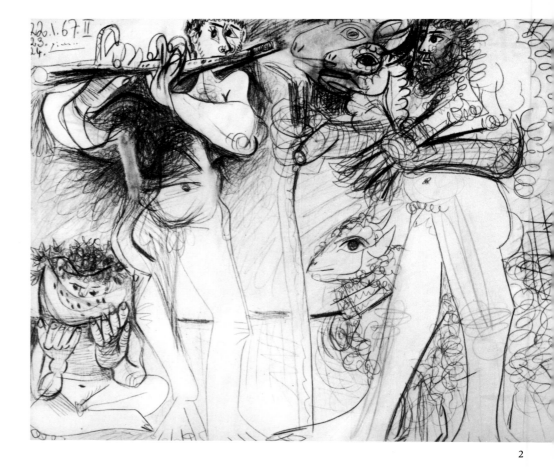

2

2 *Watermelon Eater, Flute Player and Man with Lamb*, 1967.

3 *Study of a Cast*, 1895.

4 Cranach the Younger, *Portrait of a Woman*, 1564.

5 *Bust of a Woman after Cranach*, 1958.

3

or so, there is a copy of a fragment of a classical bas-relief of a man carrying a lamb, the motif which subsequently became the Good Shepherd. It was during the Second World War that Picasso created his great bronze, *L'homme à l'agneau,* after numerous sketches. Was it as a symbol of human goodness, during those years of horror? Years later the theme appeared again. Picasso was coming down from Mougins towards Cannes when his car was stopped by a flock of sheep crossing the road. The shepherd was driving them into the meadow beside the road. And that same evening there was born the first of a series of drawings depicting the shepherd carrying a lamb which, bizarrely, is leaning down to listen to a flute-player. I don't know where Picasso saw this flautist. He told me, in any case, that he had only just remembered the proper way to hold a flute.

One of Picasso's notable characteristics was his need to transform existing works of art, to compose 'variations on a theme', as it were. His point of departure was often simply a reproduction in a book; or even a postcard sent by myself, such as Cranach the Younger's *Portrait of a Woman* in Vienna, which became his first linocut in colour. Among other things, what struck him in particular about this painting was the way the woman's shadow 'rhymes' with the upper part of her body. 'How pleased Gris would have been', he said to me. There were so many other 'themes': Delacroix's *Femmes d'Alger*, Courbet's *Demoiselles des Bords de la Seine*, Velazquez's *Las Meninas*, Manet's *Déjeuner sur l'Herbe*, El Greco's *Painter*, Cranach the Elder's *Bathsheba*; sometimes prompting only one 'variation', often several.

8

This need to transform was certainly an important characteristic of Picasso's genius. 406

As an inventor of 'significant' forms, Picasso never tired in his enrichment of our visual treasury. Every great painter enlarges the exterior world of mankind in this way. None, I believe, added so much as Pablo Picasso.

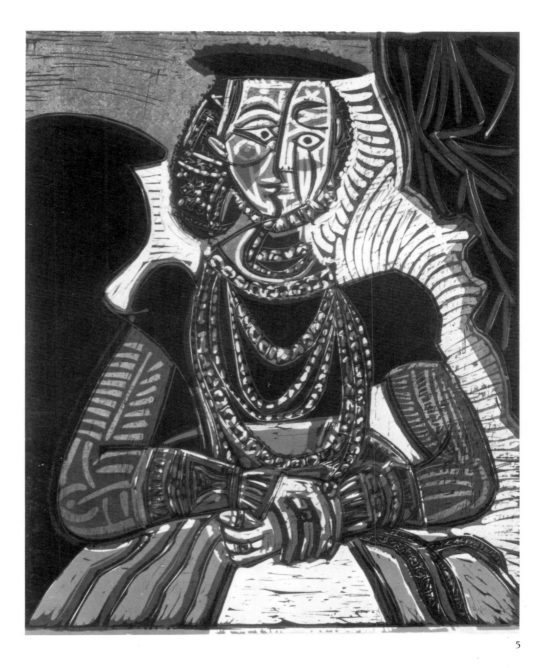

5

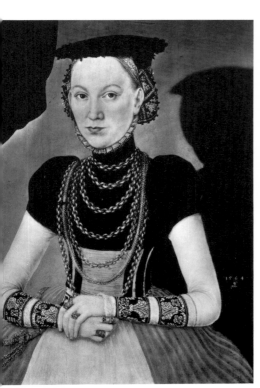

4

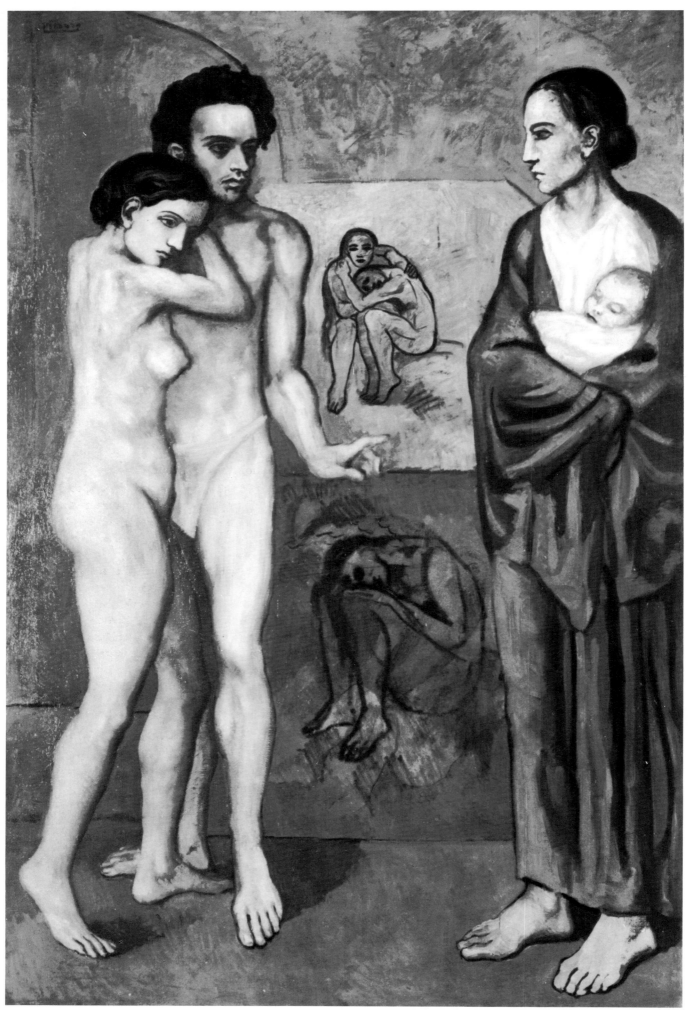

Themes of Love and Death in Picasso's Early Work

Theodore Reff

The discussion of Picasso's early work has thus far been dominated by attention to stylistic phenomena. The decade of intense activity from about 1900 to 1910 is generally divided into periods whose names alone—Toulouse-Lautrec, Blue, Rose, Neo-Classical, Negro, Early Cubist—are evidence of a preoccupation with stylistic issues. This is hardly surprising, given the remarkable variety of European and exotic, of older and contemporary styles that he assimilated in those years, the extraordinary pace of his own stylistic development from one period to the next, and above all the emergence of Cubism as a radically new style whose evolution can be followed year by year. But as a result, much less attention has been paid to iconographic phenomena and especially to those themes and motives that recur throughout Picasso's early work despite its frequent changes in style.[1] The subjects typical of the periods before 1907, from the early dancers and prostitutes through the blind beggars and destitute families and the Harlequins and saltimbanques to the later nudes of classical and primitive inspiration, have of course long been recognized. Yet rather little has been said about their underlying unity, either as images of certain types and conditions of human life or as expressions of certain attitudes of the artist himself. And this is even more true of the continuity between these earlier periods and Cubism, as if the change that occurred with *Les Demoiselles d'Avignon* were an absolute one rather than a shift to a new form of expression.

This essay is an attempt to trace the history and interpret the meaning of a few recurrent themes and iconographic motives of particular importance in the first decade of Picasso's career. Like those in much of his later work, they centre on the eternal issues of love and death, to which he was already able in these years to give intensely personal expression, although at first in a conventional language ranging from religious and secular allegory to genre and caricature. Inevitably, the discussion touches on ideas and attitudes that also find expression much later in Picasso's art, but since these are treated thoroughly in other essays in this volume, only a few examples will be mentioned here.

Before the autumn of 1901, when the Blue Period began, Picasso's subject-matter was predominantly secular, if not worldly. Except for a few still lifes and a larger number of portraits, mainly of himself, his family, and friends, it consisted of urban genre scenes that tended to concentrate on the extremes of contemporary society. They ranged from views of the poorest quarters with haggard mothers and proletarian couples in the manner of Steinlen to scenes of fashionable life at the Auteuil races and in theatres and private dining rooms in the spirit of Toulouse-Lautrec, the most important influence on Picasso at this time. Yet they also included such typically Impressionist subjects as boulevards crowded with strollers, children playing in public gardens, and the festivities of a national holiday; and there were several pictures of the colourful rather than dramatic aspects of the bull fight. The most striking images, however, were of the lurid world of nocturnal entertainment and pleasure: the café, the cabaret, the dance hall, and the seductive women who per-

6 *La Vie*, 1903–4.

7

7 *Courtesan with Jewelled Collar*, 1901.

8 *Girl in Prayer*, 1898–9.

8

formed or could be found there. The erotic element, already apparent in these works, became explicit in many others showing street-walkers, habitués of bars, and richly dressed prostitutes who have posed for their portraits. Obviously fascinated, the young artist painted them in brilliant colours, dwelling on their cold beauty and gleaming jewels, their strangely compelling power. As a contemporary critic remarked about the *Courtesan with a Jewelled Collar,* 'The unconscious dignity, the feline contortion of the shoulders and the hands, the fixity of the stare under a hair style like that of an idol with an enormous dark blue feathered hat, makes something hieratic out of her.'[2]

In contrast to this wordly tendency, there was in Picasso's work from the beginning a religious tendency, inspired both by the persistent strain of mysticism in Spanish art and life and by the revival of sacred themes in later nineteenth-century European art generally. Some of his earliest drawings, made at the ages of fourteen to sixteen, were of The Last Supper, Christ with His Disciples, and similar subjects; and in larger, more carefully executed paintings of the same years he represented The Nativity and such scenes of religious ceremony as *The Altar Boy* and *The First Communion,* the latter exhibited in 1896.[3] Two years later Picasso planned a major composition of private rather than public devotion, a woman kneeling in prayer before a crucifix in a garret room, of which eight preparatory studies have survived.[4] And about 1902, after steeping himself in profane subjects, he drew a crucified Christ of Romanesque severity and a fantastic vision of The Crucifixion itself that we shall discuss presently.[5] Yet these were by no means the only examples of religious inspiration in the Blue Period. The impoverished mothers in vaguely medieval dress who appeared so often at the beginning of this period were, as has often been observed, secularized Madonnas in the tradition of Maurice Denis and other artists associated with a religious revival at the end of the century. And both in costume and in composition, the several versions of *The Two Sisters* recall Gothic sculptural groups of The Visitation as well as the reliefs on Greek grave steles.[6] Characteristically, Picasso was already attracted at this time 'not by naturalistic styles but by those which had been used to convey certain religious ideas by means of a system of stylized symbols.'[7]

The two tendencies, sacred and profane, were not as isolated as this discussion might suggest. In the major allegorical pictures of the Blue Period, *The Burial of Casagemas* and *La Vie,* they were inseparable and equally potent sources of inspiration, as we shall soon see. And in another monumental work, which unfortunately has not survived, they were brought together rather violently. It was a mural representing The Temptation of St Anthony that Picasso painted in 1901 on one wall of the Café Zut in Montmartre. His friend Sabartés has described its execution: 'With the tip of the brush dipped in blue, he drew a few female nudes in one stroke. Then, in a blank area which he had purposely left, he drew a hermit. As soon as one of us shouted: Temptation of Saint Anthony, he stopped the composition. [8] Although the subject was traditional and had been popular throughout the nineteenth century, Picasso's choice of it was significant personally; for it summed up that simultaneous attraction to themes of sensuality and spiritual aspiration, overt eroticism and religious remorse, that pervaded his early work and found expression even in *Les Demoiselles d'Avignon* and several Early Cubist compositions, including a curious variation on The Temptation of St Anthony itself. The most important statements of these ideas, however, were the series of Blue Period pictures treating the love and death of his friend Casagemas.

Carlos Casagemas, a painter and writer who belonged to the same circle at Els Quatre Gats in Barcelona, was one of the young Picasso's closest friends.[9] His tall

figure and mournful yet distinguished features appeared often in the latter's portrait drawings and caricatures from about 1897 on, sometimes juxtaposed with his own.[10] In 1900 they shared a studio on the Calle Riera de San Juan in Barcelona, whose walls they decorated with murals; and in the fall of that year, with their mutual friend Pallarés, they made their first trip to Paris together and shared another studio, on the Boulevard de Clichy. Their ambitious plans were, however, soon frustrated by an unfortunate series of events, about which Xavier de Salas, who was later acquainted with some of the artists involved, has written the most succinctly:

> In Paris, Casagemas and this group of Spanish painters happened to know a French girl. Casagemas fell in love with her, and when he discovered that he was impotent he fell into a great depression and tried to commit suicide. Trying to cheer him up, Picasso left Paris with Casagemas and went to Barcelona and then to Málaga. Nothing availed, and leaving Picasso with his family in Barcelona, Casagemas went back to Paris. There he found this French girl in a café, tried to shoot her, and committed suicide. The suicide has been fully recorded through the recollections of Manolo Hughet [Hugué], the sculptor.[11]

Manolo's memoir, published in Catalan in 1927 and since then virtually ignored in the literature on Picasso, is given here in translation in an appendix.[12] It too emphasizes that Casagemas' threat of suicide was not idle, 'because he had tried it once before in Barcelona by stabbing himself', so that Picasso may well have felt some remorse later at having abandoned him to his fate.[13] And Manolo adds that, 'on hearing the news of her son's death, Casagemas' mother fell dead herself', a second tragedy and perhaps a further source of guilt. But like de Salas, he seems deliberately to avoid naming the girl in question, referring instead to a 'seamstress from Montmartre'. Only in the last ten years—more than fifty years after Casagemas' death— have her identity and her role, both in that event and in Picasso's interpretation of it, gradually become clear. Significantly, it was he who first identified her as Germaine Pichot, wife of his now deceased friend and colleague Ramon Pichot, in remarks reported by John Richardson in 1962 and by Françoise Gilot in 1964.[14] Yet the official police record of Casagemas' suicide—discovered in 1966 by Pierre Daix, thanks to another of Picasso's remarks—seemed to confuse her identity once again

9

14

by referring to a 'Miss Florentin, née Gargallo, Laure, 20 years old, who was not his [Casagemas'] mistress.'[15] That Laure Florentin, a relative of Picasso's friend, the sculptor Pablo Gargallo, was in fact later known as Germaine Pichot, her marriage to Florentin, also a sculptor, having been brief, was clearly established only in 1971, when Palau I Fabre quoted still another eye-witness account, that of Manuel Pallarés.[16]

Living in Madrid, where he had gone after leaving Casagemas in Málaga, Picasso learned of the latter's death from friends, but did not respond artistically to it until he returned to Paris in the spring of 1901. Once there, however, inhabiting the very

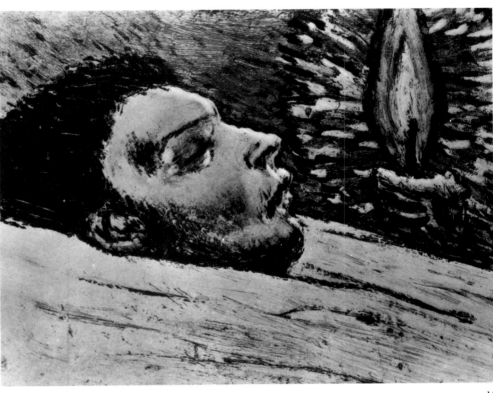

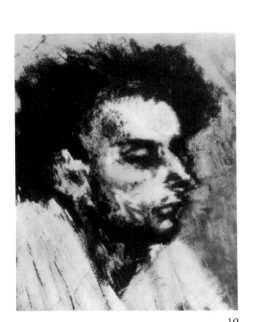

10

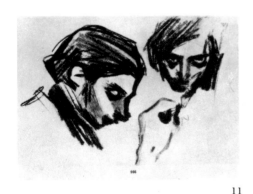

11

9 *At the Café de la Rotonde*, 1901.

10 *Portrait of Casagemas Dead*, 1901.

11 *Carlos Casagemas, Full-Face and in Profile*, 1900.

12 *The Death of Casagemas*, 1901.

12

studio on the Boulevard de Clichy that he had shared with Casagemas, and inspired by the eye-witness accounts of Pallarés and Manolo, who later observed that 'the death of Casagemas probably changed the course of my life; that tragedy made an extraordinary impression on me,'[17] Picasso could hardly help becoming obsessed by it himself. He began a series of posthumous portraits and commemorative compositions that culminated in the ambitious *Burial of Casagemas*. He even returned to the scene of the suicide and recorded its appearance in a picture, previously called *At the Café de la Rotonde,* which he has recently identified as 'the café on the Boulevard de Clichy where Casagemas committed suicide.'[18]

In the first of Picasso's posthumous portraits, a rapid sketch on cardboard, the bullet wound appears as a prominent dark spot on the right temple, the point specified in the police report and no doubt in those given to him by Pallarés and Manolo. In fact, the latter refers to this very portrait in his autobiography: 'Picasso did the head of our dead friend, with that waxlike colour that he had, the delicate nose, and the romantic air.'[19] In addition to eye-witness reports and his own visual memory, Picasso could also rely on more tangible sources in recreating the

9

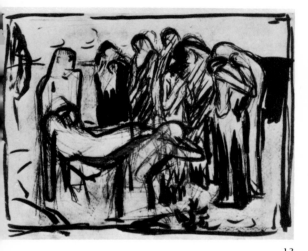

13

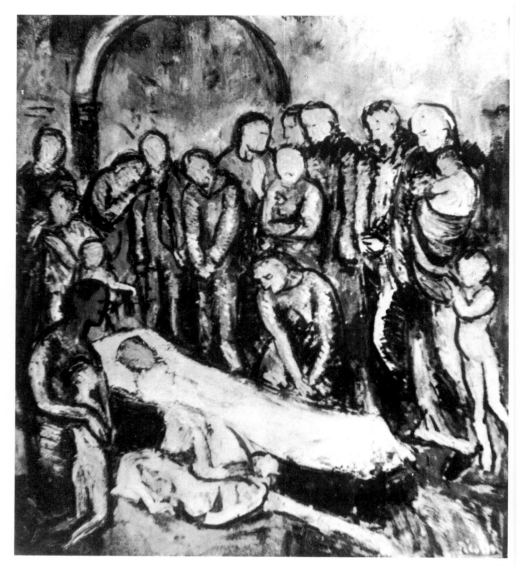

14

appearance of Casagemas—the many portraits he had already drawn, such as the one of 1900 showing both frontal and profile views that is reproduced here. It was a profile view that he chose to represent in two other paintings, executed at the same time or shortly thereafter. Both show Casagemas lying in his coffin, his eyes closed, his face gaunt and mournful even in death; but one is painted in the brilliant colours Picasso employed in the spring and summer of 1901, the other in the more subdued tones, already dominated by blues, that announce the beginning of the Blue Period in the autumn.[20] In the former, there is also an unusual iconographic feature—an extremely large candle burning beside the coffin, its light rendered by vivid touches of red, yellow, blue, and green. Intentionally symbolic, it is the first of many such candles in Picasso's art, some of which stand for the light of truth, as in the *Minotauromachy* etching and the early studies for *Guernica*, while others signify mortality, as in the still lifes of 1939 with a bull's head, a candle, and a palette that recall traditional *memento mori* types.[21] Yet the manner in which the candle beside Casagemas is painted—the heavy strokes surrounding it like a halo, making its radiance almost palpable—resembles above all the way in which candles and lamps, even the sun and stars, are represented in the art of van Gogh, where they are similarly charged with symbolic significance.[22] By the spring of 1901, a retrospective exhibition of van Gogh's work had been held in Paris, and many of his letters and some memoirs of him had been published, so that Picasso may have known both his art and the main events of his tragic life, which, like that of Casagemas, ended in a suicide by shooting.[23]

13 Study for *The Mourners*, 1901.

14 *The Mourners*, 1901.

15 Study for *The Mourners*, 1901.

16 El Greco, *The Burial of the Count of Orgaz*, 1586–8.

11

12

301

16

As he became absorbed by the meaning rather than the stark fact of Casagemas' death, Picasso turned from the posthumous portraits to allegorical compositions. According to Cirici-Pellicer, 'the event gave Picasso the idea for a painting, later destroyed, the studies for which have been published. Casagemas was seen in it wearing a hat, with a staff, a pipe, and two little angel's wings on his shoulders, presenting himself before St Peter at the gates of heaven.'[24] Unfortunately, these studies do not seem to have been published after all; but a religious inspiration, more reverent than the one Cirici-Pellicer speaks of, is found in *The Mourners,* the first surviving composition of this series. The group of grieving figures surrounding the coffin laid out in the foreground, and even the arch in the background, recall older 14
pictures of The Lamentation over the Dead Christ. And the little nude boy at the right, although inappropriate iconographically, is evidently based on another religious work, El Greco's *Holy Family with St Anne and St John.*[25] Yet the number of mourners—seventeen men, women, and children—is much larger than in traditional scenes of the Lamentation, and suggests instead a secular occasion involving a whole community, as in Courbet's *Burial at Ornans.* This impression is reinforced by the prominently placed mother and child—a motive we shall encounter again, in an equally conspicuous position at the right side, both in *The Burial of Casagemas* and in *La Vie.* The two tendencies, religious and secular, are also evident in the preparatory studies for *The Mourners;* for as Blunt and Pool observe of the most important examples, 'one is quite traditional in composition 13
and might be an Entombment of Christ, while the other shows a female nude 15
floating mysteriously over the body of the dead man, stretched out with dramatic stiffness on the ground.'[26] The latter does not seem quite so mysterious, however, when we recall that Casagemas' suicide—and he is shown here with the bullet wound in his temple—had ultimately been caused by a woman. According to Palau I Fabre, the nude may symbolize either her soul, since Casagemas had died believing he killed her, or, what is more likely, his own 'feminine' soul leaving his body.[27] He is in fact shown again in a rigid posture and with a floating female nude, this time clinging to him as he ascends to heaven, in the final painting of this series, the monumental *Burial of Casagemas.*

The major work of the early Blue Period, it dominated Picasso's studio both 32
physically and symbolically after its completion, like a grim reminder of death. 'The first thing one saw on entering,' Sabartès recalls, 'was the big picture *El Entierro de Casagemas,* which hung, I know not with what or how, slightly away from the wall.'[28] One of the first paintings by Picasso in which blue and its neighbouring tones, green and purple, dominate the colour harmony, with relatively few accents of ochre, white, and red,[29] it conveys through this alone a mood of melancholy and spiritual reverie. Inevitably, its subject and general design, as well as its extremely tall figures, its dramatically accented clouds hovering close to earth, have reminded several writers of El Greco's *Burial of the Count of Orgaz,* which Picasso already 16
knew and admired at this time and later took as the subject of a fantasy he wrote.[30] In fact, his painting of another burial scene, *Kissing the Corpse,* also c. 1900, shows figures clearly inspired by El Greco's and thus constitutes a link between the two compositions.[31] Despite this, however, they differ in so many ways both formally and iconographically that the unfluence of one on the other can only have been very general. Moreover, the allegory of death is a traditional theme in Spanish art, and other examples, such as the *Resurrection of a Dead Man* painted by Mariano Maella in the eighteenth century, actually resemble *The Burial of Casagemas* more closely in format and in the placement of the deceased and the mourners.[32] In any event, Picasso clearly had some work of conventional religious inspiration in mind, just as he recalled an old tradition of religious numerology in grouping his figures

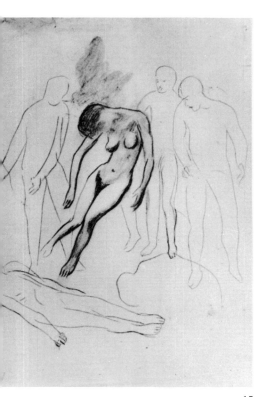

15

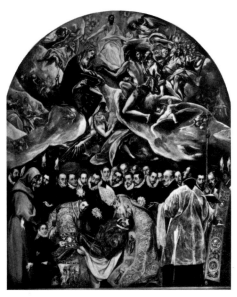

16

17

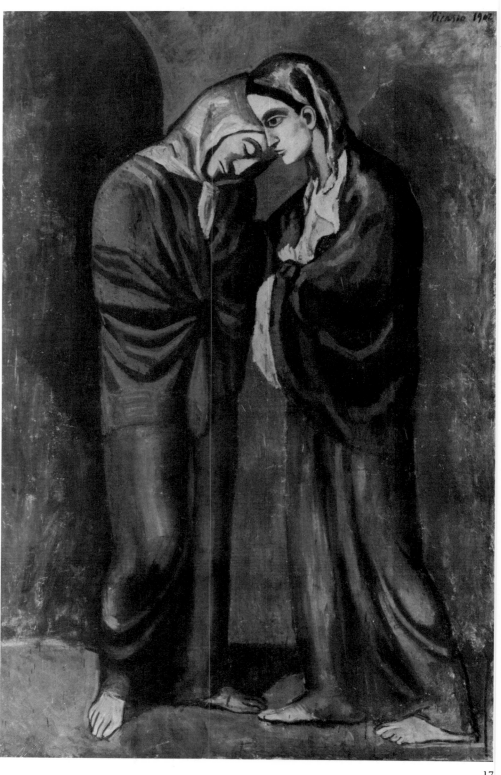

17

by threes or multiples of three. Thus, the centre of the earthly zone, the dead man's corpse wrapped in a white shroud, is surrounded by nine mourners, and the centre of the heavenly zone, his soul ascending on a white horse, is surrounded by nine women and children. Moreover, the latter are partly divided into groups of three: below Casagemas' soul at the left, three nudes who are identified as prostitutes by their sensual poses and colourful stockings; and below it at the right, a mother and two children who are associated with holy figures by their vaguely medieval costume. And these in turn form the bases of a roughly triangular pattern whose apex is another group of three—the ascending soul, the horse carrying it, and the

woman clinging to it—which becomes the focal point of the heavenly zone and of the entire composition.

Obviously about love, the ultimate cause of Casagemas' death, the allegory centres on the contrast between two traditional types of love, sacred and profane, as embodied in the prostitutes and the mother and children.[33] Ironically, the latter look downward, toward the corpse on the ground, while the former look upward, at the soul ascending to heaven. (The two nudes at the far right seem to stand outside the scene and to comment on its significance, like the marginal figures in Reinaissance art; formally, they echo the embracing couple at the right side of the earthly zone.)[34] In the group surrounding Casagemas, then, Picasso combines in a single image, and in an allegorical form, types he had often depicted separately and realistically in pictures of prostitutes and Madonna-like mothers. In *The Two Sisters,* a work of the following year, he juxtaposes the two types again, 17 and in a style that mediates again between realism and quasi-religious symbolism. For the two women, confronting each other with a formal severity that we have already linked with Greek grave steles and Gothic groups of The Visitation, are in Picasso's own words 'a whore of St Lazare and a nun,' whom he had observed in the St Lazare hospital for venereal diseases.[35] It is true, as Palme points out, that they cannot simply be that, since the so-called nun holds an infant against her breast and the allusion to a Visitation implies that they are indeed 'two sisters', neither of whom is more virtuous than the other.[36] Moreover, the half-dozen preliminary studies now known show clearly how Picasso changed their costumes, postures, and ages, hence their roles and meaning, in the course of his work[37]—a practice we shall discover again in the several studies for *La Vie*. What remains significant nevertheless is that he chose to speak of the figures in those terms, just as he later chose to inform Françoise Gilot that 'For me, there are only two kinds of women—goddesses and doormats.'[38] Yet the prominence of the mother, who is by far the largest figure in *The Burial of Casagemas,* may have a more specific source in the tragic incident reported by Manolo, that on hearing the news of his death Casagemas' mother had fallen dead herself. This would also explain why the mother seems to be led by the children, or angels, to observe the scene of mourning on earth.

More difficult to explain is the central image, the ascending soul mounted on a white horse and embraced by a nude woman. The theory that Picasso may have remembered the legend of Phaeton, recently illustrated by Redon, and therefore 'may have been implying that Casagemas, who was both painter and writer, had tried to drive the horses of the Sun and had been held back by a woman,'[39] is rather too learned for Picasso and inconsistent with the limited achievement of Casagemas. If any ancient legend is relevant, it is more likely that of the Valkyrie, the *psychopompos* who rides a white horse into the heavenly Valhalla in Scandinavian mythology; for it figures prominently in the work of Wagner, a composer so famous in Barcelona around 1900 that a popular artists' meeting place was named after the Valhalla.[40] There is, in addition, a well-known Christian context in which such a horse figures, the celestial vision described in Apocalypse, chapter 19: 'And I saw heaven opened, and behold a white horse; and he that sat upon him was called Faithful and True . . .'[41] But if this image of Christ Triumphant corresponds to that of the ascending soul of Casagemas, the latter's stiffly outstretched arms suggest a different image, Christ on the Cross. Such an allusion would hardly be surprising, since Picasso has throughout his career represented The Crucifixion more than any other Christian subject, and often as an expression of despair or tragic loss. His grotesque transformations of Grünewald's Isenheim altarpiece, his own intensely 135 surrealistic interpretation of 1930, and his introduction of Crucifixion motives into 324 *Guernica* are well known examples.[42] Less familiar, yet even more relevant here, are the drawing of Christ on the Cross, motivated by the death of his mistress in 1915, and the allusion to that subject in the *Three Dancers*, a picture directly inspired by

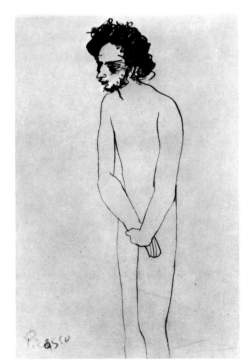

18

19

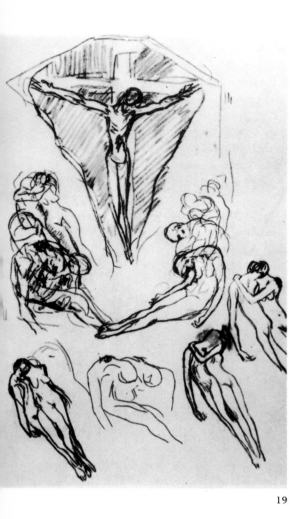

19

the death of an artist friend in 1925,[43] and one that is related thematically to *The Burial of Casagemas*, as we shall see presently.

It was suggested earlier that the rigidity of Casagemas' outstretched arms may have a sexual as well as a religious significance. The nude woman clinging to him, attempting to embrace him, seems to reinforce this expression of involuntary resistance. De Salas states explicitly that the discovery of his impotence was the cause of Casagemas' depression and eventual suicide; and Palau I Fabre, evidently relying on information given him by Pallarés, adds that this was confirmed by an autopsy.[44] Picasso himself seems to describe precisely this condition in a full-length drawing of Casagemas made a year or two later, in which the figure is entirely nude, the heavily shaded features express disillusionment, and the hands are locked together in anguish and helplessness. Significantly, the same gesture is found in these years in two drawings of closely related subjects: one shows an old lecher, short and bald, admiring a tall young nude;[45] the other, a similar man whose skull is being torn by a huge black bird perched on his shoulder. The fusion of erotic and religious themes in *The Burial of Casagemas,* although apparently irreverent and even blasphemous, is not only appropriate to the circumstances of his death, it is also characteristic of Picasso's religious imagery in general. If the sexually charged forms of *The Crucifixion* and the variations on Grünewald can be understood as products of a typically Surrealist preoccupation with the erotic, those in several works roughly contemporary with *The Burial of Casagemas* must be understood differently. Curiously, one is a drawing of The Crucifixion itself, in which the Christ, rendered more or less conventionally, is surrounded by single or paired nude figures reclining in melancholy attitudes like that of the floating nude in one of the studies for *The Mourners*. Another such work is the drypoint showing Salome dancing before Herod and Herodias, who like her are entirely nude, while a servant woman, who is also nude, holds the Baptist's decapitated head on a salver. The presence of this subject, a popular one in Decadent and Symbolist art,[46] among Picasso's early prints suggests how much his fusion of sacred and profane themes owes to his immediate predecessors. In the same year, in fact, his friend Apollinaire, who was at this time equally indebted to Symbolist poetry, published his own version of *Salomé* in *Vers et Prose*.[47]

18

272

19

54

The Burial of Casagemas was by no means the last work in which Picasso expressed the powerful feelings aroused in him by the suicide of his friend. In *La Vie*, painted more than two years later, he treated once again in allegorical form and on a monumental scale its themes of love and death, and introduced once again as the central figure its protagonist Casagemas. As in the drawing of him in an 'impotent' pose, he appears 'dignified, handsome, tall, gaunt, with a romantic and pale face', which was the way Manolo remembered him,[48] and is shown nude, or nearly so, the oddly shaped shift he wears at once concealing and calling attention to the problematic nature of his sexuality.[49] In introducing his image into a picture painted so long after his death, Picasso may have been inspired by precisely the kind of circumstance that had inspired his earlier portraits: although he apparently did not complete *La Vie* until the following winter,[50] when he began it in the spring of 1903 he was living in the studio on the Calle Riera de San Juan that he had shared with Casagemas, a studio filled not only with memories but with the murals they had painted on its walls.[51] Another possibility, mentioned by Daix and Boudaille, is that *La Vie,* a philosophical picture reminiscent of Gauguin's *Where Do We Come From, What Are We, Where Are We Going,* was inspired by the art of that master, who died in May 1903, the very month that is inscribed on one of the preparatory studies for *La Vie*.[52] But intriguing as this theory is, especially in view of the stylistic affinities

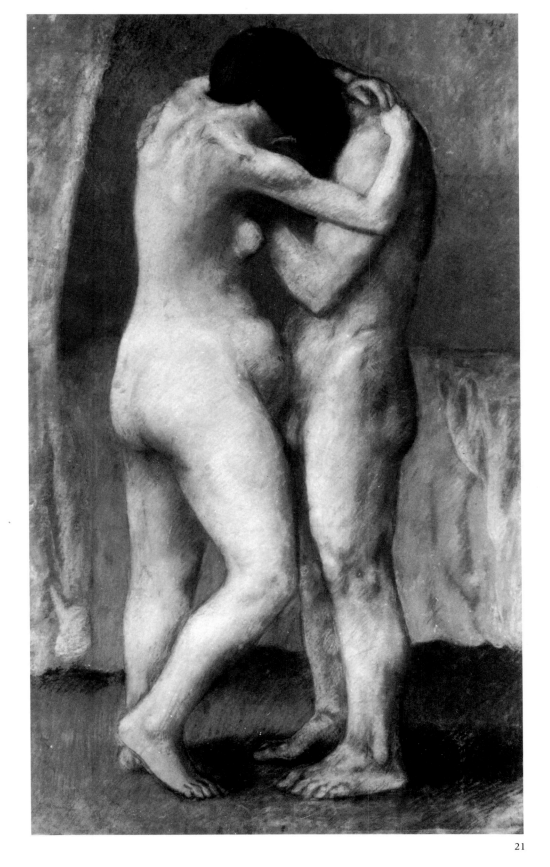

21

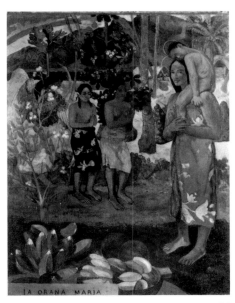

20

19 *Crucifixion*, 1903.

20 Paul Gauguin, *Ia Orana Maria*, 1891.

21 *The Embrace*, 1903.

between the mothers in *La Vie* and a picture like *Ia Orana Maria*, the date of 20
Gauguin's death is irrelevant, since news of it reached Paris from the Marquesas
Islands fifteen weeks later and Barcelona obviously still later.[53]

In *La Vie*, not only Casagemas himself but the women, or types of women, with
whom he appears in the earlier picture figure again, and in essentially the same

21

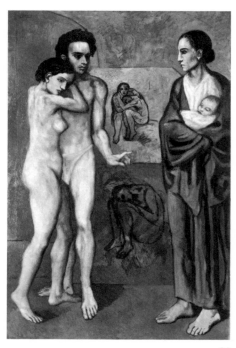

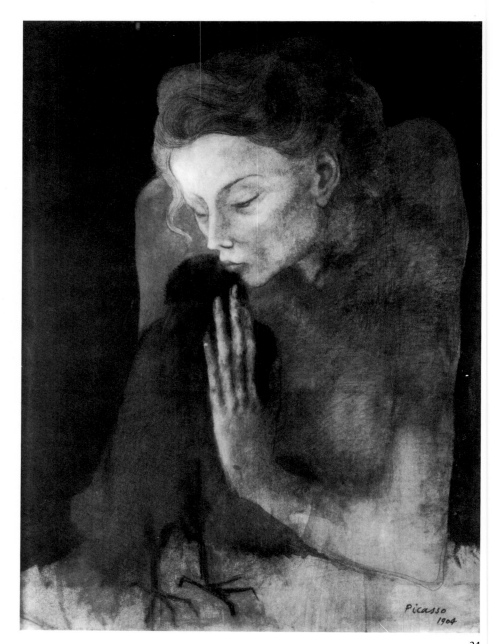

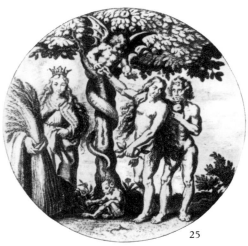

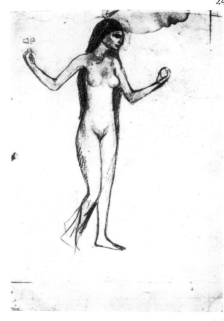

22 *La Vie*, 1903–4.

23 Max Klinger, *Genius (The Artist)*, 1900–3.

24 *Woman with a Crow*, 1904.

25 Flemish School, *Eve and Mary*, 1634.

26 *Nude Woman (Eve)*, 1902.

22

24

25

26

27 *The Couple*, 1902–3.

28 Study for *La Vie*, 1903.

29 *Standing Male Nude*, 1903–4.

30 Study for *La Vie*, 1903.

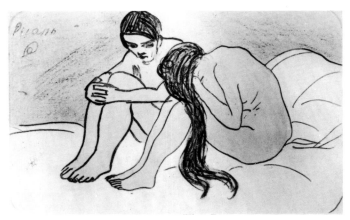

27

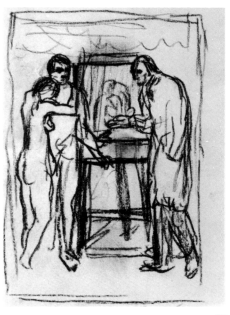

28

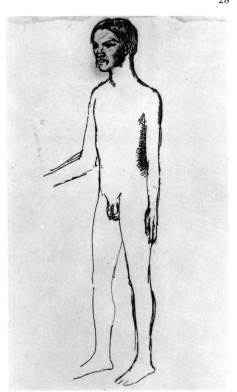

29

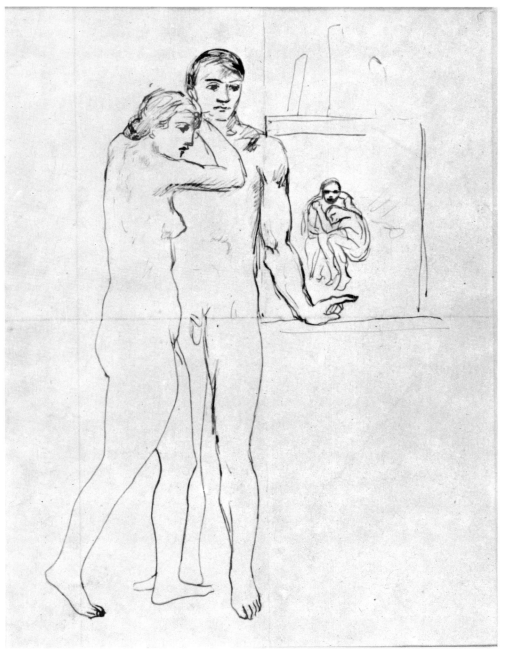

30

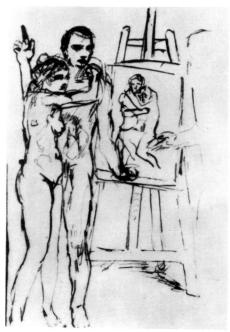

31

symbolic roles. The composition is of course much more compact and rigorously ordered, and the setting, an artist's studio with two of his canvases in the background, is far more intimate and restricted. Yet Casagemas is still shown between women who, whatever their specific allegorical meaning, suggest a contrast between two types of love.[54] Only their attitudes and actions have changed, in accordance with the greater pessimism of the image as a whole: the nude woman now leans against Casagemas in a passive, dejected mood; the mother confronts him with a stern, unyielding glance; and he himself, standing between them, reluctantly accepts the presence of one and points ambiguously toward the other. It is a curious gesture, reminiscent of a type sometimes used in older religious art to express a transcendent emotion or to denote a superior being, but here made to seem more personal and obscure. If it refers to the child, it may express Casagemas' regret that, despite his intimacy with the woman beside him, he will never father a child of his own.[55] In one of the preliminary studies, however, the nude man, who does not yet have Casagemas' features, points in a similar manner with his left hand and upward with his outstretched right hand, evidently alluding to the latter's heavenly abode[56] and at the same time reinforcing the contrast between a higher and a lower condition. These do not necessarily correspond to sacred and profane love; and the figure barely indicated at the right is, as we shall see, more likely an artist for whom the other two are posing than a mother with a child. But in the final painting the contrast between the two types of women is even more explicit than in *The Burial of Casagemas*. The mother, whose presence may once again allude to the tragic death of Casagemas' own mother, is an ominous figure who has with reason been compared with the image of death as an intruder in Maeterlinck's play *L'Intruse,* a work popular enough in Barcelona in the 1890s to have been translated into Catalan.[57] Directly descended from her are the figures who play a similar role in Picasso's later work, such as the student who enters a brothel carrying a skull as a kind of *memento mori* in the earliest studies for *Les Demoiselles d'Avignon*.[58] In contrast to the mother, the nude couple in *La Vie* symbolize sensual love, but in a disillusioned and guilt-ridden state, the man half turning from his companion to face the reproachful mother. This image, too, has counterparts elsewhere in Picasso's art, notably in the deeply moving pictures of a similar couple embracing with bowed heads and weary bodies, the woman's evidently swollen with pregnancy, that culminate in *The Embrace,* a pastel of 1903.[59] Significantly, the latter is also related in form, if not in content, to the embracing couple who appear among the mourners in *The Burial of Casagemas*.

31

21

Sacred and profane love are not the only allegorical types the two women in *La Vie* bring to mind and perhaps not the most relevant ones, since the former was traditionally shown nude and the latter clothed, rather than the reverse. For Blunt and Pool, 'the older woman represents a more ominous time in the young woman's life' and the picture 'probably alludes to the old theme of The Three Ages of Man and particularly to its late nineteenth-century version, which took the form of Cycles of Life.'[60] But popular as these were in the art of Munch, Toorop, Klinger, and others, their relevance to *La Vie* rests on the doubtful assumption that the two women in it are equivalent to the three usually shown in such compositions (the sleeping baby is clearly no more than an 'attribute' of the mother). Moreover, effective though this formulation is in characterizing the two women in *La Vie*—and Palme, too, sees in the older one an image of that abandonment and despair which the younger one already anticipates[61]—in focusing exclusively on them it ignores their symbolic roles in the life of the male figure who, as Casagemas or as Picasso himself, is the picture's visual and emotional centre. In fact, such a formula applies far better to the confrontation of two women shown in *The Two Sisters* and

31 Study for *La Vie,* 1903.

32 *The Burial of Casagemas (Evocation),* 1901.

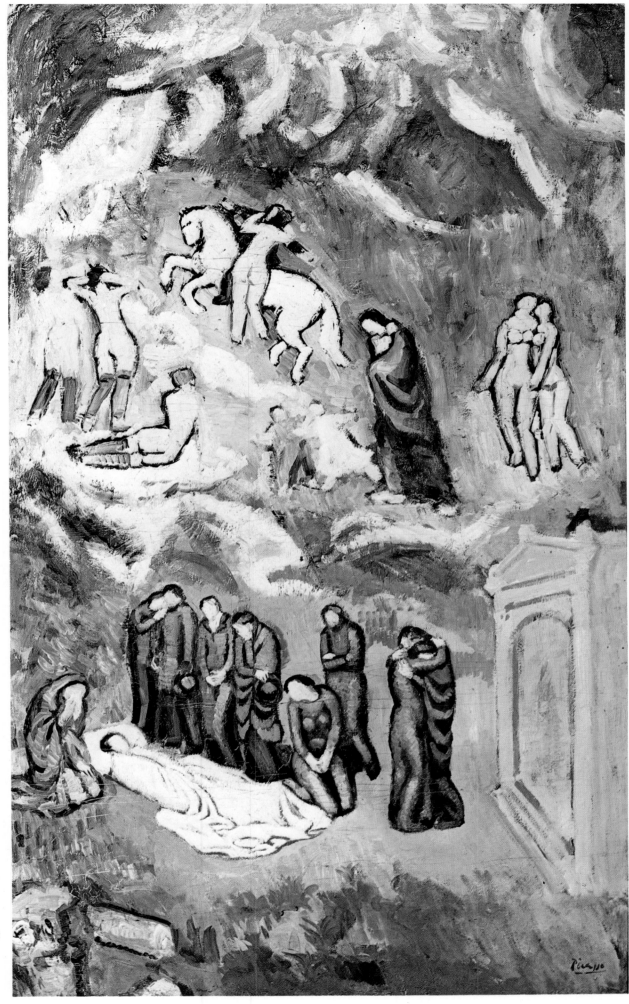

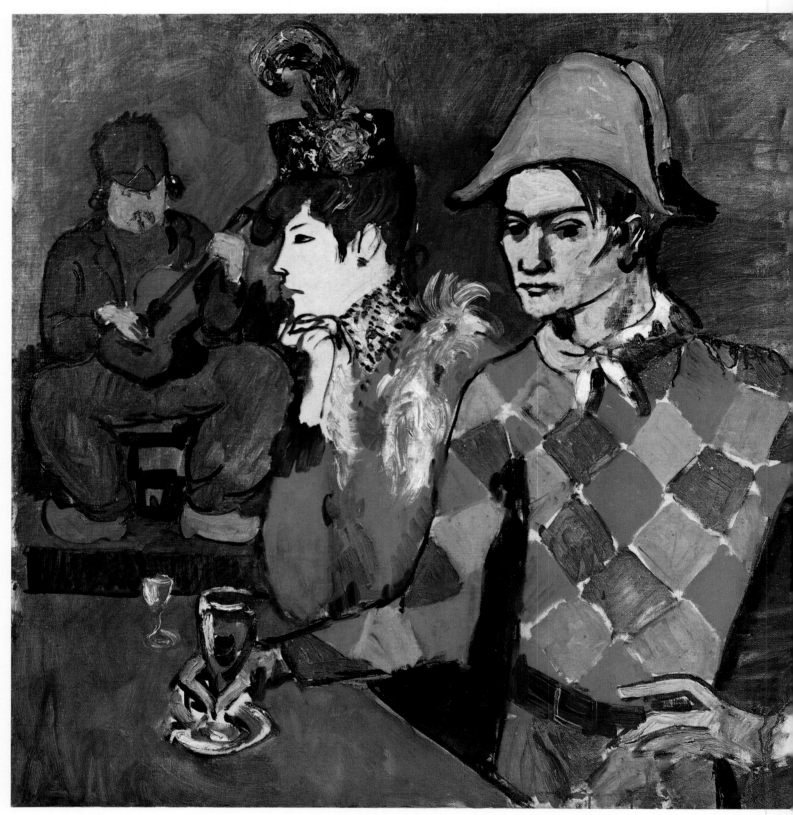

33

again, thirty years later, in the *Girl Before a Mirror*.[62] A traditional allegory more 184
closely related to *La Vie* is The Choice of Hercules, where the male figure is likewise
shown between two female figures symbolic of a sensual and a moral life.[63] It too
remained popular throughout the nineteenth century, witness the versions by
Delacroix, Moreau, and Fantin-Latour, among others; and it too was reinterpreted in
terms close to those of *La Vie,* notably in an allegorical print by Klinger entitled *The* 23
Artist that is exactly contemporary with it.[64] Like Casagemas, the young artist here
turns uneasily from the beautiful woman at one side to face the older woman who
advances toward him reproachfully at the other; only the fact that all three are
clothed distinguishes them significantly from the figures in *La Vie*. Yet the contrast
in Picasso's composition between a nude couple and a fully dressed woman, dis-
posed in a symmetrical manner, suggests still another iconographic precedent,
perhaps the most appropriate of all. It is the emblematic image of the Tree of Life
with Adam and Eve at one side and Mary at the other, the former standing for sin
and death, the latter for eternal life. In some examples, such as the seventeenth-
century engraving reproduced here, Mary holds a sheaf of wheat symbolic of life; 25
in others she holds the infant Christ, like the Madonna figure in *La Vie*.[65] And if it is
difficult to cite examples of this subject in the Symbolist art to which Picasso's
picture seems related stylistically, there are in it many images of Adam and Eve
alone beside the Tree of Life, especially in the work of Gauguin and Munch, for
whom, as for Picasso himself, it was a metaphor of the problematic relations of the
sexes in general.[66] Appropriately, his 1902 drawing of a nude woman holding an 26
apple, obviously Eve, imitates the firm contours and restrained shading of Gauguin's
graphic style; and as we shall see, a 1905 etching of a similar nude, here in the role
of Harlequin's wife, is directly inspired by the prints of Munch. As early as 1899,
Picasso caricatured a pregnant woman and inscribed beside the figure: 'Eve after
the fall.'[67] And in 1903 he drew a reclining nude with a flower growing from the 280
pubic area and a tiny skull connected by an arrow to the exposed heart—an ironic
fin de siècle variation on the traditional Eve and Mary symbolism.[68]

Adam and Eve after the fall, and indeed after the expulsion from Eden, may also
be the subject of the upper painting shown in the background of *La Vie*. The
anguished couple depicted in it, clinging to each other in a naked, destitute con-
dition, would thus represent a later stage in the lives of the disillusioned lovers who
stand beside them, like a reflection of their pessimistic thoughts. An image of the
suffering inherent in love, its source is almost certainly in the work of Munch,
specifically in the lithograph *Vampire* or the woodcut *Man and Woman*.[69] The
lower painting is similar in content, but shows the naked woman alone, seated with
her legs drawn up and her head buried between her knees in a defensive posture
suggestive of primitive terror; it too has been related to prints by Munch and—in
a manner more convincing visually—to van Gogh's lithograph *Sorrow,* a deeply
moving image of a woman in a similar state, though whether Picasso would have
known the latter seems doubtful.[70] The many *pentimenti* in this area of *La Vie,*
however, indicate that the subject of the lower painting was once very different: a
reclining nude rather like Titian's *Danae* and a huge black bird apparently perched
on her knee, one of its wings extended to the left. A curious mixture of sensuality
and menace, this group suggests simultaneously classical images of seduction such
as Leda and the Swan—in the famous version by Michelangelo, Leda is shown
reclining—and romantic images of terror in which a monster appears in a sleeping
woman's dream, as in *The Nightmare* by Fuseli or the Mannerist works on which it is
based.[71] The black bird, whether a raven, a vulture, or a crow, is of course a familiar
omen of misfortune or evil, and figures as such in two other works of the Blue Period:
overtly in the drawing discussed earlier of a vulture tearing the skull of a helpless

33 *At the Lapin Agile*, 1905.

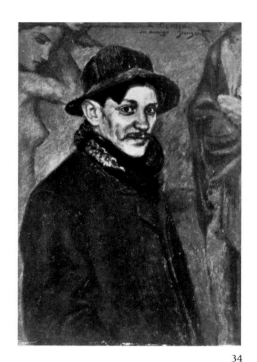

34

man; more allusively in the well-known gouache of a diabolical woman stroking and kissing a crow. Thus the lower painting in *La Vie* may have referred to the terrors of a guilty, sensual love, as the upper one refers to its desperate consequences.

Not only from its extensive *pentimenti*, but from the four preliminary studies now known,[72] it is evident that Picasso's conception of many features changed in the course of his work on *La Vie*. In the first three sketches, whose setting is more clearly identified as an artist's studio with a single painting on an easel, the nude figures depicted in the latter are more closely related to those standing at the left, who can therefore be seen as models posing for it or for a similar painting. However, the figure shown at the right in the first two sketches, and barely indicated in the third one, its right hand extended as if in response to the nude figure's left hand, is a tall, gaunt, bearded man, wearing a ragged coat, who resembles a Blue Period beggar or madman more than an artist at work. Yet he seems to become just that as the composition develops, for a drawing contemporary with *La Vie* of a nude man in exactly this pose is evidently a study for this figure and also a self portrait, confirming Runnquist's speculation that at one point Picasso may have thought of placing the artist himself where the mother now stands.[73] And this becomes more significant when we discover that the male model in the third and fourth preliminary studies, but more obviously in the fourth one, is likewise an image of Picasso, and further that the closest parallel in his work to the naked couple in the background painting is a nearly contemporary drawing of a similar despairing couple, in which the man once again has his features.[74] In the final painting, of course, the setting is no longer necessarily an artist's studio, and none of the figures is modelled on Picasso himself, so that the whole is less overtly personal in content. Moreover, the pervasive blue colouring, whose coldness affects even the normally warm flesh tones, enhances this existential mood, projecting the conflicts and sorrows shown onto a more remote or universal plane. Yet the substitution of Casagemas' features for his own merely expresses in another form that sense of himself has having been thrust by women into an untenable and ultimately tragic position with which Picasso evidently began. It reminds us of his later comment on Charlie Chaplin, another 'artist' with whom he easily identified himself: 'He's a man who, like me, has suffered a great deal at the hands of women.'[75] And it explains why, in posing for the portrait painted by his friend Sebastiàn Junyent early in 1904, he chose to stand before the central portion of *La Vie*, so that he would be framed by the two women and the nude one would appear to look, with disillusioned eyes, directly at him.[76]

As the mood and tonality of Picasso's art began to brighten in the fall of 1904 and the Blue Period gave way to the Rose, a new range of subjects began to appear in it. The tragic and pessimistic images of the earlier phase, typically Spanish in their mingling of the morbid and the erotic, were gradually replaced by the pathetic and subtly ironic images of the later phase, more characteristically French in their fusion of realism and poetic mood. The suicidal artists, impoverished mothers, and blind beggars were replaced by circus entertainers, wandering acrobats, and their families, figures who, although equally alienated from the rest of society and often equally destitute, are no longer victims but agents of their own fate. Set apart from normal life both by their roles as performers and by their costumes, which they wear in all circumstances like special insignia, the Harlequins, saltimbanques, clowns, and fools who now dominated Picasso's imagery possess a stoic pride and exalted sense of self which were not given to their predecessors in the Blue Period. Significantly, none of these circus and fairground subjects appeared in his art during that period; and the fools he did depict were not jesters in fanciful costumes

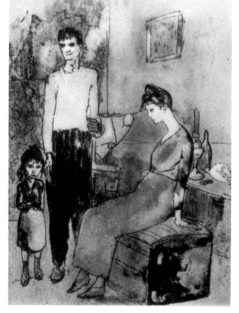

35

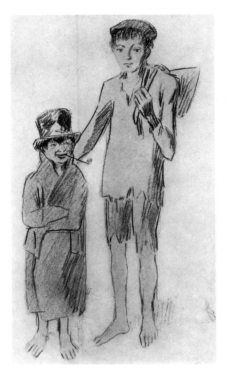
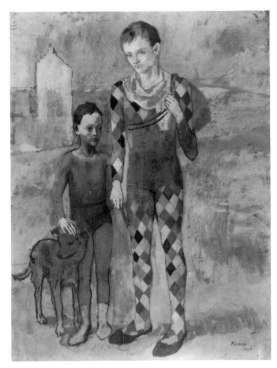

36 37

but idiots whom society shuns and fears. Between the middle of 1901, when he painted a few such subjects—a circus clown and monkey bowing in an arena, a Harlequin and Columbine seated in a café, another Harlequin in an attitude of *fin de siècle* preciosity[77]—and the end of 1904, when he took them up again, he seems to have ignored those subjects entirely. For even in the lonely and melancholy condition in which he tended to represent them both before and after the Blue Period, they were probably too redolent of entertainment and personal achievement to be compatible with its unrelenting pessimism.

Yet there is a greater connection between, say, the later jesters and the earlier idiots than is generally recognized, and one which in turn hints at other continuities of subject-matter from the Blue to the Rose Period. The sympathy with madmen as symbols of an absolute alienation, both social and psychological, can be traced directly from one period to the other, from the destitute and bizarre outcasts in drawings like *The Fool, The Idiot,* and *The Madman* of 1902-04 to the pathetic old jester in *The Organ Grinder* and in a sheet of drawings, both of 1905.[78] Moreover, many of the later pictures of a brooding acrobat's or Harlequin's family have thematic precedents in the earlier period, quite specifically in *The Seizure,* a drawing 35 of a grim father, mother, and child facing eviction, more generally in *The Tragedy* and *Figures by the Sea,* paintings of a similar group now homeless and cast adrift.[79] The latter in turn announce several compositions in which a family of saltimbanques is shown standing dejectedly in a barren landscape, although their costumes and few possessions imply a professional competence not found in their forerunners. In some instances, the thematic parallel is reinforced by a formal one, the two boys 36 in *Street Urchins* so closely resembling those in *Two Acrobats with a Dog* that only 37 the changes in dress and of course in colour identify the latter as a work of the Rose Period. Even the more animated and informal scenes, such as that of a circus family rehearsing outdoors, are anticipated by a drawing like *La Jota,* which shows a group of Catalan peasants dancing.[80] And one scene of an altogether different character, the mysterious and moving *Death of Harlequin,* is related both thematic- 39 ally and compositionally to the pictures of 1901 commemorating the death of Casagemas.

It is in fact only in terms of personal symbolism that *The Death of Harlequin* can

34 Sebastian Junyent, *Portrait of Picasso,* 1904.

35 *The Seizure,* 1904.

36 *Street Urchins,* 1904.

37 *Two Acrobats with a Dog,* 1905.

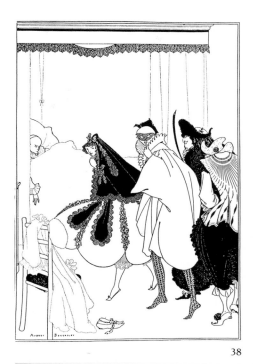

be fully understood. Altogether alien to the boisterous spirit of the Commedia dell'Arte, this solemn and mystical subject occurs neither in any of the theatrical scenarios nor in any work of art inspired by them, except perhaps an eighteenth century painting identified as *La Morte d'Arlecchino*.[81] Harlequin does meet his death in some of Goldoni's plays, but it is of an appropriately violent sort; and the only other relevant works depict either the death of Punchinello, as in a drawing by Domenico Tiepolo, or that of Pierrot, as in certain pantomimes by Champfleury.[82] By the end of the nineteenth century the latter had become a popular subject, often a metaphor of the artist's or writer's alienation and despair, as the 'pauvre Pierrot' drawings of Willette and poems of Verlaine and Laforgue make clear.[83] Perhaps the most interesting example is Beardsley's drawing *The Death of Pierrot*, first published in *The Savoy* in 1896; it shows four of the dying clown's colleagues entering his room on tip-toe; and even more explicitly than *The Death of Harlequin*, it expresses what was for its fatally ill author a profoundly personal sentiment.[84] Yet its elegant, affected figures and rather whimsical tone belie this origin and remove it in spirit from the Picasso. Indeed, none of the works just discussed possesses its gravity or spiritual intensity, which are more like those of the earlier *Mourners* and *Burial of Casagemas* or the religious pictures from which they in turn derive. Stretched out in a plane strictly parallel to the picture surface, his body

38

38

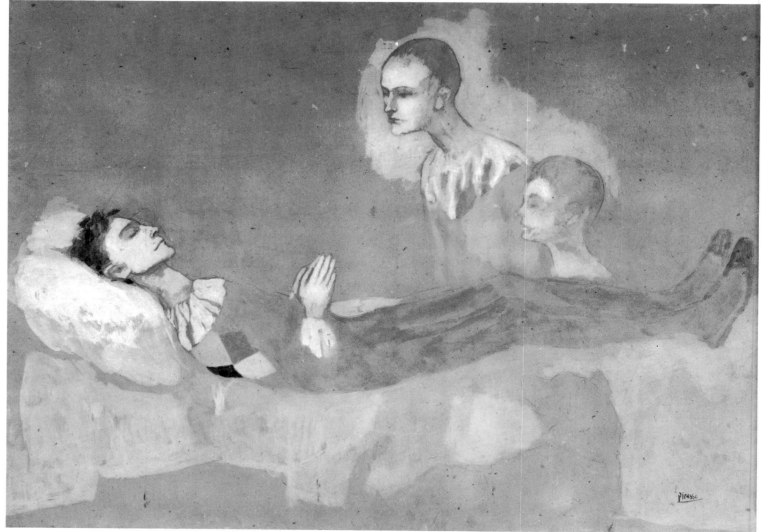

39

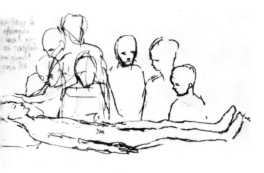

40

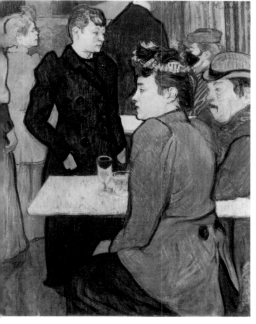
41

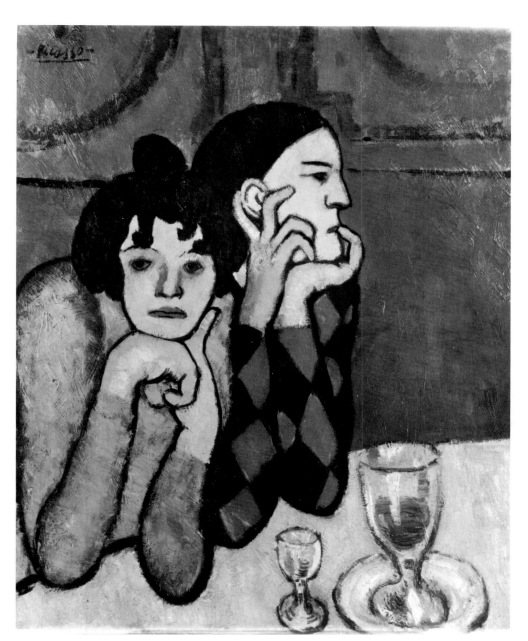
42

ascetically attenuated, his hands joined as if in prayer, the dead Harlequin recalls both the recumbent effigies in Gothic tomb sculpture and the central figure in Renaissance pictures of The Entombment or The Lamentation. The attitudes of his former companions, gravely bending over him in mourning, are like those in Lamentation scenes by Fra Angelico and other Quattrocento artists; and this is even more apparent in a preliminary drawing, in which many more mourners are shown and Picasso contemplates in a note introducing a traditional motive for expressing grief.[85] But if his use of religious prototypes in *The Mourners* and *The Burial of Casagemas* is based on a fairly obvious identification of his dead friend with Christ, the connection here is more obscure and suggests instead some identification of himself with both the dead Harlequin and Christ.

40

That the Harlequin type has often served as an alter ego for Picasso, who in two pictures of the Rose Period gave this figure his own features, has long been recognized. Interpretations of his reasons for choosing this type in particular have

38 Aubrey Beardsley, *The Death of Pierrot*, 1896.

39 *The Death of Harlequin*, 1905–6.

40 Study for *The Death of Harlequin*, 1905–6.

41 Henri de Toulouse-Lautrec, *A Corner of the Moulin de la Galette*, 1892.

42 *The Two Saltimbanques*, 1901.

31

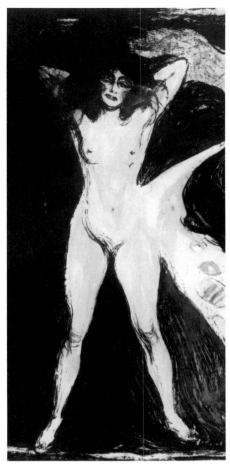

44

45

43 *Woman with a Shawl (Germaine Pichot),* 1902.

44 Edvard Munch, detail of *Woman (The Sphinx),* 1899.

45 Carlos Casagemas, *At the Café,* 1900.

varied from psychological to sociological, depending on the critic's viewpoint, but its significance as the first of those imaginary characters through whom he has often expressed the themes of alienation and fraternity, jealousy and love that haunt his imagination is generally accepted. Indeed, two of these characters, the Harlequin and the Minotaur, meet their end simultaneously in a remarkable drawing of 1936 that closes the cycle of Minotaur subjects corresponding in that decade to the Harlequin subjects of *c.* 1905.[86] Here the dying Minotaur, once again the victim of a woman who directs or spurs on his aggressor, wears a Harlequin's costume as if to reinforce the pathos of his condition. Thus *The Death of Harlequin,* which was evidently the last of the circus subjects painted in the Rose Period—a preliminary study in watercolour is dated 1906[87]—may well express not only a passing morbid sentiment, but the end of a phase in Picasso's personal and artistic development, exactly like the dying Minotaur thirty years later. 326

Even more explicit in revealing the survival of a theme first stated in the Casagemas pictures is the *Harlequin in a Café,* more commonly known as *At the Lapin Agile,* of 1905. On one level an image of Harlequin and Columbine as sad bohemians, like the bored and lonely creatures in the so-called *Two Saltimbanques,* an earlier painting of the same subject, it is on another level an image of Picasso himself and the woman ultimately responsible for Casagemas' suicide. For this is one of the pictures in which the Harlequin is a self portrait, and he has told John Richardson that the Columbine is 'a likeness of Germaine, for whom his great friend, the painter Casagemas, committed suicide.'[88] (The guitar player in the background is Frédé, owner of the Lapin Agile café, which Picasso and his friends frequented at this time.) Thus he imagines himself in a milieu of bohemian gaiety, but in the company of a woman associated with the earlier tragedy. Hence no doubt his total estrangement from her and his brooding expression, whose sombreness is enhanced by the use of cool blue and tan tones in contrast to the brilliant red, yellow, and green tones of his costume and the gaudy feathers and jewels of hers. This typically modern sense of alienation is of course already found in Degas' *L'Absinthe* and in the café and dance hall pictures of Toulouse-Lautrec, whose influence on Picasso is so evident around 1900 and appears here, too, in the diagonal composition, the shrill colouring, and above all the incisive drawing—witness Columbine's sharply etched profile. In the foreground of Lautrec's *Corner of the Moulin de la Galette,* a work Picasso may have seen in Paris, there is an equally disenchanted couple whose isolation is made poignant by their physical proximity.[89] Yet nowhere among the sordid or pathetic habitués of Lautrec's world, and rarely even among the introspective acrobats and clowns of Picasso's, is this suffering as intimately related to the artist himself or as enigmatic as it is here. For its cause is apparently located not in the present, but in an event that had occurred four years earlier, and above all in his later brooding on the meaning of that event. 33 41

Significantly, it was Picasso himself who later identified Germaine Pichot as the woman whom Casagemas had loved—not only in his remark to Richardson, but in a longer, more explicit statement recorded by Françoise Gilot. After taking her to visit 'a little old lady, toothless and sick, lying in bed' in a small house in Montmartre, Picasso explained his didactic purpose:

I want you to learn about life . . . That woman's name is Germaine Pichot. She's old and toothless and poor and unfortunate now. But when she was young she was very pretty and she made a painter friend of mine suffer so much that he committed suicide. She was a young laundress when I first came to Paris. The first people we looked up, this friend of mine and I, were this woman and friends of hers with whom she was living . . . She turned a lot of heads. Now look at her.[90]

33

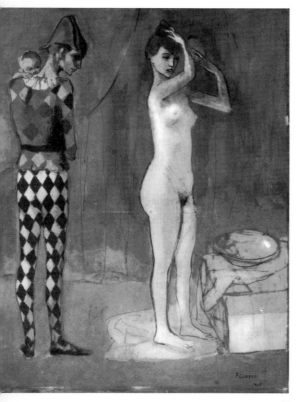

46

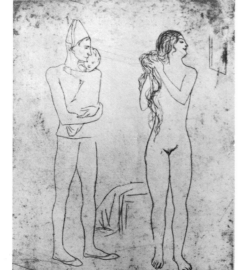

47

46 *The Harlequin's Family*, 1905.

47 *The Mother's Toilet*, 1905.

48 *La Toilette*, 1906.

Thus, having forgotten or chosen to forget about Casagemas' impotence, Picasso came to think of Germaine as the sole cause of the latter's suffering and death. She had clearly become associated in his imagination with the *fin de siècle* type of the fatal woman. Yet she seems to have contributed to this association herself, not least in the frequency with which she changed husbands and lovers. Within months of Casagemas' suicide she was evidently married to Pichot, to judge from the manner in which Sabartès refers to them; [91] yet Gertrude Stein implies that this marriage inhibited her no more than the previous one: '[She] was the heroine of many a strange story . . . There were many other tales of Germaine Pichot and the circus where she found her lovers.'[92] and Alice Toklas alludes to Germaine's seductive appearance in contrasting 'Alice Derain, whose calm beauty had given her the nickname of La Vierge, and Germaine Pichot, whose looks were quite the opposite.'[93] The same can be said of the vivid and sensual features of the *Woman with a Shawl*, a painting of 1902 that Picasso has recently identified as a likeness of her,[94] and of the other works in which it is now possible to recognize her features. Foremost among them is *La Vie* itself; for as Palme observes, the face of the younger woman in it is an idealized portrait of Germaine, and hence Picasso's earliest statement of her part in his friend's tragic death.[95] Not surprisingly, she also appears in one of Casagemas' own drawings, one that anticipates *At the Lapin Agile* in an uncanny manner, since it shows her seated in a café, her face in profile to the left.[96]

43

45

Having played the fatal woman in Casagemas' life and, as several clues suggest, perhaps even in his own life,[97] Germaine Pichot thus came to represent all such women in Picasso's imagination. This would explain why he cast her in the same role when, four years after the events of 1901, he depicted himself as a brooding Harlequin, standing beside her yet totally alienated from her. It would also explain why, twenty years after that, he recalled her features again in painting the frenzied figure at the left in *The Three Dancers* of 1925.[98] It is a figure whose grotesque expression and abandoned posture suggest simultaneously the opposites of grief and ecstasy, embodying in a concentrated, paradoxical form that deep conviction of the fatality of love which must already have crystallized in his mind around her person many years earlier.

129

The notion of the clown or acrobat as a symbol of human suffering, and of the artist's special form of suffering, was of course familiar well before the Rose Period. Its origin is in Romantic art and literature, and its most poignant expressions are in such works as Baudelaire's prose-poem *Le Vieux Saltimbanque* and Daumier's pictures of wandering acrobats and circus side-shows.[99] What is striking in Picasso's imagery is his insistence on locating this suffering not only in the Harlequin's or saltimbanque's alienation from society, but in that more tragic estrangement he feels at times from the woman who shares his life. Hence no doubt the prevalence in the Rose Period of intimate domestic scenes, an altogether unusual type in earlier imagery of circus life, and particularly of scenes expressing a tension between the sexes. In *The Harlequin's Family*, for example, the tall, slender Harlequin, a figure of almost feminine proportions holding an infant on his shoulder, looks on with mingled admiration and resentment while Columbine, who is completely nude, admires her cold beauty in a mirror. Shrewdly, Apollinaire observed in his 1905 article on Picasso: 'The Harlequins attend on the women in their glory and resemble them, being neither males nor females.'[100] In a second version of this composition, a drypoint called *The Mother's Toilet*, the veil of lyrical pink and blue colour is lifted, and the underlying tensions are revealed in sharply bitten lines. Harlequin, his features more gaunt and bitter, observes while Columbine, her posture no longer that of a classical Venus, fingers her long, flowing tresses and smiles voluptuously at her reflection. The image of the fatal woman in late nineteenth century art,

46

47

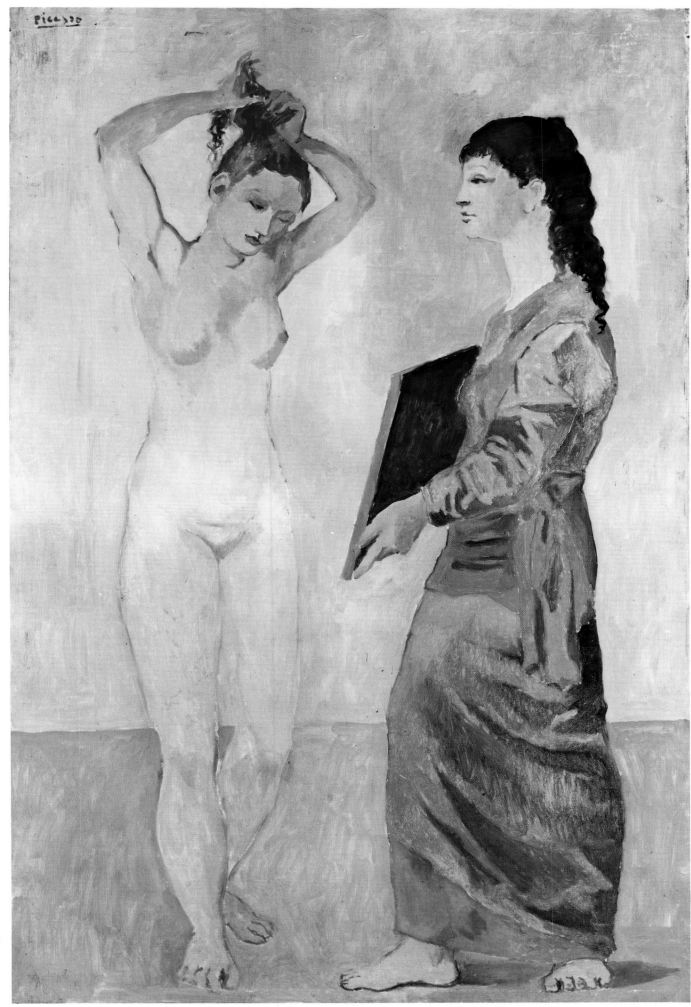

48

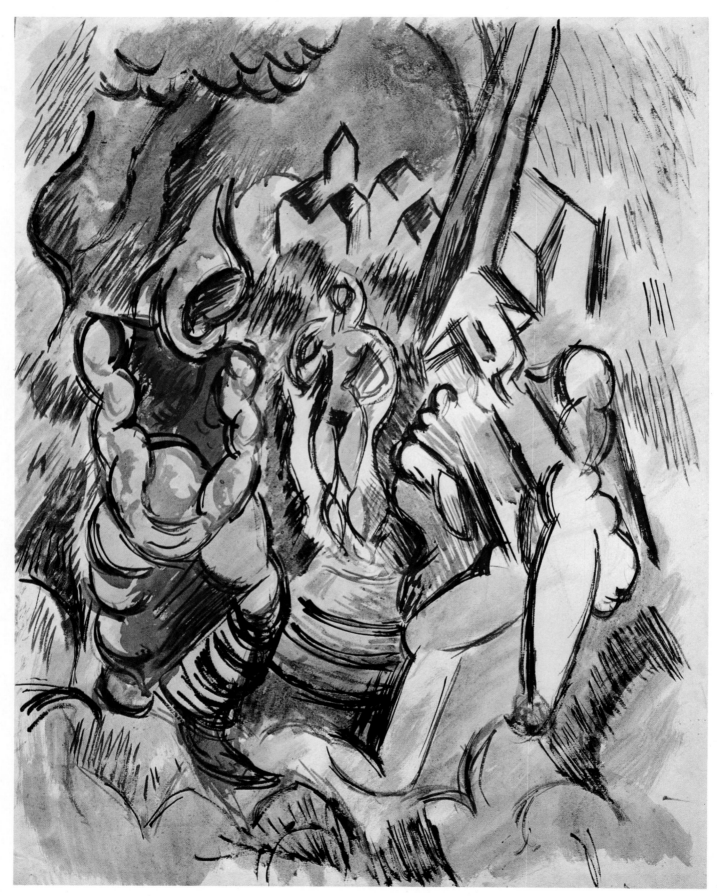

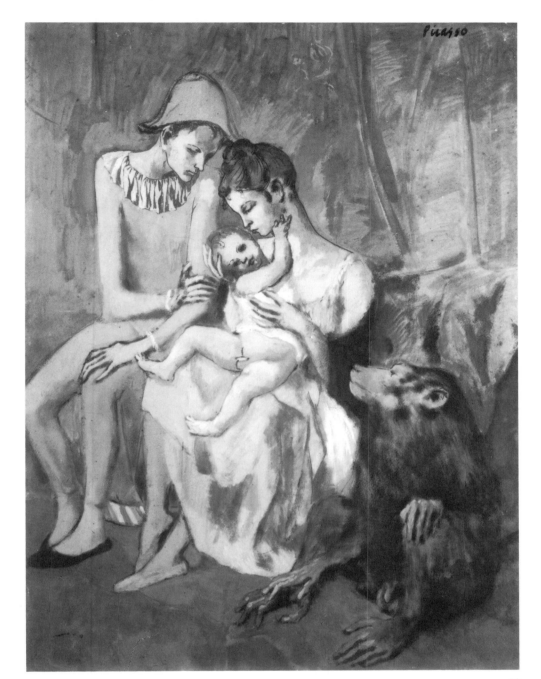

49 *St Anthony and Harlequin*, 1908.

50 *The Acrobat's Family with a Monkey*, 1905.

51 Raphael, *Holy Family with the Beardless St Joseph*, 1505.

50

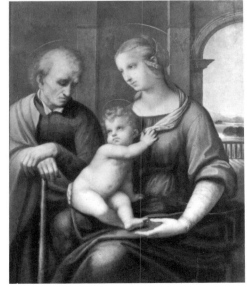

51

especially in works like Munch's lithograph *Woman (The Sphinx)*, clearly lies 44
behind this conception.[101] Yet it is also closely related to an earlier work by Picasso
himself: reversed, as it was when drawn on the plate, it repeats the confrontation
found in *La Vie* between a sternly disapproving figure with a child at the right and a
sensually nude figure at the left. It is true, however, that in other images of the
clown or acrobat at home Picasso dwells on the satisfactions and pleasures of
domestic life. In the *Jester Holding a Child* and *The Jester's Family,* which are no less
personal in inspiration—significantly, one is dedicated to Apollinaire, the other to
Fernande Olivier—he holds up his baby joyously or plays an accordeon as his wife
tends to it; and in the drypoint *Family of Saltimbanques with a Monkey*, the father
looks up proudly as she holds the infant above her head.[102]

Just how much all these works reflect the circumstances of Picasso's life and his
ambivalent feelings about them is perhaps most evident in the painted version of
The Acrobat's Family with a Monkey. Its most striking feature, the complete devotion 50
of the parents, and especially of the mother, to the child she holds on her lap, con-

firms rather than contradicts this statement; for if Picasso and Fernande Olivier had no child of their own, there is evidence that she had adopted one. It was long concealed, but when Carco published a distorted version he had heard, Salmon provided a fuller, more credible one, confirming that Fernande adopted her from a nearby orphanage and treated her like a daughter, while Picasso was alternately paternal and distant.[103] Even the monkey, the other striking element in this picture, must have been inspired by the one whom Picasso kept as a pet, together with three Siamese cats and a dog, in his studio.[104] In fact, he specifically told Leo Stein, the first owner of the picture, that he had not seen the monkey with the acrobat's family, but had added it as his own invention.[105] Yet the ape or monkey has since the Middle Ages been considered the natural companion of acrobats and fools, whose symbolic roles it often shares, and in more recent times it has become the professional colleague of circus clowns, as Picasso himself indicates in a painting of 1901.[106] Moreover, a monkey is shown at the feet of another mother and child in Dürer's engraving *The Madonna with a Monkey,* a frequently copied work that may actually have contributed to Picasso's conception of this unusual subject.[107] For however personal it may be in content, it is obviously inspired in design by Renaissance pictures of the Holy Family, not only that of Dürer, with which it shares one distinctive feature, but those of his Italian contemporaries, which it recalls in its compact, pyramidal composition, its image of the elegant, refined mother and actively twisting child, and even its conventions of drawing and modelling their features.

Of these earlier works, perhaps the most relevant is Raphael's well-known *Holy Family with the Beardless St Joseph,* since it not only shares those stylistic traits, but shows a male figure in the same position and in very much the same attitude as the acrobat in Picasso's composition.[108] If the Renaissance picture was indeed one of his models, then the attitude of St Joseph, a concerned yet apparently somewhat disgruntled observer, paternal yet like Picasso not truly the child's father, in

turn hints at his own inevitably alienated role. It is in fact no more or less essential a role than that of the monkey, a very human creature of serious mien in the tradition of Pope's 'mute philosopher,'[109] with whom the acrobat is compared visually both in the positions of his head and hands and in his compositional relation to the mother and child. As Apollinaire put it in his 1905 article, 'Placed at the limits of life, the animals are human and the sexes indecisive.'[110] Thus, even in a scene of greater domestic harmony than the ones discussed previously, there is a latent mood of estrangement in which it is not difficult to recognize the same ambivalent feelings of love and jealousy that appear more overtly in the others.

Nowhere in the Rose Period does Picasso express these feelings more poignantly than in the so-called *Wedding of Pierrette*. Although this title, which has become traditional, was evidently bestowed on the picture by a dealer many years later,[111] it is an appropriate one. The lady shown is not necessarily Pierrette, or Columbine, for in the colour notes on a preliminary drawing Picasso refers to her simply as 'the lady,' while specifying that the man bowing to her is 'the Harlequin.'[112] And she is not necessarily marrying the rich man seated beside her, but may instead be part of the group observing Harlequin's performance. Yet the latter clearly is blowing her a

52

53

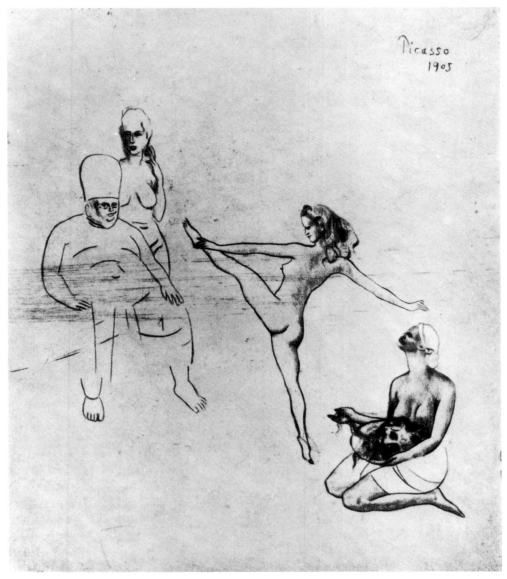

52 *The Wedding of Pierrette*, 1904–5.

53 Study for *The Wedding of Pierrette*, 1904–5.

54 *Salome*, 1905.

54

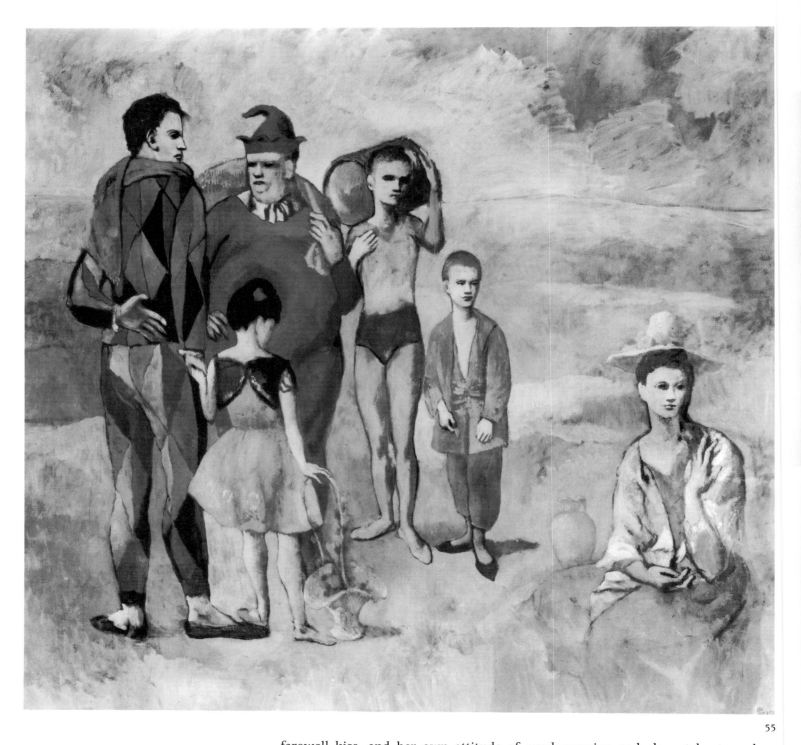

farewell kiss, and her own attitude of condescension and elegant hauteur does distance her from him, implying the kind of separation that her marriage would necessitate. If the subject is indeed The Wedding of Pierrette, it is entirely Picasso's invention, for it occurs neither in the surviving scenarios of the Commedia dell'Arte nor in any work of art they have inspired. Like *The Death of Harlequin,* to which it is a thematic pendant, it suggests a moment in a theatrical performance without being linked to any one in particular. In fact, the preliminary studies represent a different moment, in which the lady, wearing a dress more traditional for Columbine but accompanied by a page and two costumed attendants, turns slightly as Harlequin bows to her.[113] Similar encounters do occur in some of the plays employing Commedia dell'Arte types that were popular at the time, such as Rudolph Lothar's *Harlequin King,* a satirical comedy produced in Paris and Barcelona around 1903 and widely discussed in the French and Spanish magazines read in Picasso's circle;[114] yet

39
53

none of these plays corresponds closely enough to be considered a direct source for his conception. Nor is the role he gives in it to Harlequin, that of the pale, wistful suitor whose love the lady rejects, his traditional one; for as Apollinaire noted a few years later, he is as a lover 'never bashful, brave, crafty, graceful, ingenious, and without scruples.'[115] Rather it is the role of Pierrot, especially in the ironic and pathetic spirit of the Romantic mime Deburau, the Symbolist poets Verlaine and Laforgue, and the *fin de siècle* draughtsman Willette, in whose illustrated fantasy *Pauvre Pierrot* 'three motifs recur constantly: Love is not won, money is not made, death is not avoided.'[116] Or it is the role of the clown who partly absorbs the Pierrot type in the nineteenth century: the circus clown of whom Gomez de la Serna, later a friend of Picasso, was to write, 'They have very sad expressions, because women do not accept them as lovers'; the poetic clown Picasso himself was to identify with Charlie Chaplin, 'a man who, like me, has suffered a great deal at the hands of women.'[117]

It is not surprising, given the essentially symbolic nature of their roles, that the protagonists of *The Wedding of Pierrette* should appear in other costumes and situations in other works of the Rose Period. In the drypoint *Salome*, an image of the fatal woman discussed earlier in relation to the Casagemas pictures, all the major figures are directly descended from those in *The Wedding of Pierrette*. The rich man has become Herod, and wears an emperor's rather than a modern gentleman's hat, yet has the same stout proportions, coarse features, and smug expression. The lady has become Herodias, and like the other figures is entirely nude, yet maintains the same disdainful aloofness, and plays in the same affected manner with her hair. The young girl, apparently a dancer to begin with, has become Salome and dances provocatively before Herod, yet is still seen from behind as in the wedding picture. And Harlequin himself has become, at least by implication, John the Baptist, whose severed head is the ultimate emblem of the ascetic's defeat at the hands of a woman. 54

More important, the same symbolic types are also found in the great painting *Family of Saltimbanques*, and as a result they help to clarify its enigmatic meaning. Like *The Wedding of Pierrette*, it is a composition built on a continuous curve, unwinding from left to right both on the surface and in depth, and consists of six figures.[118] Again the movement begins with the young girl seen from behind, a figure more clearly identified now as a dancer not only by her costume and stance, but by her evident derivation from a type shown in Degas' ballet pictures.[119] Again there is a tall Harlequin, here explicitly bearing Picasso's features and thus confirming the personal significance of his role in the other picture, who closes the composition at one side, though it is the opposite one. Again the figure with whom he is contrasted is a shorter, much stouter man with a distinctive hat and an air of authority, the saltimbanque in a red costume whose fleshy face with close-set features recalls not only the rich man's and Herod's but that of Apollinaire as he appears in the guise of King Dagobert in a bookplate Picasso designed for him in 1905.[120] Again there are two lesser figures, perhaps brothers, who observe the others with sad, deeply shaded eyes. And again the compositional movement ends with an isolated figure who is its psychological focus, although this is not as obvious as in the dramatically concentrated *Wedding of Pierrette*, and the figure is not Harlequin but Columbine. Like the fat saltimbanque and no one else in the group, she wears an unusual hat, and in the picture in which she first appears, the *Woman of Majorca* painted earlier in the same year, it is the still more exotic head-dress typical of that island.[120a] Thus her affinities in this family constellation are not only with the Harlequin, whose age is closer to hers, but with the stout saltimbanque; and this is confirmed by her close resemblance in expression and gesture—the same affected movement of the hand—to the lady in *The Wedding of Pierrette*. Much more remains 55

56

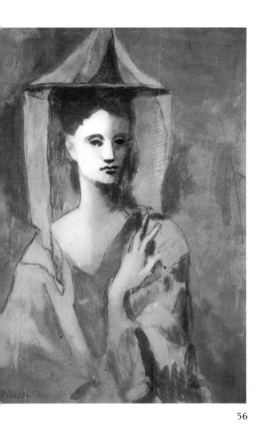

56

55 *Family of Saltimbanques*, 1905.
56 *Woman of Majorca*, 1905.

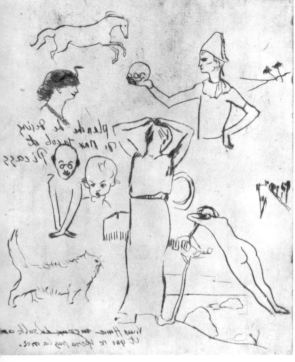

57

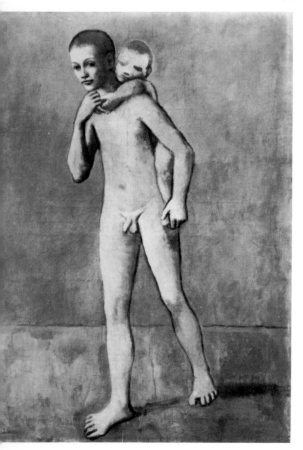

58

to be said about this endlessly fascinating work; yet it is evident from what has already been said that its deeply poignant mood reflects not only the artist's alienation from society, but something of that tension in his relation to women which appears in many other pictures of the Rose Period.[121]

Given his role in those works, it was almost inevitable that Picasso would choose as his ultimate 'circus' role that of the Harlequin who is also Hamlet, and this is precisely what he did in one of the sketches on the so-called *Planche de Dessins*, a drypoint on which he and Max Jacob collaborated in 1905. Seen in profile, Picasso's preferred view of himself, and with the classical yet sullen features of the Harlequin in the *Family of Saltimbanques*, he holds up a skull toward the faintly smiling woman's head, obviously Fernande Olivier's, that is seen in profile facing him. Thus he is both the profoundly melancholy Hamlet who laments the death of Yorrick—the king's jester, an entertainer like Harlequin—and the bitterly ironic Hamlet who would send Ophelia to a nunnery; both the moralist who reflects on the vanity of all human affairs, and the ascetic who rejects all love as sensual and corrupting.[122] The whole vignette may in fact have been conceived as a kind of *vanitas* lesson for Fernande, exactly like the one Picasso later provided for Françoise Gilot. After he had taken her to Germaine Pichot, once the cause of Casagemas' death and now approaching death herself, Françoise concluded: 'I think Pablo had the idea that he was showing me something new and revealing by bringing me to see that woman, a little like showing someone a skull to encourage him to meditate on the vanity of human existence.'[123] In both cases, the drawing etched on a plate and the scene enacted in life, it is a specifically Spanish form of *vanitas* in the tradition of Zurbarán, Valdes-Léal, and the *Caprichos* of Goya. Yet the drawing at least would probably not have been conceived without the 'Hamletism' of the times, as it was evident, for example, in the poetry of Laforgue and Mallarmé and in the play *Pierrot poète* by Gauguin's friend Aurier, the opening scene of which shows Harlequin in a cemetery, 'in the pose of Hamlet', contemplating a skull and quoting the famous soliloquy as he waits for Columbine.[124] It was also evident on a more popular level at the Cirque Médrano, where the famous clown Antonet, with whom Picasso was acquainted, nightly hurled cream pies at the ghost of Hamlet's father.[125]

In the history of Picasso's art 1906 is, as has often been observed, 'the year of the great turning point', the time of his 'return to Mediterranean sources' in classical and archaic Greek art and ultimately in Iberian art, and of his 'search for objectivity' in reaction against the unrelenting pessimism and often enigmatic symbolism of the Blue and Rose Periods.[126] Consequently, his subjects now were, apart from a few portraits and still lifes, single or paired figures, generally nude and always impassive, seen against a neutral background. The most important examples of this style, painted in the primitive milieu of Gosol in the summer of 1906, are suffused with a new tonality, neither spiritual like blue nor sentimental like rose, but warm, luminous, and natural, like the red ochre earth of Gosol itself. Hence it seems unlikely that the symbolic content of the earlier works should also find expression in these more classical and objective ones. Yet, as in the transition from the Blue to the Rose Period, there are many signs here of continuity in theme or conception, indicating the survival of older attitudes despite significant changes in style. Thus *The Two Brothers*, although entirely nude and placed against an undifferentiated reddish background, are direct descendants of the *Two Acrobats with a Dog*; in fact, the older boy's sensitive features and sullen expression are identical in the two pictures, and another version of the later one contains a still life in which there is, besides a pitcher with flowers typical of the Gosol period, a saltimbanque's or

58
37

59

60

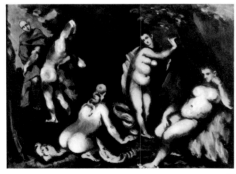

61

circus acrobat's drum.[127] Even *La Toilette,* a painting often singled out as showing 48 'the most complete mastery of the "Greek" idiom,'[128] is closely related to the earlier images of a clothed Harlequin observing a nude Columbine at her toilet, as well as to the image of a heavily draped woman confronting a sensually nude one in *La Vie.* Moreover, the role of the draped figure in the latter is similar to that of the woman, now nude herself, who draws open a curtain as if to reveal the other nude women in the brothel picture entitled simply *Three Nudes* and in the related *Nude in* 60 *Profile,* both of which were painted after Picasso's return from Gosol in the fall of 1906.[129] And of course it is the role of the intruding figure in the great picture to which these others lead, *Les Demoiselles d'Avignon.*

Of the first compositional studies for the *Demoiselles,* consolidated in a charcoal and pastel drawing made early in 1907, Picasso himself has explained that the man 59 standing at the left draws back a curtain with one hand to disclose a sailor surrounded by nude women, flowers, and food, and carries a skull in the other hand.[130] In this drawing it is more likely a book, but in several others published recently it is clearly a skull, sometimes held with a book,[131] so that the whole is evidently conceived as a kind of *memento mori,* in the spirit of the 1905 drypoint sketch of himself as Harlequin showing a skull to Fernande Olivier. That the standing man in some of the recently discovered studies is recognizably a self portrait, despite his tall, slender stature,[132] suggests that his role here is indeed like the Harlequin's in that sketch, as well as the similarly proportioned Harlequin's—again himself, in profile, at the left—in the *Family of Saltimbanques.* That he has also identified the standing man in the *Demoiselles* studies as a student, and more recently as a medical student, for whom both the skull and the book would be appropriate emblems,[133] in any event as an introspective type of whom he was later to make a satirical portrait in a Cubist collage,[134] further suggests that this scene is related thematically not only to the pictures just discussed, but to the lost one of 1901 representing The Temptation of St Anthony. Hence it was altogether appropriate

for him to base the composition and even the poses of individual figures on those of Cézanne's *Temptation of St Anthony* and certain Bather pictures derived from it, which he would have seen in reproductions or at the retrospective exhibitions of 1904-06.[135] In the final version of the *Demoiselles*, both the sailor and the student are eliminated, and the resulting image of five monumental nude women, inexplicable now in narrative or allegorical terms, is far more enigmatic. Yet in their alternately sensual and grotesque appearances, something of the moral conflict and sexual tension of the original conception remains, linking even this version with the Blue and Rose Period works discussed previously.

Memento mori is more explicitly the theme of the extraordinarily violent *Still Life with a Skull* that Picasso painted in the spring of 1908, for almost all the objects shown in it are traditionally found in moralizing still lifes. If the skull symbolizes

61

62

62 *Still Life with a Skull*, 1908.

63 Paul Cézanne, *The Smoker*, c 1895.

64 *Harlequin Leaning on his Elbow*, 1909.

the transience of human life, the books and pipe beside it and the palette and brushes behind it stand for the sensory and intellectual pleasures of that life; and the same is true of the framed object in the background, whether it is a mirror, as has been suggested, or a painting of a nude woman related to *The Offering*, also from the spring of 1908.[136] The intensity of feeling aroused in Picasso by this macabre subject is expressed in the conflicting, angular rhythms and dissonant red, brown, and lavender tones employed throughout. It may well reflect his reaction to the suicide of another artist he knew, the German painter Wiegels, just as the long opium pipe beside the skull may allude to the reputed cause of Wiegels' depression. This tragic event occurred in a studio in the same building as Picasso's own and, according to Fernande Olivier, made so profound an impression on him that he was still haunted by it later in the spring.[137] Thirty-four years later, he was to paint another still life with a skull, this time an ox's skull, to commemorate the death of another colleague, the sculptor Julio Gonzalez.[138]

The melancholy and the sensual, the hermit and the provocative nude, are again depicted, in a style again reminiscent of Cézanne's, in a remarkable water-colour of 1908 that has remained unpublished and unexhibited outside Scandinavia;[139] and what is more, these figures are now joined by a meditative Harlequin who is also based on specific works by Cézanne. In a symmetrical, almost heraldic composition whose highly structured character is typical of Early Cubism, Picasso juxtaposes on the surface three figures occupying different positions in space: St Anthony and Harlequin, the one identified by his monkish cowl, the other by his bicorn hat, are seated in the foreground; and between them, like a statue on a pedestal, is a nude woman standing in the distance. Thus the traditional theme of The Temptation of St Anthony is fused with the more personal one of the ascetic Harlequin. Yet the latter, too, had a tradition in the Romantic and Symbolist type of the *pauvre Pierrot,* and the two themes had even been combined in a *Tentation de Saint-Pierrot* that Hennique and Huysmans announced in 1881 as a pendant to their pantomime *Pierrot sceptique* but never actually wrote.[140] If Picasso was almost certainly unaware of this, he would nevertheless have associated The Temptation of St Anthony with the milieu of Harlequin and Pierrot, since it had long been a favourite subject in the pantomimes performed at French carnivals and fairs and, at least in a slightly earlier period, at the Cirque Médrano itself.[141] It was presumably the same sort of association that led him in 1921 to paint Harlequin, Pierrot, and a Franciscan monk as the *Three Musicians,* an enigmatic work which this double historical precedent—in the popular theatre and in Picasso's own art—makes more intelligible.[142] But in 1908, a year of intensive investigation of Cézanne's work, he would also have had in mind the latter's treatment of The Temptation of St Anthony, whose influence on *Les Demoiselles d'Avignon* the year before has already been mentioned. And for the meditative posture of the Harlequin in his watercolour, he obviously turned to the type of seated, solitary smoker that Cézanne painted often in the 1890s, of which more than one version was exhibited or otherwise available to him.[143] The bent right arm of Harlequin is in fact understandable only in relation to that of Cézanne's smoker, which rests more plausibly on a table.

In the same year, Picasso drew another version of the same composition on a woodblock that he never cut or printed. Here the nude woman remains in the central position, but a second one occupies that of St Anthony, so that she alone now appears opposite Harlequin and the latter's identification with the hermit of the temptation scene is complete. Later in the year and in the following one, he carried this process of reduction one step further by eliminating the nude and showing Harlequin seated alone at a table in a neutral interior, as in the *Leaning Harlequin* of 1909.[144]

49

132

63

65

64

63

64

But if this suppression of the anecdotal is in keeping with the increasing austerity of Picasso's art at the time, it does not conceal the strong affinities between a Cubist Harlequin like this one and the more overtly hermetic Harlequins that precede it: the act of temptation may be gone, but the mood of ascetic withdrawal remains. And this continues to be true even when the style has become so little representational as to be virtually abstract; for the intricately Cubist paintings of Pierrot and Harlequin made in 1911-12 may no longer be identifiable with the earlier types, but they retain in their austerely geometric structure and mysteriously resonant colouring an introspective, even hermetic quality that is closely linked with them in spirit.[145]

65

Appendix: Manolo's Account of the Suicide of Casagemas[146]

One of the persons with whom I planned to be in touch was Mr Casagemas, a fellow from Barcelona who liked me a lot, and this I wanted and could do. I went to see him at 40 Boulevard de Clichy, third floor, where he was staying. Casagemas was a restless man, dignified, handsome, tall, gaunt, with a romantic and pale face. He resembled an Espronceda without the beard.[147] He wore an olive-coloured suit made of velvet, his hair was long, and he had an air of grandiosity about him. He received me very well, and told me that I could count on him in everything and in every way. But during the visit, if I had not been so tired from travelling and from the bustle of the city, I would have realized that there was something wrong in the studio; I would have realized, for example, that on a table there was an enormous heap of letters, addressed and with the stamps put on, ready to be mailed. In spite of the fact that such a thing was uncommon for a studio, I was not going to make an issue of it. In any event, talking a lot he invited me for dinner, and we went out, mailed the letters, and went into a restaurant in the same building where Casagemas

65 *Composition (Harlequin and Nude)*, 1908.

lived. We ate dinner, joined by a certain Pallarés, two other men whose names I don't remember, and two seamstresses from Montmartre. The dinner was good, and perhaps we all drank a little too much. That made me even less capable of seeing things clearly. Because it appeared that during the entire dinner Mr Casagemas was excessively nervous and that he did not know what he wanted to do. At a certain moment my friend rose from the table and gave a speech in French, of which I did not understand a word. Then, in the middle of the speech, with a violent gesture he reached in his pocket, pulled out a gun, and took a shot in the direction of one of the two ladies who were sitting at the table. The girl, who had realized what he was about to do, just had time to duck her head, and the bullet went by her, grazing her nape. There was a moment of general confusion and everybody thought that he had shot her. I myself was in a daze, but after an instant of hesitation I jumped up and attempted to put my arms around Casagemas in order to stop him. He was much taller than I, and I was not able to pin his arms. For a moment I saw a gun in front of my nose. I got scared. So I twisted around and tried to seize him from behind, and I rammed my head forcefully against his shoulder. But another shot was heard, and in front of me there was a dry sound from his throat. Casagemas fell in my arms with a tired expression of death. His face, like a crushed strawberry, was all blood. I lost consciousness, and when I came to, I was told that he had been taken to a distant hospital.

Torres Fuster, who was a painter living in the same house and who looked like a Lohengrin, came down, and with him and the two ladies we went to the hospital to inquire about the suicide. As we arrived, they told us that he had just died. This, really, was my entrance into Paris, but I want to tell you this: I swear on the memory of my mother that on that day I did everything I could to save poor Casagemas, whom I esteemed so much. The letters that we mailed were part of his death, and they were written a few hours before he killed himself. This showed me that Casagemas was more conceited than he appeared the first time.

Next day I met Jaume Brossa,[148] whom Torres Fuster asked to arrange the papers of the deceased man. Among ourselves, more dead than alive, we decided to send a telegram to Pere Romeu,[149] asking him to notify the family. I don't know if Romeu did this; I only know that on hearing the news of her son's death, Casagemas' mother fell dead herself. While the family had to busy itself with this corpse, Brossa gave a number of difficult tasks to the different bureaus. The officials did not know what to do, and Brossa wanted to gain time to wait for the arrival of the family and to be able to move the dead man to Barcelona. Finally the family came and took charge. This terrible drama occurred two days after my arrival in Paris. The studio of Casagemas was afterwards taken by Picasso, who did the head our our dead friend, with that waxlike colour that he had, the delicate nose, and the romantic air.

The death of Casagemas probably changed the course of my life. That tragedy made an extraordinary impression on me. Years after his death I found out other things about Casagemas, which allow one to say that he was predestined to commit suicide, because he had tried it once before in Barcelona by stabbing himself. No doubt, if Mr Casagemas had lived, I would always have had something to eat and I would have been forced to do something constructive. His death caused an inexpressible period of misery in my downtrodden state.

66

Picasso and the Typography of Cubism

Robert Rosenblum

By now it is a commonplace of art history to say that the innovations of Cubism altered the structure of Western painting to a degree unparalleled since the Renaissance. Indeed, so drastic were Cubism's shattering and reconstruction of traditional representations of light and shadow, mass and void, flatness and depth that discussions of Cubist art have rightly concentrated upon the nature of these overwhelming changes. But for most commentators, the formal revolutions wrought by Cubism are so arresting that many secondary aspects of Cubist art tend to be neglected, particularly those which, at least at first glance, seem to be peripheral or even irrelevant to the multiple new visual problems posed. Above all, the subject matter of the great masters of Cubism—Picasso, Braque, and Gris—has been of minimal interest, for the themes they preferred—single figures, still lifes, and less often, landscapes—were so traditional that, in themselves, they hardly detracted attention from the most anti-traditional Cubist language into which they were translated. And with this broad assumption in mind—that the subject matter of Cubism plays an intellectually and emotionally neutral role in the restless formal explorations of Cubist art—even the most unconventional aspect of Cubist subject matter, that is, the abundant intrusion of words and printed papers culled from everyday life, has often been construed as a device primarily oriented toward the solution of the successive formal problems raised by the rapid changes of Cubist structure in the years between 1910 and 1914. How many times have we read that the introduction of hand-painted and stencilled words by Braque and Picasso in 1910-11 was a means of asserting the flatness of the picture plane; or that the pasting of bits of newspaper onto canvas or paper, beginning in 1912, was motivated by the need for enriching the lean textural vocabulary of Cubism![1] Such explanations are by no means incorrect, but their exclusivity has blinded most spectators to the possibility of additional interpretations that would enrich, rather than deny, the formal ones. Indeed, this indifference to the actual reading matter in Cubist art has often been so deeply ingrained that, on more than one occasion, the date printed on a newspaper used in a Picasso *papier collé* has been overtly contradicted by the date assigned to the work by historians and cataloguers.[2] The question, simply, is this: could it really have been that Picasso and his fellow Cubists chose the words, the newspaper clippings, the calling cards, the cigarette-paper packets, the advertisements, the bottle labels, even the kind of type-face (roman, italic, Gothic) with total indifference to their potential verbal meaning or associative value?

Consider, to begin with, the recurrent references to newspapers in Picasso's Cubist paintings, drawings, and collages. Although at times, Picasso painted, stencilled, pasted or drew the names of such French newspapers as *L'Indépendant, Excelsior,*[3] *Le Moniteur,*[4] *L'Intransigeant,*[5] *Le Quotidien du Midi,*[6] *Le Figaro,*[7] as well as the Spanish newspaper, *El Diluvio,*[8] and the new Italian Futurist periodical, *Lacerba,*[9] it was, above all, *Le Journal* which recurred in these works as well as in those of Braque and Gris.[10] Characteristically for the aesthetic of Cubism at its most inventive, even this ephemeral commonplace, that daily newspaper read by Picasso

66 *Bottle of Suze,* 1913.

and other Parisians, is thoroughly transformed. Like the objects that surround them —whether figures, stringed instruments, bottles, wine glasses—the letters on the masthead, LE JOURNAL, are subjected to constant metamorphosis, changing from lucid, discrete wholes to ambiguous, interdependent fragments. Indeed, it is almost a rule that in no Cubist work of Picasso does the entire newspaper name, LE JOURNAL, appear;[11] and even when it is most legible, as in a *papier collé* of winter 1912-13, where it hovers together with a siphon, wine glass and violin upon a drawn tabletop, the article, LE, is omitted. Far more commonly, it is shattered into yet smaller parts. Thus, in the case of a painted still life of 1914, the same two-syllable newspaper title is broken into three syllabic parts, JO/UR/NAL, the verbal equivalent of the planar dissection of Cubist objects, and this release from conventional verbal completeness permits, in turn, a whole series of permutations and combinations that, to be understood, must often be *read* as well as *seen*. Students of Cubism have frequently used the metaphor of a pun to characterize the visual ambiguities so intrinsic to Cubist art, but in fact, such puns exist on a more literal, verbal level as well. Like his fellow Cubists, Picasso was a member of that literary

67 *Still Life with Bottle of Vieux Marc, Glass, Newspaper,* spring 1913.

68 *The Card Player,* winter 1913–14.

generation which included the greatest punster in the history of Western literature, James Joyce. And in more personal terms, too, Picasso was an intimate of such Parisian poets as Apollinaire, who, in the *Calligrammes* of 1914,[12] confounded words and images with a new-found typographical freedom; and of Max Jacob, who was often obsessed with the possibility of endless transmutations of common words.[13] And among his fellow artists, such Dadaists as Duchamp and Picabia would delight in elaborate puns that, at simpler moments, parallel variations on LE JOURNAL. Thus, Duchamp once provided a parody dictionary entry for another Dadaist, Man Ray, whom he defined as: n.m. synon. de Joiejouerjouir.[14]

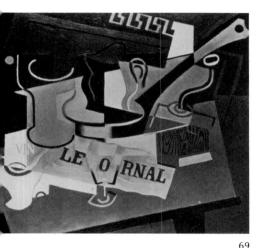

69

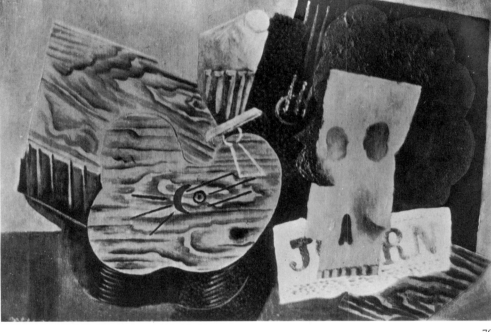

70

It is exactly this kind of multiple verbal-visual reading of similar sounds and letters (*joie*=joy; *jouer*=to play; *jouir*=to enjoy or, in sexual slang, to come) that we can trace in Picasso's metamorphoses of LE JOURNAL. Freed from an absolute form and meaning by the Cubist aesthetic of the relative and the ambiguous, this prosaic word can take on new guises in new contexts. Thus, a simple transformation can be achieved merely by bisection. In *Still Life with a Bottle of Vieux Marc*, dated 67
spring 1913 (but usually misdated spring 1912[15]), LE JOURNAL becomes LE JOUR (the day). But with bisections at different points in the word, other, more evocative puns are also made possible. Thus, JOURNAL can become just JOU, a word fragment that, in French, conjures up the root of the verb *jouer*, to play, a concept that is not only generally appropriate to Picasso's first collage,[16] with its capricious 116
interplay of multiple realities, where the true and the false, the handmade and the machine-made are constantly shuffled, but is even more specifically appropriate to *The Card Player* of 1913–14, whose playing cards, part revealed, part concealed, are 68
echoed in the almost clandestine disclosure of the first letters, JOU, of the newspaper included on the table top.

 In other cases, the fusion of word and image is more complex, in the manner of an Apollinaire *calligramme* whose disposition of letters creates an image of the subject described. Thus, in the *Still Life with Skull* of 1913, which repeats the macabre 70
memento mori still-life theme that Picasso had already introduced in 1907,[17] the

69 Juan Gris, *The Saucepan*, 1919.

70 *Still Life with Skull*, 1913.

grey, papery, mask-like skull merges with the equally grey and papery newspaper in an evocative way. The vowels, OU, of JOURNAL, are obscured by the lower part of the skull, whose nasal cavity suggests a carat, which points upward to the eye cavities, whose rounded hollows fulfill, as it were, the visual and verbal expectation of the concealed vowels. The same kind of fusion of an image and the word JOURNAL occurs, without such grim associations of time and death, in a later still life, *The Saucepan* of 1919 by Juan Gris, whose verbal and visual punning so often rivals that of his compatriot, Picasso. In this example, the J and U of the newspaper title are obliterated by the presence of a wine glass, whose sloping sides isolate the

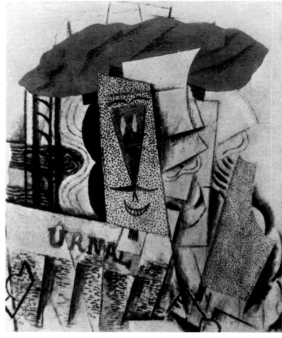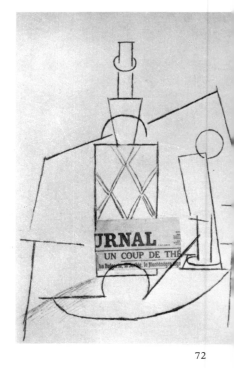

71 72

letter O. As a result, this vowel functions ambiguously as both a single letter, excerpted from JOURNAL, and as a description of the round rim of the glass, transformed by Gris's flattening and geometricizing stylizations into an oval.

Elsewhere, still other possibilities are extracted from the simple verbal premise of LE JOURNAL. In Picasso's *Student with a Newspaper* of 1913-14, one finds the intrusion of a slightly off-colour pun, here perfectly suited to the schoolboy grin of the scarecrow figure, who wears a broad-brimmed *faluche*, the French student's cap: the JO is dropped, leaving URNAL, a combination of letters easily associated with URINAL.[18] The same joke recurs in an earlier still-life context, where the newspaper title, URNAL, is followed by another fragment, UN COUP DE THÉ, which, heading an article about the Balkan Wars that appeared on 4 December 1912, originally read UN COUP DE THÉATRE. Moreover, with the multiplicity characteristic of the Cubist aesthetic, the phrase UN COUP DE THÉ may evoke not only tea, but also the title of Mallarmé's famous poem, *Un Coup de dès n'abolira jamais le hasard*, whose typographical freedom was a major inspiration to the poets in Picasso's circle,[19] and whose titular subject, a die, was a common object in Picasso's still lifes.[20]

The sullying of the ostensibly pure and cerebral character of Cubism with *risqué* verbal puns can be demonstrated in other works by Picasso. In depicting a still life and a man with guitar, both of 1913, Picasso continues his and Braque's frequent intrusion of lettering inspired by posters, in this case announcements of a GRAND

71 *Student with Newspaper*, 1913–14.

72 *Bottle and Newspaper on Table*, 1912.

52

CONCERT.[21] Again, through simple Cubist bisection, Picasso evokes, instead of GRAND CONCERT, GRAND CON,[22] a commonplace French insult that is further compounded, in 1917, in the lettering (as well as the position of hand and bow) of a sandwich-man costume for the ballet *Parade*, which adds, *à la* Jarry's *Ubu Roi*, 74 MERD, to the suggestion of GRAND CON.

Far more clandestine and witty is the lascivious joke concealed in a masterly collage of 1912-13, which substitutes for the commonplace of the newspaper title, LE JOURNAL, a collection of pastings that advertise two famous Parisian department stores, LA SAMARITAINE and AU BON MARCHÉ. Above, we see a commercial drawing of a properly dressed lady, cut off at the waist; below, the label of the *lingerie* and *broderie* department at the Bon Marché; and below that, in much smaller letters that point directly up to the word 'lingerie' and that, in turn, partly fill a pictorial 'hole' in the jigsaw-puzzle compactness of this collage, we read the 117 fragmented words TROU ICI (hole here).

The stimulus of brand names, labels, advertisements, posters was constant in the Cubist milieu and, in two cases, Picasso even managed to combine the very word 76 Cubism with a commercial commonplace, the trade name, KUB, of a bouillon cube 77 that is still sold in France today. Here the letters KUB, together with the number 10 (the price in centimes), are imposed upon the schematic drawing of a cube, which then, as now, appears in the advertisement. In fact, the unexpected topicality of this familiar French advertising emblem for the milieu of avant-garde painting was seized as well by Mondrian, who, engrossed by Cubism in Paris between 1912 and 1914, made both a relatively literal drawing of this advertisement on a Mont- 78 parnasse facade and an abstract composition in which the same letters, KUB, can 79 be read.[23] And it is said, too, that in 1911, upon arriving in Collioure for his summer holiday, Matisse was chagrined to discover that even there he could not escape Cubism, for he found a KUB poster on his house.[24]

Picasso's singling out of the KUB advertisement was clearly motivated by the

73

74

75

53

76

77

78

79

joke on Cubism that it offered both verbally and, in the transparent cube drawing, visually. In the same way, his choice of the popular slogan (and title of a brochure[25]), NOTRE AVENIR EST DANS L'AIR (Our future is in the air), for inclusion in three Cubist still lifes of spring 1912[26] may allude to his and Braque's private joke that their experiments in collage and constructed sculpture paralleled the innovative techniques of such pioneer aviators as Wilbur Wright, whose death on 30 May 1912 might even have provided the stimulus for Picasso to commemorate this topical phrase by inscribing it in works of art.[27]

80

Most often, however, Picasso's selection of commonplace words, like his selection of commonplace objects, belonged to the milieu of the French café (whose ambiance provided the richest stimulus for Cubist art) and, in particular, to the inventory of alcoholic drinks available there. Even in a pair of such casual Cubist drawings as those made during the summer of 1912, Picasso chose to record, with the eye of a *flâneur* on holiday, 1) a café corner with chair and table top laid out with newspaper headlines (La Vie au Gran . . .), bottle, glass, and in the background, lettering with the price (50 centimes) of Munich beer; and 2) a street facing the old port of Marseille, where the nearly illegible scaffolding of Cubist hieroglyphs, punctuated by an anchor, is suddenly given a prosaic point of visual entry by the lettering, APERITIF, on a café awning, by the fragment of a street sign, LA CANE (BIÈRE?), and by the no less literal rendering of figures at a café table and of the carriages below.

81
82

From such cafés Picasso selected the names and labels of apéritifs like Pernod, Anis del Mono, and Suze, brandies like Hennessy, Vieux Marc, and Françoise, and ales like Bass, all of which turn up with the frequency of the daily newspaper and are subjected to similar metamorphoses. Picasso especially enjoyed a kind of Cubist prestidigitation of these identifying labels, that is, a constant oscillation of their levels of fact and fiction. At times, as in the case of a bottle of Suze, he actually pasted a real label onto a Cubist bottle; elsewhere, at the opposite extreme, he would label a bottle of Bass with his own, irregular hand lettering in typographical contrast to the printed lettering on a calling card and the label of a package of tobacco. But at other times, with even richer Cubist wit, he would further compound

66
120

80

76 *Landscape with Poster*, summer 1912.

77 *Still Life with Bouillon Cube*, spring 1912.

78 Piet Mondrian, *Paris Buildings (Rue du Départ)*, 1912–13.

79 Piet Mondrian, *Oval Composition*, 1913–14.

80 *Still Life ('Notre Avenir est dans l'Air')*, spring 1912.

81 *Café Table*, summer 1912.

82 *The Old Port at Marseilles*, summer 1912.

81

82

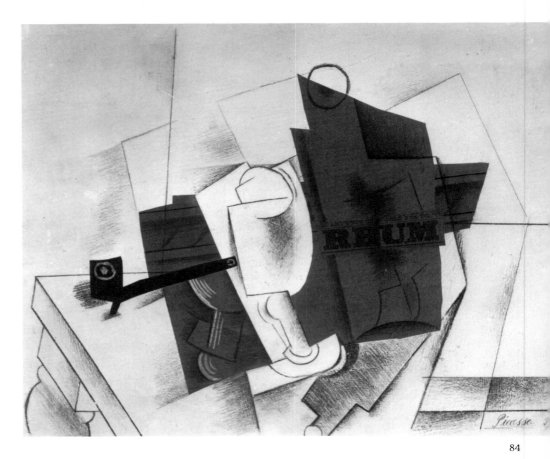

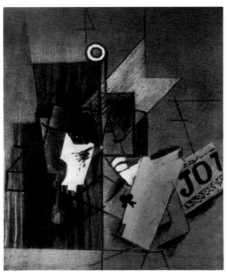

83 *Bottle and Glass on Table*, winter 1912–13.

84 *Pipe, Glass, Bottle of Rum*, 1914.

85 *Still Life with Bottle of Bass*, 1912.

these levels of fact and fiction by identifying a Cubist bottle neither by hand nor by the actual label, but rather by pasting a newspaper advertisement for the alcohol in question. Such is the case in a still life of 1914, where the lettering RHUM simultaneously identifies the contents of the Cubist bottle and suggests the presence of the newspaper itself on the still life table, or yet more ambiguously, in an earlier *papier collé* of December 1912,[28] where, if we trouble to read the trapezoidal column of advertisements Picasso selected from the newspaper, we discover not one, but two possibilities—MARC 'A LA CLOCHE' and VIN DÉSILES—for identifying the exact contents of the drawn bottle to which the clipping has been affixed. And with still greater duplicity, Picasso could also turn a bottle of BASS into a playing card simply by isolating the AS (French for ACE) of BASS on a flat plane and locating it next to a floating symbol of a playing card club. The result is an ace of clubs split into verbal and symbolic fragments that, like the evocative JOU of the JOURNAL which hovers on this table top, keep changing identities.

Such Cubist conundrums are quite as common in the labelling of the bottles of Picasso's compatriot, Juan Gris. On his café table tops, even humble bottles of Beaujolais can suddenly be transformed into verbal jokes. Often, the word BEAUJOLAIS is fragmented to a simple BEAU, which, in addition to taking on adjectival status that might define the quality of the wine, could even confuse the wine drinker into thinking that he had a bottle of Beaune; and in one case this word fragment joins verbal forces with the equally fragmented newspaper title, LE JOURNAL, so that the two elide in a new phrase that begins, BEAU JOUR (beautiful day). In another example, Gris offers the most comic metamorphosis of all. Here, in identifying a bottle of red wine, he permits only the letters EAU to show on the label (originally B*eau*jolais, B*eau*ne, or Bord*eaux*), and thereby performs his own

Cubist version of The Miracle at Cana. And in yet another case, the name of the popular apéritif, DUBONNET, is observed on a matchholder and faceted into separate syllables—BON and NET[29]—which again provide a permutation of verbal meanings that creates the exact linguistic counterpart of the Cubist visual legerdemain that questions the identity of objects through fragmentation and elision.

Like newspapers and the brand names of alcohol, references to music are as common in the Cubist dictionary of words as in the Cubist repertory of still life objects. Although Braque, in particular, alluded often to classical music, with sprinklings of words like SONATE, ETUDE, DUO, ARIA, RONDO, or even the

88

89

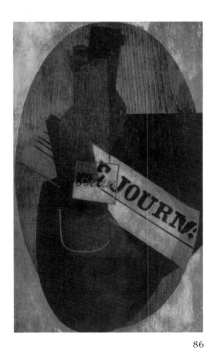

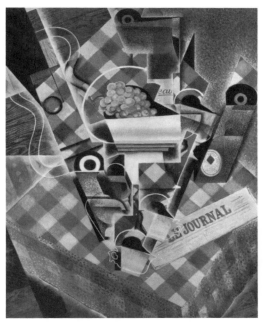

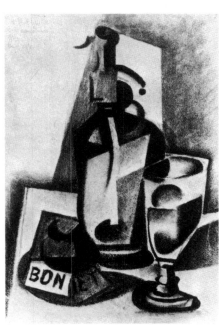

86 87 88

names BACH, MOZART, KUBELICK, it was popular music that dominated most Cubist art. For Picasso especially, popular songs provided further possibilities for the piquant intrusion of the commonplace within the arcane visual environment of Cubist art. These may range from unspecified waltzes[30] to a mazurka like *Trilles et Baisers*,[31] from more sentimental songs like *Sonnet* (after Pierre Ronsard)[32] to the famous habanera, *La Paloma*.[33] But the most frequent musical reference is undoubtedly MA JOLIE, words excerpted from the refrain—'O Manon, ma jolie, mon coeur te dit bonjour!'—of a popular song, *Dernière chanson*, written by Fragson in 1911.[34] Shortly after, in the winter of 1911-12, the phrase MA JOLIE appears in Picasso's work, at first in the magisterial figure painting now commonly known by this title, although originally catalogued by Zervos as 'Femme à la guitare'.[35] The inclusion of the phrase MA JOLIE in this complex, nearly indecipherable Cubist context can be interpreted in many ways.[36] For one thing, it functions here as a pseudo-title, mocking with its impersonal lettering and its position at the bottom of a nearly illegible painting the identifying title one might find on a picture in a museum. For another, it must have provided in 1911-12, the time of the song's debut and success, a jolting reminder of a popular tune, known to all, in the midst of an avant-garde pictorial style, understood by few. Indeed, this abrupt confrontation between a new experimental art of overt difficulty and an easily comprehensible fragment culled from popular art is paralleled at exactly the same time, 1911, by Stravinsky, who, in the first scene of *Petrouchka*, suddenly introduced

86 Juan Gris, *Still Life*, 1916.

87 Juan Gris, *The Check Tablecloth*, 1915.

88 Juan Gris, *The Siphon*, 1917.

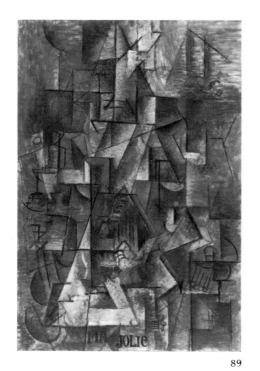

89

into a daring new musical fabric of polyharmony and polyrhythm (the musical counterpart of Cubist visual multiplicity) a simple and lilting popular melody— 'Elle avait un' jambe en bois'—which he had often heard played on a hurdy-gurdy outside his window in Beaulieu.[37] But Picasso's use of the phrase MA JOLIE could have, with typical Cubist ambiguity, yet another meaning, this time private and sentimental rather than public and aesthetic. For Picasso's new girlfriend of the Cubist years, Marcelle Humbert, was called 'Eva' by the artist, who, on 12 June 1912, wrote to his dealer Kahnweiler that he loved her and would write her name on his pictures.[38]

That name, EVA, like a still-life object or the words of a newspaper clipping, was subjected to Cubist metamorphoses which combined it with the refrain, MA JOLIE. In one case, JOLIE, in its role as half of the song phrase, is inscribed above EVA, offering an adjectival embellishment to a lover's tribute to his loved one. Elsewhere, Picasso inscribes more explicitly J'AIME EVA.[39] But more often—at least twelve times[40]—he simply writes or stencils MA JOLIE, which in this context becomes, as it were, a clandestine reference to Eva in the guise of a public reference to a popular song.

Again, Picasso's exploration of song titles for secret allusions or puns was

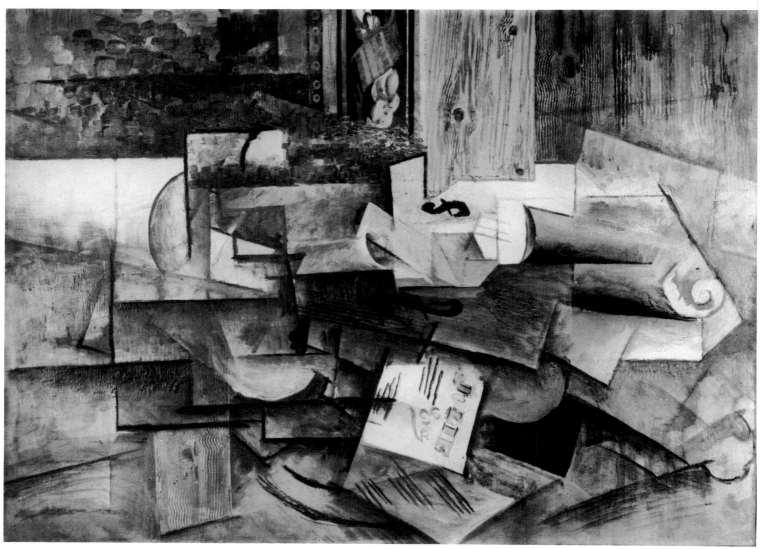

90

89 *Woman with Guitar ('Ma Jolie'),* winter 1911–12.

90 *The Violin ('Jolie Eva'),* 1912.

91 *Still Life ('The Architect's Table'),* 1912.

92 Max Weber, *Avoirdupois,* 1915.

93 Juan Gris, *The Package of Coffee,* 1914.

94 Juan Gris, *The Violin ('Auprès de ma blonde'),* 1913.

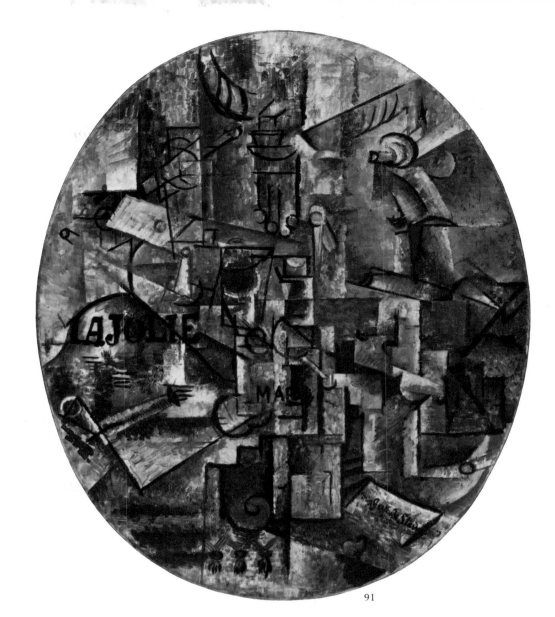

91

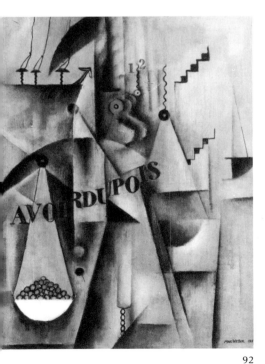

92

93

94

paralleled by Gris. In one particularly witty example, a café still life of 1913, Gris inscribes on his table top a fragmentary sheet of music which reads, AUPRÈS DE MA BLONDE, the name of the well-known French folk song, and locates this title next to a fluted beer glass, of a kind so common in his still lifes. A joke may well have been intended, for French café slang refers to a glass of light beer as 'une blonde,' a reference that would here unite, in a verbal and visual joke, the love song and the beer glass. In a similar example, Gris establishes yet another connection between word and image. Here, in a still life of 1914,[41] which includes a package of coffee, a bottle, two cups and a newspaper, the clipping at the left reports on the French invasion of the Moroccan city of Tazza and diagrams these military manoeuvres on a map. Again, the juxtaposition of the printed word TAZZA and the drawn shadow of a Cubist cup at its right would hardly seem accidental; for especially to Gris, a Spaniard in France, the word TAZZA would offer a kind of Romance language pun on both French *tasse* and Spanish *taza*. Even in lesser Cubist masters like the American Max Weber, this kind of punning can be found (perhaps expectedly in his case, in view of his efforts to create in *Cubist Poems* of 1913[42] the verbal equivalent of his pictorial Cubist aesthetic). In his representation of a scale, painted in 1915, the stencilled word AVOIRDUPOIS hovers precariously in letter fragments that echo the movement of the balancing mechanism, and is then translated into a visual joke by the contents of the scale: a mound of peas (*pois*).

It was the words and images of the newspaper clippings, however, that tended to produce the wittiest and most clandestine jokes in Cubist art. Consider a Picasso *papier collé* of 1913, in which a trapezoidal newspaper clipping, pasted upside-down, enlivens an unusually ascetic drawing of a still life. One might well ask why Picasso had chosen to paste this clipping upside down, and the answer, to begin with, might be that this position contributes to the Cubist sense of weightlessness, of gravity-defiant objects. But if one also takes the trouble to read the small print, one sees that the upper portion is an advertisement for an electric light bulb, which is illustrated, and that the text boasts that this bulb is 'la seule qui éclaire dans toutes les directions' (the only one which gives light on all sides) and 'la seule qui se place *indifféremment* dans toutes les positions' (the only one which can be placed in any position at all)—which is exactly what Picasso has done. Indeed, the location of the commercial illustration of the bulb in the centre of a skeletal linear network transforms this bottle-shaped volume into a lamp base (with arced shade), yet another example of Cubist sleight of hand.

The same attention might be paid to an earlier *papier collé* of winter 1912-13, where a clipping from LE JOURNAL joins visual, verbal, and conceptual forces with the dissected wine glass that is drawn upon it. To begin with, the square frame of the diagram provides another geometric variation among the trapezoid of the siphon at the left, the spiral of the violin at the right, and the circle and parallelogram of the wine glass's lip and bowl. But even more, the diagram within the newspaper frame is delightfully appropriate, for it illustrates, as the caption explains, 'Comment on pose une ligne à 1000 mètres de fond' (how to lay a line at a depth of 1000 metres). Here, in a cross-section of the sea, almost Cubist in its schematic transparency, a fishing boat is seen dropping a line that visually connects with the drawn circle of the wine glass's lip and that almost seems to attempt to anchor, with its plumb-line verticality, the swaying, teetering rhythms of the Cubist objects set afloat around it.[43] In gravitational contrast to Picasso's deep-sea fishing, Gris, on one occasion, used a newspaper diagram to make his still life airborne. Here, the illustration, formally analogous to the checkerboard squares to the right, shows us the lower part of a dirigible, whose swollen arc seems to hover under the base of a wine glass that, with an almost Futurist path of movement, floats up to the

95

96

97

98

95 Detail of *Bottle and Glass*, 1913.

96 *Bottle and Glass*, 1913.

97 Juan Gris, *Still Life ('The Table')*, 1914.

98 Detail of Gris' *Still Life ('The Table')*, 1914.

99 *Still Life with Siphon, Glass, Violin,*
1912–13.

100 Juan Gris, *Still Life (Glasses and
Newspaper),* 1914.

left-hand corner, as if propelled skyward by this fragment of an airship.[44]

Gris, in fact, was especially canny about choosing newspaper clippings that pertained to the aesthetic of Cubism, whether in terms of gravity,[45] the interplay of fact and fiction, the technique of collage itself, or the question of signatures. In one case, *The Table* of 1914, the headlines of the lead article announce LE VRAI ET LE FAUX . . . , an appropriate comment on a still life that constantly confuses, in a manner worthy of Pirandello, the true and the false components in an array of illusionistic devices that range from the *trompe l'oeil* key to actual pastings from books and newspapers.[46] Moreover, at the extreme right, another newspaper clipping offers a joke on the Cubist aesthetic: the upper half of a photograph of a man's head, whose face disappears beneath an opaque plane, is topped by the word fragment DISPAR . . . , which might be *disparu* or *disparition* (disappeared or disappearance), a reference, as it were, to the missing person who vanishes in accord with the Cubist principle of the fragmentary and the elusive.

Les Villes sœurs

DIX PAGES. — CINQ CENTIMES

LE JOU

Un de nos
" l'Adjuda
détruit par

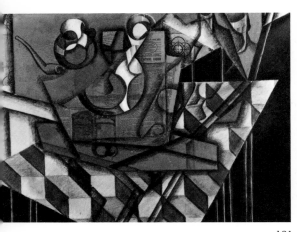

101

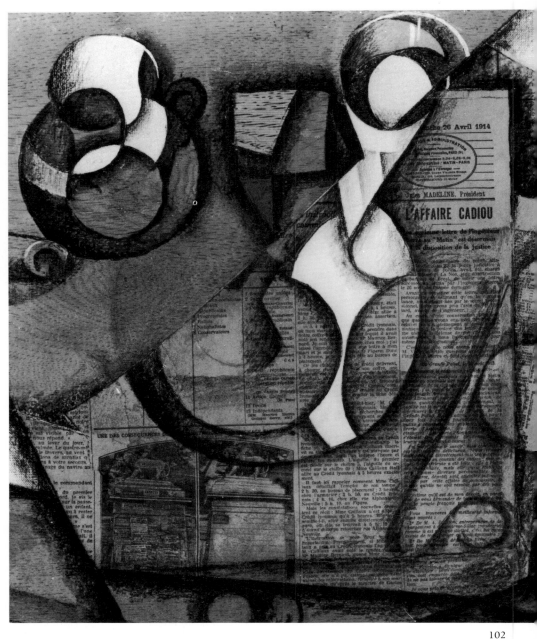

101 Juan Gris, *The Tea Cups*, 1914.

102 Detail of Gris' *The Tea Cups*, 1914.

In another collage of 1914, *The Teacups,* Gris alludes to the very technique of pasting papers. Here, a pair of before-and-after photographs of the statue of a lion on its plinth in the Place de la Concorde demonstrates, as the caption explains, 'Une des conséquences de la loi restreignant l'affichage électoral' (One of the consequences of the law restricting the posting of electoral notices). The text of the article,[47] not included in Gris's clipping, actually went on to explain how the photograph at the left showed the statue in January, 1889, during the electoral campaign between Jacques and General Boulanger, whereas that on the right showed the same statue just yesterday (i.e., 25 April 1914). The lesson was that the picturesqueness of these pasted posters may have been lost, but that beauty and cleanliness had certainly won. It is almost as if Gris jestingly suggested that henceforth the technique of Cubist collage was to be a subversive activity, not only made illegal by the new law, but aesthetically condemned as ugly and untidy.[48] And in yet another collage of 1914, Gris offers perhaps his wittiest newspaper clipping of all. A faceless gentleman is concealed behind a newspaper, LE MATIN, and a glass of beer, evoking perhaps the sinister mystery associated with that famous fictional detective, Fantômas, so popular in Paris at the time, thanks to Marcel Allain and Pierre Souvestre's book (1911) and the cinema serial made from it by Louis

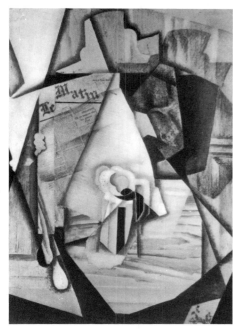

103

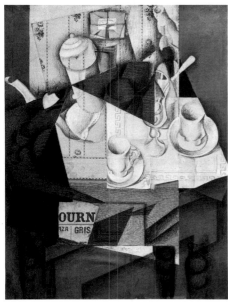

105

104

103 Juan Gris, *Figure Seated in a Café*, 1914.

104 Detail from Gris' *Figure Seated in a Café*, 1914.

105 Juan Gris, *Breakfast*, 1914.

Feuillade.[49] The article that faces us bears out this allusion to criminology. Entitled 'Bertillonnage: On ne truquera plus les oeuvres d'art', it refers to the famous French criminologist, Alphonse Bertillon, who had devised a new system that would prevent forgeries. The small print, only partially included by Gris, goes on to propose that artists fingerprint their own works, so that authentic works could be distinguished from forgeries by criminological methods, an idea approved, so the newspaper reported, by such painters and sculptors as Harpignies, Bonnat and Rodin. The article went on further to include a diagram of fingerprints, a fact which may well have stimulated Gris's idea of permitting the naturalistically drawn fingers of the invisible man to make their imprint, as it were, on the front of the newspaper as a kind of mock signature.[50]

The very idea of true and false works of art and true and false signatures could hardly have been more timely to the Cubist milieu.[51] Indeed, in the same year, 1914, Gris was sharp-eyed enough to find his own name in LE JOURNAL as part of a headline, and used it comically as a mock signature that might have unsettled Bertillon's criminological methods.[52] But it was Picasso, above all, who experimented with the typographical jokes and disguises potential to a signature in a Cubist work of art. It should be remembered, to begin with, that in the period 1908-

104

105

106

107

108

13, Picasso, like Braque, almost never signed his Cubist pictures on the front side, presumably to underline their anonymity. When such a signature does, in fact, appear on the front of a Cubist picture it generally has been added by Picasso at a much later date in order to authenticate it.[53] But given this voluntary proscription of traditional signatures, Picasso began to find Cubist fictions that could re-introduce his signatory identity in as unexpectedly witty and stealthy ways as his surreptitious references to Eva in the guise of the song phrase, 'Ma jolie'. In a tiny, oval still life, probably dating from spring 1912,[54] Picasso painted a letter with a handwritten inscription, 'Monsieur Picasso, 11 Bd. de Clichy, Paris,' which functions, with

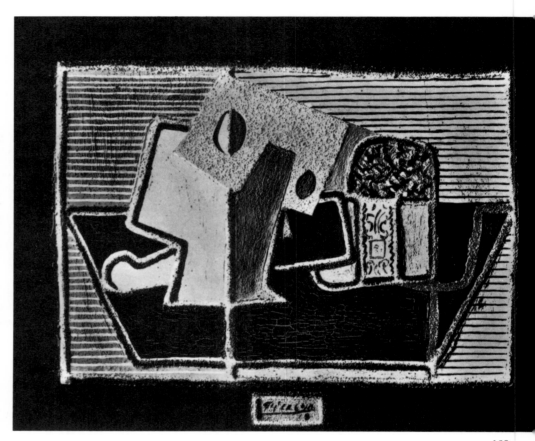

109

typical Cubist double-entendre, as both an imitation of a real letter addressed to the artist and the artist's own handwritten signature.[55] Perhaps, too, it was the same impulse to break the facade of pictorial anonymity in 1911-12 that may help to explain Picasso's occasional choice, at this time of his and Braque's greatest stylistic convergence, of specifically Spanish motifs: Spanish words, references to the bull fight, and in one case, even the bright red-and-yellow Spanish flag, which forms a background to the bullring phrase, SOL Y SOMBRA.[56]

By 1914, however, Picasso once more began to sign his pictures in an explicit way, except that now, in many cases, his signature was the subject of the same kind of metamorphoses which characterized his Cubist treatment of other objects and typographical elements. In one such work, his signature reappears in the unexpected role of a mock printed label, affixed to a frame as mock as the rope frame on the first collage. This, in turn, encloses a matting of speckled paper, upon which is illusionistically affixed a small still-life drawing which casts a mock shadow. Like Pirandello's *Six Characters in Search of an Author,* this collage keeps juggling layers of

106 *The Letter*, spring 1912.

107 *Spanish Still Life*, 1912.

108 *Still Life with Pipe*, 1914.

109 *Still Life*, 1918.

artistic illusion, which here reach their most ambiguous point in the *trompe l'oeil* name plate. Together with the decorative paper border, which parodies the baroque carved frame of a traditional masterpiece, the name plate ennobles, as if in a museum display, the modest little Cubist still-life of pipe and music score (again 'Ma jolie'). And as a further complication, the printing on the name plate, though nominally impersonal in its block letters, is nevertheless sufficiently irregular to suggest that it, unlike the decorative frame, is handmade, not machine made, so that all facts and fictions are cast into doubt. And later, in 1918, Picasso added still another level of complication by signing the *trompe l'oeil* name plate on a little still life not with

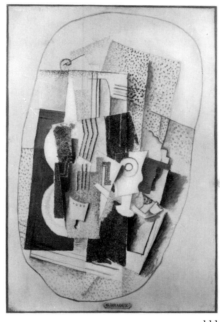

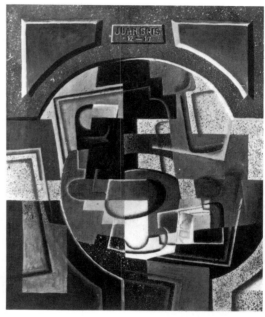

impersonal block letters, but rather with his usual personal signature, a hand-painted flourish underlined and followed by the date, 18.[57] Such ideas, in fact, even preceded Cubism; for already before 1900, Picasso had made many casual drawings that included *trompe l'oeil* frames and labels, as in the case of a portrait drawing of his friend, Hermen Anglada, presented within a pseudo-frame whose prominent inscriptions identify both the sitter and the artist.

The aggrandizement of a Cubist still life to the pretensions of framed and labelled museum pieces must have seemed at the time a particularly ironic joke, for Picasso could hardly have suspected then that one day his modest studio experiments would, indeed, be publicly displayed and esteemed in the company of earlier master-pieces of Western painting. The joke, in fact, was shared by other Cubists. For example, Braque, in his *Music* of 1914, enclosed a still life in an irregular, biomorphic frame, outside of which he added a *trompe l'oeil* name plate that also functions, like Picasso's, as both an official museum label and (since it is handmade) a mock signature and equally confounds the proper boundaries of the work of art.[58] Gris, too, was later to explore the joke in 1917, when he enclosed a Cubist still life with an elaborate *trompe l'oeil* frame, at the top of whose arced grey boundaries are inscribed, as if by machine, the artist's name and the date of the work: JUAN GRIS 12-17. Again, the frame and the label are, so to speak, both inside and outside the picture, and the signature itself is both true (having been made by the artist's own hand) and false (having been imitated from an impersonal inscription made by a machine).

110 Diego Rivera, *Still Life with Carafe*, 1914.

111 Georges Braque, *Music*, 1914.

112 Juan Gris, *Still Life with Plaque*, 1917.

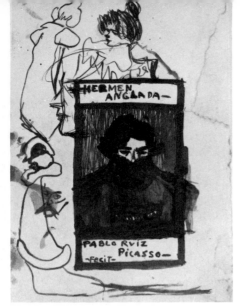

113

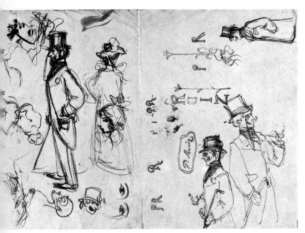

114

115

113 *Sketch of Hermen Anglada*, 1900.

114 *Various sketches*, 1898.

115 *Still Life with Bottle of Bass*, 1914.

An even more complex example of mistaken identities in Cubist signatures may be found in a work of 1914 by the Mexican master, Diego Rivera, who was then part of the Cubist milieu in Paris. Included in a Cubist still life of a glass and carafe is a real telegram received by the artist, with his name and address (26 rue du Départ) handwritten by an anonymous postal clerk, presumably with the *trompe l'oeil* fountain pen (then a new invention) that hovers beside it. In contrast to this 'signature' of the artist, hastily scrawled in ink by someone else, is another signature, this time drawn by the artist himself on the table's rounded edge, as if carved in wood in impersonal block letters. The Cubist delight in confounding identities reaches a baffling climax here, for the overtly impersonal, printed signature is, in fact, the true one, made by the artist's own hand, whereas the overtly personal, handmade one is, in fact, the false one, made by a stranger.

The idea of a signature that could mimic styles of writing other than the artist's own appealed particularly to Picasso. Even before 1900, first as a child and then as a prodigious young artist in Madrid and Barcelona, Picasso made endlessly imaginative and abundant doodles in which he experimented with all manner of monogram and signature, ranging from lettering styles that echoed the inventive new shapes of Art Nouveau typography to those that mimicked the traditional elegance of cursive script.[59] In the Cubist years, this precocious diversity was revived and expanded, not only by signatures in the form of a name plate, but also by signatures in the form of a calling card. In one example, a still life of c. 1914,[60] a papery plane with a dog-eared upper right-hand corner has the artist's name stencilled upon it, continuing in the realm of signatures Picasso's earlier use of stencilled letters to suggest the more impersonal realm of posters and newspapers.[61] Here, the artist's traditional handwritten flourish is transposed to stencilled lettering that seems to be stamped upon a calling card, which is then dropped upon the table with the other still life objects. That the card is dog-eared suggests, according to traditional rules of etiquette, that the owner of the card has paid a personal visit, but found no one at home.[62]

The same kind of wit (used as well by the Futurist Carla Carrà after a visit to Paris in 1914[63]) could be applied to the calling cards of Picasso's friends. Already in spring 1912, Picasso translated the fact of a friend's visit into a pictorial fiction. According to Gertrude Stein,[64] she and Alice B. Toklas visited Picasso in his new studio on the Rue Ravignan; but finding him not at home, she left her calling card there, only to discover a few days later that Picasso was working on a painting which included the card on the lower right-hand corner of a table.[65] This hand-painted illusion of a calling card, inscribed by Picasso MIS (sic) GERTRUDE STEIN, was to be transformed, two years later, into a real calling card in a still life of 1914. This time, the story is even more complicated, at least according to Miss Toklas,[66] who recounted that she and Gertrude Stein, again finding Picasso not at home, left a dog-eared calling card to signify their visit. Picasso then stripped off the real folded corner, and, replacing it with a *trompe l'oeil* fold, included it in a still life of a die and a package of cigarettes. To compound the irony, so prophetic of the switched identities that later would characterize Miss Stein's Cubist idea of writing her own autobiography in the guise of Miss Toklas's autobiography, Picasso then left the still life for Miss Stein and Miss Toklas at 27 rue de Fleurus as a kind of Cubist calling card in which the identity of the original owners had been completely absorbed, as it were, by the identity of Picasso and his art.[67]

In another example of 1914, Picasso used the actual calling card of André Level (a dealer and the author of a book on Picasso published in 1928). Here, in a manner rivalling Diego Rivera's confusion of signatory identities, the card provides the typographical stimulus for Picasso's own signature (in the lower right-hand corner),

116

117

118

119

116 *Still Life with Chair Caning*, spring 1912.

117 *Still Life ('Au Bon Marché')*,
winter 1912–13.

118 *Restaurant Still Life*, 1914.

119 *Still Life with Grapes and Pear*, 1914.

120 *Still Life: Bottle of Bass, Glass, Package
of Tobacco, and Calling Card ('André Level')*,
winter 1913–14.

121 *Still Life with Calling Card*, 1914.

120

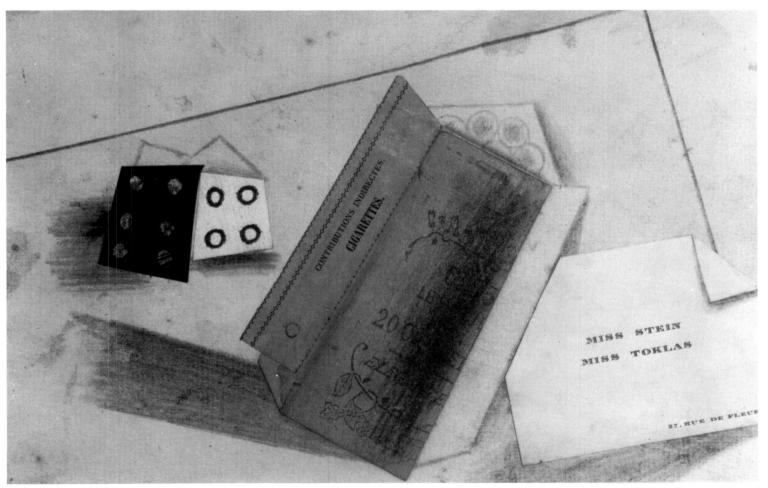

121

122

123

which imitates the elegant italic type used for the printing of Level's name. Indeed, this joke of handwriting, in which the artist's handmade signature mimics the elegance of a name printed on a calling card, occurs often in Picasso's work of 1914[68] (as well as in the work of Braque[69] and the Futurist Gino Severini[70]); and once, quite explicitly, Picasso signs his name in a cursive script upon an illusionistic piece of paper that suggests an analogy in type face and shape to a real calling card.[71]

122

The chameleon guises of Picasso's signatures in these works enormously enriched the Cubist idea of the artist as a kind of actor-magician, who could suddenly appear in surprising roles within the shifting realities of his own pictorial stage. Moreover, these various kinds of handwriting and type-faces correspond to the characteristic Cubist insistence that no one way of representing a thing was absolute. Indeed, just as Picasso explored a wide variety of illusionistic and symbolic means to represent Cubist figures, landscapes, and still life objects, so, too, did he compile, as it were, a typographical dictionary that similarly provided the multiple means of representing words in art. If in actual writing techniques he could range from the hand-painted to the hand-drawn, from the stencilled to the machine-printed, in choice of writing style he could be equally diverse. Thus, the words in his Cubist years not only appear in the guise of roman and italic type, in their many variations, but at times extend to less familiar type faces and even alphabets.

In one case, this pleasure in exploring diverse ways of representing words led him to include a phrase written with the Russian alphabet. Kahnweiler recalls that several of Picasso's pictures which had been on loan at an exhibition in Moscow organized by the 'Jack of Diamonds' Group were returned carefully wrapped in Russian posters.[72] Picasso was sufficiently fascinated with these Russian words to incorporate them into a Cubist picture of music-making: a woman strumming a stringed instrument. Characteristically, Picasso was interested not only in the formal patterns of the Russian letters, but in their meaning; in fact, according to Gertrude Stein, Picasso, about this time, had troubled to learn the Russian alphabet from his Russian friends the painter Serge Férat (called G. Apostrophe) and his sister the Baronne d'Oettingen (called Roche Grey).[73] For, the words he has copied from the poster—БОЛ . . . КОНЦЕРТ—are taken from the phrase transliterated as BOLSHOI CONCERT, i.e., the announcement of a 'big concert', which is perfectly appropriate to the musical subject at hand as well as being a phrase used in French *(grand concert)* in other Cubist works.[74]

124

But even within the customary range of Western script, Picasso was endlessly curious about typographical variety. In a painting of 1911, the Cubist hieroglyphs that include a flower in a vase, a fan, and a wine glass are brusquely juxtaposed with a daily newspaper, whose bisected name, *L'Indépendant*, is surprising not only in its sudden legibility within a nearly illegible pictorial vocabulary, but in its use of as old-fashioned and picturesque a type face as Gothic within this avant-garde pictorial context. Moreover, Picasso's eye was constantly alert to the lesser variations of type-face invented in modern advertising.[75] Thus, when he included a packet of cigarette papers in his Cubist still lifes and identified the brand as JOB, he was careful to imitate in the lettering the lozenge-shaped 'O' that still characterizes the product.[76] Indeed, Picasso's scrutiny of such typographical variants must have been stimulated in good part by the innovations of commercial art and, in particular, the posters of La Belle Époque, which provided him and his fellow Cubists in Paris with a ubiquitous visual environment.[77] Thus, in a typical *fin-de-siècle* poster design for JOB by Jane Atché, not only does one find at the lower right-hand corner the distinguishing letter forms that label the product and that recur in Picasso's still life, but any number of other variations on typographical styles, right

126

123

127

124

down to the Picasso-like contrast of the artist's signatory flourish with the roman letters above. Moreover, such posters often explored a wide variety of visual tricks that prophesy Cubist techniques—the *trompe l'oeil* shadows cast by the letters JOB below, or the spatial intertwining of the chiffon-like smoke with the perfectly flat letters JOB above.

In this context, it should be remembered that already in the late nineteenth century—witness Toulouse-Lautrec, Denis, Bonnard, Vuillard—ambitious painters had been involved in poster design and had become increasingly aware of the role of words and lettering in their art; and that the Cubist generation was an heir to this tradition. Like Gris, who made book illustrations and newspaper drawings both as a youth in Madrid and in his pre-Cubist years in Paris,[78] not to mention such other artists as Villon, Duchamp, and Marcoussis, who also were to belong to the Cubist milieu,[79] Picasso, in his early years, was often obliged to leave the art-for-art's sake ambiance of the studio for the practical realities of commercial illustration[80] and, in fact, remained throughout his life one of the masters of modern poster design.[81] Thus, looked at from the point of view of Cubism, even so modest and youthful a design as the menu card Picasso designed about 1898 for the Barcelona café, Els Quatre Gats,[82] offers prophecies of the more intricate juggling of words and images that abound in the Cubist years. Here, the more traditional illustrative techniques that describe the casual stance of the waiter, bottle in one hand, platter in the other, are contrasted with the flattening letters of the name of the café—4 GATS—and the weightless announcement of the PLAT DEL DIA (Plat du jour), whose identification presumably would have been inscribed in the empty frame below. Indeed, just such a pot-pourri of letters, whether printed or handwritten, and varying degrees of illustrative description, from the naturalistic to the schematic, recurs constantly in the Cubist years, and even, at times, in the context of what might be called Cubist menu cards. Thus, the Barcelona menu card is brought up to date in several Cubist still lifes where Picasso displays the typographical repertory to be found at any restaurant table. In two such works, Picasso reproduces the Art Nouveau lettering of the word RESTAURANT itself, floating in the background as if seen on a window, and then, in the foreground, presents the diner with a flurry of words, numbers, and scripts that range from the block letters of a bottle of *moutarde de Dijon* or the word MENU itself to the handwritten word fragments *boeu(f), veau, trip(es), 40 (centimes)* that describe the *carte du jour*. Amid this profusion of letters, Picasso then juxtaposes the more palpable facts of the table: a more illusionistic rendering of a knife and

125 *Plat del Día (Menu Card from Els Quatre Gats),* 1897.

126 *Still Life with Fan (L'Indépendant),* 1911.

127 Jane Atché, *Poster for Job Cigarette Paper.*

fork against, in one case, a roast chicken, in the other, a ham.[83] Or, on the contrary, are these Cubist still-life objects less real than the letters and numbers, which can suddenly seem so literal a record of prosaic visual truths?

Surprisingly, then, such Cubist still lifes can be thought of not only as inhabiting the private, cerebral world of an artist's ivory tower, but also as exploring the most ordinary printed, handwritten, stencilled, pasted typographical facts experienced by any twentieth-century urban man. Thus, the familiar assertion that Picasso is always a realist may not even demand, for the Cubist years, so abstract or metaphysical an interpretation of realism as is often attempted. For not only do the

128

words that proliferate in Cubist art enrich intellectually the ambiguous formal language of Cubism with equally ambiguous verbal double-entendres, but they also establish, with startling vividness, Cubism's connections with the new imagery of the modern world. Like Apollinaire in his epic poem *Zone* (1913), Picasso embraced the realism of the printed word that abounded in the city. When Apollinaire sings the praises of 'prospectuses, catalogues, posters', of 'newspapers and cheap detective stories', of 'inscriptions on walls, street signs, name plates, notices',[84] he might almost be cataloguing the very repertory of printed matter that stimulated Picasso and his fellow Cubists. In this light, the Cubist sensibility to the kaleidoscopic assault of words and advertising images to be found in the most commonplace urban situations represents the first full-scale absorption into high art of the typographical environment of our century. So important was this insight that the consequences—from the social aggressiveness of words in Futurism and Dada to the aesthetic ironies of commercial imagery in Pop Art—are still to be assessed.[85]

128 *Restaurant Still Life*, 1912.

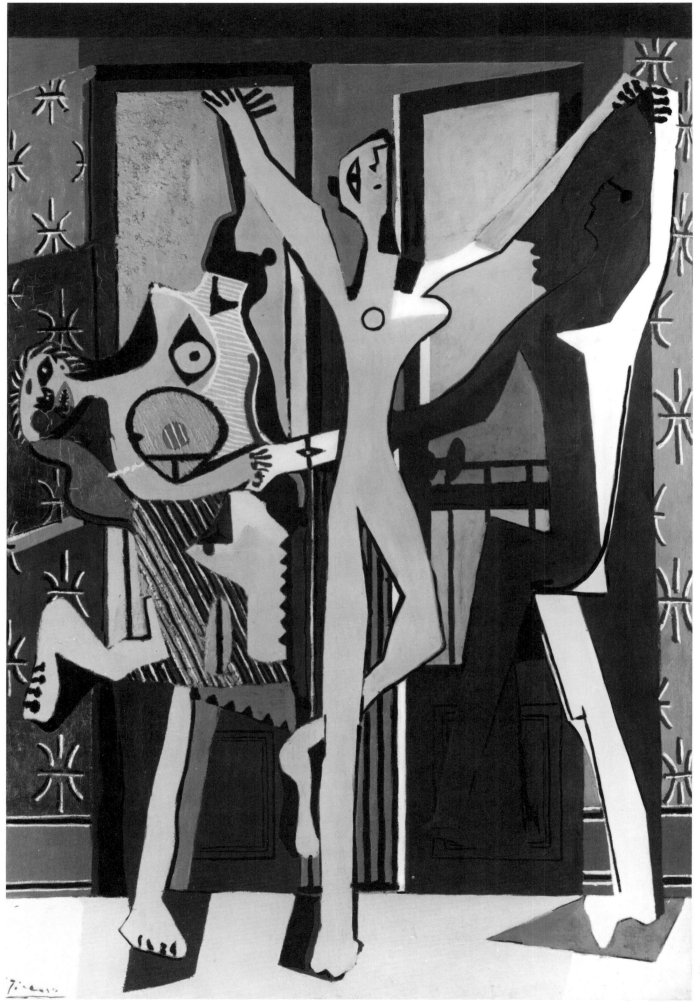

129

Picasso and Surrealism

John Golding

' . . . he always in his life is tempted, as a saint can be tempted, to see things as he does not see them. Again and again it has happened to him in his life and the strongest temptation was between 1925 and 1935.' Gertrude Stein, *Picasso*, 1938.

'Everybody knows by now,' wrote Pierre Naville in April 1925, in the third issue of *La Révolution Surréaliste*, 'that there is no Surrealist painting.' Two months later the same review published André Breton's brilliant article, 'Le Surréalisme et la Peinture',[1] in which he set out to refute Naville's statement. It was the work of Picasso, Breton claimed, that held the most rewarding answers to the problems involved in the creation of a truly Surrealist visual idiom. 'A single failure of will-power on his part would be sufficient for everything we are concerned with to be at least put back, if not wholly lost', Breton declared. And in one of the key passages of the article the leader of the Surrealist movement went on to say, '. . . we proudly claim him as one of ourselves, even though it would be impossible and would besides be impudent to bring to bear on his means the critical standards we propose to apply elsewhere. Surrealism, if it is to adopt a line of conduct, has only to pass where Picasso has already passed and where he will pass again . . .'

Subsequently Breton was to modify his views; even Picasso was unable to escape totally unscathed from the endless series of pogroms which characterize the most fanatical and least sympathetic aspect of the Surrealist world. But towards the end of his life, striking a more objective and factual tone than was his wont, Breton wrote, 'The attitude of Surrealism to Picasso has always been one of great deference on the artistic plane, and many times his new propositions and discoveries have renewed the attraction which drew us to him . . . [but] what constantly created an obstacle to a more complete unification between his views and ours is his un-swerving attachment to the exterior world [to the 'object'] and the blindness which this tendency entails in the realm of the dream and the imagination'.[2]

This was to be Breton's final pronouncement on the subject, and it was in many ways a fair one. Picasso never became a true Surrealist because he was unable, as William Rubin succintly remarks, to approach external reality 'with the eyes closed',[3] Surrealism's ideal way of facing the material world. As early as 1930, at a time when to many observers Picasso might with some justification have seemed very much a part of the Surrealist world, Michel Leiris wrote with great perception, 'In most of Picasso's painting one can see that the subject is almost always completely down to earth (*terre à terre*), in any case never borrowed from the hazy world of the dream, nor immediately susceptible to being converted into a symbol, that is to say never remotely "Surrealist".'[4] And in a statement made to André Warnod in 1945, Picasso himself remarked, 'I attempt to observe nature, always. I am intent on resemblance, a resemblance more real than the real, attaining the surreal. It was in this way that I thought of Surrealism . . .'.[5]

But if time has shed a cooler light on the vexed problem of Picasso's relationship to Surrealism, Breton's panegyric of 1925 contains an equal proportion of historical

129 *Three Dancers*, 1925.

truth. Together with de Chirico and Duchamp, Picasso was one of the three major influences on the development of visual Surrealism, and within this trinity it was undoubtedly to the Spaniard that Surrealism, during the heroic years of the movement, gave pride of place. For its painters and writers he was a figure apart, a prophet who had pointed the way forward and whose miraculous powers of invention continued to be a source of inspiration even at the moments when they recognized that his path was not their own. In return, the admiration of a group of young artists unique in the annals of history for the intensity with which they sought to free the creative imagination provided Picasso with renewed stimulus; he enjoyed their company, particularly that of the poets, allowed his work to be shown in the first major exhibition of Surrealist art,[6] and agreed to the reproduction of his paintings in various Surrealist publications. And his contacts with Surrealism released in his art a fund of new imagery that was to result, in the second half of the 1920s and in the early 1930s, in a flood of works of extraordinary strength and originality: not since the creation of Cubism had his powers of imagination been so concentrated, his vision so revolutionary and intense.

Around 1921 *Les Demoiselles d'Avignon* had passed into the collection of Jacques Doucet, perhaps through Breton's offices, and it was reproduced in the 15 July issue of *La Révolution Surréaliste*. It was a work that had to a large extent provoked the Cubist revolution, but its impact had been so great, so stunning, that artists (including Picasso himself) had tended to concentrate on the many formal problems raised by the painting rather than on the work as an emotive whole. Sometime early in 1925 Picasso set to work on another canvas, comparable in dimensions, that was to mark a turning point in his career almost as great as that initiated by the *Demoiselles* eighteen years earlier.[7] The *Three Dancers*, like the *Demoiselles*, was worked on over a space of several months, and the rough, uneven quality of paint (particularly in certain passages in the left hand side) testifies to the way in which Picasso's original concept of the subject was modified and revised as the work progressed. The finished painting was reproduced in the same issue of *La Révolution Surréaliste* as the *Demoiselles* and there can be little doubt that the two works are intimately connected—not so much on a visual level as on a deeper psychological and emotional plane. Picasso's work during the previous years had been occupied with the decorative possibilities of latter-day Cubism (and also, to a lesser extent, with a simplification of its formal, architectural properties) and simultaneously with the evolution of a Neo-Classical idiom, which for all its beauty had brought him as close to conformity as was possible for an artist of his temperament. It was not surprising that a reappraisal of the *Demoiselles*, the most significant work of his first artistic maturity, should have forced him to reassess his position as the most important single force in contemporary art.

The *Three Dancers* is not a Surrealist work, but the quality of obsessive neuroticism that radiates from the canvas and the sense of unease and displacement which it produces in the spectator serve to place Picasso's art in a Surrealist context. The *Demoiselles*, for all the violence of the heads at the right hand side, is disturbing primarily because of its stylistic inconsistencies. The problems that it posed were mostly formal, pictorial ones. Originally it had been conceived of as a moral allegory, but the physical implications of the subject matter had been slowly and deliberately suppressed as the work progressed, and in the final product only the title hints at any hidden layers of meaning. In the *Three Dancers* the process was reversed. The title suggests nothing that the viewer's eye cannot apprehend for itself, and what had in all probability begun as a simple restatement of a theme that had occupied Picasso since his encounter with the Diaghilev ballet eight years earlier, acquired,

130 *Les Demoiselles d'Avignon*, 1907.

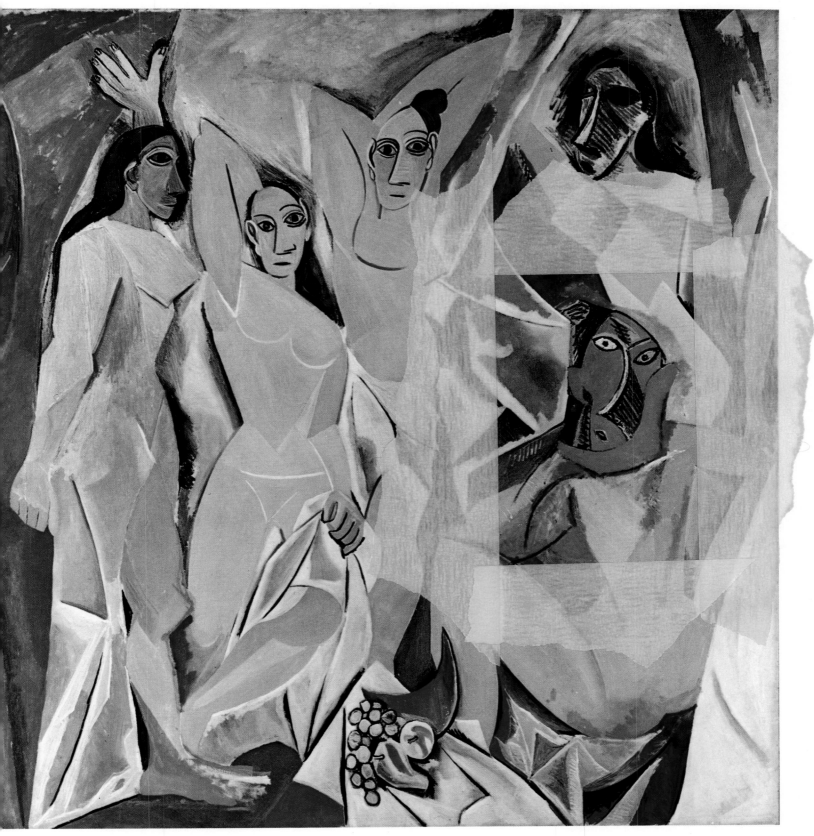

131

as the painting developed, a multitude of hidden references and a wealth of meanings.

The author and painter, John Graham, writing of Picasso's art in 1937, compares it to that of primitive artists who 'on the road to the elucidation of their plastic problems, reached deep into their primordial memories',[8] and there is certainly about the *Three Dancers* a strong air of ritual. The painting's rhythms progress from the frozen balance of the central figure to the stately *passacaglia* executed at the right, to the frenzied, possessed convolutions of the dancer at the left. The dancers are clearly all women, but as we study the work we become aware of a brooding male presence in the form of a great black profile, half shadow, half substance, situated behind and linked to the figure on the right. Like some mysterious atavistic dignitary this presiding genius seems to control and direct the activities of the three initiates.[9] While he was working on the painting Picasso had received the news of the death of a close friend of his youth, the Catalan painter Raymond Pichot, and he remarked to Roland Penrose that the painting should really be called 'The Death of Pichot'; he added that 'the tall black figure behind the dancer on the right is the presence of Pichot'.[10]

The untimely loss of an old friend must certainly account for some of the element of anguish and emotional distress which the painting so powerfully conveys. And Pichot's death must have in turn reminded Picasso of the tragic end of another friend from his Barcelona days, Carlos Casagemas; indeed the lives and deaths of these two men were curiously interrelated.[11] Casagemas's suicide had induced Picasso to produce, in the autumn of 1901, a strange painting called *Evocation*, a work with strong allegorical overtones ranging from the mystic and religious to the profane and quasi-blasphemous, and rich, like the *Three Dancers*, in iconographic complexity. Casagemas's death is also commemorated, in a more indirect fashion, in *La Vie* of 1903, a canvas of deep philosophical significance that appears to be primarily concerned with death, rejuvenation, love, loneliness and betrayal. Originally the male protagonist was to have borne Picasso's own features, but the melancholy countenance of Casagemas was eventually substituted: as the sombre meaning of the painting had revealed itself to the artist, memories of his friend's unhappy life must have returned to haunt his imagination.

When the great psychiatrist C. G. Jung came to write on Picasso's art he did so with little sympathy and with a strange lack of historical perception.[12] Picasso's work is viewed by Jung in terms of a progressive detachment from exterior reality and a move into more 'interior', 'unconscious' or 'subconscious' realms. The early Blue Period is seen as evidence of the first stages of schizophrenia and as the symbol of 'Nekya', a descent into hell and darkness. Picasso's subsequent evolution, Jung felt, was an ever more desperate effort to shelter behind a barrage of unintelligible symbols, leading the painter inexorably into the murky gloom of a neolithic night. Jung's analysis of Picasso's Cubism and of his Neo-Classicism reveal a totally negative appreciation of the problems facing contemporary art, but if he had been able to appreciate Picasso's achievement at its true historical worth he might with justification have remarked that in the *Three Dancers* and much of his immediately subsequent work Picasso had embarked on the journey inwards and downwards that was the ultimate destination and aim of all the true Surrealists. Picasso's journey, it is true, was undertaken for very different purposes. He never shared in Surrealism's programmatic (or even in its semi-programmatic) approach to the problems of the subconscious, and he rejected the supremacy of the dream world over the stimulus of the waking, visual world. Basically he was driven in on himself for personal reasons and in a totally intuitive fashion; he had come, too, to a stage in his career when he felt the need to examine his position in relationship to his

131 *Woman in an Armchair (La Femme en Chemise)*, 1913.

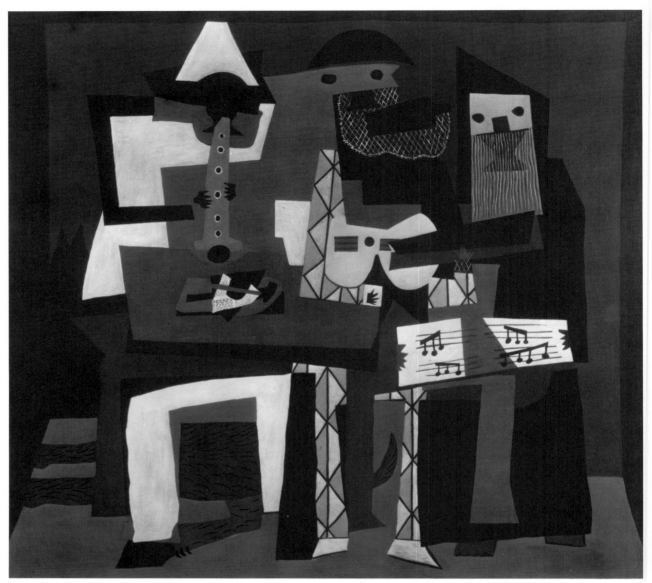

earlier art and to the sources of his creativity. The conclusions which he reached when he had explored the labyrinths of his psyche were not those of his Surrealist friends; but for some ten years their paths were parallel, and it was in part at least the Surrealist experience which endowed his work of the period with its depths of psychological meaning and its emotional intensity.

If Jung was insensitive to the beauties of Cubism and to the currents of experimental formalist art that sprang to so large an extent from it, he was nevertheless to be an influence on the Surrealists, and the strong neo-romantic flavour of his thought was in many ways more congenial to the Surrealist climate than that of his master, Freud, to whom the Surrealists paid greater honour. Ironically enough, Jung's contribution to Surrealism was one which served to underline the links that it had with Picasso's art. It was at least in part through their appreciation of Jung's writings that the Surrealists became so deeply absorbed by the interrelations of myths, of patterns of thought and behaviour—by the symbol behind the symbol. Their interest in primitive ritual and in the art to which it gave expression was to be one of the movement's principal characteristics, and in the 1920s when the painters were working in a wide variety of individual styles, it was their common fascination with primitive sources that was to be one of the most consistently unifying factors in their art. Picasso, who had already explored the possibilities of African art in great depth, and whose influence on the younger Surrealists was

another factor that bound them together, was now in return stimulated to a new interest in the primitive forms that obsessed them.

In terms of its composition achieved through the interlocking of flat, upright shapes of unmodulated colour, the *Three Dancers* is still basically a Synthetic Cubist work. A comparison with the two versions of the *Three Musicians*, executed four years previously, and generally acknowledged to represent the climax of Picasso's post-war Cubism, reveals a complete similarity of procedure. But whereas the faces of the *Three Musicians* are masklike (indeed they appear to be wearing masks) and slightly sinister, they lack the expressive force of the heads of the *Three Dancers*. Ultimately it is African art that accounts for the facial conventions employed in the two great canvases of 1921, for the devices Picasso uses are an extension or clarification of certain techniques he had evolved between 1911 and 1914, years when a second wave of interest in African art had affected the appearance of his work;[13] but in the musicians' heads the conventions of African art have been simplified and to a large extent made more decorative. And they certainly convey little or nothing of the *Three Dancers*' atavistic intensity. It was while he was at work on the *Demoiselles* that Picasso had first become aware of the formal and expressive properties of African masks, and in the *Three Dancers* he appears to have once again consulted the art forms that had been one of his major sources in the creation of Cubism. The head of the central dancer is primitivizing only in its angular simplicity, but the pointed black skull of Pichot's profile, with its knotty projections caused by the gaps between the fingers of the hands that touch each other above, has a strongly African flavour, while the sharp contrasts in light and dark (to become a prominent feature in Picasso's figures in the succeeding year), the predatory mouth and the treatment of the hair in the figure to the left suggest that Picasso had returned to a study of the masks he had so avidly collected when he made his first dramatic break with the conventions that had governed Western art for five hundred years. One mask from his collection, of which Picasso had executed a painting in 1907, seems particularly relevant in relationship to the frenzied dancer.

132

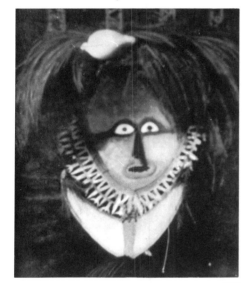

133

Underpaintings reveal clearly that it was this figure which underwent the most drastic revisions in pose, and the distortions in anatomy and facial expression are the most drastic and extreme—in a sense she is the direct descendant of the squatting figure in the *Demoiselles*, the last section of the painting to be executed as well as the most daring and prophetic. A young art historian, Elizabeth Nesfield, has recently suggested that while he was at work on the *Three Dancers* Picasso may have been looking at Eskimo art, which was much in vogue in Surrealist circles, and she remarks on the way in which certain Eskimo masks divide the face into two contrasting parts which fuse together to produce a single Night-Day or Tragedy-Comedy image.[14] Eskimo art may also account for the strange, contorted anatomy of this figure and the way in which the various members of the body are hinged together rather than organically connected. Similarly Eskimo figures sometimes have holes punched through the body, just as Picasso has done: the circular form between lower arm and breast can be read as a negative space, and yet the addition of a striped red disc in the centre forces the shape up onto the picture plane and makes it suggestive of the breast above (itself rendered like an Eskimo eye), while the blue lozenge between the legs, bisected by an upright black stripe, seems to belong to the plane and imagery of the metal railing of the balcony beyond the window, and yet to act simultaneously as the figure's sex.

134

If Picasso's reawakened interest in primitive art accounts for some of the expressive distortion that is so much a feature of the *Three Dancers*, the painting was simultaneously being informed by other, very different iconographical

134

references. The fluted or pleated shift which clothes the upper part of the left hand dancer (falling away from one of her breasts and reappearing below in corrugated stripes of green, red, black and white) recalls Picasso's earlier interest in classical drapery, and Professor Lawrence Gowing in his brilliant analysis of the painting has drawn a parallel between this possessed dancer and the 'Weeping Maenad at the Cross' from one of Donatello's San Lorenzo pulpits, a figure directly inspired by classical prototypes;[15] only an artist of Picasso's stature could have recreated an image from the most sophisticated period of classical art in forms derived from primitive sources. Then again, while it is unlikely that any Christian imagery was in Picasso's mind when he began the *Three Dancers*, he can hardly have been unaware that as the painting progressed the composition took on strong similarities to traditional Crucifixion scenes. The way in which the suspended central dancer, with her raised arms fixed to a line corresponding to the top of the window, is flanked on one side by a comparatively calm male presence and on the other by a frenzied woman is reminiscent in particular of Grünewald's *Crucifixion* panel from the Isenheim Altarpiece, in which the figure of St John acts as moral commentator while the Magdalen on Christ's right is contorted with grief; Picasso's admiration for Grünewald led him in 1932 to execute a series of variations on the Isenheim *Crucifixion*, and it is possible that Grünewald's great masterpiece was already at the back of his mind in the finishing stages of the *Three Dancers*. Not until he executed his own more strongly Surrealist *Crucifixion* in 1930 was Picasso to produce a work so multi-layered in meaning, so richly complex in its iconography.

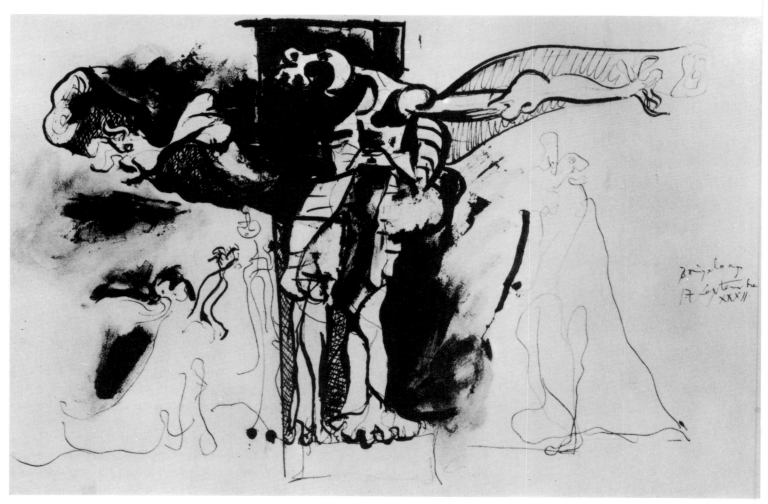

136

137

135 *Crucifixion (after Grünewald)*, 1932.

136 Donatello, the 'Weeping Maenad at the Cross' from San Lorenzo pulpit, *c* 1460–70.

137 Mathis Grünewald, *Crucifixion* (Isenheim Altar), 1505–15.

The sense of structure that underlies and governs the emotive properties of the *Three Dancers*, the pictorial sophistication involved in the manipulation of the composition's planar architecture, and indeed Picasso's whole method of work, building up to a final statement through a long succession of related works (in this case the groups of dancing figures that had preoccupied him since 1917), all these are qualities which serve to place the canvas to one side of true Surrealism. But if it is the Cubist heritage that underlies the formal properties of the *Three Dancers*, paradoxically it was a reassessment of his pre-war Cubism that was to lead Picasso to adopt in the succeeding years an approach that was to bring his art closer in feeling and appearance to the Surrealist works executed by his younger colleagues in the automatic techniques which represented the Surrealist ideal in the early and middle years of the 1920s.

Breton pinpointed what was perhaps most fundamental to Surrealist visual techniques when he wrote, quite simply, that Surrealism had suppressed the world 'like'; a tomato is no longer 'like' a child's balloon, rather for anyone with the slightest appreciation of 'the marvellous', a tomato *is* also a child's balloon.[16] It has never been sufficiently stressed that the question of the interchangeability of images had been posed, within the context of twentieth-century art, by Synthetic Cubism, and most markedly by that of Picasso. Indeed Breton himself appears to have been to a certain extent aware of this when, in *Le Surréalisme et la Peinture*, he mentioned that the principles involved in Picasso's and Braque's use of *collage* had analogies with certain Surrealist procedures; and later in life he was to reaffirm that it was Picasso's Synthetic Cubism (and in particular his constructions in assorted materials of the period) that remained, from the Surrealist point of view, his most creative period.[17] Picasso was in fact subsequently to come closer to Surrealism than Breton in old age was prepared to admit, but Breton was right in underlining the importance of Picasso's immediately pre-war works.

During the second, major or Synthetic phase of Cubism, initiated by the discovery of the techniques of *collage* and *papier collé* during the course of 1912, the Cubists had evolved a method of work by which they now built up towards a representational subject matter by the manipulation of abstract pictorial elements, rather than, as in their previous work, beginning with a clearly legible subject which was subsequently fragmented and abstracted in the light of the new Cubist concepts of form and space. In the case of Picasso's Synthetic Cubism, the process of qualifying the highly abstract shapes he was employing in such a way as to give them a representational coefficient, or in order to relate them to recognizable phenomena in the material world, was given a certain quality of ambiguity and paradox. During the preceding years of Analytical Cubism he had been working with a relatively limited range of subject matter: almost exclusively the human head or three-quarter-length figure and still lifes comprising musical instruments and a few ordinary objects of daily domestic usage. As his Cubism became increasingly abstract in appearance he had evolved a kind of sign language, a form of pictorial shorthand, to represent the ever recurrent themes; this pictorial sign language could, with very slight modification, be used to render objects which in the external, material world are very disparate in their formal properties. For example a simple double curve could be used to represent the side and back of a human head, drawn up onto the picture surface in simultaneous or multi-viewpoint perspective. The identical double curve could be used to render the outline of a guitar, or even on occasion the contour of a bottle. Now, with his adoption of a 'synthetic' method of work, working from abstraction towards representation and beginning more or less at random with forms that had become an almost automatic part of his vocabulary, Picasso could, in the next stage, qualify them in such a way that they

211

138

139

140

 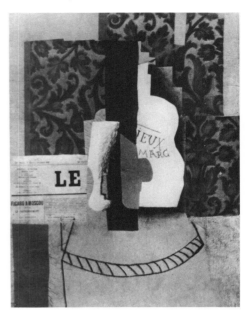

138 139 140

become the representations of particular objects with analogies to the other objects which they *might* have become. To pursue the example of the head and guitar: by drawing symbols of the human physiognomy (eyes, nose, mouth) to the side of a double curve, this basic pictorial substructure can be made to read as a man's head, while by sketching in a circular sounding hole and the neck of a guitar over an identical double curve form Picasso presents us with the pictorial equivalent of a particular kind of musical instrument.

What distinguishes Picasso's approach from that of the Surrealists, not only in his Cubism but in his works of the 20s, is that he always tells the spectator how his images are to be read: his heads are heads, his guitars are guitars, however comparable or interchangeable their basic pictorial forms. In other words, Picasso refuses to suppress the word 'like'. And even at his most Surrealist he avoids the total ambiguity of imagery that the Surrealists courted as an ideal. Yet there is about much of his Synthetic Cubist work a strong element of alchemy, a sensation of the very physical manipulation of forms to produce unexpected images, which distinguishes his procedures from those of his Cubist colleagues, Braque and Gris. Apollinaire in his lecture *L'Esprit Nouveau et Les Poètes*, delivered in 1917 and eagerly discussed by the future Surrealists, constantly stresses the importance of 'the effect of surprise' on emergent art forms. 'Surprise' he writes, 'is the greatest source for what is new'; and he would almost certainly have agreed, as Breton did, that this was a characteristic of much of Picasso's immediately pre-war Cubism. In a sense it was the element of 'surprise' that was to a certain extent already detaching Picasso in those years from a purely Cubist aesthetic. Perhaps this is what Breton sought to convey when he wrote in his 1925 article, 'O Picasso, you who have carried the spirit, no longer of contradiction, but of evasion to its furthest point'.

Erotic imagery, all-important to Surrealism, played a very minor role in Cubist iconography. But in a series of drawings executed in Avignon during the summer of 1914, works so markedly fantastic as to make them genuinely proto-Surrealist, Picasso makes use of what might be called his 'procedure by analogy' to produce effects that are disquietingly physical in their impact. In *Nude with Guitar Player*, 14 a typical example, the right hand section of the torso of the reclining female nude is rendered by a simplified version of the ubiquitous double curve, while exactly the

138 *Man with a Hat*, 1912–13.

139 *Violin on a Table*, 1912–13.

140 *Bottle and Glass*, 1913.

141 *Nude with Guitar Player*, 1914.

same linear convention is used to convey the outline of the guitar which rests on the musician's lap and across which he runs his hand, with the result that an undercurrent of erotic tension communicates itself to the spectator. The breasts of the reclining woman, rendered twice (thus giving an erotic twist to Cubist multi-viewpoint perspective) are derived from a slightly earlier work, *Woman in an Armchair*, a canvas that was understandably much venerated by the Surrealists.[18] Here the upper breasts with their peg-like nipples, strongly reminiscent of certain 131 conventions employed in African art, appear to nail into place the oversized, pendulous projections below, while the relatively naturalistic flesh tones and the insistent modelling (which do not appear in any other Picassos of the period) underline the figure's physicality. As in many of the Avignon drawings of 1914, a surrealistic sense of displacement is produced by the way in which the features of the head, traditionally the seat of intelligence and spirituality, are reduced to a few insignificant dots and dashes while the breasts, stomach and even the hair underneath the woman's raised arm are given exaggerated emphasis. The depiction of the features of the face by a series of abstract forms (dots or circles for the eyes, a single or double straight line for the nose, and in the case of the Avignon drawings discussed above a curved comma for the mouth) are recurrent devices in Picasso's Synthetic Cubism and derive from a study of Wobé masks of which he owned an example. In these masks, as in Synthetic Cubist painting, very disparate forms, abstract and meaningless when seen out of context, are assembled in such a way that they take on a symbolic representational significance: two circles placed at either side of an upright linear form become eyes, the curved gash below a mouth, and so on.

The idea of painting as a sign language was one which was to fascinate the Surrealists[19] who, particularly during the early years of the movement, appear to have seen the visual arts as aspiring to the condition of literature rather than, as in the case of so many of their predecessors, to that of music, an art form which Breton despised for its formalism and its inability, in his view, to disorient conventional thought patterns and modes of perception. The imagery of the Avignon drawings and the idea of painting and drawing as ideogram seems to have been very much in Picasso's mind when he was working on the ballet *Mercure*, mounted in the summer of 1924 by Count Etienne de Beaumont's *Soirées de Paris*, with music by Eric Satie and choreography by Léonid Massine. One of the original sketches for the night scene shows a reclining figure on a sort of bed or table, and rendered as in the 142 Avignon series in terms of simple linear means, although the line has here taken on a more spontaneous, free-flowing almost quasi-automatic quality. The Surrealists, who despised ballet as a form of corrupt bourgeois entertainment, had originally been hostile to the idea of *Mercure*, but after seeing it had been forced to change their minds. Breton was drawn to it for its visual simplicity and above all for the way in which it helped to project the spectator back into a state of childhood and hence onto the psychoanalytical path inwards. In his 1925 article on painting he wrote:

'When we were children we had toys that would make us weep with pity and anger today. One day, perhaps, we shall see the toys of our whole life, like those of our childhood, once more. It was Picasso who gave me this idea . . . I never received this impression so strongly as on the occasion of the ballet *Mercure*'

and he specifically (and rightly) links the ballet in this respect with *La Femme en Chemise*.[20] The critic Max Morice, writing in the first issue of *La Révolution Surréaliste* (December 1924), discusses *Mercure* in connection with the possibility of achieving an automatic visual procedure that would parallel automatic tech-

141

ETOILE

ETOILE

ETOILE

ETOILE

ETOILE

ETOILE

ETOILE

ETOILE

142

143

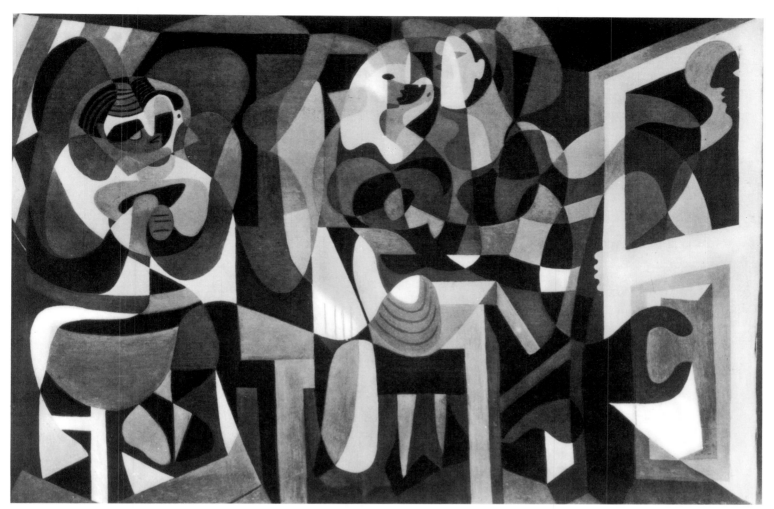

niques in literature. Morice must have been familiar with the first sketches for the night scene as well as with the final spectacle, for he dwells admiringly on Picasso's contemplated use of the word 'étoile', scattered across the background, to replace the painted or drawn image of a star—a device which he felt could convey to the spectator equally pungently the atmosphere of a constellated night sky. Gertrude Stein in one of her remarkable flashes of insight wrote, 'Calligraphy as I understand it in him had perhaps its most intense moment in the *décor* of *Mercure*. That was written, so simply written, no painting, pure calligraphy'.[21]

Picasso's collaboration on *Mercure*, the most progressive and inventive of his excursions into the theatre since *Parade* of 1917, and the Surrealists' enthusiasm for it, appear to have brought him closer into the movement's orbit; he was at the time seeing Breton with some frequency and had in the previous year executed two line portraits of him. In 1924 he produced a remarkable series of drawings, composed of large dots of varying sizes in seemingly arbitrary arrangements, linked by curved and straight lines, and several of these were reproduced prominently in the January 1925 issue of *La Révolution Surréaliste*. Most of these drawings can in fact be 'read' as musical instruments and occasionally in terms of body imagery, but the Surrealists undoubtedly saw them as essays in pure 'automatic' drawing, and the starting point for some of them may indeed have consisted of a random sprinkling of dots over the white paper surface. At the time Ernst was independently executing comparable works, possibly inspired by astrological charts, in an attempt to evolve a technique more truly in keeping with the Surrealist writers' contemporary insistence on the supreme validity of automatic, stream-of-consciousness procedures.[22]

The extent to which Picasso was now prepared to submit his art to new and

143

142 *Sketch for the Night Scene of the ballet 'Mercure'*, 1924.

143 *Drawing*, 1924.

144 *L'Atelier de la Modiste*, 1926.

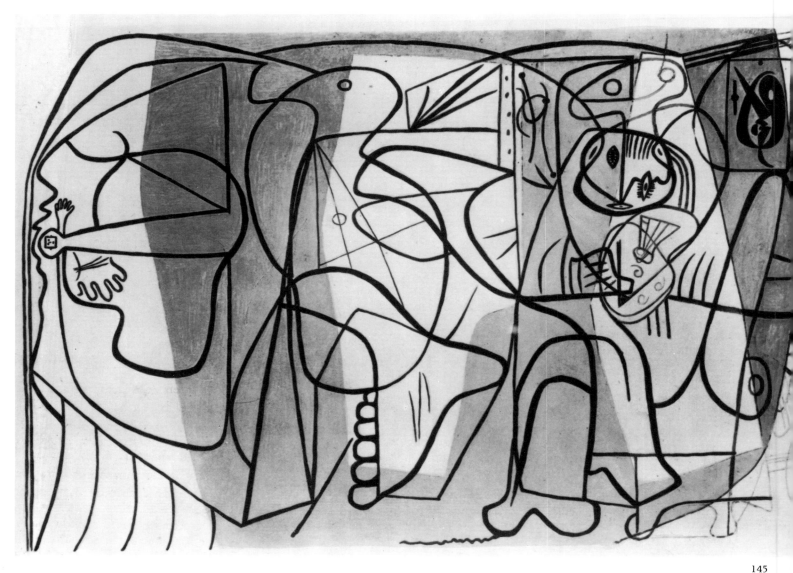

revolutionary technical experiments is vividly emphasized by comparing two large, important works of 1926, identical in size: *L'Atelier de la Modiste* and *The Painter and his Model*. The first of these could with some justification still be classified as a latter-day Cubist work; there is a strong insistence on undulating forms, but these are superimposed onto an angular compositional substructure and basically the painting is constructed on the same principles as those underlying the two versions of the *Three Musicians* of 1921. The proportions of the figures are naturalistic and the use of a multi-viewpoint perspective is emphasized only in the treatment of the heads. In *The Painter and his Model* the subject is conveyed by a meandering, 'automatic' line applied over a background broken down into simple shapes slightly differentiated in tone. The head of the reclining model is reduced to a tiny calligraphic mask, while her hands, crossed behind her head, differ wildly in scale; a giant foot projecting at the bottom centre of the composition introduces a sensation of violent foreshortening. The anatomy of the painter, who occupies the right-hand side of the composition is treated with the same somewhat baffling anatomical freedom and the features of his head, his eyes and mouth, have been reversed on their axes with disquieting effect. The inclusion of a naturalistically

145 *The Painter and his Model*, 1926.

146 Max Ernst, *One Night of Love*, 1927.

rendered thumb, clutching a palette, adds further to the sense of fantasy and displacement. Subsequently Picasso was to revert frequently to the theme of artist and model to ring very consciously the changes on different stylistic procedures, rendering the model, her depiction on the canvas at which the painter works, and the painter himself in different idioms. Here, however, the effect is one of a totally intuitive work, executed at great speed. The imagery and exuberant fantasy recall the Avignon drawings, and the fact that Picasso was now exploring their possibilities on a large scale is suggested not only by the similarities between some of them and the *Mercure* sketches, but also by the fact that four of them were reproduced as full-page illustrations in Waldemar George's *Picasso: Dessins*, published in 1926, the year in which *The Painter and his Model* was produced.

Picasso's Avignon drawings and the paintings of the mid-twenties that represent in many ways a continuance and development of them, after a lapse of some ten years, were to have a considerable impact on the art of Ernst, Miro and Masson, the three painters who illustrate, in different ways, the various tendencies that characterize visual Surrealism during the middle years of the decade. In Ernst's *One Night of Love* of 1927 the linear skeins of paint (achieved in part by throwing 146 string dipped in paint at the canvas, but subsequently somewhat 'doctored') take on configurations reminiscent of those in *The Painter and his Model*, while the conventions used to represent the head of the upper, dominant presence owe much to Picasso's heads of 1926. Miro, who had looked up Picasso immediately upon his arrival in Paris in 1919 and who later willingly acknowledged his debt to him, studied his work year by year and with particular attention in the early thirties. Picasso by his own admission was in turn influenced by the discoveries of the younger men, particularly by those of his Spanish compatriot.[23] Breton in *Genèse et Perspective Artistique du Surréalisme*, published in 1941, wrote that 'the tumultuous entrance upon the scene of Miro in 1924 marked an important stage in the development of Surrealist art', and he goes so far as to add, 'It might be fair to suggest that his influence on Picasso, who joined Surrealism two years later, was to a large extent a determining factor'.[24]

Breton's claims for Miro are exaggerated, but it was partly at least through Miro's example that Picasso began to explore a range of new primitive sources which were to bring his art closer to true Surrealism, and it was through these sources and Miro's interpretation of them that a rich vein of erotic imagery was released in his art. The iconography of Surrealism was charged with a very high degree of sexuality and sexual symbolism, and the eroticism so much a feature of Picasso's work in the years immediately following 1925 was to ally his art still further to that of his Surrealist colleagues.

Miro appears to have discovered neolithic cave art while he was working on *The Tilled Field* of 1923-24, a work which more than any other marks his entry into Surrealism. The importance of neolithic art for Miro was incalculable; its impact upon him was comparable to that of African art on Picasso in the years between 1907 and 1909, and it was to condition his subsequent development at an equally deep level. A comparison between a chart of neolithic tracings compiled from various 147 sources to illustrate motifs that appear also in Miro's work and almost any of his 148 drawings of the thirties or forties shows how completely he had identified himself 149 with an art for which he felt an admiration of an almost mystic intensity.[25] One of the features of neolithic art that seems to have interested Miro from the start is the way in which frequently the various limbs of the human body and the genital organs are rendered in exactly the same way so that all the parts of the body appear to be interchangeable and each is endowed with phallic significance. Sometimes the sex is so highly exaggerated in proportion that it becomes the largest member of

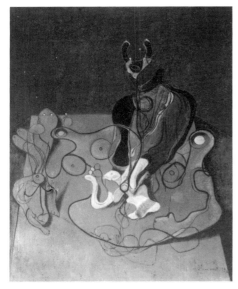

146

147

148

149

147 Chart of tracings of neolithic motifs.

148 Joan Miro, *Drawing*, 1944.

149 Joan Miro, *Drawing*, 1929.

150 *Woman in an Armchair*, 1927.

151 Easter Island hieroglyphs representing men.

152 *Acrobat*, 1930.

153 Neolithic rock painting from the Baghdi Valley, Algeria.

154 *Artist and Model*, 1927.

150

the body, and at times it appears to be deliberately confounded with or equated to the whole figure, while in other instances the organs of both sexes seem to combine within a single figure. All these become characteristic features of Miro's work after 1924, and particularly over the succeeding fifteen years when his work is often so notably characterized by the aggressiveness and invention of its erotic imagery.

Neolithic art also provides the key to some of Picasso's stylistic innovations during the second half of the 1920s and, like Miro, he exploits its sexual symbolism; it seems likely that the frankness and spontaneity of the younger man's handling of erotic imagery may have acted as a challenge to Picasso's own powers of invention. Through African art he had become interested in the evolution of a pictorial sign language and now the ideographs of man's earliest ancestors must have had for him some of the same fascination that they held for the Surrealists who yearned, so to speak, to put themselves in a state of primitive grace and innocence, free from prudery and restraint. (The taboos of primitive people they found more sympathetic than those of their own age, and although they were interested in ethnography and

151

152

153

anthropology, at the same time they found it easy to ignore the conclusions of these sciences when they contradicted their own highly romantic approach to cultures of the past.) Picasso seems to have been particularly drawn to Easter Island hieroglyphs, and *Woman in an Armchair* executed in January of 1927, for example, is like a gigantic, scaled-up version of one of these lively little images.[26] Once again in the Easter Island symbols the limbs are stylized and distorted and virtually interchangeable. The same is true of Picasso's sleeping figure: the forms of her right arm and her left leg are almost identical and the curvilinear rendering of the limbs retains a strong calligraphic flavour. The way in which arms and legs seem to swell and expand until they become virtually the whole figure is a characteristic of much of Picasso's work in succeeding years and reaches a climax in the Acrobats and Swimmers of 1929 and 1930. In one instance, the *Minotaur* of 1928, Picasso actually reduced the figure simply to head and legs, which support an enormous phallus, a kind of configuration anticipated by Miro several years earlier.

A comparison between the 1926 *Painter and Model* and a reworking of the same theme the following year illustrates how quickly Picasso had assimilated the language of neolithic art. The figure of the model has many of the properties of the Easter Island hieroglyphs, while the painter is rendered in a simple, stiff, stick-like style

150
151

152

145
154

153

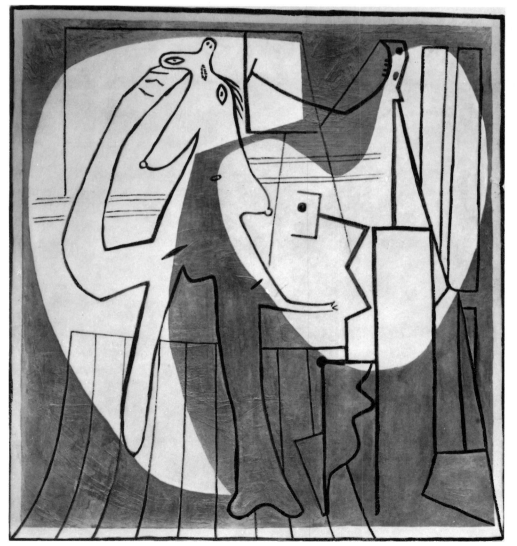

154

93

155

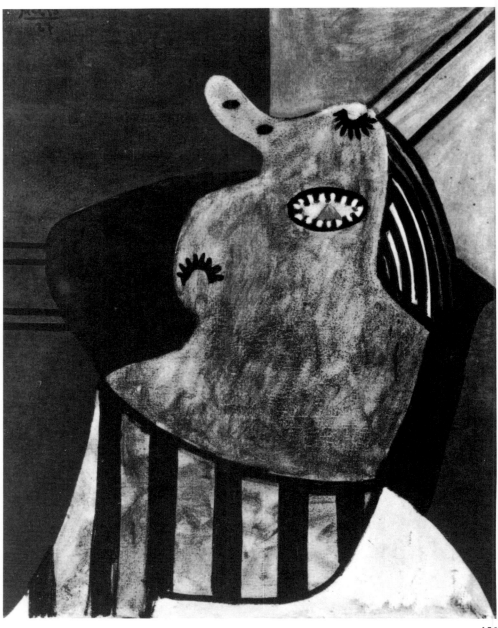

156

found in certain neolithic ethnographic groups; the dichotomy between soft swelling, pendulous forms used in one figure and the stiff angular forms of the other was one which was to fascinate Picasso in the following years, and often paintings which employ only one of these conventions are immediately succeeded by others using a contrasting or complementary technique. Here, the strongly sexual flavour of *Woman in an Armchair* has been further exaggerated and to a certain extent bestialized by the way in which the enormous breasts of the model hang down from the head in a single continuous line, while the limbs, particularly the right leg, assume phallic overtones. The disturbing reversal of the axes of mouth and sex suggest analogies between the different organs of the head and body, and in the series of heads begun in 1927 the features of the face are frequently charged with erotic implications.[27] This is particularly true, for example of *Woman Sleeping in a Chair* where the metamorphosis of the features into sexual organs in a sleeping figure suggests, as Professor Robert Rosenblum remarks, that the relaxation of consciousness has released the sitter's repressed sexuality.[28] Particularly disquieting is *Study for a Monument* of 1929, where the mouth, reversed on its axis and open to expose two rows of sharp, barbed teeth, acts as a symbol of sexual

155 René Magritte, *The Rape*, 1934.

156 *Woman Sleeping in a Chair*, 1927.

94

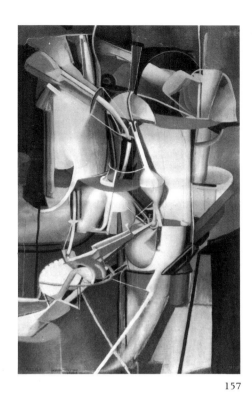

157

menace to the small male figures below. The displacement of the different parts of the human body and in particular of the genitals to the head was a device fundamental to much Surrealist painting. As early as 1912 Duchamp had suspended the 'sex cylinder', his symbol for the female organs, in front of the face of *The Bride*. 157 Miro constantly equates the pubic areas of the body to the head, and Magritte 155 was to give the device its most explicit treatment in his *Rape* of 1934.

In keeping with the climate of Surrealist taste Picasso's art in the years immediately after 1925 was being informed not only by neolithic sources but by a wide variety of other primitive art. The 1920s witnessed the climax of the Parisian intelligentsia's passion for primitive art, and the Surrealist writers and painters were, like Picasso himself, compulsive collectors. However, as the decade progressed there was a pronounced shift in emphasis away from African art; the Surrealists now condemned it for its formalism, for its occasional realism and above all they felt that it had too often been tainted by contacts with the west—the classical African civilizations of Ife and Benin in particular were shunned. On the other hand Eskimo

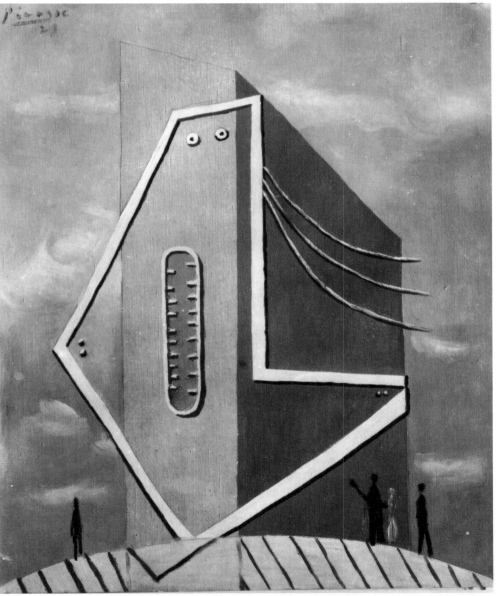

157 Marcel Duchamp, *The Bride*, 1912.

158 *Study for a Monument (Woman's Head)*, 1929.

158

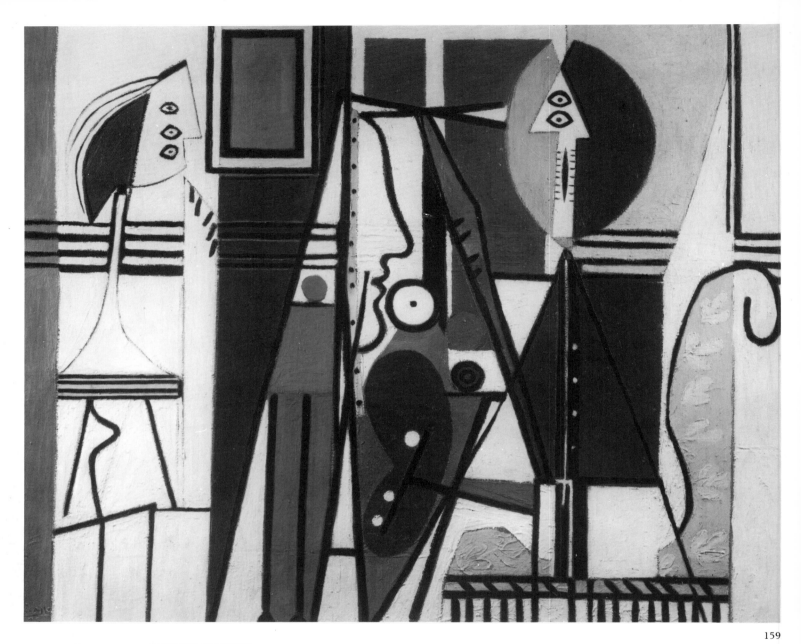

160 161

and American Indian pieces were much in demand and Oceanic art in particular was admired for the qualities which they had come to feel were lacking in much African art. They saw it with some justification as being more lyrical, more imaginative, more grotesque and fantastic. Most of all they loved what they felt to be its childish innocence, its flashes of humour, and they delighted in its characteristic element of metamorphosis which so often carried with it an enrichment of sexual imagery. 'Oceanic art', Breton was to write, 'expresses the greatest immemorial effort to take into account the interpenetration of the physical and the mental, to triumph over the dualism of perception and representation'.[29]

Picasso never turned his back on African art, but he seems to have shared to a large extent in the Surrealists' new enthusiasms. It has already been suggested that Eskimo art, which was also influencing Miro at the time, may have been in part responsible for the most startling deformations of the *Three Dancers*. The elongated, flattened heads of the *Artist and Model* of 1928 in the Janis Collection (to take one example amongst dozens) with their strongly incised, linear features may owe something to Oceanic shields, although the realignment of the features of the head of the model is reminiscent, too, of certain African masks. But whereas at the time of his first infatuation with African art Picasso had from time to time made specific borrowings from individual pieces, in keeping with his greater maturity the new

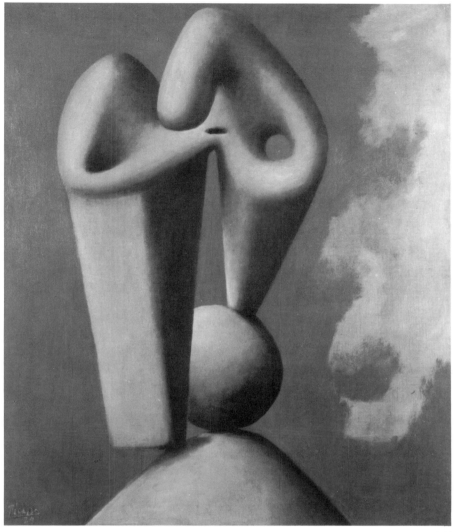

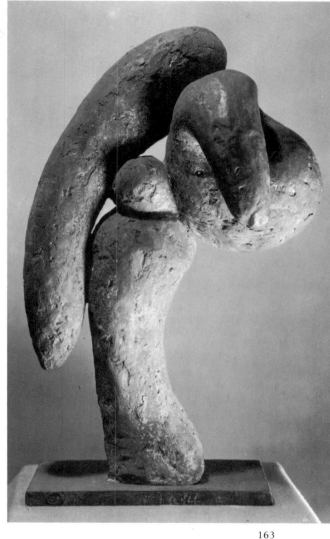

162 163

primitive sources are always fully assimilated before they are allowed into his canvases, so that it is harder to make specific confrontations. And just as in the formation of Cubism Picasso was ultimately more interested in the principles behind African art than in its visual appearance, so now he approached Oceanic and other primitive art at a deeper level than many of his younger colleagues. He was alive to its linear beauties and to its strong decorative appeal, and its fantasy undoubtedly encouraged him in taking the extreme liberties with natural appearances that are so fundamental a characteristic of his art during the years of his association with Surrealism. But it was above all his understanding of the techniques by which Oceanic artists endowed their work with its deep sexuality that allowed him to achieve such disquietingly surreal effects of his own, and to achieve them with a force all the greater for its subtlety—a subtlety that sometimes evaded artists more orthodoxly Surrealist in their orientation.

The interchangeability or confounding of the different members of the human body, so characteristic of neolithic art, tends to resolve itself in much Oceanic art into an equation between the features of the human face and the sexual members of its body. In a characteristic type of Sepic Valley statuette, for example, the nose and the penis are joined in a single, unbroken form, and hence unequivocally equated. Picasso's interest in introducing sexual imagery into the treatment of the

159 *Artist and Model*, 1928.

160 Wooden dance shield from New Guinea.

161 Wooden figure from the Sepic Valley, New Guinea.

162 *Head (Blue Bone)*, 1929.

163 *Woman's Head*, 1932.

161

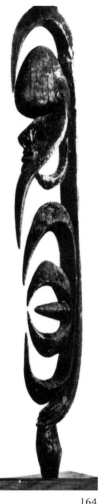

164

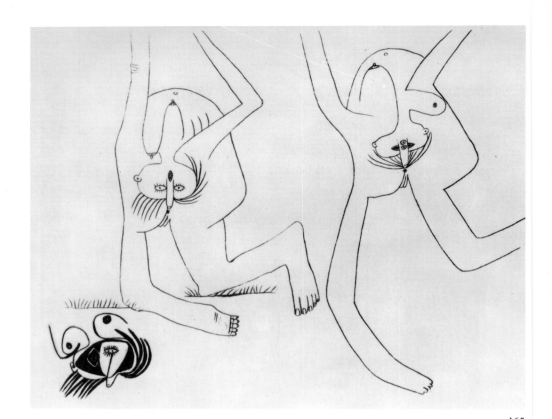

165

human head had been a feature of his art since 1924.[30] The fact that he was conscious of the implications of what he was doing is confirmed by a series of drawings of naked women executed in 1929, in which the heads are bent over backwards until the features become confounded with the pubic areas of the body and in the process acquire unmistakeably phallic properties. In certain works by Picasso, his *Head* of 1929 is a good example, the entire female head appears to stand proxy for the male genitals; and this painting and similar works evoke comparison with certain New Guinea masks. A related sculpture, *Woman's Head*, executed three years later, makes the same point even more forcefully in its three-dimensionality.

166

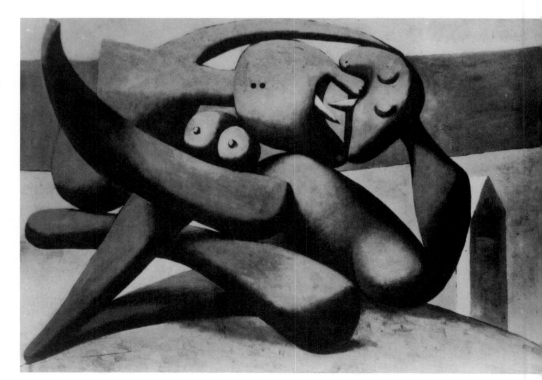

167

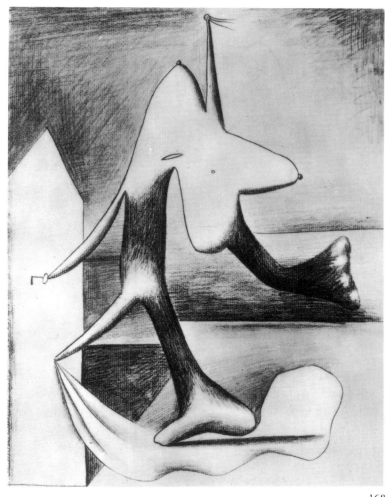

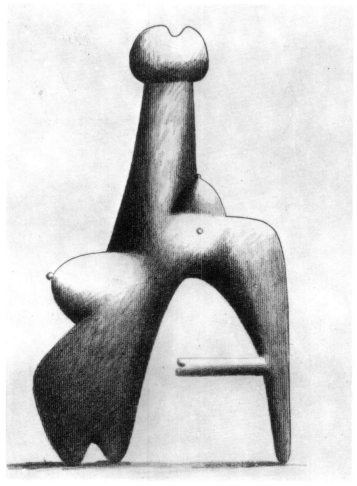

168 169

This *Head* relates in turn very directly to another sculpture of the same year, Picasso's *Cock*, a powerful depiction of the sexually aggressive bird which from 240 some of the earliest manifestations of art had been used to symbolize the erect male organ. Yet another powerfully disturbing piece of sexual imagery may be derived from a study of Oceanic art. The sharp, pointed, stabbing tongues, which appear first in the *Sleeping Woman* of 1927, and are later used in more aggressively 156 physical encounters, appear to derive from the conventions used in much New Guinea sculpture to depict the male phallus. In this type of Oceanic art the curved 164 or pronged shapes that protect the sex give it an air of mystery and magic; in Picasso's work variations of the same encircling motifs endow the same form, transferred to the ʰuman head, with a quality of menace and aggression. *The Kiss* of 1931 uses the devices of Oceanic art to produce an atmosphere of sexual violence 167 paralleled only in certain esoteric forms of Oriental art. Perhaps it is Picasso's 166 ability to incorporate into a single form the elements of both male and female sexuality, and yet to leave each image so unequivocally itself that both separates Picasso's vision from that of the Surrealists and yet enables him to achieve some of their aims so powerfully and independently.

Premonitions of some of the disturbing violence to come, and of the assault upon the human head and body in terms of extreme and at times sadistic distortion can be sensed in certain works of 1924 and in the *Three Dancers* of 1925. But it is in the years between 1927 and 1932 that Picasso makes his most concentrated attack on the female form. In a series of Bathers, initiated in the summer of 1927, the human 168

164 Wooden figure from the Sepic Valley, New Guinea.

165 *Study for a Crucifixion*, 1929.

166 Detail of painted wooden figures from Tibet.

167 *Figures by the Sea (The Kiss)*, 1931.

168 *Bather*, 1927.

169 *Bather*, 1927.

head is often reduced to a grotesque pinpoint, while the enormous breasts, sex and limbs (particularly the legs) are inflated almost out of recognition and appear to be composed of tumescent substance, half pulp, half bone. Often their sexuality is symbolically underlined by the way in which they insert a key into the door of a beach cabin; sometimes their arms can be read as phalluses and occasionally head

170–71 *An Anatomy*, 1932.

172 *Drawing*, 1928.

173 *Drawing*, 1928.

174 *Nudes (Copulating Couple)*, 1933.

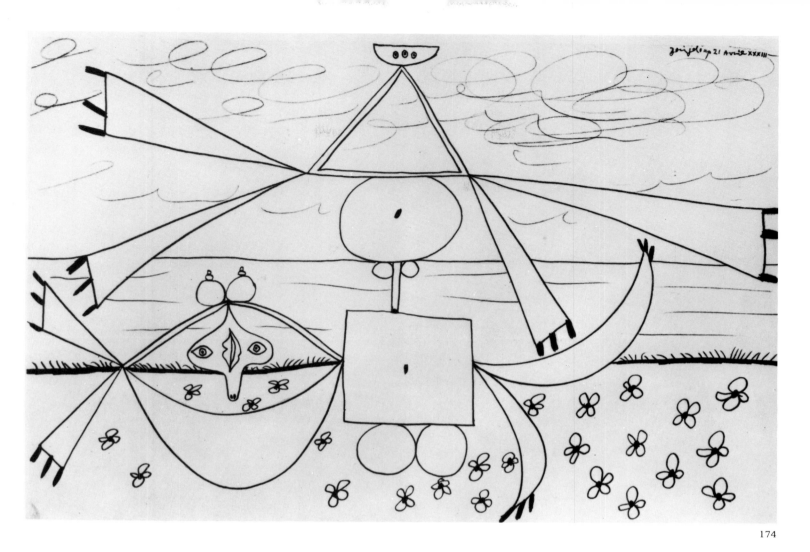

174

and neck too acquire a thrusting, masculine urgency; parallels can be made with the biomorphic idiom developed by Arp in previous years, but although the heavy, swelling forms used by both artists have a certain similarity, the confrontation serves to underline the witty but grotesque sexuality of Picasso's work. When the theme of the Bathers is tackled again over the following years the forms of the bathing women either become flatter and more angular, or else harder, rounder and more flinty, more purely bone-like. This is true, for example, of a series of brooding 172 pen and ink drawings executed during the summer of 1928, where the human form 173 is conveyed by configurations of forms reminiscent of weather-worn stones and bones, propped and piled onto each other in arrangements that are precarious and yet have a quality of static balance reminiscent of ancient dolmens. In their extreme distortion and abstraction of body imagery and in their composite quality, the way in which the figures are built up of various formally independent elements, these 'bone' drawings of 1928 look forward to the more orthodoxly 'Surreal' drawings of *An Anatomy*, reproduced in 1933 in the first issue of *Minotaure*, a publication with strong Surrealist leanings, and for which Picasso also designed the first cover. *An Anatomy* consists of thirty small images in which the human anatomy is re-invented with every imaginable permutation: a chair becomes a torso, sporting 170 two cups for breasts, a circular cushion with a serrated wheel dropping from it 171 stands for loins and sex, a door and a form reminiscent of a coat-hanger are trans-formed into trunk and arms, and so on. Basically all the figures are female, but each one carries within herself a powerful symbol of her male partner: one dangles a second pair of circular breasts between her legs, while another balances a cylin-drical cup in a triangular tray, situated between her thighs. In a unique series of 174 drawings executed a few months later depicting copulating couples, and which

101

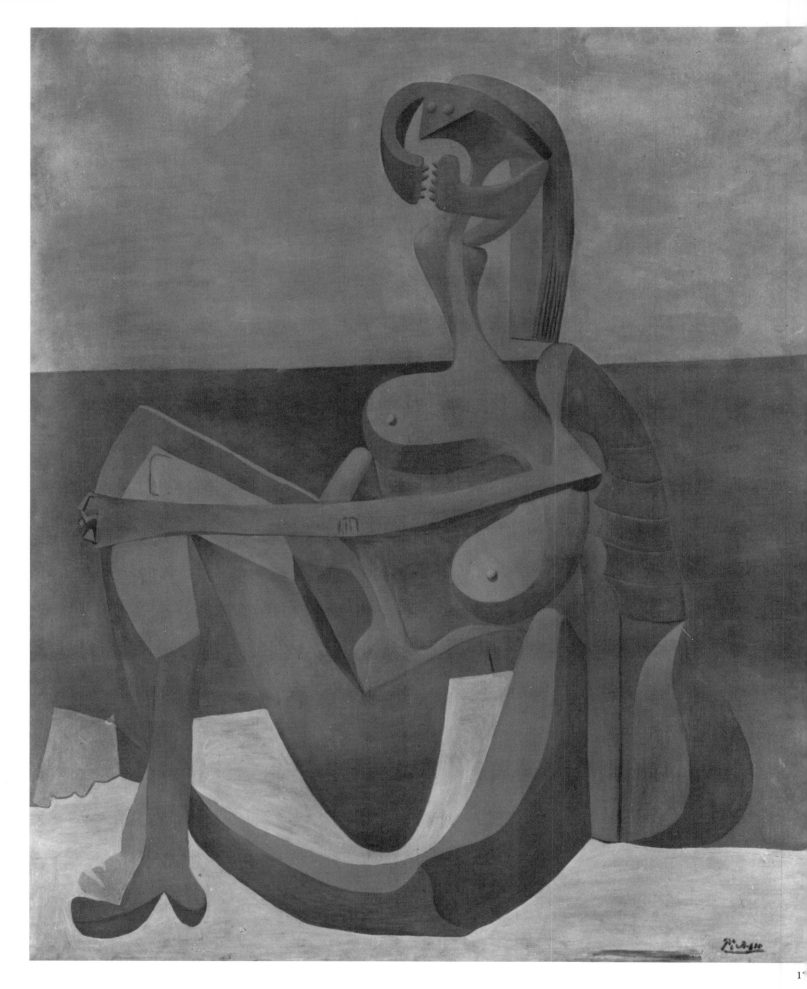

176 177

range in mood from the idyllic to the bestial, or to the wittily obscene, Picasso's flights of anatomical fantasies reach an almost science fiction level.

The image of woman as a predatory monster reaches its ultimate expression in Picasso's work in two complementary images of 1930 and 1932. The first of these, *Seated Bather*, appears to have her face and limbs chiselled out of stone, and she 175 relates, once again, to the 'bone' drawings of 1928, although in contrast to their megalithic simplicity the balancing of the head, breasts and limbs on the spinal column involves a more elaborate feat of balance; in keeping with his sculptural experiments of the time, much use is made of negative spaces or volumes: the stomach, for instance, is present by its absence. The air of menace about the figure is intensified by the fact that it is placed against a calm blue background of sea and sky. Her pincer-like arms and jaws and her expressionless, sub-human eyes give her the air of an enormous praying mantis, carved in granite. The praying mantis was an insect which held a morbid fascination for the Surrealists because of its unconventional marital habits; that the image is one which interested Picasso is suggested by a group of drawings of 1932 in which bathing figures are rendered by leaf-like forms suggestive of the mantis's camouflage wings.[31] The *Seated Bather's* pictorial counterpart is *Bather with a Ball*, executed two years later. Here the 186 rubbery, swelling forms of head and limbs refer back to the first works of the Bathers series, the drawings of 1927. The gay colour and an air of wilful absurdity only partially disguise the bather's true nature: her mouth, eyes, nose and hair take on the configuration of a giant squid, and her limbs though grotesque are sinister and tentacular.[32]

In keeping with Surrealist concerns, or paralleling them, the element of sexual drama in Picasso's art is sometimes placed within the wider context of its relationship to the creative act. In *Figure and Profile*, for example, probably a work of

175 *Seated Bather*, 1930.

176 *Figure and Profile*, 1927–8.

177 *Bust of a Woman*, 1929.

early 1928, the male presence makes itself felt in the form of a simple black profile
to the right, rendered with classical economy, its mouth slightly parted as though
in pain. The female figure has been reduced to an obscene diagrammatic polyp.
She appears as a painting within a painting, and it is as if the male (the painter)
has sought to exorcize her powers of destruction by depicting her as twice removed
from reality. Sometimes the relationship is reversed. In a work of the following year
it is Picasso, the male profile, who appears as a painted effigy, hanging on the wall
behind the female fury. Head thrown back, hair bristling and teeth and tongue
bared, she seems to menace not only the painter's manhood but his creative powers
as well. In another work of the series the male presence has disappeared leaving
behind as his symbol the blank, dark canvas, now totally at the mercy of the saw-
like teeth and the dagger tongue.

Picasso's final separation from his wife Olga did not take place until the mid-
thirties, but the paintings of the late twenties bear eloquent testimony to the way
in which the social habits imposed upon him by an increasingly unhappy marriage
had come to seem a threat to the well-springs of his creativity. Olga had entered his
life at a crucial moment; already in the months before the outbreak of war in 1914
his ever-increasing celebrity, and the fact that alone amongst his Cubist colleagues
Picasso was entering a phase of real economic prosperity, were serving to detach
him from the life of communal bohemian existence that was in many ways funda-
mental to the Cubist aesthetic. His loneliness and isolation during the war years,
when Paris was abandoned as the home of the *avant garde*, must have been great,
and a certain lack of artistic direction is visible in the style-searching to which his
wartime work bears witness. His first working contacts with the Diaghilev Ballet
in the winter of 1916-17 must have given him the sense of belonging once again to
a particular aesthetic and intellectual world, and he undoubtedly enjoyed the
element of teamwork involved in working as guest designer for one of the most
progressive theatrical ventures of its time; even the odd moments of friction
between the various collaborators on *Parade* carried with them an element of
excitement. Olga was a dancer with the company. The fact that he met this beautiful
woman with her fine, symmetrical features and her sense of style in Rome (from
whence he travelled to Naples), that is to say in surroundings that evoked for him

178 *The Open Window*, 1929.

104

very vividly the sensation of the classical past, probably encouraged him to believe that a reassertion of classical values could solve the artistic dilemma that faced him. His first portraits of Olga testify to the calm, contained nature of his love. The magnificent Maternities which followed the birth of his son Paul in 1921 reflect perhaps the summit of his love for his young Russian wife, although the element of heavy, almost elephantine distortion that begins to inform many of these canvases would suggest that the implications of conventional family life were already producing an undercurrent of unease.

Olga was a woman of a certain natural distinction, but she was on the whole conservative by nature and not the ideal wife for someone of Picasso's extreme, passionate, elemental nature. Olga's ideal world was that which marked the boundary line between high bohemia and high society; Picasso though obviously happier in the former, belonged to neither. The theme of the dance, so intimately related to memories of his first encounters with Olga, was given a cataclysmic change of mood in the great canvas of 1925, a work in which Picasso re-examined his artistic conscience and returned to some of the sources that had helped to transform him into a symbol of pictorial revolution. There can be little doubt that sub-sequently he came to see married life with Olga as incompatible with the total freedom necessary to him as an artist. The sense of conflict and claustrophobia produced by his desire to fulfil the obligations of his marriage and yet retain the emotional and moral independence demanded of him by his art resulted in a series of works of compelling if disturbing power and originality; but the tensions were too great to be maintained.

Not only the sources behind Picasso's imagery, but the sensation of unease, of displacement and of occasional violence which are conveyed by so many of the canvases executed between 1925 and 1932 serve to relate Picasso's work, at a distance, to that of the Surrealists. On the other hand the fact that these qualities were the result of undercurrents in his personal life, and not part of an intellectually-conceived programme to dislocate conventional modes of morality and perception, underlines very forcefully the differences between his own and the Surrealist approach. And it is characteristic of him as an artist that when further developments in his private life were to channel the main currents of his art through fresh territory,

179 *The Painter*, 1930.

he should have felt free to acknowledge more overtly his links with the Surrealist world.

Picasso's brief adherence to orthodox Surrealism is presaged in a handful of works executed between 1929 and 1930. It was a time when he was subjecting the human body to a series of violent deformations and dislocations, but these, as he was to stress, were invented as a means of rendering his art more physically real than the real. On the other hand a work such as *The Open Window* of 1929 does appear to show a genuine interest in 'the marvellous', and in the deliberately ambiguous effects that were so much the province of true Surrealism. The painting is obviously basically a still life, but its imagery remains obscure. Two feet, one upside down above the other, are joined together at the calf to form a single unit, which is then transfixed by an arrow; this sort of anatomical operation, of the most disquieting implications, might well have delighted Dali, Magritte or Belmer. (In his play *Le Désir attrapé par la queue*, a work which for want of a better definition can only be called Surrealist, Act Two, Scene I is set in 'A corridor in Sordid's Hotel. The two feet of each guest are in front of the door of his room, writhing in pain'.) On the other side of the canvas a bodiless head (a plaster cast?) is fused to a hand, fingers outstretched, which acts as a base or support, a device reminiscent of those employed on occasion by Miro. In *The Painter* of 1930 the painter's head, a 'soft' version of the mannequin head so dear to de Chirico and the Surrealists, reaches out an enormous hand; a body, the size of the hand and apparently female (yet belonging to the painter?), sits under the head, its members taking on the configuration of an Egyptian cat. The painter's model, at the extreme right, is in Picasso's by now familiar 'stick' style, while two 'neolithic' acrobats disport themselves on the canvas

180 *Minotaure*, 1933.

within the canvas. This latter work could with justification be seen as a latter-day version of the great *Painter and Model* of 1926, one of the most Surrealist of the canvases of the twenties, although the even more extreme switches in scale and the obscurity of the body imagery (as opposed to the curvilinear confusion of the earlier work) place it, like *The Window* slightly to one side of the main developments in Picasso's art.[33]

Picasso's collaboration with *Minotaure* in 1933 served to strengthen his contacts with the Surrealist writers, many of whom he had known for some time. To the first issue Breton contributed an important essay, 'Picasso dans son Elément', and other collaborators included Reverdy (an old friend of Picasso's and in many ways a father figure to the Surrealist poets), Eluard (to whom Picasso was drawing ever closer), Michel Leiris, Tériade (the magazine's publisher) and Dali, by now one of the movement's stars, who was represented by a spirited essay on Millet's *Angelus*. The magazine was not exclusively Surrealist in its policies (the first issue included also an essay by Raynal, another friend of Picasso's of long standing whom the Surrealists distrusted) and this may in itself have made Picasso happy to be so closely associated with its inception.

Picasso himself admitted to being influenced by Surrealism only in 1933, 'at the moment when he was suffering from matrimonial difficulties which were soon to culminate in a separation from his wife Olga', and he added that this was 'mostly in his drawings'.[34] This was the year that saw the cover for *Minotaure*, *An Anatomy*, and the erotic drawings, all works of the late winter and spring, and all showing marked affinities with Surrealism, although the cover design was linked to the movement only iconographically and was rendered in a pure, linear, Neo-classical style. During the summer, while staying at Cannes, Picasso executed yet another series of drawings which are more immediately recognizable as Surrealism than anything he had hitherto produced. The most characteristic drawings of the series consist of two upright, composite images, which suggest human presences; usually these have specifically male and female attributes, although this is not always the case. The drawings have obvious affinities with the personnages of *An Anatomy*, but whereas these had a certain iconographic unity, despite their fantasy, and were still related to the 'bone' drawings of 1928, the Cannes figures or presences are characterized by the apparently gratuitous assembly of totally unrelated objects which achieve a semblance of coherence only because each element is rendered by the same quick, nervous line. In *Minotaure*, a characteristic work of the series, the presence to the left consists of a flowering armchair which sports a human arm, and which supports, precariously, a chequered board. From the chair and the board rise forms suggestive of a young tree trunk and a rough-hewn wooden plank. To the former is pinned a piece of paper corresponding to the position of a human head. Opposite this presence, passive and presumably feminine, is raised a formidable male counterpart, standing on a low base or plinth. A straightbacked chair is surmounted by a naturalistic arm and shoulder, while the shoulder in turn balances a bull's head. Opposite this head and pointed towards the presence opposite is a dagger, apparently fixed by wire to the back of the chair. The drawing which appears to have been executed at great speed in a state of semi-trance contains, as one might expect, familiar Picassian imagery. The woman/armchair, for example, recalls *La Femme en Chemise* while the flowering plants which it sprouts are echoed in the backgrounds of contemporary nudes. The bull's head and dagger relate to the cover of *Minotaure* and to the series of works which were to lead up to *Guernica*. Much of the imagery in these drawings (the fragments of furniture used in *An Anatomy*, for example, and which John Richardson has suggested may be symbolic of the breaking up of the painter's household)[35] can be paralleled in

145

170

180

107

181

drawings and paintings by wholly Surrealist artists; other works of the series make use of an architectural setting, and sometimes an architectural element, a column 18 for example, is made to stand as a substitute for the human figure. Ultimately, however, Picasso's excursion into official Surrealist territory would seem to owe most to the Surrealist 'Exquisite Corpse', a game practised avidly not only by the movement's painters but also by its writers. In this game each player draws an element to the human body, attaching it blindly to that which the previous player has folded over out of sight. Played by a single artist it is not surprising that the imagery in the component parts would relate to his work, past, present and future.

There can be little doubt that in the last analysis Picasso was more deeply drawn to the Surrealist writers and to Surrealist literature than towards visual Surrealism which, for the most part, he regarded with a certain element of mistrust. Since his Cubist days he had been fascinated by the interrelationship between the written word and the painted image, and like the Surrealists he was interested in the idea of painting as sign language. The years 1935 and 1936 were in many ways distressing for Picasso, from a personal point of view, witnessing as they did the legal complications of his final separation from his wife, and his normally prodigious output much reduced. It was perhaps only natural that he should have turned to the written word as an alternative to paint and canvas. His poetry and his prose poems were to occupy him some eighteen months, until the outbreak of the Spanish Civil War brought on a renewed frenzy of pictorial activity; the winter months of 1935-36 witnessed the most concentrated phase of literary activity. Picasso's Surrealist friends were needless to say delighted, although at first Picasso seems to have been diffident about exposing his ventures into a new territory to the public. Early in 1936 however, *Cahiers d'Art* brought out a special Picasso number (it was classified by the magazine as the last of their 1935 publications) built around extracts of his recent writings.[36] Breton, who despite the fact that he was often irritated by Picasso's total independence, was constantly looking for ways of grafting his genius onto official Surrealism, wrote a eulogistic and perceptive introduction, *Picasso Poète*, and the same issue contained a beautiful essay on Picasso by Eluard and sympathetic texts by Christian Zervos (the periodical's editor), Dali, Man Ray and Georges Hugnet. Benjamin Peret, one of the original

181 *Composition*, 1933.

members of the movement, contributed a long poem which bore Picasso's name as its title. Surrealism had originated as a literary movement and Picasso's writings undoubtedly place him, more squarely than anything he ever produced in the visual field, in a Surrealist context. They give the impression of having been written quickly in a stream-of-consciousness technique (although we know they were much revised), and to this extent they relate more closely to Surrealist texts produced in the early twenties during the *Saison des Sommeils* than to the more self-conscious and pondered literary products of the late twenties and thirties. In common with these early Surrealist texts, Picasso's writings are fantastic, often hard to follow, and lacking in any conventional literary structure: originally dashes were used as punctuation but in accordance with technical procedures laid down in the first Surrealist Manifesto, these were subsequently suppressed. But even in these most wholehearted excursions into orthodox Surrealism Picasso's fantasy is ultimately not of a Surrealist brand. What distinguishes his work from that of his poet friends of the movement is its extraordinary physicality, its earthiness and directness. These qualities are achieved, technically, primarily by the way in which he tends to group and concentrate types of words; noun is piled upon noun, adjectives are strung together one after another, verbs follow each other rapidly. Every image calls up another which serves to reinforce it rather than to dislocate it from everyday reality. The chain reaction from image to image often works around in a circular fashion to its starting point. When the images act or are acted upon, their action serves to underline their vital material presence and function: doves fly themselves to death, wooden boards nailed with rose thorns bleed (the wood is presumably alive still with sap) and so on. It is interesting to note that although as a painter Picasso had never been primarily a colourist, in his poetry colour is all important, and his insistence on it helps to reinforce the tangibility of the visual imagery which is obsessively physical. There is for example an insistence on food and kitchen utensils which looks forward to his still lifes of succeeding years. Breton, searching for *leitmotifs* in the poems, comes up with a series of images relating to the bullfight, and these, while they relate simultaneously to concerns in Picasso's contemporary paintings and drawings, seem to project him back in time to his Spanish boyhood and adolescence; he talks of Barcelona and in the passages which relate to his childhood the recurrent colours are, significantly, the varying shades of blue of his Blue period. The Surrealists who constantly sought to project themselves back into a state of childhood seldom succeeded in doing so, other than in a selfconsciously analytic way, and their art is by and large characterized by its extreme adult sophistication. Picasso, on the other hand, can evoke a feeling of awakening sensibility with a feeling of almost anguished poignancy.

The Surrealist drawings of 1933 are of great historical importance, but they have about them the air of being experiments and are ultimately peripheral to Picasso's achievement. Similarly the poems are in the last analysis perhaps not great works of literature. But they have about them a hallucinatory intensity. Here, for example is a passage which evokes the atmosphere of an empty room:

'the wing twists corrupts and eternalizes the cup of coffee of which the harmonium in its timidity caresses the whiteness the window covers the shoulder of the room with thrusts of goldfinches which die in the air . . .'

And at its best, as in the passage which Breton rightly exalts, Picasso's writings have a quality of apocalyptic grandeur worthy of the writings of those visionary saints for which Spanish literature is so rightly famed:

109

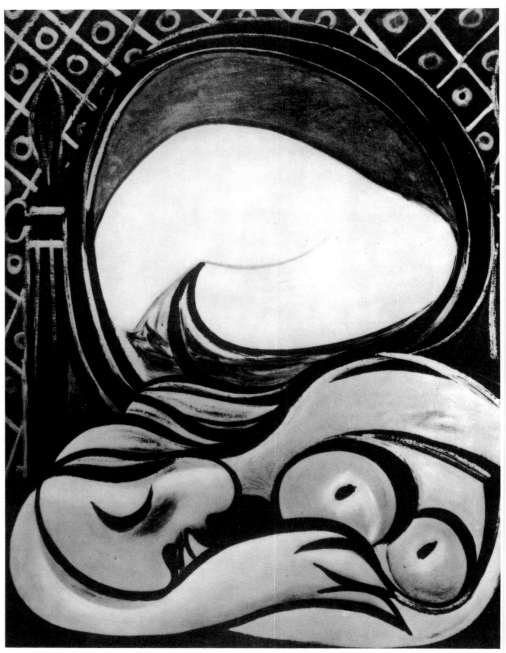

' . . . give tear twist and kill I cross light and burn caress and lick embrace and watch I strike at full peal the bells until they bleed terrify the pigeons until they fall to earth already dead of fatigue and bar all the windows and the doors with earth and with your hair I shall hand all the birds which sing and cut all the flowers I shall cradle in my arms the lamb and I shall offer him to devour my breast I will wash him with my tears of joy and grief and I shall lull him with the song of my solitude by Soleares and engrave the etching the fields of wheat and oats . . .'

1932 saw a marked change in Picasso's art, not so much stylistic as in terms of mood and of sexual imagery. The exact date of his meeting with Marie-Thérèse Walter is not certain but the visual evidence of the paintings of 1932, which radiate so strong an air of erotic fulfilment and relaxation, would suggest that their love was consummated early in this year. Marie-Thérèse's full, passive, golden beauty was to preside over Picasso's art for the next four years; most typically she is seen in what appears to be a dreamless sleep. Her heavy, pliant limbs are rendered by the

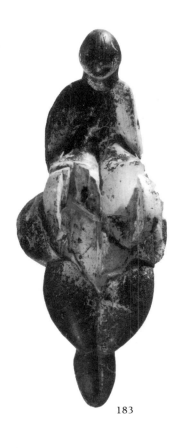

183

same undulating forms that had characterized much of Picasso's work since 1925, but whereas before these had so often seemed predatory or tentacular, their rhythms now become slower, softer, more welcoming and more organic. In *Bather by the Sea* of 1930 and *Bather with a Ball* of 1932 the forms are strongly, almost aggressively three-dimensional. The Marie-Thérèse paintings on the other hand tend to be flatter, more elaborate and more lyrical in their colouring and often the backgrounds are highly patterned. Everywhere there are symbols of growth and fertility. Rosenblum points out how in *The Mirror*, a work dated 12 March 1932 and one of the most beautiful of the first Marie-Thérèse series, the forms used to render the sleeper's yellow hair resemble silky seed pods, while the same shapes repeated in the mirror, directly above, and which spill out from the supple buttocks, are rendered in green, the colour of nature's renewal;[37] and indeed at this time Picasso makes constant if intuitive use of colour symbolism. In the works which followed from the *Three Dancers* Picasso had adapted the devices of Cubist multi-viewpoint perspective to include in each figure the maximum amount of

186

182

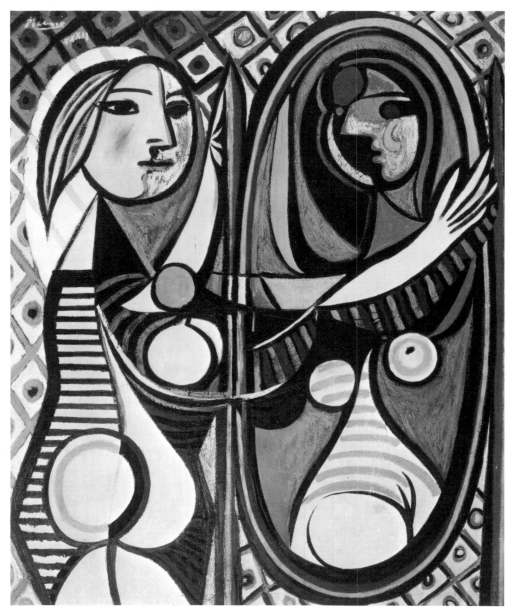

182 *The Mirror*, 12 March 1932.

183 *Lespugue Venus*.

184 *Girl in Front of a Mirror*, 14 March 1932.

184

sexual imagery; here the mirror reflects not the woman's shoulder and back but the lower part of her body, so that we experience a sense of physical totality although the painting is basically a study of a half-length figure. In *Reclining Nude* a work of the summer, the sleeper has become a sort of Persephone figure, garlanded and recumbent on a carpet of flowers, while out of her loins there issues forth a surge of flowers and foliage. *Girl in Front of a Mirror*, executed a couple of days after *The Mirror* and perhaps the most famous painting of the series, introduces a note of psychological complexity. The girl confronts her own sexuality calmly and with a certain reverence; the tender lilacs of her face and body have become in the reflected image deeper, more mature, and the breasts have ripened into fruit, while the wallpaper behind echoes their circular forms discretely but insistently. Just as in the work of the second half of the twenties the single female figure generally carried within herself the symbols of her male counterpart, so here the girl's breasts and forward arm raised in a gesture of embrace and acceptance form a giant phallus which reaches forward and up towards the reflection which suggests the girl's prospective maturity.

In the works of the late twenties the brutalized female form had been presented

185 *The Painter*, 2 May 1934.

186 *Bather with a Ball*, 1932.

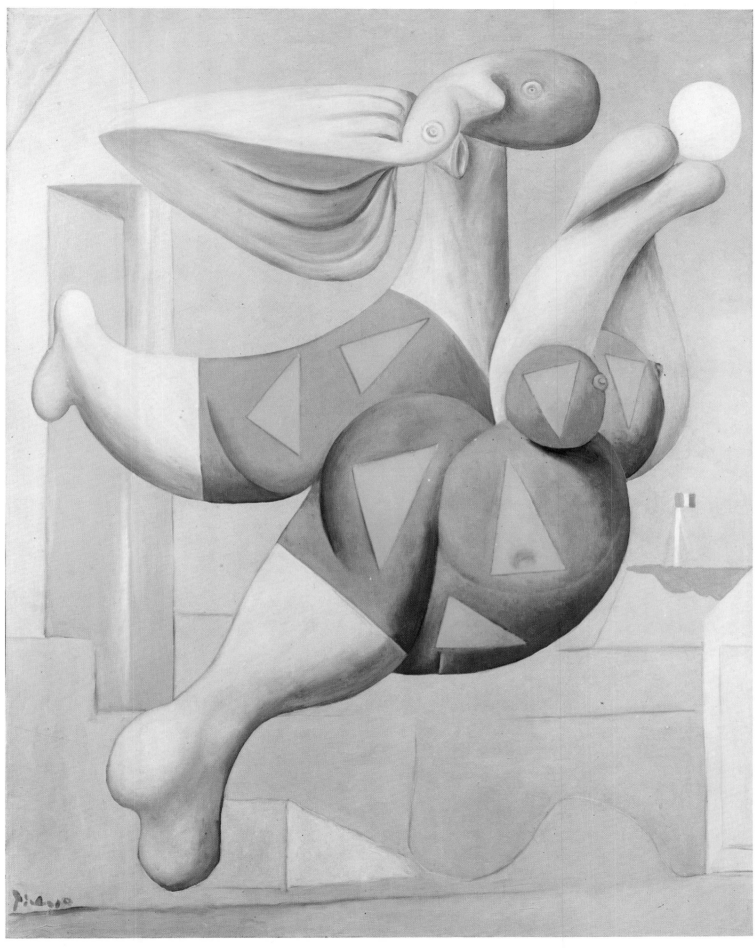

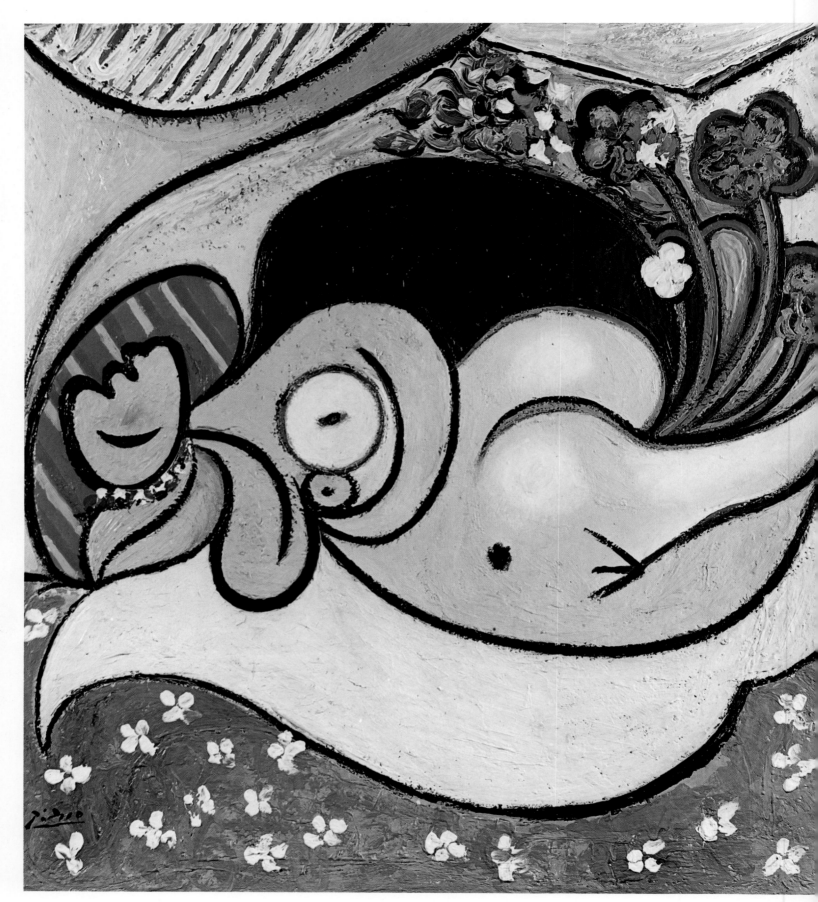

188

as a threat to creativity. *The Painter* of 1934 shows the sleeping model giving herself 185
up to the painter's art, like an offering of fruit and foliage. She has become simultaneously mistress, model and muse, and in a sense it is she who has now become the victim, in that her sexuality has so clearly been laid out as a sacrifice to the artist's gifts.

The image of woman as a predatory monster, the theme which had endowed Picasso's art with the 'convulsive' drama so dear to Surrealist aesthetics, was one which was to recur in his art sporadically during the succeeding years. A drawing 305
of the summer of 1934, for example, shows a female fury (descended from the tumescent bathers of 1926) holding a dagger to the throat of her gentler, flower-like sister. Earlier in this same year the recumbent Nudes of 1932 had been reinterpreted in disquieting, highly Surrealist imagery. And throughout the thirties Picasso continued to produce periodically works which like the best Surrealism of the period had the power to shock the spectator out of his habitual modes of perception; many of the works of 1938 in particular, which take up again the themes of the late twenties and early thirties, have about them an obsessive, somewhat horrific and shocking quality. Generally speaking, however, the symbolic quality of the eroticism and the violence that had been so characteristic of the work of the late twenties and early thirties and which had owed so much to a reappraisal of primitive art, is replaced as the thirties progressed by an increasingly overt physicality and by an explicitness and forthrightness that was removing Picasso's art ever further from the world of Surrealism.

Picasso's most completely Surrealist works date, it is true, from the years between 1933 and 1935. But these excursions into a world that was not fundamentally his own, although they were of great importance to his development as an artist, stand aside from the mainstream of his talent. The paintings which celebrate his relationship to Marie-Thérèse are already at a further remove from Surrealism than those which had recorded his increasingly desperate and negative feelings towards Olga. The techniques he employed in *The Mirror* of 1932 are not fundamentally different from those of *Woman in an Armchair* of 1926: there is the same use of a free, metamorphic line, capable of describing an arm, a leg, a nose or a plant in terms of the same basic repertory of forms. And yet there is a feeling of contentment, an extrovert enjoyment of the healthily physical that removes the later work from almost everything that Surrealism aimed for. It is true that the Surrealists extolled the value of love 'in its broadest sense', but basically they were, in the words of Aragon, 'the mind's agitators',[38] and on the whole their use of the erotic in their art was placed at the service of jolting the spectator out of an unthinking acceptance of conventional and traditional patterns of behaviour and moral standards. Picasso's previous work had produced much of the same sense of shock, not it is true so much because of its subject matter (which by Surrealist standards was for the most part conservative), but by virtue of the extraordinary distortions to which the human body had been submitted and because of the savagery of the erotic imagery which these distortions so often suggested.

It was his fascination with a new range of primitive sources and their use of metamorphic, erotically charged imagery that had related Picasso's concerns most closely to those of his younger Surrealist colleagues in the years before he was prepared to overtly acknowledge the movement's influence. The series of sleeping nudes initiated in 1932 were still to a large extent being informed by primitive sources or at least have strong affiliations with certain forms of primitive art; it has been suggested, for example that Picasso may have been influenced by the much reproduced Hal Saflieni *Reclining Woman*, one of the most ancient renditions 188
of the female form, and the Venuses of Lespugue and Willendorf, which with their 183

187 *Reclining Nude*, July 1932.
188 *Hal Saflieni Venus.*

heavy, ripe, bulging forms can be viewed as ancestresses of Picasso's images of female fecundity.[39] But it is significant that these art forms of the remote past were precisely those which over long centuries were to be transformed into the classical figures of Greece and Rome. In a sense the Venus of Lespugue is closer to the Venus of Milos (and hence to Titian, Rubens and Renoir) than the work of a Sepic Valley craftsman of the nineteenth century is to a contemporary sculpture by Rodin. Picasso's Neo-classicism had to a large extent gone underground during the second half of the twenties but it had never been totally suppressed and during the 1930s classical values and imagery were once more to assert themselves strongly (if sporadically) in his art. Classical mythology, in a Freudianized form, began to interest the Surrealists in the latter stages of the movement,[40] and to this extent

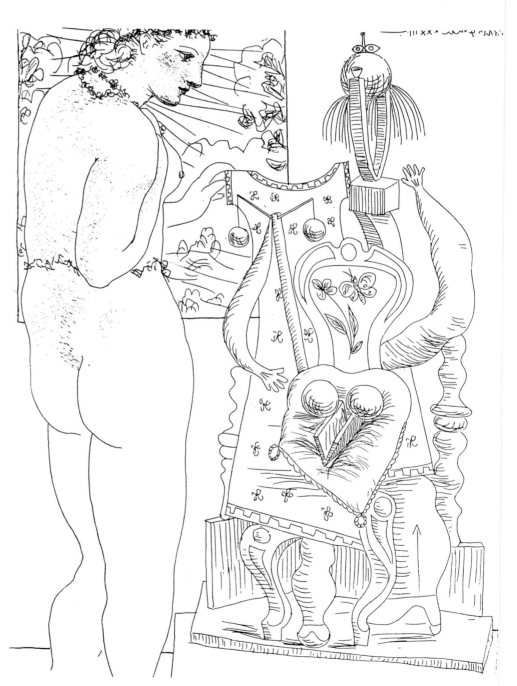

189 *Model and Fantastic Sculpture*, 1933.

190 *The Flood*, from the commentary on the Apocalypse of Beatus of Liebana.

191 Aborigine cave painting from Oenpelli, Arnhemland.

192 *Crucifixion*, 1930.

189

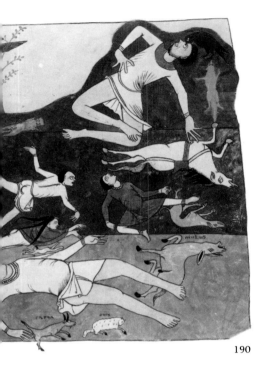

191

192

Picasso was once again a pioneering figure in its history. But basically it was in large part against the classical heritage of the West that the Surrealists were in revolt. The tradition to which they belonged was that of northern mysticism and northern romanticism; the cultures of the past which they admired were those remote in spirit from the world of antiquity or so primitive in their evolution as to seem to have little to do with its products. Their love of Oceanic, Eskimo and North American Indian art and of neolithic cave painting was perfectly in keeping with their romantic impulse towards the irrational and the intuitive. It was all part of what might be called the journey downward. This was a path which from time to time fascinated Picasso, but he refused to see it as leading only in one direction, and he continually felt the need to fuse his art onto the great traditional sources from which in the last analysis it had sprung. An etching of 1933, *Model and Fantastic Sculpture*, shows a young woman directly descended from the nudes of 189 antiquity confronting her Surrealist counterpart, a fantastic composite image simultaneously comic and frighteningly grotesque—as strongly as any other single work the etching illustrates Picasso's recognition of the two worlds to which his art at the time owed allegiance.

The classicizing not only of the outward forms of Picasso's art but of its imagery and symbolism can be seen most clearly by comparing his *Crucifixion* of 1930 to the mythol010gizing works which succeeded to it and to which it in many respects forms a prelude. The *Crucifixion*, despite its small scale, was the most complex painting, 192 both formally and iconographically that Picasso had produced since the *Three Dancers* on which he had been at work five years earlier. Virtually every figure in the crowded composition is treated in a different idiom and the painting as a whole reads like a dictionary of the different manners of distortion to which Picasso had subjected the human form during the years before and immediately after its execution. The sources involved, both stylistic and iconographic are legion. To those already discussed could be added Cycladic sculpture, Australian aboriginal 191 art, and, as scholars have pointed out, the apocalyptic imagery of the eleventh century commentaries of Beatus of Liebana or the *Apocalypse of Saint Sever*, a work 190 which Picasso almost certainly knew.[41] The preparatory sketches show not only 193 an obvious interest in Christian iconography and a strongly primitivizing strain but 194 also an interest in classical art. The Mithraic references stressed by Ruth Kaufmann in her analysis of the painting[42] are overlaid (particularly in the figure of the horse-man with a lance) with suggestions of the ceremony of the bull-ring. The work is deeply irreligious in spirit and it evokes the sensation of some primitive atavistic ritual, cruel and compulsive. In all these respects the *Crucifixion* can be considered a product of Surrealism, and its affiliations with the movement are further strengthened by the fact that some of the related sketches appear to be indebted to the work of Miro—one of the rare instances of Picasso borrowing directly from a 195 Surrealist colleague.[43]

The importance of the *Crucifixion* for an understanding of *Guernica*, the crowning achievement of the 1930s, has been often and justifiably stressed. But a comparison 197 between the *Crucifixion* and the large etching entitled *Minotauromachia*, perhaps 301 the most important single work produced by Picasso in 1935, and highly relevant in its iconography to the great mural, illustrates the extent to which Picasso was prepared to sever his connections with the world of visual Surrealism. The stylistic differences between the two works speak for themselves: the primitivizing has given way to the classicizing. And although some of the motives in *Minotauromachia* are not unrelated to the earlier work its iconography has undergone the same classicizing process, the same movement upwards into the realm of traditional, identifiable moral allegory. The imagery is deeply personal and much of the

193

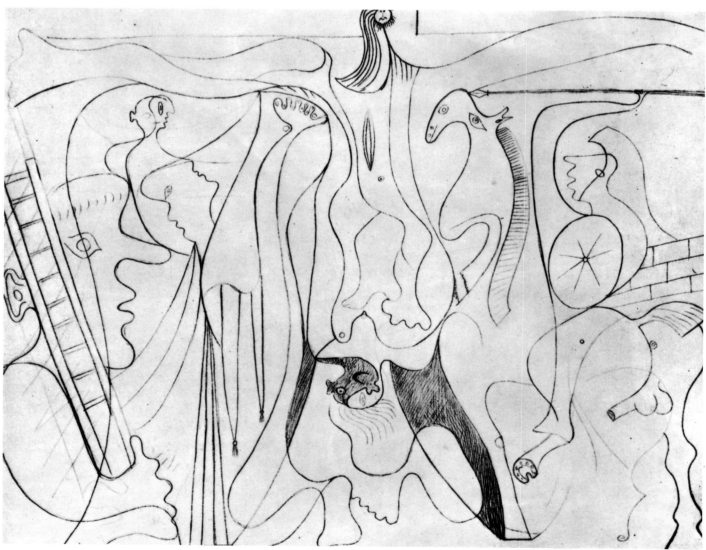

194

symbolism defies analysis; indeed it is doubtful if Picasso himself had any very explicit programme in mind when preparations for the work were begun. But whereas in the *Crucifixion* a traditional theme had been drained of its religious connotations and imbued with a quality of primeval brutality and darkness, many of the motives of *Minotauromachia* are readily identifiable within the context of traditional Western art. The doves, the young girl and the flowers she clutches are all obviously symbols of innocence and peace, while the candle she holds, and against which the monster shields his face, surely stands for truth and light. The Minotaur was a creature who had interested the Surrealists because of the sexual irregularity of his conception and because he could be taken to represent the unbridled forces of the Freudian id. For Picasso he was a more human and more complex creature, more man than beast even at his most savage, and embodying in his multiple guises much of the human predicament. In *Minotauromachia* he appears at his most rapacious and destructive and the work can be viewed as a symbolic depiction of the battle between unreason and truth, between darkness and light, with the forces of good challenging those of evil. These were exactly the traditional moral distinctions which the Surrealists had sought to destroy; the words which one is forced to use in an attempt to interpret Picasso's allegory have no validity and indeed no place in their vocabulary.[44] The symbolic depiction of moral and ethical conflicts and concepts was obviously not one that was exclusive to classical and traditional Western art but it is noteworthy that when Picasso introduces into the Minotaur series elements borrowed from more distant or esoteric traditions (the winged, birdheaded figure which appears in the sketch for the drop curtain for Romain Rolland's *Le 14 Juillet*, for example), the effect is immediately markedly more Surrealist. 326

It was soon after finishing *Minotauromachia* that Picasso plunged into his most intensive phase of literary activity, the products of which belong very directly to Surrealism. Some twelve months later, in January 1937, he embarked on another work to be intimately bound up with his conception of *Guernica*, and one which represented an almost unique fusion between visual imagery and the written word. This was the *Dream and Lie of Franco*, a folder consisting of two etchings each divided into nine sections treated in the manner of a strip cartoon or a Spanish *alleluia*, and accompanied by a short, wild and violent poem. The first stages of the work, etched in pure line (the aquatint shading was added subsequently), and consisting of only fourteen scenes appear to have been executed at white heat, as does the poem; the quality of the line is hectic, compulsive and conveys a sense of overriding urgency. Much of the imagery is also highly surrealistic: the figure of Franco, 'an evil-omened polyp', is rendered as a cluster of obscene, hairy, root-like forms with strongly phallic conotations, which in one of the scenes become metamorphosized into the horse's head. The sequence of images appears to be unimportant although it is perhaps significant that the first compartment shows the 196 polyp attacking a beautiful classical head with a pickaxe. The riot of imaginative fantasy which spills out without regard to the unities of time and space, the blasphemy and iconoclasm, the erotic exaggerations, the way in which the pictorial idiom is so completely at the service of the artist's obsessed and frenzied vision, all these factors ally the work to Surrealism; and perhaps more than any other work by Picasso *The Dream and Lie of Franco* breaks down, as the Surrealists so passionately longed to do, distinctions between thought, writing and visual imagery.

Guernica, the great mural to which the last four episodes of the *Dream and Lie* 197 so concretely relates, detaches itself once again from the world of Surrealism. A large public statement, inspired by a particular event in contemporary history, it militates against much that Surrealism stood for. Its imagery, though in some ways

195

193 *Study for a Crucifixion*, 1930–31.

194 *Study for a Crucifixion*, 1930–31.

195 Joan Miro, *Harlequin's Carnival*, 1924–5.

baffling, is once again susceptible to the kind of analysis that is customarily applied to great mythological works of the past, and its sources, as has often been stressed, are also embedded in the traditions of classical Western art. And yet the debt of *Guernica* to Surrealism has perhaps never been sufficiently emphasized. The expressive distortions, the ability to render states of emotion by the use of a few calligraphic markings, the conventions used to evoke grief and horror, these were features of Picasso's art that had been developed during the years of his association with the movement; in the last analysis the work owes as much to the primitive sources of Surrealism as it does to a knowledge of the traditions of classical art. And

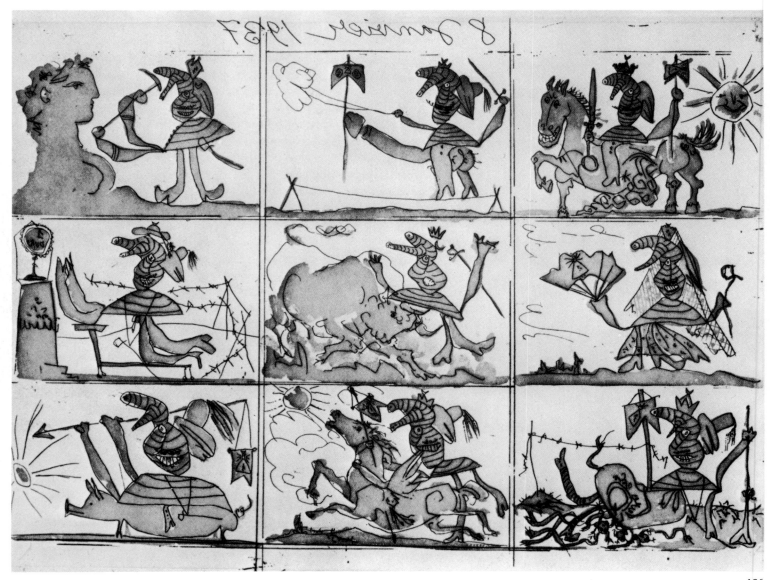

196

196 *The Dream and Lie of Franco*, January–June 1937.

197 *Guernica*, May–June 1937.

Picasso's method of work, his ability to think aloud in images, to contradict himself and change his mind in mid-stream, to fuse such a multitude of widely diverse iconographic material in a single work, speak eloquently of the Surrealist experience.

In the second Surrealist manifesto, which appeared early in 1930, Breton declared:

'Surrealism's dearest aim now and in the future must be the artificial reproduction of the ideal moment in which man is a prey to a particular emotion, is suddenly

caught up by the "stronger than himself", and thrust, despite his bodily inertia into immortality. If he were then lucid and awake he would issue from that predicament in terror. The great thing is that he should not be free to come out, that he should go on talking all the time the mysterious ringing is going on.'

Nothing could better underline both the surreality of Picasso's achievement and the differences between his position and that of the members of the movement than an attempt to relate Breton's words to Picasso's art of the period between the *Three Dancers* and *Guernica*. Like the Surrealists Picasso had experienced 'the stronger

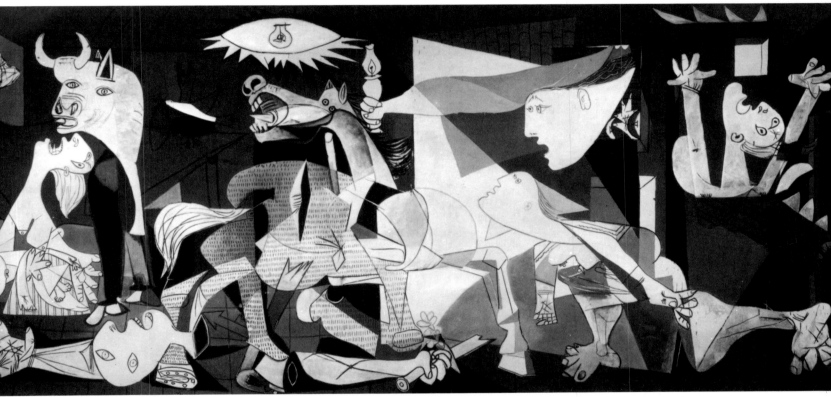

197

than himself'; but it was not a condition he had, or could have, induced artificially and it arose from certain inevitable circumstances in his private life and, in 1937, from the recognition of a world tragedy. He continued to be 'lucid and awake' and he issued forth from 'that predicament' not 'in terror' but with a combined sense of relief and anguish. It would never for a moment have crossed his mind that he might not be free 'to come out'. He had simply, as always, obeyed the dictates of his art.

Picasso's Sculpture

Alan Bowness

Picasso's sculptural work was always tangential to his main artistic activity, which was that of painter and draughtsman. Most of the sculpture was produced in sudden short bursts of activity, followed by long periods when Picasso was thinking of other things. There is no consistent line of development, no progression of any kind. The sculpture of the last thirty years is almost self-contradictory in character, so various has it become that we lose any very clear sense of purpose. And in the 1960s, with his sculpture at its most personal and pictorial, Picasso was at last asked to make the public monuments that should have been commissioned forty years before.

Yet, paradoxically, Picasso's contribution to sculptural thinking in the twentieth century is enormous, rivalled only by Brancusi's, who was in so many ways his antipode. And in Picasso's case, it is an influence exerted both indirectly and directly—by the sculptural implications of his painting, in particular the revolutionary consequences of Cubism, and by certain, often isolated, pieces of sculpture, dropped into the fast-flowing current of twentieth-century sculptural development with a markedly disturbing effect.

Picasso's earliest sculptures echo very closely the paintings that are contemporary with them. They were modelled in clay, and the bronzes that we know today are presumably those sculptures which the artist thought worth casting and not the only ones that were made. That these works survive at all is due to the dealer Vollard, for we know exactly what happened. Picasso told Brassai on 12 October 1943:

> 'One day I had a pressing need for money, and I sold almost all my old sculptures to Vollard . . . He was the one who had them cast in bronze. There was, apart from the two women, the head of an old man, a head of a woman, and a harlequin with a cap which I must have made seven or eight years later.'[1]

Picasso thought he had begun to make sculpture in 1899, but this is almost certainly too early. His lack of certainty about the beginnings of his career was understandable, and was demonstrated by the fact that on the occasion of the 1943 conversation he could not remember which he had made first, the *Seated Woman*, or the *Woman Combing her Hair*. There can be no doubt that it is the *Seated Woman* which is the earliest known bronze. It is usually said to have been made in Barcelona by 1901, but the firmness of even this date may be doubted. As so often with the sculptures of Picasso, there is no real evidence to confirm a traditional dating, and variations of a year or two are always possible. Works in bronze, for example, seem often to have been given the date of their casting, not that of their making in clay or plaster. As we shall see, exact chronology is a constant problem.[2]

The pose of the *Seated Woman* and her facial expression immediately suggest that feeling of brooding melancholy so characteristic of Picasso's Blue Period.

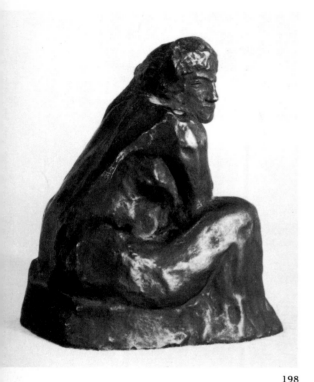

198

198 *Seated Woman*, 1901(?).

199 *Woman Combing her Hair*, 1906.

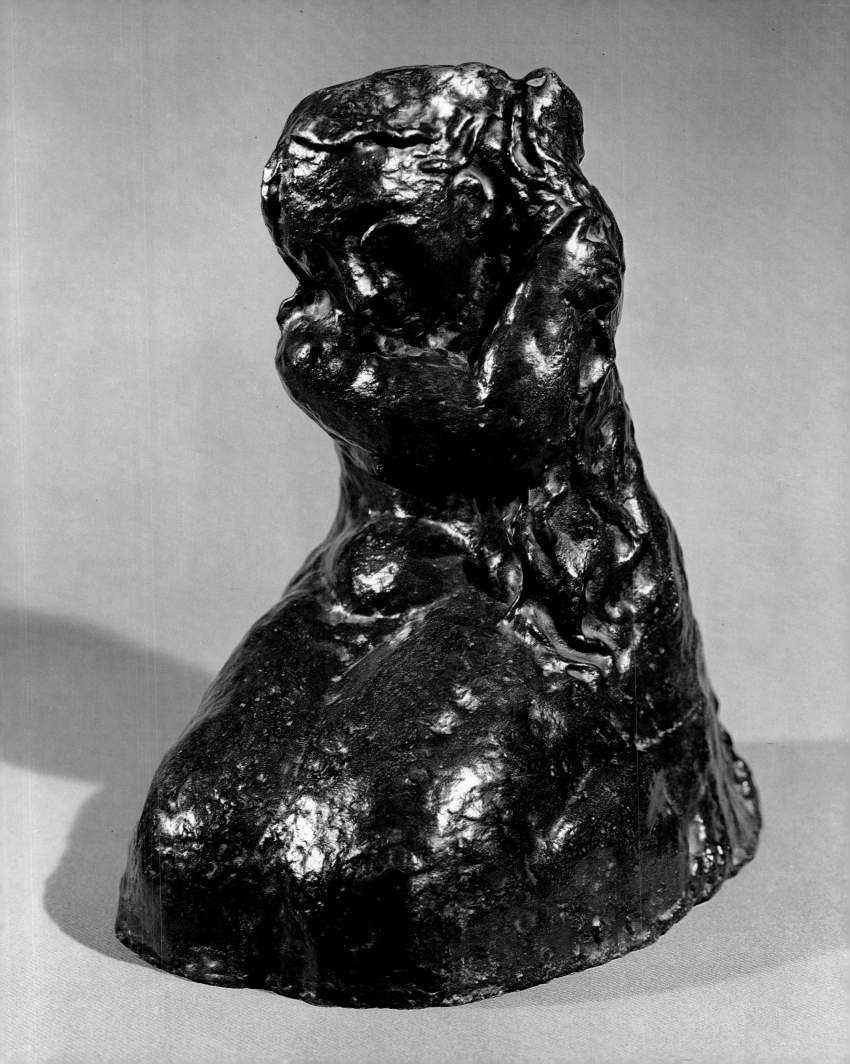

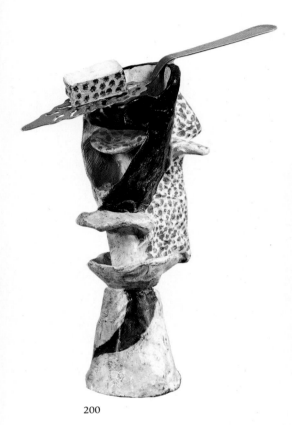

201
202

200

200 *Glass of Absinth*, 1914.

201 *Still Life*, 1914.

202 *Guitar*, 1914.

203 *Head of a Picador with a Broken Nose*, 1903.

203

Though there are no precise parallels, the sculpture is very close to the series of women seated and crouching on the ground, executed in Barcelona in 1902.[3] One is even tempted to suggest that the model for the *Seated Woman* may have been the woman who modelled the mother in *La Vie* of 1903, except that the long 22 face and bunched hair are as much stylistic simplifications as personal features.

The *Seated Woman* is an extremely small pyramidal composition, in which Picasso used the woman's robe to cover the limbs and allow a natural build-up to the head. This is a perfectly traditional procedure, classical in its strict employment of contained forms, and already showing that sensitive awareness of the object's three-dimensionality which is the hallmark of a great sculptor. There appeared to be no particular practical difficulty in Picasso's way : as with painting, the medium itself offered no problem. In fact we do not know for certain whether Picasso ever had any instruction in sculptural techniques. It is perhaps more likely that he learned from friends. He always numbered sculptors among his closest acquaintances—Pablo Gargallo, Manolo Hugué and Julio Gonzalez were all members of the Barcelona-Paris circle, and Gonzalez at least is said to have already known Picasso in 1900. Manolo, a Catalan ten years his senior, was much liked by the young Picasso, but the relationship seems to have been on an entirely personal level, without any artistic consequences except perhaps technical ones.

The two early heads, *Blind Singer* and *Head of a Picador with Broken Nose* are 204 traditionally dated Barcelona 1903, an acceptable date because of correspondences 203 with the painting of the time. The *Picador* is perhaps the earlier; the mask form and the broken nose immediately suggest a connection with Rodin's first important sculpture, the *Man with a Broken Nose*, which exists in several versions and many casts and would certainly have been familiar to the young Picasso. It was displayed in the enormous special exhibition which Rodin organized at the time of the Exposition Universelle of 1900; Picasso must surely have visited this exhibition on his first short stay in Paris in October–December 1900.

Like every other artist of his generation, Picasso could not escape the shadow of Rodin. The treatment of the facial surface in the *Picador* and *Seated Woman* is Rodinesque (though one must insist on the small scale of these works): the modelling has that pattern of low bumps and shallow hollows which break up the light as it falls on the sculpture's surface—a technique very obvious in Rodin. Yet we have observed a certain classicism in the *Seated Woman*, quite unlike Rodin, and the treatment of the eyes in the *Picador* has that slightly archaizing flavour more typical of Rodin's assistant and follower, Bourdelle, than of the master himself.

The *Blind Singer* takes this archaizing further, and seems to move away from Rodin in a quite deliberate manner. The liberation of sculpture in the very early years of this century lay primarily in a steady assimilation by young sculptors of all those varied kinds of sculpture which were outside the established classical-Renaissance tradition. Rodin had restated that tradition as the central one for any sculptor, yet he had already hinted that its narrowness was restrictive: his own interest in oriental art came only at the end of his life when his active career as a sculptor was over. Bourdelle was turning very deliberately to Gothic and archaic Greek sources, and amongst other sculptors in the years up to the 1914 war we can trace the progressive absorption of ideas from Egypt, Assyria, India and China, and finally from the primitive societies of Africa and the Pacific. The same cultural imperialism was at work in the painting of the period, and in this artistic process Picasso played a prominent part.

Both the *Picador* and the *Blind Singer* belong in subject-matter to the pathetic tribe of whores and beggars that haunt Picasso's work in Barcelona in 1903 and 1904. The facial expressions are strongly marked, and invite a sympathetic inter-

204

pretation—for the rude strength of the *Picador,* or for that sharp contrast between dead eyes and live mouth in the *Singer.* Our heartstrings are unashamedly plucked. Again one can find direct parallels in the drawings and paintings of this period, and it would seem more than likely that Picasso used certain models on several occasions. The *Blind Singer* is presumably the figure who appears in the Metropolitan's *Blind Man's Meal,* and in the Fogg's gouache of the seated blind man, which can be related to a sketchbook dated Barcelona October 1903. Similarly the *Picador* may possibly be the same model as the *Ascetic,* which is also of this date.[4]

In April 1904 Picasso left Barcelona for good to settle in Paris. The first sculptures that he made were, at least in origin, portraits of his French friends, rather larger in scale than the earliest works, and all traditionally (and acceptably) dated 1905. The bust portrait of Alice Derain, the painter's wife, is still strongly Rodinesque —that slightly twisted position of the head on the shoulders is a commonplace of Rodin's female portraiture, though Madame Derain appears reticent and withdrawn in comparison with Rodin's more overtly sensual sitters.[5] There is a tendency for the features of the head to sink into the sculptural surface, as if the head were trying to force its way out through the material.

The portrait of Alice Derain is close in handling to the *Harlequin* (or *Jester*), which is in fact signed and dated 1905 at the back of the base. This sculpture belongs precisely among the circus folk of the Rose Period, and indeed this particular figure occurs in the *Two Harlequins* in the Barnes Foundation. There is also

205

204 *Blind Singer,* 1903.

205 *Head of a Woman (Alice Derain),* 1905.

206 *Harlequin (Jester),* 1905.

207 *Figurine,* 1907.

208 *Figure,* 1907.

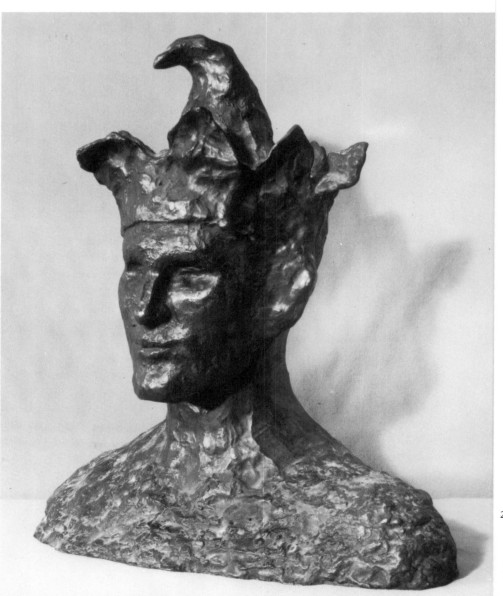

206

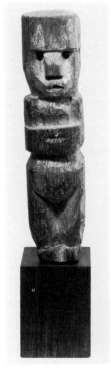

207

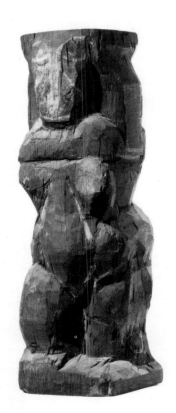

208

a gouache study of the head of the left hand figure in the painting, which is extremely close to the sculpture.[6] Could Vollard have seen this, and suggested to Picasso that he turn it into sculpture? This is, after all, the way in which most of Renoir's sculpture came into existence. All that Picasso told us is that he began work on the *Harlequin* at night immediately after a visit to the circus with the oldest of his Parisian friends Max Jacob. Jacob was the model for the head, though only the lower part of his face is recognizable in the work's final form.

The *Head of a Woman* is a head of Fernande Olivier who became Picasso's mistress in 1905; it must have been made at the end of that year, after the visit to Holland. The most beautiful of the early sculptures, it marks a decisive step away from the impressionism of Rodin; that particular turn to a more severe classicism which Picasso found necessary to his development as a painter has here its exact equivalent.

Close to the head of Fernande in style is the small full-length study of the *Woman Combing her Hair*, usually dated 1905 but more probably early 1906. This relates to the painted and drawn versions of this subject which begin late in 1905 and culminate in the two big *Toilette* pictures that Picasso painted in Gosol in 1906.[7] There is also a drawing for the sculpture ambitious enough to suggest that Picasso may have been uncertain as to the final medium. In the bronze we notice a certain simplification of the forms around the eyes which may have derived from Picasso's new interest in Iberian sculpture. This began in 1906, and culminated in his unwitting acquisition of the two stone heads stolen from the Louvre in March 1907: it was a discovery that profoundly affected the painting of 1906–7, but, apart from this small example, had no repercussion in Picasso's sculpture. From 1906 onwards, Picasso's interest in sculptural form found primary expression in the notable increase in three-dimensionality of the figures in his painting, and not in sculpture at all.

The half dozen or so sculptures known from the years 1907–09 have little homogeneity among themselves, and display nothing that can be called development. They do however relate very closely to the paintings of these years. Having reached a certain stage, Picasso seemed to have found it useful to make an isolated sculptural demonstration. And, as in the painting, we move into a more frankly experimental phase.

For there is, in 1907, one of those sudden radical breakaways so characteristic of Picasso. The exact moment of his discovery—or rather of his awareness—of Negro sculpture is still not established,[8] but it was probably in the spring of 1907 that Picasso went to the Trocadero for the first time and was excited by the masks and ancestral figures from the Ivory Coast and the French Congo that he saw there. No doubt he remembered the sculpture he had seen in the Gauguin retrospective at the Salon d'Automne 1906, and asked himself whether he should not also seek an understanding of this very alien and hitherto unregarded art by imitating it himself. At all events, Picasso began to carve in wood, and for the first time, so far as we know. A number of pieces exist, one at least cast in bronze. They exhibit a ferocious crudity of approach: Picasso could make a virtue of his own limited carving technique, seeking that same barbaric violence of expression which he admired in African art and wanted to introduce into his own.

The largest of these carvings is the half-life-size *Figure* in rough-hewn wood. Having indicated the forms of the female body in a somewhat summary fashion, Picasso drew the features of the head with red chalk, exaggerating the eyes but not disturbing their symmetry over much in exactly the manner of drawings and paintings of 1907. The relationship to African and Oceanic sculpture is a real, though generalized, one—as with Gauguin—but it exists on the formal level alone:

209

199

48

207

208

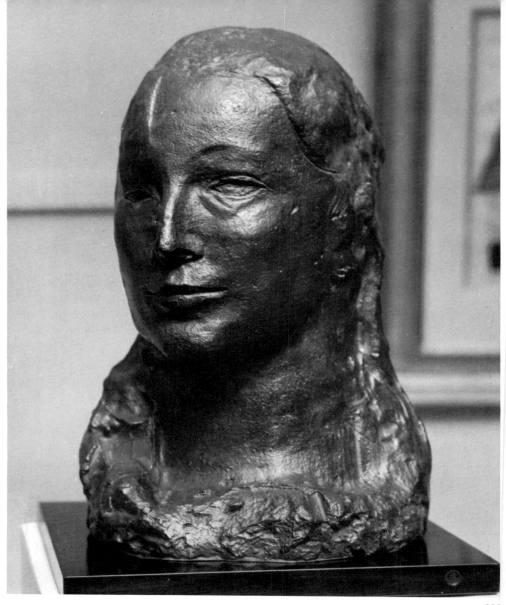

209

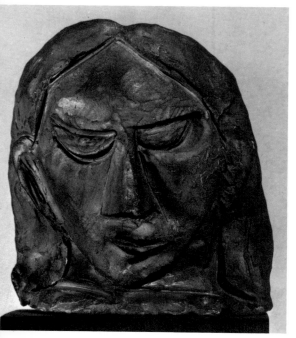

210

note for example the omission of the ears, in which Picasso followed African example. He was also here breaking with a centuries-old tradition of sculpture as imitation, searching, as in the contemporary painting, for a new way of approaching the external world.

Picasso's debt to African sources seems evident again in two small masks made in 1907–08, where the features shift into the asymmetrical disposition of the later heads of *Les Demoiselles d'Avignon*. One of them, a unique terracotta in the Musée d'Art Moderne, is dated 1908, and comes from the collection of Gertrude Stein. The model was probably Fernande Olivier, but the nose is elongated and given a rigid definition, the mouth purses forward, and the eyes are reduced to near geometrical forms. One is reminded of the even more radical treatment of the face in the Leningrad painting *Woman with the Fan* of the summer of 1908,[9] which the sculpture must surely immediately precede.

In both works the direct influence of African carving is now less obvious. Picasso had started to collect African and Oceanic objects in an unsystematic way; his studios in the Bateau Lavoir and, after 1909, in the Boulevard de Clichy, were full of such material, and many of his friends of this period were enthusiastic collectors. But after the initial formal impact, absorbed almost unconsciously, it was the symbolic, conceptual quality of African art that began to fascinate Picasso —the fact that these masks and figures were clearly not representational, but made

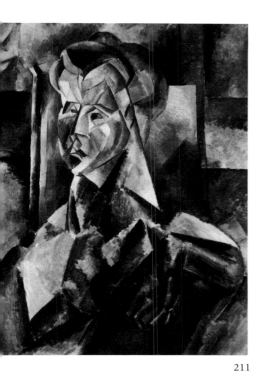

211

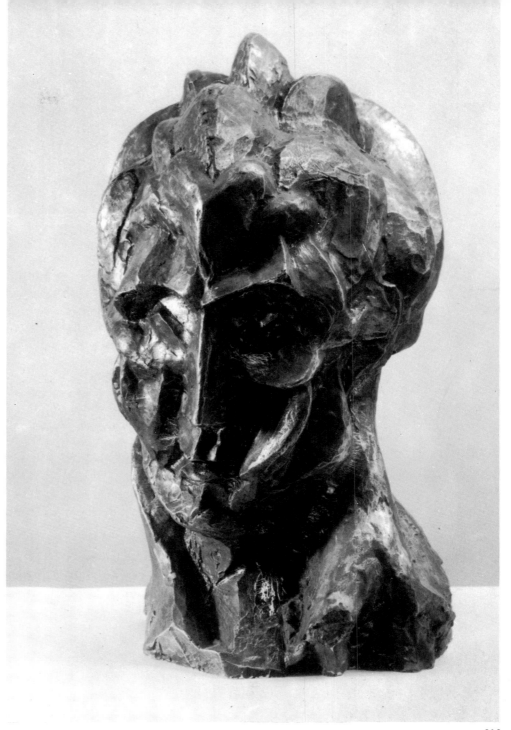

212

use of stylized conventions for the features and parts of the body. These anonymous savages seemed to have invented an artistic language which related to appearance in a truly rational way, a language not tied to the description of particular things seen which dominated European art. But the working out of this idea is to be found in Picasso's painting of 1908–10, not in his sculpture.

There is however one major exception, for the whole early phase of Picasso's sculptural activity reached an isolated climax with the *Head of a Woman* of 1909, 212 a bronze modelled in the studio of Julio Gonzalez. Once again, Fernande Olivier was the model, and we can place the work chronologically in the autumn of 1909, as it clearly comes between the painted portraits of Fernande, made at Horta de Ebro in the summer, and the more radically distorted *Woman in Green*, painted in the last winter months of 1909.[10] This is the moment when Picasso was fast 211 developing the language of Cubism, and the *Head of a Woman* is the early Cubist

209 *Head of a Woman (Fernande)*, late 1905.

210 *Woman's Mask*, 1908.

211 *Woman in Green*, 1909.

212 *Head of a Woman (Fernande)*, 1909.

129

213

sculpture *par excellence*. Picasso translates into the three-dimensional medium his new technique of breaking down the planes of the body into a succession of faceted forms.

The difficulty arises however over the fact that a sculpture does not present a flat surface, as a painting does, and the illusionistic properties of the picture are irrelevant to the formal problems involved. In a sense, Picasso is confronted with two distinct kinds of sculptural analysis in his representation of the head of Fernande: that of surface, and that of form. The surface of the head might be treated as analogous to the picture surface, and susceptible to procedures invented for Cubist painting; but the underlying form proves indissoluble and can be reduced only to an ovoid shape set upon a twisting pyramidal support. The dilemma can be illuminated if we consider the exactly contemporary work of Brancusi, who had reduced head and shoulders to virtually the same basic forms, though he was not of course concerned with the treatment of surface which still preoccupied Picasso. Yet both men emphasize a certain spiralling movement in the way the head is twisted, as though to indicate that quality of sprung tension discernible in African negro art.

Picasso in fact does seem to have been aware of an unresolved conflict between surface and form. In an interesting comment made a few years ago to his biographer, Roland Penrose, he remarked: 'I thought that the curves you see on the surface should continue into the interior. I had the idea of doing them in wire.'[11] Yet such a solution must seem inconceivable in terms of sculpture made in 1909, and one may question whether Picasso could really have considered using wire at such an early date. Perhaps this remark more accurately reflected his long period of worrying after making the sculpture as to whether in fact it had resolved the problems set.

Whether we regard the *Head of a Woman* as a failure, because it shows up the inherent impossibility of applying a technique invented for painting to the very different medium of sculpture, or as a triumphant success, because it demonstrated immediately and totally the application of Analytical Cubism to sculpture, the fact remains that it was the end of a road for Picasso. He attempted nothing comparable, and for a year or two virtually lost interest in sculpture altogether. So far as he was concerned, in this one work he had shown the sculptural implications of his painting. The lesson was not disregarded.

Writing in the 1930s, Julio Gonzalez remembered Picasso's attitude at this moment:

'In 1908, at the time of his first Cubist paintings, Picasso gave us form not as a silhouette, not as a projection of the object, but by putting planes, syntheses, and the cube of these in relief, as in a "construction".

'With these paintings, Picasso told me, it is only necessary to cut them out—the colours are only the indications of different perspectives, of planes inclined from one side or the other—then assemble them according to the indications given by the colour, in order to find oneself in the presence of a "Sculpture". The vanished painting would hardly be missed. He was so convinced of it that he executed several sculptures with perfect success.

'Picasso must have felt himself to be of a true sculptor's temperament, because in recalling this period of his life to me, he said: "I feel myself once more as happy as I was in 1908".'[12]

Picasso's return to sculpture was the logical outcome of the invention of *papier collé* in 1912. Once he had begun to introduce real elements into a pictorial composition there was no reason why this should be restricted to flat surfaces, and a

213 *Violin*, 1913.
214 *Guitar*, 1913.
215 *Glass, Pipe and Playing Card*, 1914.

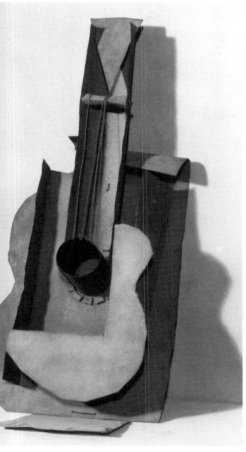

214

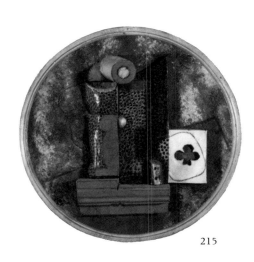

215

natural extension to the relief and then to the free standing object was an inevitable consequence. How precisely this happened is not clear: once again there are probably irresolvable problems of dating. A rational sequence would seem to start from the *Violin* of 1913, which is essentially a *papier collé* on cardboard, with some drawing and a tentative projection into the third dimension through the use of some thick cut paper. The formal treatment of the violin can be paralleled in many contemporary drawings. None of the constructions appear to have been exhibited at the time of their making, but five were reproduced by Apollinaire in his review *Les Soirées de Paris* on 15 November 1913, and this gave them artistic currency within an extremely restricted circle. 213

The very simple realization that one could build away from a flat surface by folding and gluing on pieces of paper and cardboard was one of the great innovations in the history of sculpture. It opened up a completely new way of making sculpture, not by the two traditional approaches of modelling or carving, but by assembling ready-made or prepared components into a three-dimensional construction. Just as Cubist painting implied a new kind of pictorial space, so did this new sculptural technique involve a radical re-thinking of sculptural space.

With obvious excitement, Picasso made a whole series of constructions in 1913 and 1914: had he done nothing else, his place as a master in the history of sculpture would have been ensured. Working within the subject matter of Cubist still life, he introduced a variety of new materials—at first paper and cardboard, then cotton and cord for the strings of the instruments; then, as if to resist the obvious impermanence of his materials, wood and sheet metal and wire in such work as the *Guitar,* usually said to date from 1912, but more likely to have been made in 1913. 214

The *Guitar* is unpainted, and now very rusty. Other constructions have disintegrated, though some are known from old photographs. There is a black and brown *Violin* of 1913–14, made out of cardboard and string, in which Picasso introduced wallpaper with imitation woodgraining to indicate the wood of the instrument itself; and the dialogue between real, simulated and illusory now assumes greater importance. It is the nature of art, and its relation to reality, that Picasso is now putting into question. The constructions seem to have altogether transcended painting, bringing the argument out of the enclosing frame and into the real world.

These still lifes offer a variety of ways of approaching the objects which they incorporate. In the *Glass, Pipe and Playing Card* of 1914 the card is a black ace of clubs painted on a white rectangle, the pipe bowl a wooden cylinder projecting from the surface of the oval board, the glass a flat shape cut in relief in wood. A dice in reverse perspective rests near the table edge. Stippled paint surfaces indicate light and shadow, as they do in the paintings of 1914. 215

Some of the same elements reappear in *Glass and Dice,* probably made at exactly the same time. Instead of the upturned oval table, a shallow shelf supports the glass, which throws both real and painted shadows on to the wall behind. The dice is placed casually on the ledge beside the glass; this is a less integrated composition than the *Glass, Pipe and Playing Card,* suggesting the movement towards more informally arranged structures. Yet the fact that the *Glass and Dice* is made entirely of wood gives it a strength and a solidity that the metal constructions lack. 216

The Tate Gallery's *Still Life* shows a glass on a table covered by a cloth, fringed with bobbles. There is also a knife, and what looks like a slice of bread with two slices of salami sausage on top—a modest café snack, brought into the studio and translated into the permanence of art, albeit out of somewhat unsubstantial material. As in almost all the constructions the colours are sombre and subdued—black and grey and the natural brown of wood. Once again in Picasso's work there 201

131

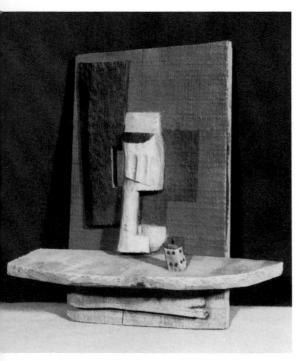

216

is an intimate relationship between sculpture and painting, for the Tate *Still Life* is very close to the *Glass, Newspaper and Bottle* in the Janis collection at the Museum of Modern Art, New York.[13] Until 1970 the *Still Life* was the only relief of this period to leave Picasso's possession: he gave it to Paul Eluard, the poet, from whom it was acquired by Roland Penrose.

Probably executed at the same moment as the Tate *Still Life*—the early months of 1914, before the outbreak of war—is the *Musical Instrument*. The materials and colour are very similar, so are the forms, and although both are wall-hanging considerable use is made of projecting elements. There is a logical progression from these two works to the *Violin and Bottle on a Table,* said to have been made in the winter of 1915–16. This makes use of the same sort of materials—wood, sometimes painted black and white, scored and drawn on, with the addition of tacks and string for the violin's strings—but it is now more of a free-standing construction, with marked sculptural implications, although the relief element has not entirely disappeared.

Standing a little apart from the constructed still lifes and in fact the only true three-dimensional piece made by Picasso between 1909 and 1928 is the *Glass of Absinth* of 1914. When he showed Françoise Gilot a cast in 1943, Picasso said: 'I modelled it in wax and added a real spoon and had six of them cast in bronze, then painted each one differently.'[14] Some of the casts are highly coloured, another was given the texture of sand. As revolutionary as the painting of the bronze is the way that Picasso has cut open the side of the glass to reveal the interior—an opening up of the sculptured object that possibly owes something to Boccioni's

216 *Glass and Dice*, 1914.

217 *Musical Instrument*, 1914.

218 *Violin and Bottle on a Table*, 1915–16(?).

219 *The New York Manager in 'Parade'*, 1917.

220 *Packet of Tobacco*, 1921(?).

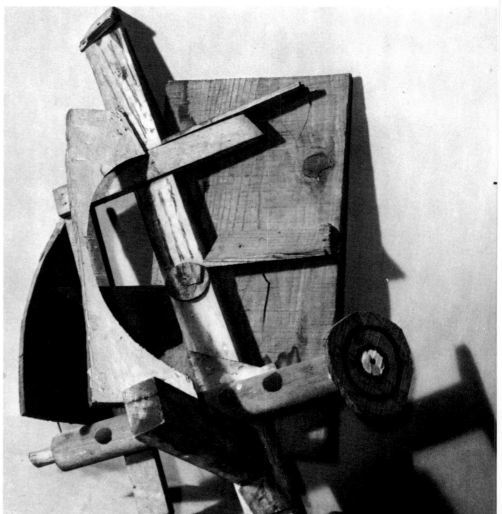

217

Development of a Bottle in Space of 1913. Like Boccioni's *Bottle,* the *Glass of Absinth* marks the clear emergence of still life as a subject for sculpture: in its time another major innovation, though no longer remarkable today, when the essential object quality of modern sculpture is taken for granted.

The painted element is important also in the 1914 *Guitar,* constructed from sheet metal cut and bent and coloured black and white and blue, with plain areas contrasting with others of a lattice pattern. The *Guitar* seems to be the sculptural equivalent of the gaily coloured 'Rococo' Cubism of 1914; there is however a certain intractability about Picasso's handling of the material in comparison with the wood constructions. 202

At this point, Picasso's interest in sculpture flags. After the *Violin and Bottle on a Table* of 1915–16, only two works from the decade are known, and I wonder how hard and fast the dates traditionally given to them can be. These are the *Packet of Tobacco,* allegedly of 1921, and the *Guitar* of 1924; both are made from soft sheet metal, cut and twisted and painted—the *Guitar* in dull colours—greys and dirty white—but the more inventive *Packet of Tobacco* in green, blue, brown, black and white. The familiar glass with fluted sides in the latter confirms that, whatever their actual date, both works belong formally with the constructions of 1913–15, and bring the series to a conclusion. 220

There is a curious coda to this phase of Picasso's sculptural activity. When asked early in 1917 by Diaghilev to make the designs for Jean Cocteau's ballet *Parade,* Picasso adapted the style of the Cubist constructions to dress the eleven-foot-high figures of the two Managers. In these cumbersome cardboard costumes 219

Picasso for the first time demonstrated the new language of Cubism to a wider audience, for the performance of *Parade* in Paris on 18 May 1917 marked his public re-emergence after many years of secluded private activity. It was a strange but significant choice for a début, and it led directly to the sudden reputation of Picasso as the most famous painter in the world.

Yet why did Picasso stop making sculpture? Was it simply that his painting had changed, and the new directions announced in the war years were filling all his creative energies? One might also argue that there is an emphasis on sculptural elements in the painting of the early twenties, whether in the style of the *Three Musicians* or of the *Three Women at the Fountain.*[15] Picasso now has alternative, even contradictory, modes of expression at the end of his brush, and does not need recourse to sculpture. For better or worse, close personal contact with the world of 132

the theatre changes his whole attitude to life: he now sees the artist as actor, in a position to adopt different parts and drop them at will. Thus begins that disconcerting profusion of styles so characteristic of Picasso's work between the wars. The fact that at a certain point Picasso is painting figures of remarkable plasticity—the two boys of the *Pipes of Pan* of 1923 for example[16]—obviates the making of sculpture. In any case one cannot imagine Picasso bringing himself at this date to the manufacture of such naturalistic images. These figures if transmuted to become the solid occupants of our own space would lose that context of a timeless dream which enfolds them. Not until *L'homme a l'agneau* of 1943 does Picasso find a way of using the harsher reality which sculpture offers.

The paintings of the twenties, when no sculpture is made, are full of what might be called a longing for sculpture. Take for example the beautiful *La Statuaire* of 1925,[17] in which a girl sits by the side of a sculptor's modelling stand on which a male plaster head is placed. The French title is ambiguous: it can describe the girl —the sculptress; or the sculpture on the modelling stand—the statuary; or perhaps it is used in the even broader meaning of the art of sculpture itself. Similarly the black shadow of the girl seems to indicate some kind of alter ego, as do the dark shadows of the figures in the Tate's contemporary *Three Dancers*.[18] And Picasso continues to develop these ideas about the relationship of artist to art-work in paintings and drawings from this moment forward, often preferring to introduce the sculptured image instead of the painted one, as something more tangible, more a part of our own world.

That his preoccupations were personal as much as philosophic is I think evident, but with Picasso the two concerns could not be disentangled. Further evidence for this situation occurs in 1924, when Picasso began to make drawings illustrating Balzac's *Le Chef-d'œuvre inconnu*. At first these appear to be meaningless abstractions, appropriate to the story; but we quickly notice that these apparent abstractions are on the one hand musical instruments (guitars, violins and the like), and on the other hand designs for linear constructions in space. These sculptural implications could not be immediately realized by Picasso because at the time no technique existed which would allow their manufacture.

Or again, consider the plans for a monument to the poet Apollinaire, which with one exception remained at the stage of paintings and drawings, and never actually reached three-dimensional form. Picasso began work on the subject at Cannes in the summer of 1927, and continued at Dinard the following summer. He filled two notebooks with drawings which explored ways of turning the bathers on the beach before him into architectural designs that could have been executed on a grand scale. The flood of ideas is extraordinary: perhaps too much for Picasso to be able to manage at a moment when the making of sculpture had become an unaccustomed practice for him. As no commission was forthcoming, he was obliged to realize these enormous monuments in paintings which are among the most imposing of the inter-war years.[19] Some of the *Projets pour un monument* were published in *Cahiers d'Art* in 1929,[20] but one small plaster sculpture, significantly called *Metamorphosis,* is the only concrete result of this phase of the project. Like the contemporary paintings, it shows Picasso breaking up the female body into separate bone-like shapes, which are then re-assembled into an ugly and disturbing image compounded with erotic undertones. These general ideas were to be developed in the Boisgeloup sculptures of 1932–33: but for the moment Picasso had decided to follow a different path.

For, still thinking about the memorial for Apollinaire, Picasso had had another inspiration in the summer of 1928. There is a drawing dated 3 August 1928, which is clearly descended from *Le Chef-d'œuvre inconnu* designs both in its linear structure

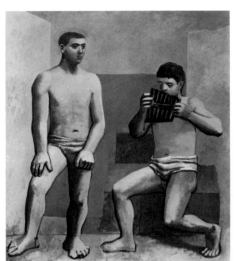

221

221 *Pipes of Pan*, 1923.

134

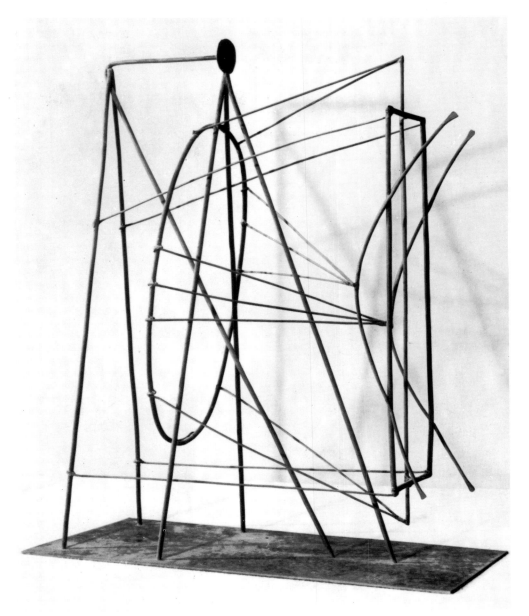

and in its use of pin-heads at the intersections of the lines. It appears to be some kind of openwork cage with a head superimposed upon it.[21] Unlike the little *Metamorphosis* sculpture, the drawing suggests something that could only be made of welded metal, and, immediately on his return from Dinard, Picasso went to see his old friend Gonzalez, in whose Paris studio in October 1928 the *Construction in Wire* was made.[22]

Here standard-size iron rods are welded together to make a construction that though far from legible is certainly not abstract. The large ring with the flat pin head above it suggests a woman pushing a swing. A second very similar construction in wire exists,[23] and probably more besides: it is never easy to know the extent of Picasso's sculptural activities at any time, as one is dependent on work exhibited and reproduced. Assumptions made in this chapter, like assumptions about the sculpture made elsewhere, may well be subsequently proved wrong, but what is patently clear is that something very exciting happened in sculpture in 1928 with the sudden opening up of a whole new area of possibilities, both formal and technical. There is an oblique but telling comment on this new beginning in an article by David Smith in the New York magazine *Arts* for February 1956; he writes: 'Xceron recalls that he (Picasso) came to Gonzalez' studio in rue de Médéah around 1928 to work on the statue for the tomb of Apollinaire.'

222 *Construction in Wire*, 1928.

223 224

Picasso must at once have made several iron sculptures. There is a head, also firmly dated October 1928, which combines a metal tripod and ring, together with sheet metal cut out and painted. The head is very obviously a direct extension of Picasso's current oil painting, in particular the two figures in the big *Atelier* of 1928.[24] Picasso had clearly begun to pick up the lengths of iron in Gonzalez' workshop, and delighted in assembling them into heads and figures.

The exact chronology of the welded metal sculptures has never been established, and it may well be impossible to see any development between them. Four important pieces are well known from exhibitions and reproduction: two heads and two figures, variously dated from 1929 to 1932, but I suspect all were complete by early 1931, if not sooner. The two heads are probably male and female. The male is built around a square plate, and in general is constructed out of regular forms: it has the hieratic, baleful presence of a fetish. The *Woman's Head* is distinguishable by the twist of hair at the back of the neck, a device familiar from slightly earlier paintings. The structure is altogether softer, less rigid, more curvilinear, the component parts easily identified—a broken-down household cistern, and various iron rods and springs. The fact that the elements are in no way disguised somehow enhances the vitality of the sculpture. It is a true metamorphosis. Picasso painted the work white, and thus made a stark contrast with the enormous iron *Woman in the Garden* when the works were exhibited at the Galerie Georges Petit in Paris in June 1932 along with five other pieces of sculpture. This occasioned André

136

Breton's comment: 'If, as we have noticed, Picasso the painter has no prejudices about colour, it is to be expected that Picasso the sculptor should have no prejudices about materials.[25]

Yet if Picasso's attitude to the materials of sculpture was revolutionary, so was his attitude to space. For the *Woman in the Garden* is a transparent sculpture, not precisely something drawn in space as is the earlier *Construction in Wire,* but an over-life-size figure with real volume which nevertheless does not occupy a solid and defined area. The implications of this idea for other sculptors have been enormous.

The *Woman in the Garden* has a characteristic Picasso head: a flat triangle set against an oval disc, with two small pin-like eyes placed close together, and a five-stranded quiff of hair swept upwards as if by the wind. The two plant-like forms on tall bending stems suggest the vegetation amid which the woman stands, although one cannot make too specific an interpretation. The basic formal language remains that of Synthetic Cubism, and we feel that Picasso had simply assembled interesting looking pieces of metal that he found in Gonzalez's workshop, allowing a figure to emerge mysteriously in the process of making the sculpture. In the half life-size *Woman,* probably made at this time—it has the same miniscule pinhead as the 1928 *Construction*—Picasso seems only to have bent nails and welded together very ordinary pieces of iron to create his figure, but some of the components of the *Woman in the Garden* are quite sophisticated. It is perhaps worth noting that at the 1896 Barcelona exhibition the twenty-year-old Julio Gonzalez exhibited a 'Branch of Flowers of forged and beaten iron'

In both works, and in the two heads, one notices technical procedures and formal devices (for example, the hair) strongly reminiscent of Gonzalez, who is often credited with being the inspiration behind this phase of Picasso's sculpture. Here for example is Andrew Ritchie: 'I think it is indisputable that certain of these Picasso constructions bear the stamp of more than the technical hand of Gonzalez. Some have a surface finish and elegance of contour, a lyrical decorativeness, that one associates with Gonzalez.'[26] But can this be a true assessment of the Picasso-Gonzalez relationship? If we digress for a moment to look at Gonzalez's career up to the winter of 1928–29 when Picasso made his first welded sculpture, the situation begins to look very different.

Julio Gonzalez was born in Barcelona in 1876; he came from a family of metal workers and craftsmen who moved to Paris in 1899. He seems to have known Picasso in Barcelona, and then to have helped Picasso on his arrival in Paris. But how close he was to Picasso's pre-war French friends like Max Jacob and Apollinaire is difficult to assess: I suspect the answer is not very close.

Gonzalez had had some art school training, and as a young man tried both to paint and sculpt. He had no success, and the surviving works of this early period that have since been exhibited—small heads and masks and female nudes—show little sign of originality. He had no exhibition until 1923, and makes no appearance in the art magazines. We are told that he had been overwhelmed by the death of his older brother Joan in 1908; that he had 'abandoned his work . . refused to see his friends. He quarrelled with Picasso'. Around 1916–17 he was working at the Renault factory, where he learnt the technique of oxy-acetylene welding, and between 1917 and 1926 he slowly resumed work, '. . . uncertain whether to concentrate on painting or sculpture . . . tortured by self-doubt, which continues for many years'.[27]

It seems clear that Gonzalez was in the whole of this early period essentially a craftsman with unrealized artistic aspirations. He had a workshop with metal working equipment in the rue de Médéah, Montparnasse, however, and it was

here that Picasso came to learn how to use iron rods for sculpture. Picasso's encouragement no doubt resulted in what seem to be the first mature sculptures by Gonzalez—the still life relief of a bottle (Magnelli Collection), and the relief of the *Woman in a Cloche Hat*. These are both signed and dated 1929 in the bottom corner of the metal sheet: they have a curious naivety that Gonzalez never quite loses, and certainly do not suggest that Gonzalez had seen the point of Cubism. It is absolutely clear that these dated works of 1929 are, stylistically speaking, years behind those metal sculptures of Picasso's that we know were made in 1928.

It is in the period immediately following 1928, however, that we confront a confused situation. If we accept the traditional date of 1929–30 for Picasso's big *Woman in the Garden*,[28] can we not confidently say that although of course Gonzalez contributed a technical know-how in the handling of iron, it was Picasso alone who realized its artistic possibilities? By 1929–30 perhaps Gonzalez had got as far as utilizing African mask-like forms in his own work,[29] but he remains essentially imitative, even naturalistic, in approach, in comparison with the extraordinary freedom at once grasped by Picasso. Some of Gonzalez's later metamorphic sculptures stem demonstrably from Picasso's preoccupations of 1928–30, and it is easy to find direct parallels.[30] The fact that Gonzalez could subsequently make simultaneously the *Cactus Men* and the *Montserrat* figures remains somewhat disconcerting, as though he was never able to consolidate his own artistic personality, and was seduced by the example of Picasso, who changed artistic styles as readily as an actor assumes different rôles. Roberta Gonzalez has said that 'Picasso was without doubt my father's best friend', but the reverse proposition would not ring true: it was a one-sided relationship. Gonzalez is of course a serious and important sculptor, and I feel sure he would have been the last person to want his debt to Picasso obscured.

The much discussed connection with Gonzalez has hidden another question we should be asking—might it not have been another artist—namely Jacques Lipchitz —who stimulated Picasso's return to sculpture? Lipchitz had a much better understanding of the real significance of Cubism than did either Gonzalez or Laurens, and in the sculptural world of the mid 1920s he and Brancusi were unquestionably the heavy-weight figures. Like Picasso he was drawn to the ideas of Surrealism without ever allowing himself to be absorbed into the movement, and during the 1920s we find him taking up and developing the crucial idea of metaphor in sculpture. Lipchitz, like Picasso, was dissatisfied with the conventional means which prevented his achieving the forms and effects to which he aspired: thus we find him in 1925 experimenting with the lost-wax process of bronze casting, and in 1928 he was using iron for sculpture.

Lipchitz was also very interested in the idea of transparent sculpture, and in the transformation of the figure into a linear structure. The series of Harlequins that he made in 1925 and 1926 show him using a lattice of bronze strips to create a sculpture with volume but without mass. By 1928 the strips have become wires, and the well-known *Harpist* of 1928 is an open-work construction which implies a revolutionary conception of sculptural space. This is precisely the point at which Picasso returned to sculpture late in 1928 with the *Construction in Wire,* and although it formally owes nothing to Lipchitz, one should remember that his experiments in transparent sculpture do immediately precede its genesis.

That total lack of prejudice towards the sculptor's materials that Breton had remarked upon was an immediate stimulus for Picasso. Spending the summer of 1930 at Juan-les-Pins, he picked up objects on the beach, placed them on the back of small canvases, sometimes sewing them down; then he covered them with glue

226

225 *Woman in the Garden*, 1929–30.

226 *Construction with Glove*, 1930.

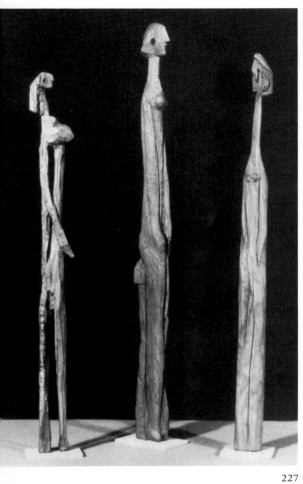

227

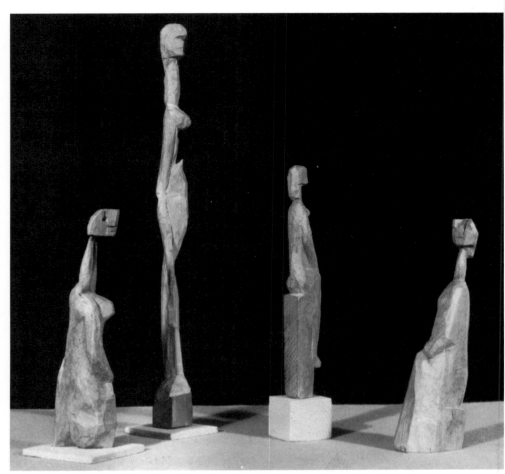

228

and sprinkled them with sand, thus making low reliefs like the *Construction with Glove*, which is precisely dated 22 August. Butterflies, children's toys, a lost glove, matchsticks, a drawing pin, torn paper, leaves, dune grass are all brought into surrealistic juxtaposition to be changed into heads or running figures.

On another occasion, in 1931, Picasso began whittling sticks of a pale pinkish-brown wood with a penknife to make a series of tall narrow figures. All are of women, often with highly positioned breasts and very small heads and an etiolated body that seems to have been stretched out to extend to the length of Picasso's piece of wood. They are extremely crude in handling, and remind one of primitive sculptures, without being close to any particular source, except perhaps the head and breasts of the Venus of Lespugue, a particular favourite of Picasso's and a work of which he owned at least two casts. Seen in isolation, or cast in bronze, the carved figurines look trivial: as a group however they have considerable presence and power. They also inspired a number of later sculptures—the dressed dolls of 1935 for example, and the small-headed bronze figurines of women of 1945–47.

A further impetus to Picasso's sculptural activities was given in 1931 by his purchase of a country house—the chateau of Boisgeloup, near Gisors. In the stable and coach-house buildings Picasso at last had room for sculpture—not only to make new work, but also to display what had been done in Paris. The move to Boisgeloup in March 1932 coincided with his liaison with Marie-Thérèse Walter, and the appearance of a new and more sensual female image in his work. This is immediately apparent in the sculpture. Picasso stops welding iron: in any case, the facilities and technical assistance of Gonzalez were not available to him at

Boisgeloup, as they had been at Paris. Instead he began to work in clay and plaster on a wire armature, using traditional methods for sculpture destined to be cast in bronze.[31]

From the beginning Picasso had seen Marie-Thérèse as sculpture, if I am right in thinking that hers is the sculpted head and breasts in the painting, *The Sculptor*.[32] 229 This is dated 7 December 1931, and it is I think the first work in which Marie-Thérèse appears. Once in residence at Boisgeloup, Picasso began work on the monumental female heads, clearly inspired by the same model. The four best-known increase in size and abstraction: the earliest is a straightforward portrait 230

229

227–8 *Group of Women*, 1931.

229 *The Sculptor*, 1931.

230 *Woman's Head*, early 1932.

230

141

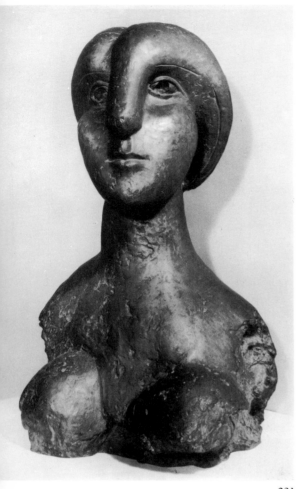

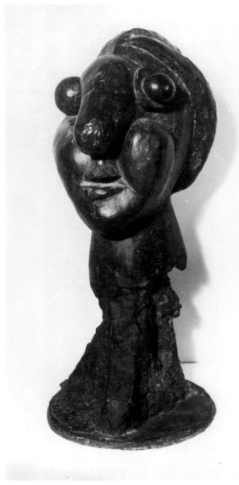

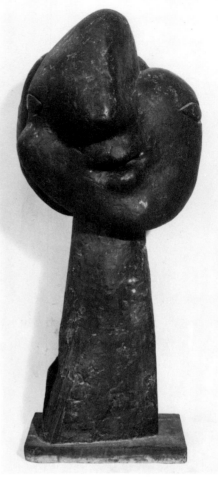

231 232 233

231 *Bust of a Woman*, 1932.

232 *Head of a Woman*, 1932.

233 *Head of a Woman*, 1932.

234 *Bust of a Woman*, 1932.

235 *Standing Woman*, 1932.

236 *Woman with Raised Arms*, 1932.

237 *Reclining Woman*, 1932.

which establishes the simple, country-girl features of the sitter. The other three, all made in 1932, probably more or less simultaneously, progressively distort by exaggeration, bringing into play a violence of approach that is ultimately disconcerting. The sequence inevitably recalls Matisse's series of heads of Jeannette, begun before 1914 but not brought to completion until 1929. Matisse's concentration on sculpture in 1929, and the peculiar stylistic characteristics of these late works, must surely have been well known to Picasso, a regular visitor to Matisse's studio. It is hard not to feel that, as so often, Picasso was quick to emulate and, if possible, to surpass his fellow-artists. Perhaps this is why the Boisgeloup heads are so large.[33]

Other Boisgeloup bronzes treat the female figure in a comparably violent manner. The *Standing* and *Reclining Woman* of 1932 are a pair of figures, a little under half life-size, which use the same formal elements—heavy thighs, tapering arms, a very small head, and an overall tendency to reduce the figure to an assemblage of pieces only loosely joined together. A single head of the same date takes this process even further: it may be regarded as the culmination of the Marie-Thérèse sequence, and shows Picasso's aversion to symmetry in an extreme stage. By contrast, the *Bust of a Woman* is monolithic in form, as if the body has been crushed and condensed to end up as some astoundingly ancient and worn image. Picasso placed in the entrance hall at Boisgeloup a rhinoceros skull—part of his bone collection—and a large Baga sculpture from the French Guinea with an exaggeratedly large

142

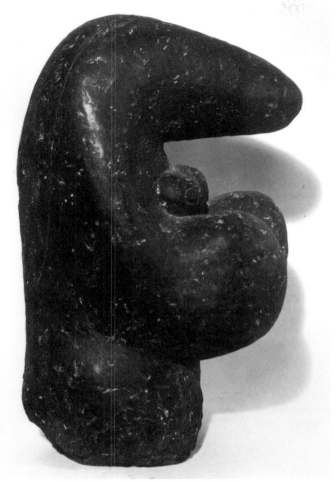

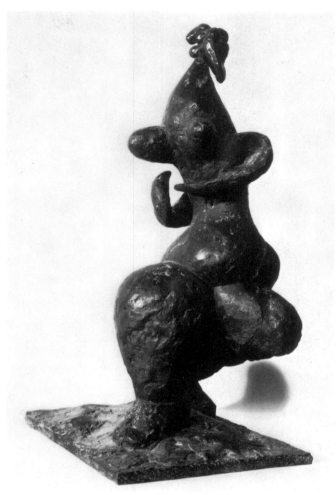

234

235

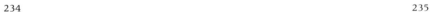

237

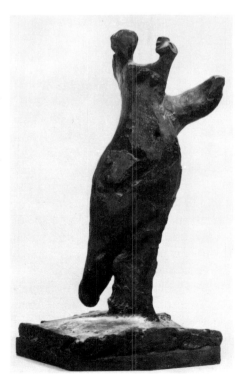

236

aquiline nose and a long thin neck. The fact that such African work was probably in conception a fertility image, intended to give special protection to pregnant women, was no doubt not lost on Picasso.

1932 was a particularly productive year[34] which also signals an important innovation in the subject matter of Picasso's sculpture. Country life made him more aware of farmyard animals, and the result is the *Heifer's Head* and the *Cock,* with its puffed out breast and curved lines of feathers that comically parody the forms of the heads of Marie-Thérèse. The surface of the animal sculptures is much

240

238

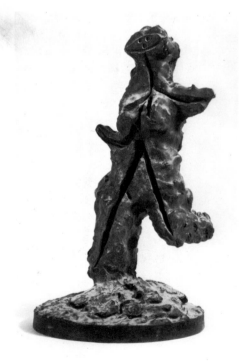

239

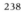
240

rougher: and certain other smaller works of this date—the *Woman with Raised* 23
Arms, for instance—have the appearance of an accidental lump of metal, where
the resemblance to any figure is almost fortuitious. The next stage was to impress the
soft plaster with whatever comes to hand, even embedding objects into it. This
practice began at Boisgeloup in 1934, when Picasso made plaster casts of box
lids, corrugated cardboard, crumpled paper, an orange, the leaves and bark of a
tree, pastry moulds—taking a child's delight in the magical change of material.
Some of these casts were then assembled into figures, the most notable being the
Woman with Leaves, but this is an isolated work which does no more than introduce 23
an idea that Picasso is not to explore seriously until almost ten years later.

The sculptural activity of 1932 coincided with the important retrospective
exhibition held at the Galerie Georges Petit in Paris: it is as if Picasso wanted to
think of himself as a sculptor rather than as a painter at a moment when so much of
his earlier work was on public view. This habit of presenting himself in a succession
of related but differentiated roles was a characteristic of all Picasso's post-Cubist
activity: at times we may wonder what has become of the real Picasso whose
identity is submerged in the ever-changing disguises. Yet such a histrionic talent
can also be a source of inspiration, as we see from the extraordinarily beautiful set
of forty-six etchings, *The Sculptor's Studio,* which Picasso made in Paris in March–
May 1933.

The action takes place in the Boisgeloup studio, and we see Marie-Thérèse, the model, and the over-life-size heads that Picasso is making of her. The artist himself appears as a naked, bearded, ivy-garlanded Greek god, and the style and spirit of the etchings are distinctly Neo-Classical. As the series progresses other naked figures, 287 male and female, are introduced; so are horses, centaurs and a bull. A window opens up on to the landscape outside, and there is a sense of a moving away from the narrow world of the sculptor's studio towards a preoccupation with issues that lend themselves uneasily to sculptural expression.

After the intensive period at Boisgeloup in 1932–33 Picasso again lost interest in sculpture, and did no serious work until 1941. Apart from the dolls made for his daughter Maia in 1935 there exist only some incised pebbles and bones, and a few reliefs in the most ephemeral materials which could as well be classed as painting. In 1941 however, there was suddenly a burst of activity. Living a somewhat restricted life in Paris during the German occupation, Picasso found himself with space to spare in the big rooms of the rue des Grands Augustins apartment, and he converted his bathroom into a sculpture studio—the only room that was easy to heat. Somehow he seems even to have found a source of supply of bronze, so that some of the smaller works made in plaster could be clandestinely cast throughout the war years.

There is no stylistic unity discernible among the score of sculptures, large and small, that Picasso made in occupied Paris between 1941 and 1944. In itself this is disturbing, but consistency is the enemy of invention, and for late Picasso, inventiveness was all. At first Picasso seems to have picked up the threads of the last Boisgeloup sculptures; the small *Running Woman*, allegedly of 1940, is so close to 239 the 1933 Running Women series that I wonder whether it does not in fact date back to the earlier period, and may only have been cast during the war. The two much-loved stray cats of 1941 and 1944—the second metamorphosed from an unsatis- 241 factory sculpture of a woman—are part of the menagerie that began with the Boisgeloup cock. They are in a more naturalistic style, and appear to be the result of careful observation; in general Picasso spared his animals the distortions and the

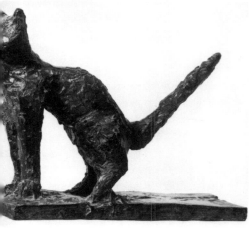

241

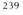

242

approximations that come so readily when he worked from or towards the human form.

The exception to this is the *Bull's Head* of 1943, made out of bicycle handlebars attached to saddle and cast in bronze. Picasso told Brassaï how he had made it:

'One day I found in a pile of jumble an old bicycle saddle next to some rusted handlebars . . . In a flash they were associated in my mind . . . The idea of this *Bull's Head* came without my thinking of it . . . I had only to solder them together . . . What is wonderful about bronze is that it can give the most incongruous objects such a unity that it's sometimes difficult to identify the elements that make them up. But it's also a danger: if you only see the bull's head and not the saddle and handlebars from which it's made, then the sculpture loses its interest.'[35]

The very simplicity of this equation has made the *Bull's Head* one of the most memorable of all Picasso's sculptures, and a striking example of that strange ambition of his: 'One should be able to take a bit of wood and find it's a bird'.[36] But the aesthetic status of the *Bull's Head* does pose a problem: for is it really more than a clever and surprising joke? How can we equate it with the *L'homme à l'agneau*, Picasso's largest and most considered piece of sculpture, with which it is exactly contemporary? In the context of Picasso's sculpture both works represent extreme positions, each seeming to deny the artistic validity of the other. But it is characteristic of Picasso's war-time activities to push his ideas to their conclusions, in whatever direction this may lead. So on the one hand we have the *Flayed Head*, or *Skull*, of 1943,[37] which must rank among the greatest bronzes ever made with its hollow eye sockets set against the smooth and polished cranium; and on the other the collage sculptures which audaciously exploit the technique invented by Picasso of assemblage and imprinting textures onto the surface of the bronze. Or perhaps it would be more to the point to compare the bronze *Flayed Head* with those works made of torn paper napkins,[38] but these most insubstantial of Picasso's sculptures have disappeared from sight and are only known from photographs. Yet Brassaï's photograph of the piece of wood on a matchbox of 1941[39] is every bit as challenging an image as the *Bull's Head* and a good deal closer to much very modern art.

Some of the collage sculptures are very large, and not all of them work satisfactorily: Picasso left us, his public, to make the choice, preferring not to exercise a final artistic discrimination himself. I can admire the *Woman with the Apple* of 1943, or the *Woman in a Long Dress*,[40] or the one-handed, grimacing *Standing Figure* of 1944, but the *Taulière*—a female gaoler rather than a prisoner—has an unacceptable Genet-like rhetoric that stems in part from the formal weaknesses of the work. Here the components do not seem to cohere: the proportions are too large or too small, so that for example the feet become awkward little appendages, and the blank eye-plates play too predominant a part in the expression of the head. Were the associations of the subject less baleful, one might be ready to accept the image; as it is, the *Flayed Head* presents a similar idea in a more satisfactory way, and the collage of *objets trouvés* works to better advantage when the end-result is no more than a *Flowering Watering Can*.

The genesis of the *L'homme à l'agneau* is in itself an object lesson for Picasso's approach to sculpture. The germ of the idea lies in a large engraving which depicts a bearded figure being offered presents—including a lamb—by those surrounding him. Picasso then made a long sequence of over a hundred drawings, mostly done in July 1942, in which he pondered the subject of the bearded shepherd and the

243

243 *Death's Head (Flayed Head)*, 1943(?).

244 *L'homme à l'agneau (Man with a Lamb)*, February–March 1943.

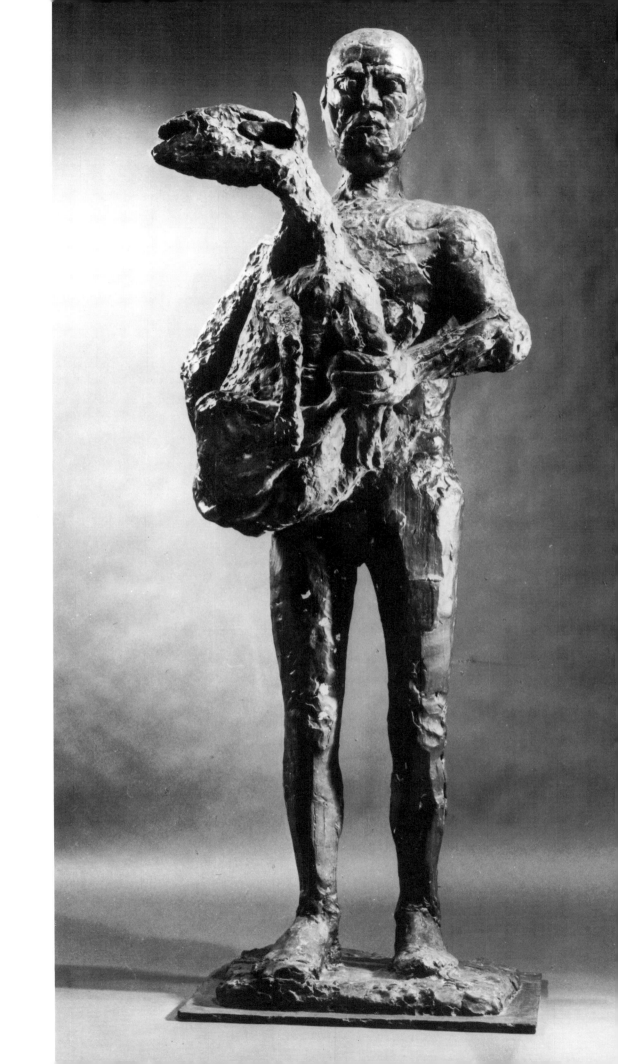

245

frightened lamb. No models were used: Picasso had no need of them. He explained to Françoise Gilot later:

'When I begin a series of drawings like that, I don't know whether they're going to remain just drawings, or become an etching or a lithograph, or even a sculpture. But when I had finally isolated that figure of the man carrying the sheep in the centre of the frieze, I saw it in relief and then in space, in the round. Then I knew it couldn't be a painting; it *had* to be a sculpture.'[41]

The idea haunted his imagination for a considerable time. An iron armature was prepared and then left untouched. Yet we are told that the sculpture itself was made in a single day (or two afternoons—accounts vary) in February or March 1943,[42] Picasso building up the clay on the armature which collapsed as he worked, the sheep falling out of the shepherd's arms. Somehow the sculpture was patched up and held together long enough for a plaster cast to be made. It was this monumental white cast that dominated Picasso's Paris studio at the time of the liberation of France, and thus the *L'homme à l'agneau* came to epitomize an act of faith in humanity on Picasso's part. It is essentially a restatement of the antique theme of the sheep-bearer, which became in Christian times an image of Christ as the Good Shepherd, and now assumes a more frankly humanitarian appeal. Here is a rare example of Picasso adopting a more public language for what is clearly intended as a universal statement. That the work coincides with his move towards the Communist Party is no accident, I feel.[43] It is also interesting to compare the *L'homme à l'agneau* with Henry Moore's *Mother and Child,* carved in 1943–44 for the church at Northampton; works made entirely independently, but at a historical moment in time when it seemed possible for a modern artist to make a genuinely public utterance.

After the liberation in August 1944 sculpture again disappeared from Picasso's

245 *Flowering Watering Can*, 1943–44.

246 *Woman with the Apple*, 1943.

247 *Standing Figure*, 1944.

248 *La Taulière*, 1943–44.

249 *La Statuaire*, 1925.

246

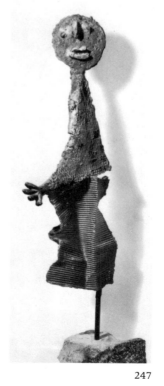

247

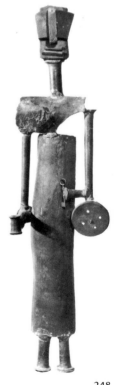

248

148

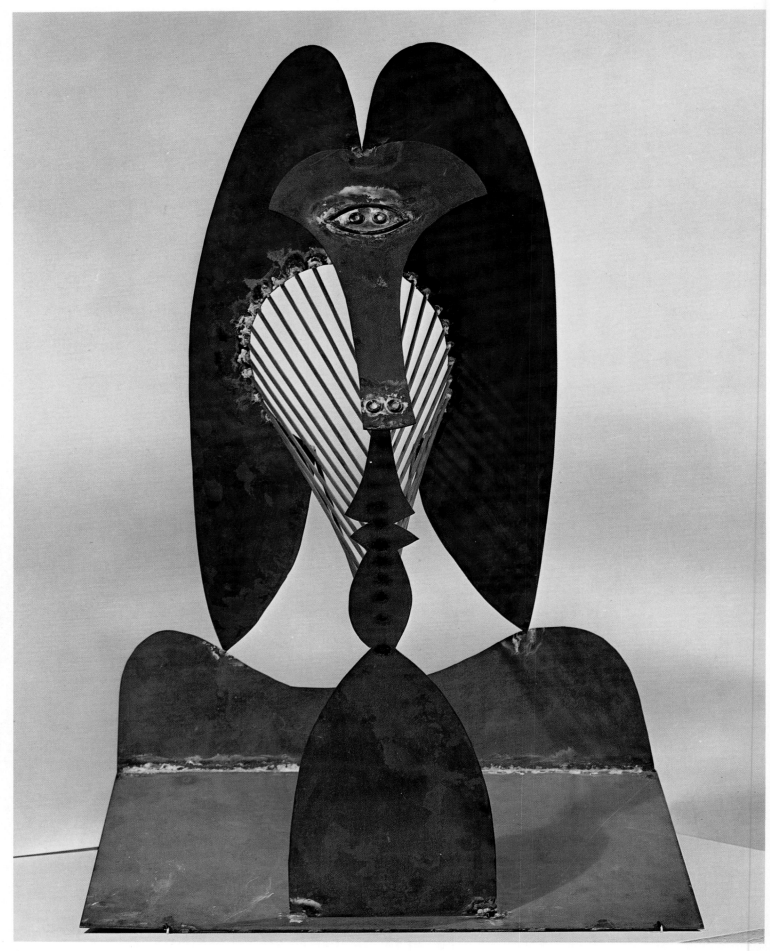

251

252

253

254

250 *Maquette for Chicago Civic Center*, 1964.

251 *Standing Figurine*, 1945.

252 *Angry Owl*, 1953.

253 *Pregnant Woman*, 1950.

254 *Female Form*, 1948.

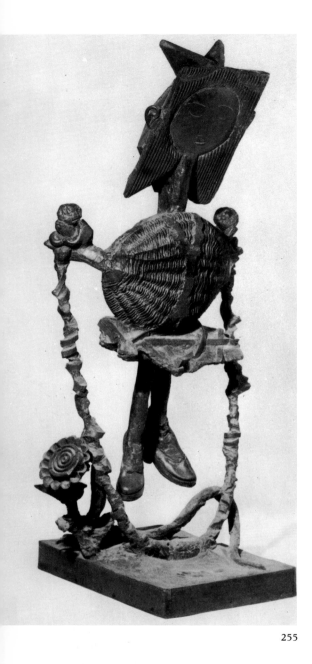

255

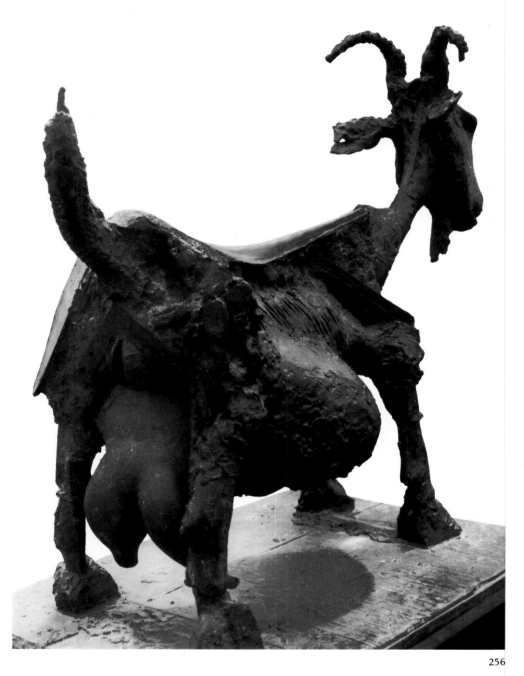

256

life for a time, apart from the three dozen or so female figurines made in two short bursts of activity in 1945 and 1947. These were evidently modelled rapidly in clay —finger and thumb prints are often visible in the cast bronze. The figurines have the quality of primitive amulets; they remind one of Picasso's interest in and respect for the sculpture of Giacometti.

By 1947 Picasso was spending most of his time in the South of France, and in August of that year he began work in Georges Ramié's Madoura pottery at Vallauris, decorating plates and bowls, and moulding unfired pots and jugs into the shapes of birds and animals and female heads and figures. Ceramic sculpture lies outside the scope of this essay, although in Picasso's work the distinction between pottery and sculpture is no easier to draw than the difference between sculpture and painting. This is particularly the case when Picasso went a step further and

cast the clay vase in bronze, as in the *Vase: Face* or *Female Form* of 1948. 254

Once settled in Vallauris, Picasso in 1949 bought an old perfume factory in the rue du Fournas to use as a sculpture studio. There exists an important group of works made between 1949 and 1953; they show similar characteristics to the wartime sculpture, and there is a comparable range of style. The *L'homme à l'agneau* has its counterpart in the *Pregnant Woman* of 1950, though this incorporates water 253
pitchers to form the breasts and belly, and is certainly a much inferior piece. The assembled sculptures continue in the Owls—especially the *Angry Owl* of 1953— 252
in the *Crane* which incorporates a shovel, in the *Baboon and Young* with its head 265

257 258

made of toy cars and pitcher handles, and, best of all, in the *Goat,* which has a 256
wicker basket for a belly and grotesquely detailed sexual organs. That there was no slackening of invention is clear from the two flower sculptures of 1953—the *Bunch of Flowers* and the *Vase*—and from the *Little Girl Skipping* of 1950, which 258
makes astonishing use of found objects, some the possessions of his children, but 257
mainly collected from scrap dumps with the help of Françoise Gilot and her pram.[44] 255

Two notable developments mark the last phase of Picasso's sculpture: the predominance of planar forms, that resulted from the use of planks of wood and sheet metal; and the increasing importance of painted surfaces. Picasso had told Kahnweiler on 2 October 1933 that 'I should like to make sculpture in colour', but although there are earlier examples he did not consistently use colour until 1953. It was in this year that Picasso began to construct figures out of rough planks of wood: these were nailed together and painted in bright colours. In 1954 he extended the series of paintings of Sylvette, the pony-tailed blonde model, into the third dimension, cutting the profile of a head out of sheet metal, folding it like 260
a screen, and painting it. Further experiments with heads and figures followed.

Some of the wood constructions were cast in bronze, a somewhat incongruous transformation of what look like broken-down packing cases, old picture frames

255 *Little Girl Skipping*, 1950.

256 *Goat*, 1950.

257 *Flowers in a Vase*, 1953.

258 *Bunch of Flowers*, 1953.

153

and broomsticks. Six of the figures were grouped together in 1956 to form the *Bathers,* yet another example of Picasso's power of endowing with vitality the most arbitrary assemblage of bits and pieces, but hardly a major work. The six figures are separately titled—from left to right in the photograph the Woman Diver, the Young Man, the Man with Clasped Hands, the Woman with Outstretched Arms, the Child and the Fountain Man.

The last important group of Picasso's sculptures dates from 1960–63: these are the sheet-metal cut-outs, mostly quite small, but culminating in the maquette for the Chicago Civic Center sculpture which, as executed, is sixty feet high. Picasso

259 260 261

drew and painted on paper or cardboard, cut and folded the paper; the shapes were then cut in sheet iron for him, and he painted them. The subject matter is what one might expect: birds and animals, heads and figures of women, a man with a sheep, even a football player. At the more intimate level, as in the heads of Jacqueline, these are delightful and amusing, but some have been re-made on an enormous scale by Lionel Prejger and Carl Nesjar to serve as public sculpture, and one may reasonably wonder whether this is not artistic inflation of an especially pernicious kind. It is ironic to recall that even for Picasso commissions could come at the wrong time: when he wanted to make monumental sculpture in 1928–29, he was frustrated. As he told Kahnweiler: 'I am obliged to paint them because nobody will commission them from me.'[45]

The metal cut-outs are closer to painting and drawing than most of Picasso's sculpture: they seem to mark the final stage of that constant process of interchange and dialogue between sculpture, painting and drawing which was so characteristic of Picasso's career. The discontinuity of his work as a sculptor results not from any drying up of inspiration, but because that inspiration could flow unimpeded into a sister art.

When in 1948 Daniel-Henry Kahnweiler wrote a short introduction to the volume of Brassaï's photographs, *Les Sculptures de Picasso,* he had to make out a case for the serious consideration of Picasso's sculpture. The eloquence of that short essay and Brassaï's magnificent photographs set in motion a revaluation that was power-

259 *Woman's Head,* 1962.

260 *Sylvette,* 1954.

261 *L'Espagnole,* 1961.

262 *Bathers,* 1956.

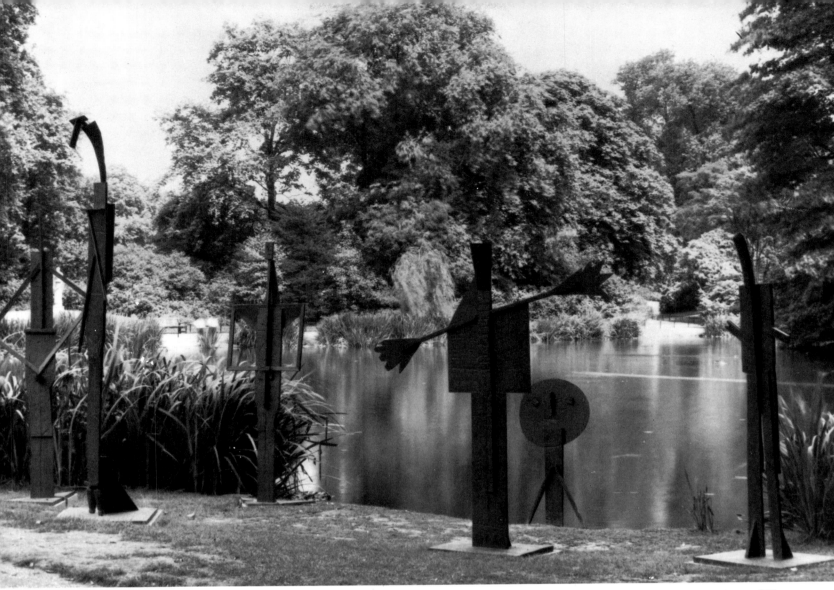

fully reinforced by Roland Penrose's books and exhibitions of Picasso's sculpture in the 1960s, when its range and quality was for the first time publicly displayed.

We have recognized the uniquely discontinuous nature of Picasso's sculptural activity, the way in which new ideas are constantly introduced yet not fully exploited. Whereas Picasso's later oil painting leaves the impression at times of a compulsive activity insufficiently considered, the sculptured œuvre is a marvellous wealth of suggestions that have been a constant source of inspiration to succeeding generations of younger artists.

More than any other single artist perhaps, it is Picasso who personifies the liberation of sculpture in the twentieth century, the opening up of new means of expression and the new dignity and eloquence that the art has found.

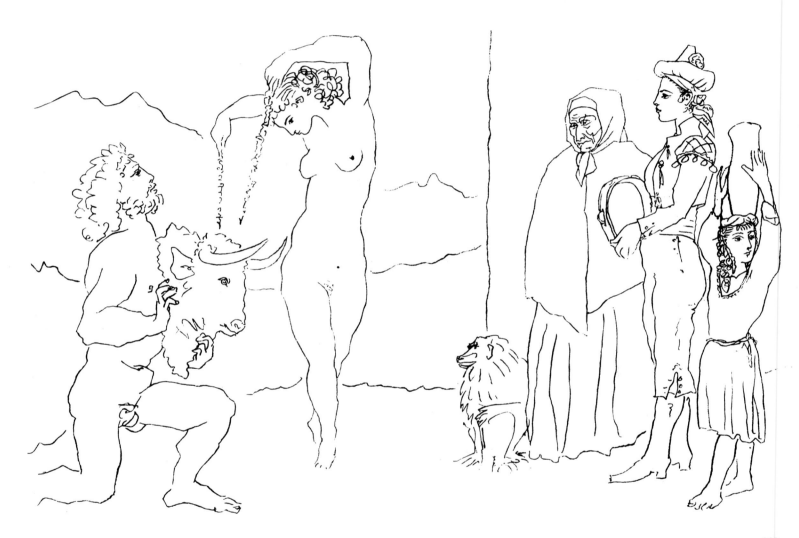

263

Beauty and the Monster

Roland Penrose

During the long life and prodigious activity of Picasso, and in spite of the fame that he was accorded almost universally, there were those who persisted that the only explanation of his success was that he was fundamentally a mocking demon rather than a great artist and poet. If we wish to give any credibility to this otherwise malicious accusation it can be found only in the bewilderment he caused in refusing to follow a path which could on the surface appear to be consistent. He did not hesitate to mingle the monstrous images which for many reasons perturb us deeply among those which our aesthetic judgement feels to be of profound beauty. It is this disconcerting duality which must be considered if we are to arrive at an understanding of his genius.

It is well known that Picasso established his reputation as a draughtsman of extraordinary ability at a very early age. Many of his drawings made before he was twenty represent female beauty in a style that can rival the refinements of the greatest masters. There are paintings of 1906 such as *La Toilette*, made when he was only twenty-five, about which Alfred Barr wrote: '[they] make the official guardians of "Greek" tradition such as Ingres and Puvis de Chavannes seem vulgar and pallid'. But even so, Picasso is as widely known, and rightly, for his ruthless dismembering and distortion of the human form, a process in which the Greek vision of beauty is deliberately and utterly destroyed in favour of a powerful realisation of a new and disturbing reality. An appropriate example among the many thousands that exist is the *Nude* of 1929 in which all classical representation has given way to a style which many would be reluctant to call beautiful.

As often happens in the work of an artist, it is from among Picasso's drawings that we can find important clues to the inner processes that brought about changes and apparent contradictions in his work. They are all the more essential as a guide since Picasso drew with great concentration and fluency whatever his imagination supplied. This faculty remained throughout his life and was still undiminished even at the age of ninety. Nor are the majority of his drawings no more than preliminary sketches for ideas that would mature later into finished works, as is so often the case with other artists. They are direct statements of his inner vision. Moreover, owing to his exceptional memory there is a coherence to be found in his work throughout, in spite of its prodigious variety, and through his drawings alone it is possible to gain a sense of its monolithic nature, even if we do not follow systematically its chronological development. In the apparent contradictions of his work, a continuity is to be found, composed characteristically of those contradictions in life itself which contribute endlessly to the history of mankind.

The work of Picasso is above all an inquiry by visual means into the nature of that elusive thing reality. Not long ago he said once more: 'Like all Spaniards I am a realist.' It is not easy to understand exactly what he meant to imply. Reality cheats us by changing its shape and its meaning so often that we may finally admit that the reality for which we search is, like life itself, no more than a dream. Of this Picasso

48

264

263 *Dance with Banderillas*, 1954.

157

264

265

264 *Nude in an Armchair*, 1929.

265 *Ape and Young*, 1952.

266 *Self Portrait and Monster*, 1929.

was fully aware, particularly owing to his close association with the Surrealists in the years before the war, and their insistence on the interrelationship between dreams and reality. In a fantasy written by him in the fifties, *El Entierro del Conde de Orgaz*, he introduced three little girls who 'fall asleep and no not dream because having dreamed so much they are always awake when they dream.'

If we describe reality as that which exists in the cleft between two dreams, there is the moment when we believe that we have established the identity of an object; but it is here again that Picasso became disconcerting. In the many forms that his expression took and particularly in his sculpture he was an accomplished master of metamorphosis. There is the well-known example of the bicycle saddle and handlebars with which he made convincingly the head of a bull, and an even more spectacular sculpture of an ape, the head of which is made of two toy motor cars. So complete is the transformation that it is impossible to decide to which category, ape or car, the head belongs. This bronze, incidentally, is one of the very rare references in Picasso's work to the machine, which to so many other artists of our time has been either a fruitful source of inspiration or a model for monsters. We find continually in his work that it was more than playfulness and a Protean ability to juggle with the nature of objects that prompted him. When he painted a head it is often both one head and two heads in an inseparable embrace, a hand can also be a leaf without sacrificing its identity as a hand and an eye weeping is also a boat rocked in a tempestuous sea. The images he employed are rich in associations with other images. They contain so often that which is called beauty on the one hand and the monstrous, that disconcerting appearance of terror which is called ugliness, on the other. It is this fundamental desire to exclude nothing that can be expressed that gives a completeness to the work of Picasso, even though he himself expressed his doubt as to the validity of the conventional meaning of the word 'beauty'. 'Beauty,' he once said to Sabartés, 'what a strange thing . . . For me it is a word devoid of meaning for I don't know from where its significance comes nor to what it leads. Do you know exactly where to find its opposite?' In this refusal to admit a simple dichotomy between beauty and its opposite we have a clue to Picasso's attitude and a reason to study the way in which he gave power to his expression in combining the two.

Far from its being a stultifying influence there is in this attitude an element which is primitive and which introduces a recognition of the attraction or repulsion which nature exerts on us. Our acute feeling for the delight in the persistent marvels of animals, birds and flowers is accompanied by an equally strong feeling for ugliness and the horror of the pestilential presence of noxious insects, hideous reptiles, leeches, slugs and vultures, although we know our horror is not due to conscious malice against us on their part. In themselves these creatures are innocent and it is man who attributes to them moral qualities because they are hostile or unpalatable to him. Throughout history we have ample evidence of a transference of the virtues and vices of which man is conscious in himself to the creatures around him. He sees in fact his own likeness in them and for this comparison to be complete, he must admit its diversity and recognise that the nobility of the lion or the purity of the lily have their complement in the cowardice of the hyena and the ruthlessness of the shark.

It is as though we were in need of horror and ugliness, not only as a foil to the tranquillity and well-being of beauty but as a condition of its presence. Ugliness can, like beauty, be captivating and the fear it can cause can stimulate the whole of our being whether its presence is real or imaginary.

Herbert Read has drawn attention to the difference between these conceptions: 'Ugliness is the physical aspect of certain objects of terror, objects which inspire

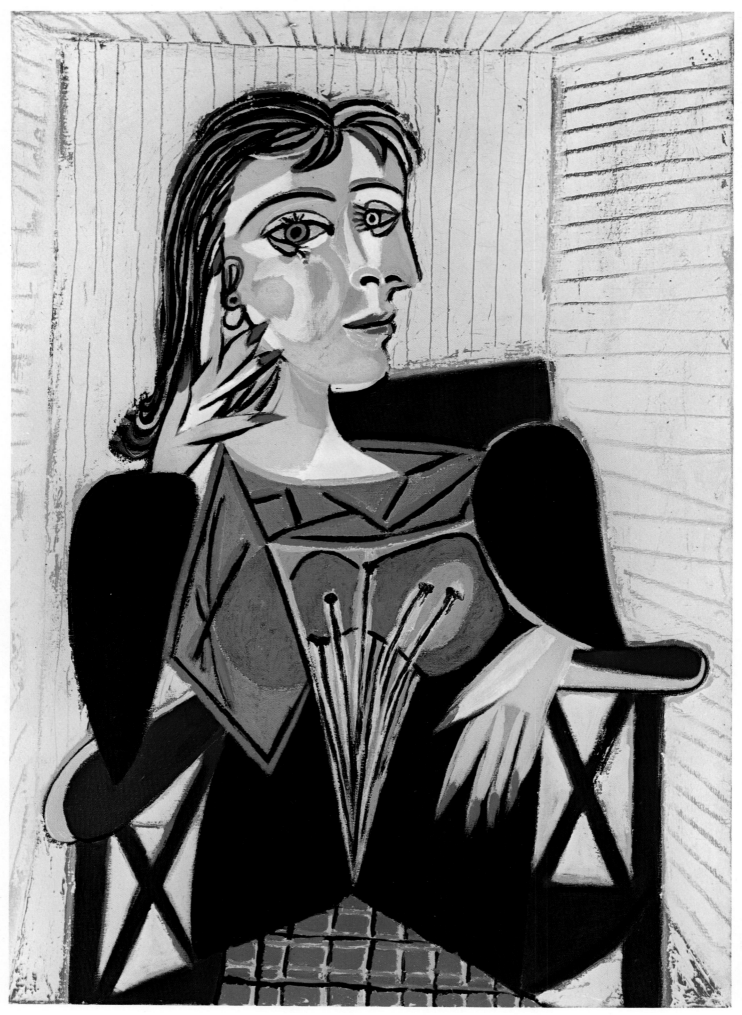

'fear and terror if they are real, but delight if they are counterfeit.'[1] In the same way that the ghost story becomes enjoyable to children and the most heartrending tragedy is a consolation to adults, art constitutes the medium in which beauty and ugliness unite. In using the word 'ugliness' I refer again to Herbert Read who points out that its derivation which is from Old Norse means 'causing fear, dreadful, terrible' rather than squalor, a human product with which it is often associated.

There are two different ways in which that force which we call ugliness appears in the work of Picasso. One of these owes it strength to stylistic innovations which cause an initial shock because they are unfamiliar and do not tally with the conventional standards of what is recognised as art. The other consists of fantastic images of creatures closely linked to our inner responses to the world around us in which we have been born and in which we make our appraisals of the nature of that which surrounds us.

The most dramatic change of style in Picasso's career, possibly the most far-reaching in its consequence for the history of contemporary art, happened with the painting in the winter of 1906-07 of *Les Demoiselles d'Avignon*, and during the period of revolutionary inventions it was not more than two years later that Cubism emerged as a new conception of visual art. In their creation of a new style Picasso and Braque were attempting to state the penetration of knowledge beneath the appearance of objects that we normally accept as reality. They succeeded in developing a visual language by which what was known about the object could be stated as well as its superficial appearance. 'I do not paint what I see, I paint what I know' was Picasso's brief explanation.

The Cubist period, being one of intensive discovery and invention, was met with violent antagonism from the public. Picasso for all except his most intimate friends was guilty of creating an art which was hideous and outrageous whereas, as we now realise, he was extending our capacity to understand and enjoy the elusive nature of reality and the mysteries of life, its wonder and its horror.

There is a painting of the Synthetic Cubist period known as *Woman in an Armchair*[2] in which Picasso made startling innovations in his treatment of the female form. During the Analytical period the structure of the human form had been dissected and reconstructed with an architectural appearance of crystalline quality, but in this painting the distortions are of another order and although at

131

267 *Portrait of Dora Maar*, 1937.

268 *Monster*, 1935.

first sight the female body is scarcely recognisable, on examination it becomes a powerful and poetic symbol of woman. It was André Breton who showed his appreciation of this painting by giving it the title 'The woman with the golden breasts' and the Surrealists with their taste for both the monstrous and the marvellous hailed it as a most eloquent example of fantastic art.

The painting evokes in the ovoid shape of the figure and the central vertical column which has penetrated it from below an allegory of the act of copulation and the dramatic fusion of opposing forces. Those elements which are clearly physical and erotic provoke in a variety of ways both awe and anxiety. There are the two breasts beautifully shaped like the teeth of a sperm whale which are pegged to the woman's chest, a symbol combining love, a desire for possession, and cruelty. The impressive sphinx-like turn of the head with its torrent of hair makes a surprising contrast with the minute features of the face, which are presented by the mere suggestion of eyes, nose and mouth. But above all it is the banality of the surroundings in which this profoundly significant and poetic presence appears that is both disconcerting and a source of delight. The comfortable purple upholstery of the armchair in which the woman is seated, the daily newspaper in her hand and the crumpled shift which hangs from her waist all bring us back to the presence of everyday life. In these disquieting relationships between abstraction and sensuality, between dream and reality, Picasso achieved a true and rewarding synthesis.

The stylistic deformations of the human body are of many kinds. Some are simplifications in which the form becomes geometric while others emphasize movement or express tensions and muscular action. They all however are derived from a visual experience and are related to desire, fear or revulsion. Certain

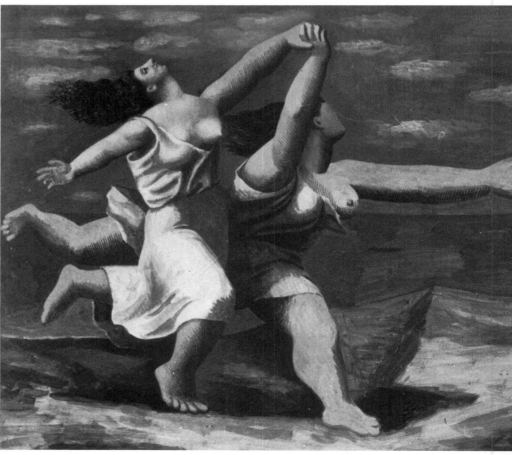

269

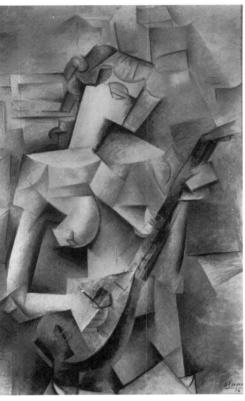

270

impressions of deformities that fascinated Picasso by their peculiarity in his child-hood or early youth appear to have left traces which reappeared years later. There is for instance an anecdote told by him which can explain in some degree the thickset limbs of the women of gigantic proportions who dominate his paintings of the Neo-Classical period of the early twenties. He remembered clearly his explorations under the family dining table when in the darkness among a forest of legs his imagination was particularly captivated by the elephantine ankles of one of his aunts, monumental and reassuring in their female solidity. In the paintings of the twenties this deformity becomes a heroic manifestation of archetypal maternity which makes a striking contrast with the emaciated versions of motherhood characteristic of the Blue Period. The thin elongated limbs of men and women of these youthful paintings originate not only in the beggars and undernourished poor who abounded in Barcelona and who confronted Picasso daily but also according to his own admission from the bony arms of the monkeys he enjoyed watching in the zoological gardens.

269

But the root of the problem lies deeper. It springs from Ficasso's desire to find a language in which he could convey the power that the external world exerts over us, and which we, in turn, desire in varying degrees to exert over it. It was in this way that he became conscious of the art of primitive peoples and the mysterious strength that emanates from it. He understood instinctively the life force that is present in African sculpture at a time when his friends, Derain, Vlaminck and Matisse had even no more than a superficial appreciation of its bizarre appearance. He realised without the aid of the analysis made later by Freud and Jung that ugliness, or rather the dreadful and the terrible, is often deliberately sought and enjoyed in order to satisfy some deep psychological need.

In order to follow what emerged from this discovery we must return to the great painting of 1907, *Les Demoiselles d'Avignon*, which caused such dismay even among his friends. Here in contrast to the relative classicism of the three standing female nudes on the left of the picture, he painted, after many alterations, two figures on the right with powerful barbaric mask-like faces and distortions in their forms which were not only prophetic of Cubism but of the complete liberty with which he was to interpret human anatomy in later years. This in fact was more than a change of style, it was a change in the conception of the emotional effect that a work of art should produce—a restatement of its ancient right to engender awe and fear as well as delight. This had been the purpose of Romanesque and early medieval art just as it was of tribal art and it is worth noting that the three more classical figures in *Les Demoiselles* also owe a great deal to the early Iberian sculpture and the Romanesque frescoes of Catalonia which Picasso had recently discovered.

130

After this initial revolutionary step the distortions which followed in Cubism became less disturbing. They produced a new kind of formal beauty, well ordered and crystalline, such as exists undeniably in the *Girl with a Mandolin* of 1910 in which there is nothing monstrous. It was not until the *Three Dancers* appeared fifteen years later, painted during an emotional crisis due to the death of an old friend, that the new idiom which had begun with *Les Demoiselles* became the means of violent emotional expression in which all respect for former conventions of beauty with ugliness as its antipode disappeared. This impressive picture is welded together by a restless disquiet which was to become increasingly acute and expressive of the catastrophic events that continued to threaten our existence as a civilisation. While at work on this picture Picasso had received the news of the death of one of his oldest friends, the painter Ramon Pichot, and as well as trans-ferring into the painting his personal sorrow he introduced a sense of orgiastic ritual. The dancer on the left is bent backwards in convulsive ecstasy, while the

270

269 *The Race*, 1922.

270 *Girl with a Mandolin*, 1910.

271

272

273

274

271 *Man Beating his Wife*, 1903.

272 *Man with his Skull Torn by a Raven*, 1903.

273 *Bullfight*, 1901.

274 *Dying Horse*, 1917.

275 *Cat and Bird*, 1939.

central figure with arms stretched wide apart introduces the suggestion of a crucifixion, the theme which Picasso was to develop with astonishing power five years later.

Just as beauty tends to lead to a tranquillity of the spirit there is good reason for us to associate ugliness with violence. The inner reactions to a world in which violence is never entirely absent can be found in Picasso's earliest drawings. There is a scene in a bull ring drawn when he was nine years old in which a toreador is tossed high in the air by a bull, and as early as 1903 there is a drawing that describes vividly a man, his expression obliterated by rage, mercilessly hammering at a naked woman with his fists. There are also early drawings and many studies, now exhibited at the Museo Picasso in Barcelona, for paintings of battles which were never completed, in which the inevitable wounded and dying are treated with disturbing realism.

But there are also drawings of the same years of an elderly, well-dressed bourgeois being attacked by malicious creatures. In one it is a spherical demon that is battering the man's head with its feet and in another a raven has pierced the old man's skull and blood streams down his face.

The appearance of the raven attacking its victim as though it were an emissary executing the sentence of some higher authority recalls the theme I have mentioned earlier, the transference of attributes between man and the animal kingdom that is found universally in ancient and tribal art and ritual. This tradition was accepted instinctively by Picasso and developed from his own observation of the behaviour of the birds and animals that he always kept around him, as well as of men and women.

The callous cruelty with which a cat seems animated when in fact it is merely gratifying its natural desire to catch and devour its food becomes in Picasso's hands the mirror image of the sadistic violence of man. In the painting *Cat and Bird* of 1939 a cat with vicious rending claws tears to pieces its victim, but the face of the cat seen against a clear blue sky is both feline and unmistakably human. Its bared teeth, its ferocious eyes and wrinkled forehead project the heartless greed of a man conscious of his crime and apprehensive that he may be unable to carry it through.

164

In a different context the identification with the behaviour of animals leads to a very moving parallel in drawings that Picasso made of a horse dying after being gored by a bull in the arena. The final movement of its head straining upwards 274 appears clearly to be an allusion to the supreme ejaculation of the male lover who metaphorically dies in the act of love.

Traditionally we attribute to animals simple, elementary virtues or vices—to the bull brute strength, the goat lechery, the dove gentle innocence, and the owl wisdom, though we are not always consistent and the same creature, the horse for example, can be either the noble friend of man or the nightmare of his dreams. But if we find contradictory qualities in animals we are even more conscious of inconsistencies in people; and when we examine ourselves no one, in particular the most virtuous, can ignore the monster within himself. This haunting presence can be the conscious result of relentless self-criticism or subconsciously it can have its origin in the traumatic experiences of childhood or an imponderable sense of sin.

Throughout his life Picasso combined a consciousness of his talent with an unusual degree of modesty and criticism of himself and his own achievements. In his youth he found a character, Harlequin, from the *commedia dell'arte*, whose temperament he imagined corresponded in many ways to his own. Harlequin was sensitive to poetry, a performer who could enthrall his audience by his brilliance

275

10.1.54. XIV

276

and his pathos and yet he was a vagrant who escaped from the demands of society, an outcast who frequented other outcasts, whores, madmen and vagabonds. Picasso's cherished association with this mercurial wanderer[4] produced many paintings during the Blue Period and even continued its influence in more stylised form in Cubism. In early paintings, such as the *Lapin Agile* of 1905, it was not infrequent that Harlequin should become a portrait of Picasso himself.

33

More recently in the many versions that he has made of the theme of the artist and his model, we find Picasso interpreting himself as the artist, most often in a denigrating manner. In the great series of drawings[5] made during the emotional crisis he lived through during the winter of 1954 the artist becomes a ridiculous figure, old, deformed, senile and even transformed into an ape. His humility is made bearable only by the intensity of his wit. Nor does he deny that in his creative life there is a strong element of destruction. 'For me,' he told Zervos, 'a painting is the sum total of destruction. I make a painting and then I destroy it', and out of destruction comes life. Once he read to me an anonymous letter from a French painter which began: 'Monsieur, the harm you have done is incalculable', and then said gravely, 'Who knows, he may be right'. In the impulse of his creation Picasso was not concerned with doing good or evil. He was concerned with the reality of his own being and the communication of his thought. It is therefore to be expected that the potential monster that he carried within himself should find ways of showing itself in visual shape.

27

There is a revealing instance of how a monster invented by Picasso could germinate unsuspected from intimate routine habits. During the Spanish Civil War he made a series of engravings to which he gave the title *Dream and Lie of Franco* and in which he devised a particularly loathsome creature of amorphous parasitic shape to represent Franco in the various activities which seemed characteristic of the enemy of the Spanish Republic and the hero of Fascism. By some diabolic magic, however, this invented shape, once it appeared on the print in reverse, had an undeniable

27

276 *Ape and Model*, 1954.

277 Detail from *The Dream and Lie of Franco (I)*, 1937.

278 Detail of signature from *The Dream and Lie of Franco* (I), 1937.

279 Detail of *La Courtisane*, 1901.

280 *Charity*, 1903.

277

278

279

likeness to his own initial P. The monster he had devised to represent Franco was in fact derived from a shape intimately part of Picasso, his own signature. The monster lurking within had emerged as a convincing proof of his own involvement.

278

In his youth Picasso became conscious very early of monstrous qualities that make themselves visible in faces and actions. In his drawings in Barcelona we recognise the obscenity of a bejewelled harridan he had observed in a restaurant, and in a coloured sketch on which he wrote 'Caridad' (*Charity*) we are shown the hypocrisy of the grossly successful tycoon patronising the poor. The Blue Period is crowded with images of the monstrous misery from which it was impossible to escape in the streets. When he was young he chose to portray such ugliness in directly realistic images. With maturity, however, he learned that distortion and caricature were often more potent means of expression.

279
280

Picasso's first circle of friends whom he met during his adolescence in Barcelona had been deeply tinged with a *fin de siècle* melancholy and a longing for the sublime which they shared with the Symbolists. There was also however a determined revolutionary group with anarchist beliefs who also attracted his sympathy. In Paris the atmosphere was more international. His new friends, more often poets than painters, belonged to a wider field of thought. They were constantly challenging the status quo of the bourgeois society in which they lived, using satire and cynical humour as their most effective weapons. Alfred Jarry exercised a strong influence over Picasso and was never forgotten by him, chiefly because of his creation of a monster, Le Père Ubu, who is both outrageously fantastic and pathetically real.[6] Jarry was as precocious in his development as Picasso and by the time the young painter arrived in Paris, Ubu had already emerged in his monstrous form. In a woodcut by the author he is seen with his distended belly inscribed with an enigmatic spiral and high pointed fool's hood like those the penitents wear in Holy Week in Spain and a baton such as Harlequin carries under his arm. These external signs were equally part of Picasso's vocabulary and the monster they clothed was the embodiment of arrogance, stupidity, guile and brutality, in fact all

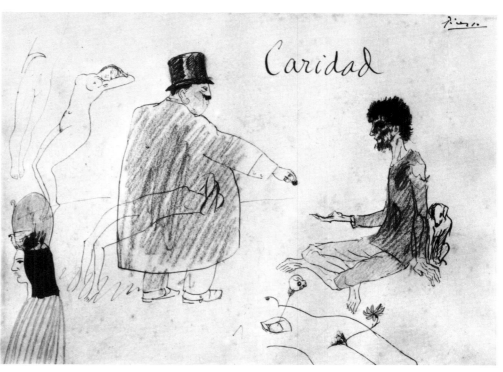

280

that is most hateful made palatable, even enjoyable, solely by the robust and lacerating wit of Jarry. Years later, in the summer of 1937, during which he had painted *Guernica*, Picasso was asked to make a drawing for the programme of a performance at the Théatre des Champs Elysées of *Ubu Enchainé*. As a background to the gross profile of the 'hero' of the play he wrote these lines full of jocular images:

281

au bout de la jetée promenade	at the end of the promenade along the jetty
derrière le casino le monsieur	behind the casino the gentleman
si correctement habillé si gentiment	so properly dressed so nicely
déculotté mangeant son	debagged eating
cornet de frittes d'étrons	his sack of fried turds
crache gracieusement	graciously spits
les noyaux des	olive stones
olives à la gueule	into the jaws
de la mer	of the sea
enfilant ses	threading his
prières à la corde	prayers on the rope
du drapeau qui grille	of the flag that roasts
au bout du gros mot	at the end of the dirty word
qui illumine la scène	that illuminates the scene
la musique cache son	the music hides its
museau dans l'arène	snout in the arena
et d'ecloue	and unnails
son effroi	its terror
du cadre de guĕpes	of the frame of wasps
jambes écartées	legs wide apart
l'éventail fond	the fan melts
sa cire sur	its wax on
l'ancre	the anchor

Mougins
Vaste Horizon
Le 12 Septembre
37
Picasso

282

Ridicule is undoubtedly a devastating weapon but caricature, in which Picasso could have been master had he wished, is used by him in a more gentle and personal way in order to amuse rather than insult when it is a question of transforming his friends into monsters. During his youth in Barcelona most of those he knew came to know themselves better by his drawings and for us it is still easy to recognise Casagemas by the long crow's beak Picasso gave him, Junyer y Vidal by his bushy black moustache and dishevelled crop of hair, even the artist himself from the lock of black hair falling over his forehead and his jet black eyes in many sketches which are characteristic rather than flattering. In the years that followed nearly all his closest friends suffered the same treatment. Apollinaire still sucking at his pipe was crowned as the massive figure of the Pope or appeared as a pin-headed muscle-bound athlete. Those elegant gentlemen without whom the Russian Ballet would not have existed, Diaghilev, Selisbourg, Bakst and Massine were sometimes portrayed with the realism of Ingres and at other moments became swaggering dandies. And so it continued whenever Picasso felt inclined in his incorrigible

283

284

285

playfulness to caricature mercilessly some of his best friends, such as Sabartés, Jacques Prévert or even Helène Parmelin who has shown great understanding of 284 him in her books. Of her there are two portraits which give her a wild Medusa-like 285 appearance.

An obvious source of Picasso's desire to link the animal kingdom with his exploration of human life is the imagery that abounds in Catalan Romanesque and Gothic art. It is not only seen in the bestiaries such as that in the Tapestry of the Apocalypse from the Cathedral of Gerona, in which the birds and animals often have a delightfully human appearance, but also in the demons that we find in the

169

frescoes at Tarragona and the multitude of sculptures in churches and monasteries scattered over the whole province.[7] Without borrowing directly from the past and without labelling them with the traditional vices and virtues, Picasso invented monsters or resuscitated them, making them the heralds of his own personal emotions and problems. Among these, the monster that provided him with the widest field of expression comes from the mythology of ancient Greece—the Minotaur. The duality of man and beast in this horned demigod appealed to Picasso as an artist and a poet. It also had a unique familiarity for him through the analogy of the bullfight.

286

As happens with the majority of Spaniards the *corrida* had been part of his education when in childhood he was taken to the bull ring in Malaga in the blaze of the summer sun. Throughout Spain this ritual of ancient Mediterranean origin, enacting continuously the duel to the death between man and beast is still a national necessity. Apart from his enjoyment of a scene full of colour and action, of contrast between sunshine and shadow, the main involvement for Picasso was not so much with the parade and the skill of the participants but with the ancient ceremony of the precarious triumph of man over beast. No moral issue is involved. The man, his obedient ally the horse, and the bull were all victims of an inextricable cycle of life and death. The bull is the hero in the same terms as the man and pity if need be must be shared out equally to all participants. But the bull is everlasting, it is continually replaced and becomes in this way the symbol of the enduring force of life, the only power capable of eternal survival. This point is clearly emphasised by Picasso in the *Dream and Lie of Franco* engravings and later in *Guernica*.

After his early impersonation of the mercurial character of Harlequin, Picasso's

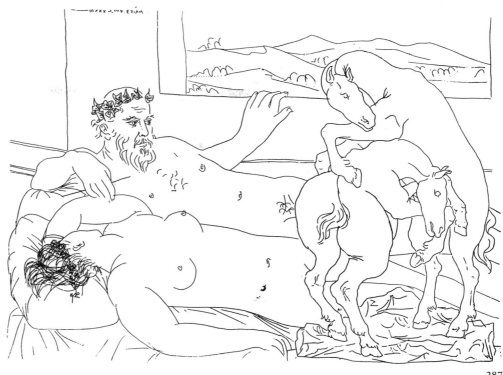

interest lapsed and if he appeared at all in paintings from the Cubist period onwards it was always in a more impersonal way, either because the diamond shapes of his costume had an affinity to the Cubist style or because the *commedia dell'arte* was one of the sources of the inventions of the Russian Ballet. The last time Harlequin appeared as a figure of importance was in a portrait of Paulo the artist's son dressed for a children's carnival.[8] In 1933, however, another character of more robust habits attracted Picasso's interest. The Minotaur had been much talked of by the Surrealists as a mythical being that corresponded in its duality to the conflicts within our conscious and subconscious minds. In spite of the obvious differences between Harlequin and the Minotaur there were however two characteristics shared by both these mythical beings; their amorous devotion to women and their reputations as rogues and outcasts from society, qualities that endeared both these mythical beings to Picasso. At this time an ambitious new publication in which André Breton and Paul Eluard had a large share of editorial responsibility was given the title *Minotaure* and Picasso was asked by them to design the cover for the first number. The invitation coincided with Picasso's new preoccupation. In addition to the cover design he worked for a long period on a series of engravings known as *The Sculptor's Studio* in which he re-invented the personality and the deeds of this fabulous monster, creating in images a new legend which starts with the boisterous arrival of the Minotaur in the sculptor's studio and closes with a drawing made four years later entitled *Le Fin d'un Monstre*.

This brilliant narrative in which archaic traditions become a passionate commentary on modern life was begun at a time when Picasso had returned to sculpture after a lapse of more than fifteen years. Harlequin had been his choice during his early years as a painter but sculpture by its nature is more terrestrial and it was therefore more fitting that if a new impersonation were in question the Minotaur, a more material being, should be chosen. However the animal head excluded the literal personal likeness that had been possible with Harlequin and a deeper more enigmatic similarity of subconscious desires was the plane on which the kinship became manifest.

The story begins after we have seen the sculptor at work in his studio in several

286 *Bullfight*, 1901.

287 *The Sculptor's Studio*, 1933.

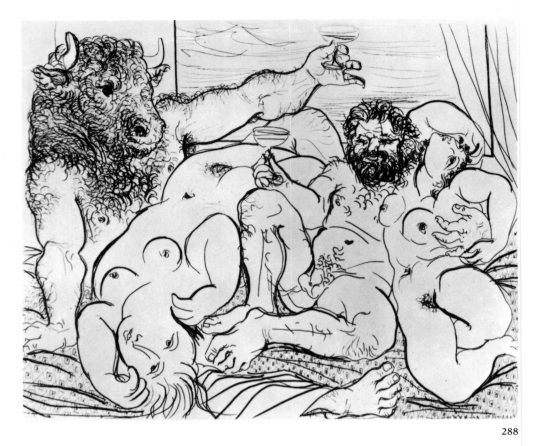

engravings.[9] Twentieth-century France has become ancient Greece, the sculptor is a bearded Athenian. His model, ever present, is found basking beside him in all her naked classical beauty but the attention of the sculptor even so is diverted from her by the concern which can be seen in his face for his own artistic efforts. They are ambitious but obviously they do not satisfy his demands. He appears to remain in a state of doubt and melancholy detachment until the sudden invasion of his studio by the shameless and lustful Minotaur. This intrusion seems to be strangely acceptable, even enjoyable, as a diversion from worry and restraint. The monster

290

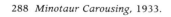

291

288 *Minotaur Carousing*, 1933.

289 *Minotaur Asleep*, 1932.

290 *Minotaur Raping Girl*, 1933.

291 *Centaur and Woman*, 1920.

292 *The Rape*, 1933.

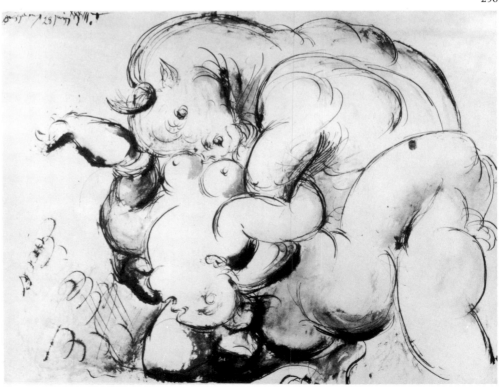

292

is at once accepted by the sculptor and is found reclining amicably among the artist's models, respectfully raising his glass of wine to their placid beauty while all concern for the sculpture which still decorates the studio is forgotten. An orgy follows inevitably in which the brute plays tenderly with the girls and this is followed by a moment of exhaustion and serenity. The monster falls asleep behind a curtain with an adoring maiden jealously watching over him.

In the next plate, however, unbridled violence has broken loose. The Minotaur throws a woman from her horse and rapes her on the ground. This scene has since been repeated in many drawings, though the aggressor is not always the Minotaur. The act of copulation in which the woman struggles to fend off her lover is a theme which gave Picasso the opportunity to express the equivocal nature of love and human desire. There is in most cases a sensation of uncertainty as to how far the woman enjoys being the victim of the overwhelming onslaught of the male. Yet there is a sense of the inevitable, a mutual sharing of the universal compulsion of sex.

The erotic encounter becomes even more dramatic when the male displays the face of the beast. Some years before, Picasso had approached a similar subject in drawings of a maiden being carried off in the arms of an eager centaur but the effect is lighthearted, even comic in comparison to the snorting passion and unrestrained fury of its mythical counterpart the Minotaur. It is the eye and the mask of the beast that convey terror. In some later drawings Picasso deliberately softened this appearance. There are drawings in which a more human version of the bull's head greatly mitigates the horror of its glance but there remains the deeply disquieting effect that follows when man has forfeited his own human nature for that of a beast.

That a degree of guilt must be attributed to the monster becomes evident if we continue to follow the story. In the next engraving the scene has changed again and we find the divine beast, the intolerable monster humbly crouching in the arena before a naked hero who is about to slay him with a sword, while from behind

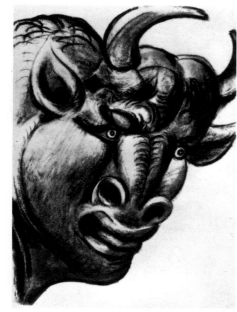

293

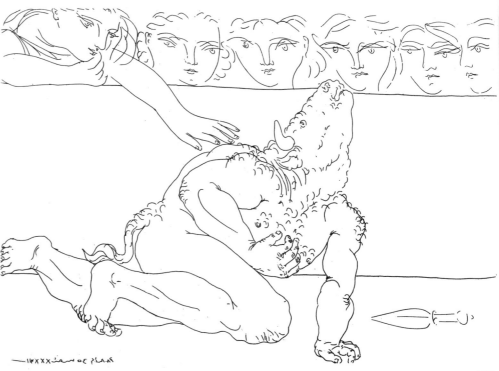

294

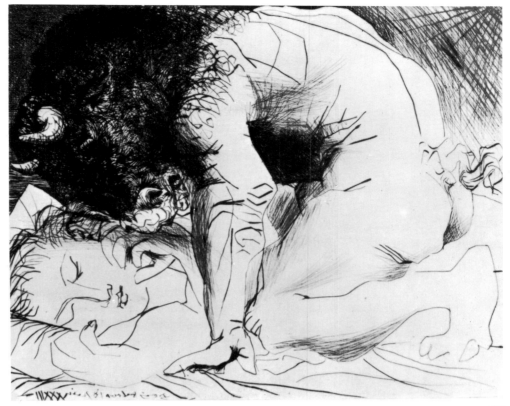

293 *Head of a Minotaur*, 1933.

294 *Death of a Minotaur*, 1933.

295 *Minotaur and Sleeping Girl*, 1933.

296 *Blind Man's Meal*, 1903.

297 *Blind Minotaur*, 1934.

295

a barrier they are watched with anxiety by a row of men and women. In the next print however the youth has gone, leaving the Minotaur in his death agony. The monster has been sacrificed and as it dies a woman stretches out her hand to touch 294 the magic hump on the horned god's back. The monster dies but like the bull in the *corrida* he remains eternal and therefore indestructible.

The sequence of these images is surprising in its eloquence and in the speed with which they were drawn, sometimes three in the same day, and the whole series of eleven plates were finished within a month. The last three form a postscript;

296

297

175

we find the monster holding a girl of great beauty in his arms and again drinking happily with the sculptor and three of his models, while the final one of the series is perhaps the most moving of all. The beast bends tenderly over a sleeping maiden, his lips curled in anguish at the hopelessness of his plight and the realisation that only an impossible metamorphosis can make his passion acceptable.

After the eighteenth of June 1933 there follows a gap of more than a year before Picasso returned to the story he was telling in the engravings, although there are numerous drawings and water colours of the theme in which the Minotaur is seen visiting in awe a sleeping nymph. But in the autumn of 1934 the series was completed with four dramatic engravings in which Picasso has found an alternative punishment for the demigod—blindness. The monster reappears chastened, blinded, feeling his way along a quay where he has been landed by fishermen. A child carrying flowers or a dove leads him, now docile and lamenting to the night. The sense of touch becomes his only means of contact and he tenderly places his hand on the girl's head or shoulders for guidance while spectators stand in astonishment.

The affliction of blindness comes as an echo of those paintings of the Blue Period in which Picasso showed his feeling for the misery of the blind beggars he saw daily in the streets of Barcelona. He also used it as a reminder that the imagination functions even without physical sight and that the inner eye is essential to the poet. It has also a bearing on the development of the sense of touch, which had been dramatically emphasised in the Blue Period painting known as *The Blind Man's Meal* of 1903 where the victim is tenderly fingering a water pot and the food placed before him. The perception of objects through the sense of touch is also in keeping with Picasso's activity in the thirties as a sculptor.

The haunting image of the Minotaur had however not yet completely vanished. Several drawings of 1936, some completed with colour, continue his exploits.

298

299

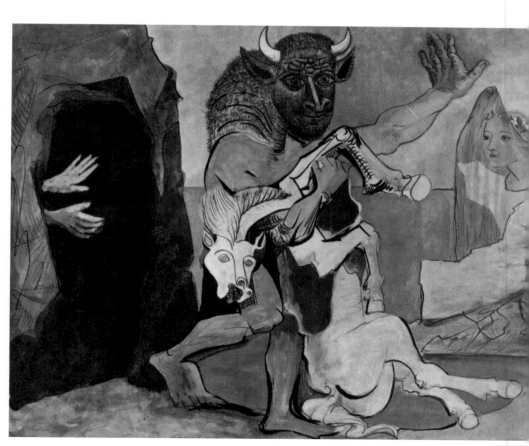
300

He is seen avenging himself on his rival the horse. He emerges from a cave by the sea carrying its limp carcase, or moves house with his only possessions, a dead mare and her foal on his cart lighted by a lantern tied to the mare's hoof. There are other drawings in which he spies enviously on a girl skipping through the meadows, or where he is making off in a boat with women he has captured, or again, we see him agonising on the ground pierced by a sword. Many of these images move us to feel compassion for the monster. Even when he appears with the dead horse in his cart he has a seductive look of innocence in his face which demands forgiveness for the inevitability of his brutish crimes. 300 298 299

301

298 *Minotaur Moves House*, 1936.

299 *Minotaur Watching Woman*, 1936.

300 *Minotaur Carrying a Dying Horse*, 1936.

301 *Minotauromachia*, 1936.

To complete the sequence there is the great engraving made in the spring of 1936 known as *Minotauromachia*, prophetic in many ways of the Spanish Civil War and *Guernica*. In this episode the Minotaur intrudes in all his might to avenge himself on the horse who carries on his back the dying figure of a girl dressed richly in the costume of a toreador. His entry from the sea terrifies the bearded sculptor who tries to escape by a ladder. Again the monster is halted in its onslaught only by the presence of a little girl who fearlessly confronts him with a lighted candle. By this gesture she is able to enforce once more a precarious balance between the dark powers of uncontrolled violence and the forces of light. 301

Finally there is a drawing of the second of December 1937 in the pure line of his pencil, entitled by Paul Eluard to whom it belonged, *Fin d'un Monstre*. It is the last appearance of the Minotaur in the work of Picasso. Two figures alone are present. A woman of classical beauty emerging from the sea, holding in her right hand a spear and in the other a mirror, is face to face with the monster who pierced by an arrow breathes his last breath. Looking into the mirror that is held to his face he recognises at last the true image of his own bestiality. Eluard in the poem he wrote inspired by this image insists on the immortality which none the less remains in the monster:

> Il faut que tu te voies mourir
> Pour savoir que tu vis encore
> La mer est haute et ton coeur bien bas
> Fils de la terre mangeur de fleurs fruit de la cendre
> Dans ta poitrine les ténèbres pour toujours couvrent le ciel.

> It is necessary for you to see yourself die
> To know you still live
> The tide is high and your heart is very low
> Son of the earth flower-eater fruit of ashes
> In your bosom the darkness covers forever the sky.

There is a detail concerning this drawing that is significant. Picasso has drawn the monster without the slightest hesitation and without anywhere correcting the line. But when faced with the perfection of the female form, Venus rising from the ocean, it can be seen on close inspection that he has hesitated and redrawn the contour of her breasts, her profile and the angle of the arm holding the mirror several times before he was satisfied. This suggests that beauty is more elusive than the more arbitrary accommodation of ugliness. Beauty however elusive it may be appears to be related to some preconceived standard, to attain which, concentration

302

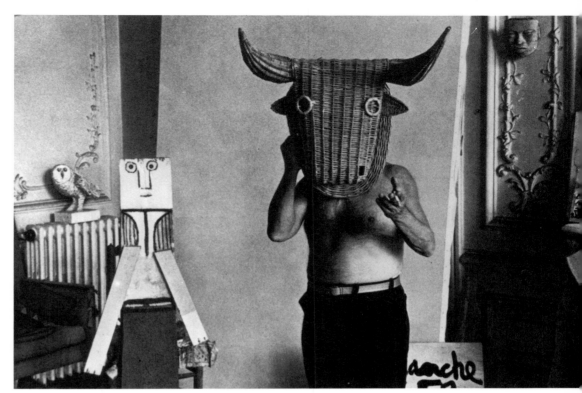

303

304

and considered judgement are required, whereas the terrible corresponds to a spontaneous unprecedented invention.

It is easy to find convincing examples of Picasso's personal involvement with the Minotaur. There is a photo taken on the beach at Golfe Juan in 1937 by Dora Maar in which, posing for the camera, he holds the skull of an ox he had found 303 among the driftwood and closes his eyes to simulate blindness. Some years later he amused himself with one of the wicker masks of a bull that are an endless source 304 of sport among youths in Spain, offered to him as a present by the toreador Dominguin. By covering his head with the mask Picasso unmasks the reality that the beast hides somewhere beneath the surface.

But Picasso did not need to return to ancient legends to find monsters. They could originate with equal violence as an expression of the miseries and provocations that happened in the loves or hates of his own life. At the time that he was undergoing great emotional stress after his separation from his first wife Olga and submitting to violent attacks from her due to her jealousy of his new love for Dora Maar, his whole production echoed his anger and his passion. Distortions of the human form became grotesque and terrible. Monsters appeared as inventions of his own fantasy even more personal than the mythical image of the Minotaur. There is a painting 266 of 1929 in which his profile like a red shadow fills the background. Superimposed on it is a sinister head with voracious jaws, a sharp incisive tongue and eyes spinning like an electric drill. Every aspect of this harpy is aggressive. The monster he could represent with such power was to continue to haunt him. It reappears in many different forms throughout the years that followed. In a drawing of July 1934, in which he had in mind David's painting of the assassination of Marat, he seems to be laughing at his own obsession. A furious female figure has invaded the room like a whirlwind. Her face with small cruel eyes is dominated by a large open mouth with fangs bared and a swollen tongue thirsting for blood. With outstretched arm 305 she plunges an enormous knife into the jugular vein of her victim seated like Marat

302 *End of a Monster*, 1937.

303 Picasso on the beach at Golfe Juan, 1937.

304 Picasso with a bull mask, 1950.

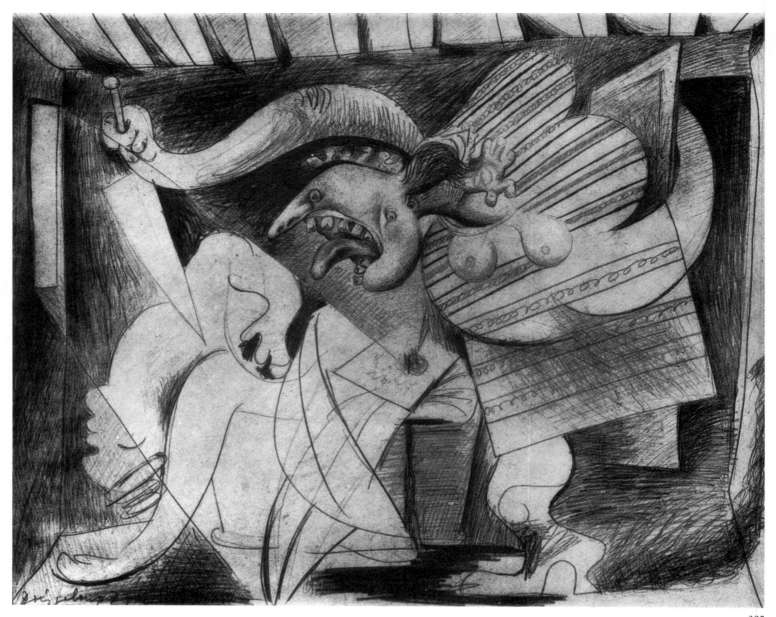

in the bath-tub, but to our surprise it is not Marat who is being murdered. It is a girl with the profile of Marie-Thérèse Walter, the sensuous blonde model who appeared in so many of Picasso's paintings at the time. A few years later he made a coloured drawing in which Dora Maar while bathing finds herself confronted with a similar terrifying presence and there are other drawings of the same creature jubilating alone in the sea.[10] There can be little doubt as to the origin in Picasso's mind of this particular monster.

Metamorphoses of this kind can, however, come from a mixture of sources, some even benign. The obsessive beauty of Dora Maar was used by Picasso as the raw material for a host of inventions. Frequently the radiant face of Dora with her shining eyes was transformed into the head of a nymph with budding horns and given the body of a bird, and at times the long aristocratic head of the Afghan hound was merged into paintings that were still in essence Dora. They should not however be called portraits of Dora Maar. Often the head became violently distorted as in the wartime painting *Head of a Woman* of 1943 in which it is broken in two. Its unity is split into separate but complementary parts. The upper half with a fierce canine appearance dominates the lower which is blindly subservient—a grim comment on the miseries of war and the triumph of monsters.

305 *Composition (Death of Marat),* 1934.

306 *Kasbec,* 1940.

307 *Dora Maar with a Monster,* 1937.

308 *Dora Maar as a Bird,* 1941.

309 *Head of a Woman,* 1943.

180

306

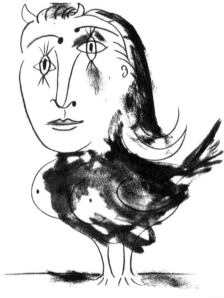

308

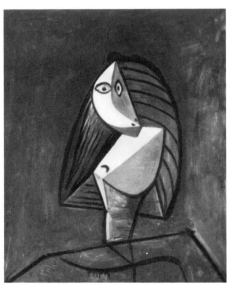

309

307

In many paintings of the war period there is also a synthesis of the two types of monstrous creatures that I have referred to earlier, those that are stylistic and those that spring from the fantastic bestiary of the subconscious. A great painting known as *Woman Dressing her Hair* is powerful and disturbing in colour and form as well as being one of the most aggressively evil images of woman that Picasso made. It was painted understandably in June 1940 when the Nazis were marching under his windows into Royan, a port on the west coast of France, where he had taken refuge with Dora Maar. Even so there are references to her in the monstrous distortions which are the antithesis of her beauty. 325

This raises a difficult question: why did he choose to mock and demolish the beauty he had known and admired so intimately even when the motive of personal animosity is absent? Can it be that the deeper the shame and the anguish brought about by outrageous catastrophies in the outside world, the greater must be the sacrifice demanded if it was to convey a message of the utmost power? In what other way could he prove better the intensity of his emotion? By this sacrifice, beauty herself gives birth to, or rather herself becomes, the monster. An earlier portrait of Dora Maar shows convincingly the tenderness that Picasso felt for her and for 267 her beauty. Here the original stylistic shock of Cubism has with time become attenuated and a spontaneous joyousness invades the painting in brilliant colour. From this we can judge the importance of the sacrifice that he made in reversing his feelings so that horror and ugliness are extracted from love and beauty.

It is evident that Picasso's obsession for women was the motive for his desire to interpret his love in images which vary between a record of their beauty and the introduction of elements which are for one reason or another its antithesis. But it would be crude and untrue to suggest that he portrayed his companions as beauties during the first flush of love and as monsters when conflicts begin to arise between them. The contrast between beauty and ugliness has no direct parallel with the contrast between love and hate. This is borne out by Picasso's assertion that rather than loving Venus, he loved a woman, which implies that in a reciprocal manner he was conscious of his own imperfection, of the monster within himself. It would oversimplify life to say that we love beauty and hate ugliness. But the artist has

181

the power to render ugly a person who is beautiful. With little effort he could change the princess into a toad and there is sometimes an element of vengeance and mockery, which became formidable in the monsters derived from Olga. At that time it would have been impossible for him to paint her as he had done in 1920, dwelling with tenderness on her charms. With Dora Maar his motives were different. He was not suffering under her attack but rather from the catastrophic atmosphere of war and defeat both in France and Spain.

I have tried to point out that Picasso's stylistic innovations are not necessarily monstrous nor were they invented with that intent. The shock that they can produce is the result of the power with which he was able to state what he saw and felt and his ability to communicate vividly the emotions aroused by what he observed in the world around him. This applies above all to the influence of women. In the studies for *Guernica* the distortion of the faces and limbs of the women conveys dramatically the agony they suffered in the bombardment.[11] A large canvas of 1937 known as *Woman with a Dead Child* is a poetic statement that contains a high degree of tenderness and compassion expressed with terrifying violence—violence which had originated in the crime that caused her anguish. The movement of the figure across the picture results in a concentration on the left side consisting of the woman's head and the child. The head, perched at the end of a long straining neck, reveals a powerful expression of agony due to the unprecedented distortions it has been given and the associations they evoke. The eyes, brought together on the same profile, rock like small boats in a storm, the nostrils suggest birds caught in a gale, while from the mouth comes a scream, shrill and as piercing as the enormous tongue shaped like a flame. The tongue itself is surrounded by teeth sharp and dangerous with an outer cordon of lips drawn taut like the arc of a bow. Every feature is rich in echoes and metaphors. The grief expressed by this fusion of images is more than a passive acceptance of misery, it calls with authority for justice in clear and resounding eloquence. Yet this head might by some be called monstrous and ugly, in which case such qualifications would become meaningless. They would fail to name or clarify the visual experience which is offered convincingly on the canvas. It would become evident that the head was thought to be hideous because of its distortions. But the monstrous shapes are there because they offer a beautiful solution, beautiful in the sense that a mathematician might use the word or in the presentation of a great tragedy. It is above all because of the distortions that emotions of anguish, compassion and indignation are aroused, and it is by the apt associations they provoke that, as in poetry, we are able to attain glimpses of a universal truth.

There is a small painting dating from a few years earlier, the *Crucifixion* of 1930 which is unique in several ways and important because of its relationships to the *Three Dancers* and to *Guernica*. It is of interest as being the only painting of a religious subject since Picasso's youth but it has received less attention than is due, partly because of its size, and also because it has rarely been seen as it remained hidden away in the artist's studio. Recently however a very thorough study of its sources has been made by Ruth Kaufmann.[12] The intimate bearing it has on Picasso's thought about myths and the drama of love, life and death as well as his attitude towards women give it a special place in our consideration of beauty and the monster.

Paradoxically, in colour the picture is brilliant in the richness of yellows and reds enhanced by vivid blues and greens, but the composition is highly disconcerting and difficult to decipher owing to the violence of the distortions and abrupt changes of scale even within the same figure. As usual the iconography Picasso uses is a synthesis of legends and myths drawn from many sources. The dominating

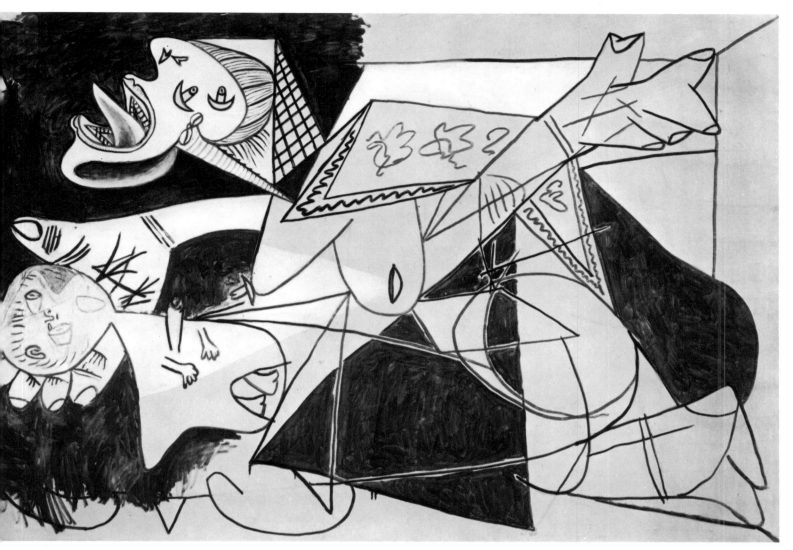

310

Christian theme is stated clearly by the central figure of Christ nailed to the cross and around it are various traditional symbols of the Crucifixion such as the two bare crosses from which the bodies of the thieves have been removed. Their mangled corpses lie on the ground in the bottom left-hand corner. In the foreground also are the two soldiers throwing dice for the garments of Christ and the ladder, easily distinguishable, is placed against the cross, at the top of which a small figure hammers a nail through the hand of Christ.

But as Ruth Kaufmann points out there are other more complex references to pagan and primitive religions which give the painting the status of a commentary on the universal sacrifice conducted with 'human irrationality in the form of hysteria, brutality and sadism'.[13] The primitive worship of sun and moon and Mithraic rituals were arousing great interest among the Surrealists in the thirties and Picasso through his close friendship with them and with Georges Bataille[14] was deeply involved in their discoveries. In an article entitled 'Soleil Pourri' Bataille drew attention to the ambiguities inherent in the sun as a symbol. The midday sun in its brilliance is beautiful but when looked at obstinately it becomes 'horribly ugly'. The bull with its sacrificial role in Mithraic ritual is also an image of the sun but only when slaughtered. It is the same as the cock, 'of which the

311 *Study for a Crucifixion*, detail, 1929.

horrible cry, particularly solar, is always close to the cry of a creature whose throat is being cut.' That these ideas permeated the thought of Picasso in *Guernica* and many other paintings is certain but they can also be shown to be at the basis of the *Crucifixion* which was painted in the same year that Bataille wrote his article. For this reason it follows naturally that the centurion should be mounted like a picador and that the idea of Christ should dissolve into the sacrificial bull. Moreover, the meaning of the figure to the right of Christ with the dual moon-sun symbolism in the same head becomes clear, and the general colour scheme of the painting gains in significance with the scorching heat of the midday sun felt everywhere except in the area of Christ himself on the cross, which like moonlight is in comparison monochromatic.

There remains however considerable uncertainty among critics as to Picasso's intentions in the interpretation of certain figures and as to the significance of this small but highly charged painting in general. The first question is whether we should expect everything to be related to religious symbolism or whether we should think of the painting as mainly a violent description of Picasso's own emotional torments transposed to the theme of the Crucifixion.

Fortunately there are several drawings made before and after the painting which can help us to elucidate some of the most ambiguous details. Already in 1926–27 there are drawings which show that in general Picasso was thinking of the subject in terms of its traditional symbols as a suitable environment for the expression of deep emotion. In the drawing of 1927 we find Christ on the cross, the ladder, the centurion mounted like a picador and piercing the body of Christ with his lance, the moon, the sun, and at the foot of the cross the ecstatic figure of Mary Magdalen.[15] But in the drawings that follow in 1929 his main preoccupation centres round the strangely distorted form of Mary Magdalen. Her naked body is arched backwards in a gesture that recalls the bacchanalian figure in the *Three Dancers* but here she bends towards us in a convulsion so violent that the extra inverted head seems to touch the buttocks, with the result that the eyes and nose seen upside down resemble the male organs, while at the same time they become confused with her own genitalia. The other distinctive feature is her arms raised up in supplication.

In the painting Picasso has simplified this impersonation of frenzied grief. It now stands high up on a structure to the right of the cross. The raised arms have been transferred to a tall mysterious figure, a symbol of supplication, next to the ovoid form of the Magdalen on the extreme right of the composition. Between her and Christ is another symbolic figure which has been described as a moon-sun image.[16] It is clear however that the frenzied naked woman of the drawings has given place to a more enduring and less emotional image, but the content of torment and despair has not diminished. Her arms now belong to the tall figure on the right and there is a close similarity between the head of the soldier throwing dice in the foreground and the hysterical inverted head in the drawings.

Although the figure of the Magdalen herself has lost some of its agonising force in the painting by becoming more symbolic, the powerful emotional value of the drawings remains throughout in other forms, making no concessions to religious decorum. Picasso often made it clear that to him religious art is in no way different from art itself but there is a violence in the drawings and the painting which would be termed blasphemy by many and which suggests a profound reaction against the strict Catholic régime of Spain in which he was brought up.

This is even more evident in another female figure the early versions of which are also to be found in the drawings. In that of 10 June 1929 there are round the feet of Christ, which come into view from above, three women closely intertwined.

On the left is the convulsed figure of the Magdalen and to its right two heads are drawn (with long hair or veils) gazing up with eyes full of sorrow. They turn their back on the ghoulish faces of a crowd of spectators. In the painting it is the upper head with its mouth open and veil, prophetic of the women of *Guernica*, that has been elevated to a central point against the breast of Christ. If we suppose, as indeed the drawings suggest, that this figure is the Virgin Mary, a troubling ambiguity follows owing now to the complete lack of tenderness in her face at a time when it is most to be expected. This also contradicts the look of compassion in both faces in the drawing. 324

It is easy to suspect that the head is that of a harpy menacing Christ and to connect it with the monster in the painting of 1929 which is superimposed on the profile of Picasso himself. In this case the major motive behind the painting would be confined to his own private matrimonial quarrels. A solution so limited does not tally with the character of Picasso nor with the richness of associations to be found in the surrounding images which are all emblems of sacrificial rites whether they be Christian or derived from primitive religions. In consequence the central figure is of necessity the Virgin. The teeth that have now become sharp and menacing and the open jaw are an indication of a violent gesture motivated by ungovernable suffering rather than spite. The immediate cause of this ferocity is in fact nearby. The horseman inserted in the composition on a smaller scale is threatening to end the last agony of Christ with his lance and the movement of the Virgin mother is a desperate attempt to protect her son, described in an idiom which is primitive and dramatic. The language invented by Picasso is subtle and deep in its meaning. The descriptions of both women, the Magdalen in her nakedness and the Virgin in her frenzied maternal love are drawn so as to reveal a characterisation which owes its power to signs that are both disturbingly original in form and profoundly appropriate. In its ambiguity the sacred and most reverenced image of woman comes 266

312 *Study for a Crucifixion*, 1929.

312

within an ace of being mistaken for the devil and the Magdalen, the redeemed sinner, is reminded in her agony of the omnipotence of sex. This mixing and fusion of sexual symbols has been noticed even in the Cubist painting *Woman in an Armchair* of 1913 (see pages 161–2) but in this context it acquires greater profundity because it has become a spiritual coitus in the climax of sacrificial death.

As usual with all the major creations, the preoccupation with the theme did not end with the painting of 1930. In 1932 Picasso made several large drawings of the crucifixion inspired by Matthias Grünewald's Isenheim altarpiece.[17] In the earliest there is some relationship to the tortured face of the Virgin in the face of Christ but Picasso's interest soon became more directed to the construction of a bone-like anatomy of aesthetic interest rather than concerned with the drama of the Crucifixion. The drawings are in fact closely associated with sculpture he was working on at the time and with the great bone anatomies such as the *Seated Bather* of 1930.

There are two more direct references to the Crucifixion. One is to be found in a drawing in mixed media of March 1936, and there is another pen drawing of 1938. In the earlier of these the bearded head of a hero lies among weeds in the centre of a romantic landscape with a gnarled tree and a ruin. Above it hangs a crucified phantom. Its arms, stretched wide apart, blue against the sunset colours of the sky, are human but the roughly sketched head is that of a horse. Again there is probably an oblique reference here to the role of the horse as the helpless victim of the bull ring. Below, the figure disappears behind a ragged loincloth, and abandoned against the ruined wall is another emblem, the ladder. There is a curiously inconsistent addition across the centre of the picture; underlining the blue arms is a strip of paper taken from an advertisement for an invention 'Le Crayon Qui Parle', an idea that had fascinated Picasso. In a moment of light-hearted affection Picasso dedicated this fantasy to Paul Eluard, his wife, and Yvonne and Christian Zervos, giving them invented names.

In the pen drawing of 1938 Picasso comes closer to his original conception but with a renewed fury and a grotesque and savage humour. It is an explosion of cynical despair at the irrational cruelty and the devouring passions of mankind

314

315

316

both in love and hate. From his horse the centurion drives his spear into the defenceless belly of Christ while the Magdalen in a paroxysm of despair is at the same time farting and clutching at the genitals of her redeemer, symbolically giving up the ghost and clinging desperately to life, whereas nearby the Virgin severs the umbilical cord of her son with her teeth, an astonishing reference to rebirth in a scene devoid of any vestige of hope and in which the convulsed face of Christ emits like a flame his last reproachful cry of despair.

After a gap of twenty years the drawings of 1959 come as a surprise. They centre round the conception of Christ as the matador, crucified and yet able to free his right hand. In some two dozen sketches made on two consecutive days Picasso explores the implications of this new version.[18] The bull rampant in its fury demolishes horse and rider at the foot of the cross to which Christ with a crown of thorns is nailed by one hand.[19] In a last gesture of compassion, however, with the hand that is free he has snatched his own loincloth and uses it as the matador's cloak to distract the brute from its victims. This hybrid version of the ancient drama underlines the close connection in Picasso's thought between the bull fight with its legendary ritual and the theme of the sacrificed god. To this he has added a partial resurrection of the god in a noble but futile effort to stay the course of uncontrollable violence. The bull here appears to signify the blind strength of evil and the insufficiency of the attempt to halt it implies—surprisingly in Picasso—an underlying state of resignation.

315
316

From his earliest drawings we find that Picasso was always very conscious of, even fascinated by, the mystery and ugliness of death. There are some realistic drawings made during his youth of dying men in hospital, and yet few artists have played more effectively, with greater realism and with greater wit with that emblem of death, the skull, which is inevitably close to the definition of ugliness as 'causing fear, dreadful, terrible'. There are innumerable drawings of skulls and a very moving wartime bronze, the *Flayed Head*, which is rounded like a pebble rolled eternally by the sea. In contrast there is a still life of 1914 in which in a jocular mood he introduced a skull decorated with the curly black hair of his friend Sebastian Junyer y Vidal. A macabre sense of humour can often be found behind

243

317

318

some of the most eloquent appearances of the skull, such as occurs in a large still
life of 1958, brilliant in colour, in which the skull of a bull, dark against the reflec-
tions of the sun in an open window, shows its teeth in a broad grin. Skulls of men
or animals laugh inevitably at their fate or even intrude into Picasso's intimacy
and are to be found enthroned in the chair where Dora Maar often sat. The skull
is the negative version of the monster, provoking pity and sardonic humour as
well as horror.

Finally I must not omit those creatures that Picasso invented deliberately as
monsters. There are lighthearted inventions such as the winged monster in an
engraving of 1934 with the head of a bull, the breasts of a woman and the feet of

188

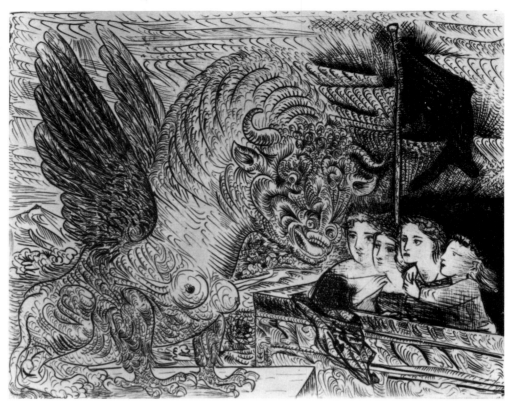

a bird, which is contemplated with wonder by four girls. Another appears in a pen drawing of 1935. It is a grotesque two-legged beast, the face of which undoubtedly had been inspired by the profile of someone seen in a café. It is perhaps surprising that with the vast resources of his imagination he so often finds the origin of these monsters in his immediate surroundings. Few of the major exotic animals, so often used by artists to express terror, find their way into his repertoire. There is more to astonish him in the behaviour of familiar creatures, of cat and bird, bull and horse, owl, cock, fish or monkey than in a lion, a rhinoceros, a shark or a Chinese dragon.

Apollinaire in 1913 had mentioned Picasso's 'hybrid beasts that have the consciousness of the demigods of Egypt'[20]. Predominantly their structure is heavy, inflated or sculptural, belonging to the soil, undoubtedly hybrid and androgynous. They are not the wraiths and will-o'-the-wisps of northern moors and forests, they are born in the clear light of the Mediterranean. Their forbears are the beasts of the Apocalypse and the black magic of Africa. A favourite type of monster occurs in many drawings and paintings of gigantic figures on the beach with accentuated female attributes but with a body that culminates in a powerful phallus. The monster in fact is always the expression of irrational sexual desire.

The monster theme is so profound and omnipresent that for Picasso it was within and around him, rather than sealed off in a realm of mystery and make-believe. It could be found in the awkward aggressivity of a child; elsewhere the senile anxiety of an old man[21] could provide the raw material, just as readily as a praying mantis found in the garden or an octopus caught among the rocks. It is with these elements that he played, separating, uniting, changing relative positions, making things grow bigger or smaller at will, reversing colours, exchanging identities, juggling with inexhaustible ingenuity and with the skill and authority of a powerful magician It was in fact his ability to unmask or transform the identity of everything around him that gave him power over the monster and made it a reality, understandable to us in its true nature. Many of the fantastic monsters invented by Picasso in the thirties are not lacking in humour. There is a drawing of 1935 in which the bull, so often seen as a terrifying brute engaged in ferocious slaughter of the horse or itself dying pierced to the heart by a lance, is found in a jovial mood, gossiping across

320

321

317 *Skull in a Chair*, 1940.

318 *Still Life with Bull's Skull*, 1958.

319 *Four Girls with Chimera*, 1934.

189

the garden fence with a horse. It is a reminder of the absurdity of attributing human habits to an animal. In another drawing of 1938 the monsters become more hideous and sinister although the models from which they were derived were a couple of unsuspecting holiday makers playing by a breakwater on the beach.[22]

There are time-honoured associations between monsters and the terrors of the night and the intrusion into our sleep of the nightmare is common to us all. These were among the phenomena that excited the interest of the Surrealists and a series of dramatic drawings of 1934 based on the terrifying visions of troubled sleep, echo their preoccupations. The female body of the sleeper is so fragmented that it is hardly possible to think of her as a single person but rather as a dualistic being in violent conflict with herself, so violent that the objects in the room are often drawn into the tumult. In the face of the woman, which has the same shape in all the eleven drawings made within a few days of each other, there is a troubling comment on this duality. From the mouth shaped like a vagina but lined with cruel teeth, protrudes a tongue, pointed and cylindrical, as though it were the male organ penetrating the open mouth from within. This hint of androgynous practices in the

320 *First Steps*, 1943.

321 *Horse and Bull*, 1935.

322 *Two Nudes on the Beach*, 1938.

321

322

191

reversal of the direction that the penis should take and the trap formed by the teeth provoke an uneasy doubt as to the normal functions and pleasures of sex.

In contrast to these drawings which belong to the world of the subconscious and which show how Picasso could use stylistic innovations to express that which is intangible, there is an important composition of imaginary monsters in a more romantic vein belonging to the Minotaur period. It is a coloured drawing that was used for the drop curtain painted for the *Quatorze Juillet*, a play by Romain Rolland. The subject is a battle between two heroic couples. On the right a hieratic winged demon with the head of a bird carries towards us in his arms the limp figure of the defeated Minotaur gasping for breath. He is challenged as he goes by a young hero mounted on the shoulders of a bearded man. The man has disguised himself in the skin of a horse and prepares to hurl a stone at the demon. It is the figure of the wounded Minotaur in the foreground that particularly attracts our attention because Picasso has dressed him in the diamond suit of Harlequin. He is doubly the adopted image of Picasso himself, a circumstance which gives a hint at the uncertainty with which he viewed himself and again provided an example of the diversity and ambiguity of the myths in which he involved himself in order to obtain a more authentic sense of reality.

'The sleep of reason produces monsters' is the title inscribed by Goya on one of his paintings. The world of monsters, the pestilence bred by wars, and the stupidity of the times through which he lived was shared more than a hundred years later by Picasso, his compatriot, and their preoccupation with violence and horror periodically outweighed the love and enjoyment of life of which they were both so acutely appreciative. These dark implacable events through which we also live are the breeding ground of the monsters that haunt us, as are the personal torments that are bound to affect all those who fall in love. But it is not only the phantoms of our dreams to which Picasso gave shape, like the white charger that rides over the bodies of women and children in a recent version of the *Rape of*

323

192

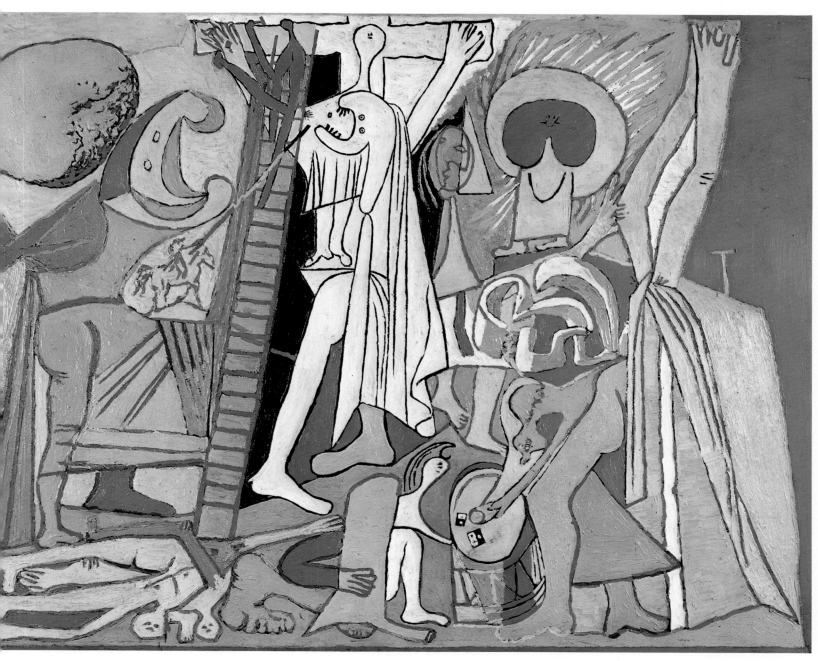

324

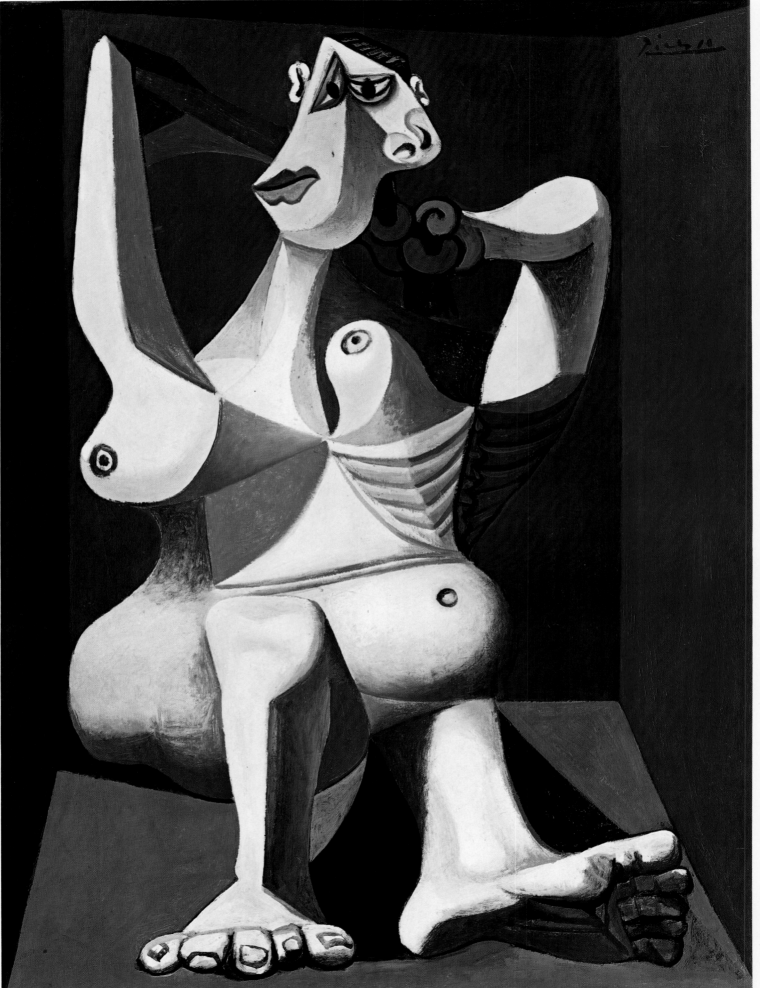

32

the Sabines, that are the deepest and most significant element in the great contribution he has brought to our lives. His recognition and his power to convince us that beauty and monsters live everywhere together, that they are complementary and inseparable, is of even greater importance. For him and for us the conception of absolute beauty is sterile; like Pygmalion we pray for the frigid form to come back to life—a life where, in the simple terms of a saying used by French peasants, there is 'no good without evil, no evil without good'. We learn from Picasso that there is no beauty without ugliness, no ugliness without beauty.

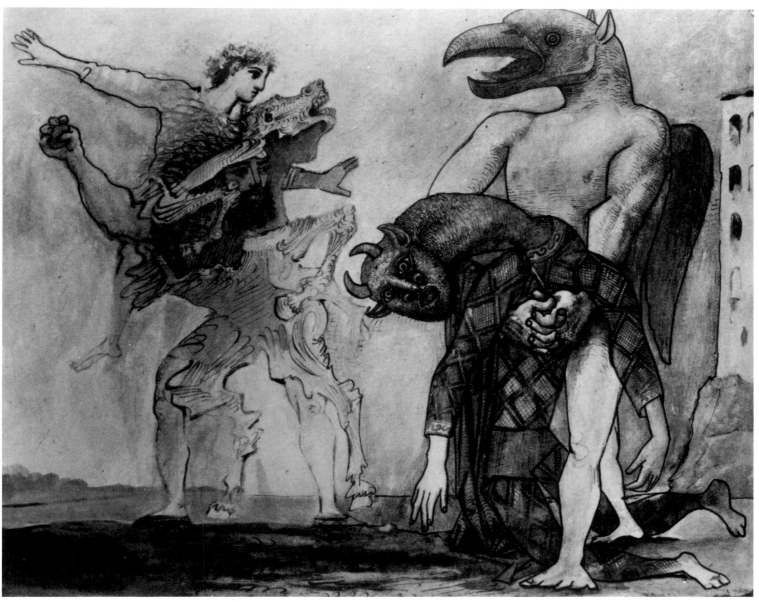

326

325 *Woman Dressing her Hair*, 1940.

326 *Drop Curtain design for the 'Le Quatorze Juillet'*, 1936.

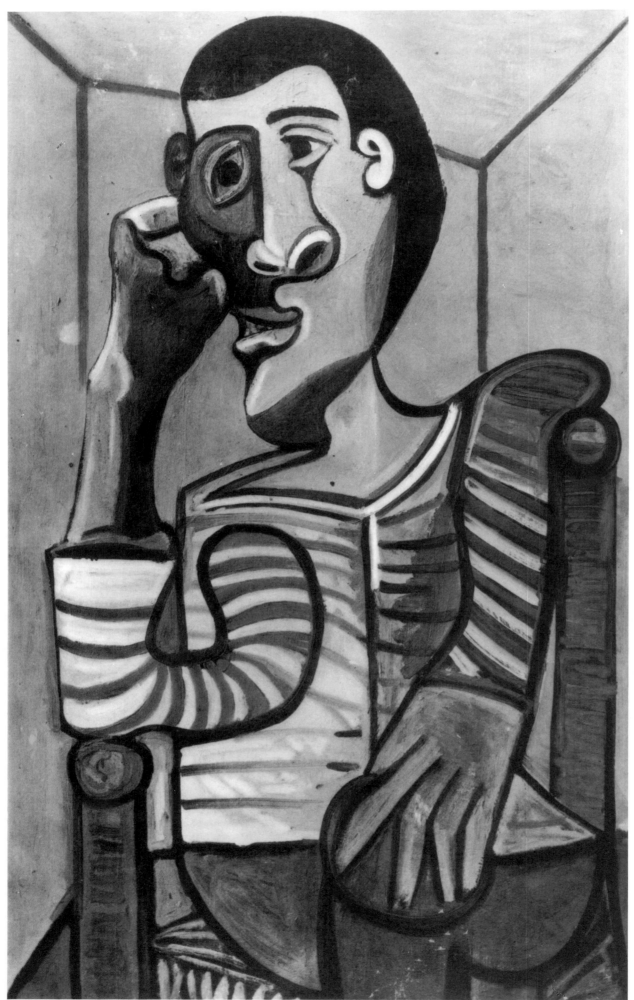

The Last Thirty Years

Jean Sutherland Boggs

'I stand for life against death.' Picasso, Sheffield, November 1950.

In 1946 Picasso was sixty-five, an age when many men retire. And yet he entered into a quarter of a century of heightened productivity in which the annual output of paintings, drawings, prints, pottery and sculpture was staggering. In addition he wrote plays and acted in films.[1] And it did not cease. In the summer of 1970 his production for thirteen months between 5 January 1969 and 1 February 1970 was shown at the Palace of the Popes at Avignon; there were 165 large canvases and forty-five black and white drawings.[2]

As an old man, Picasso could not help but be conscious of death. As a true Spaniard he faced it as a fact.[3] When he was sixty-three he had modelled the brutal, flayed *Death's Head* which was cast in bronze. Within the last thirty years many *memento mori* appeared in his work, sometimes as the skull of a goat, as they did in drawings, paintings and prints of 1951–2. The bull-fight is surely a reminder of death, and Picasso, always fascinated by it, from 1956 recorded it increasingly in several series of free drawings in ink, in lithography and on pottery. His admission of death may not have been self-pitying but it was often anguished. 243

In many ways Picasso's approach to death was Homeric. With Odysseus and Achilles he felt that to be active is to be alive and to be passive is to be dead. As a result, the confinement and boredom of the Occupation had been for Picasso a form of death—a purgatory. In his paintings he used his mistress Dora Maar to express his feelings—sometimes of a genuinely unhappy but dilettante restlessness in fashionable clothes, with a colourful setting and a glimpse of space through a window. At other times her deformations were far more sculptural and physical and the confinement greater within the claustrophobically dark and small room. 325
Later he concentrated upon the effort to sleep and the lack of rest to be achieved in it. He also showed himself the victim of this terrible passivity as the *Sailor* of 28 October 327
1943. When after the Liberation he painted one canvas which recorded the greatest barbarisms of the war—the concentration camps—he consistently emphasized the tortured struggle of bodies within a threatening and colourless space. The *Charnel* 328
House[4] is the largest and most violent image of the horror of the Second World War in Picasso's work.

Picasso did, however, express his conviction that in spite of the indignity of the Occupation man could continue to struggle to live. He found this symbolized in the tomato plant that grew in his Paris apartment and that he painted in a series that seems to have moved servicemen more than any other of his works when they visited Picasso's studio at the time of the Liberation. Another form this affirmation took was in the large painting of a child who with ugly concentration but undoubted will 320
took his *First Steps*.[5]

Having suffered the living death of the Occupation Picasso celebrated its end in a small watercolour in which he interpreted a reproduction of a painting by Poussin which seemed to represent the epitome of rejoicing, freedom and, significantly,

327 *The Sailor*, 1943.

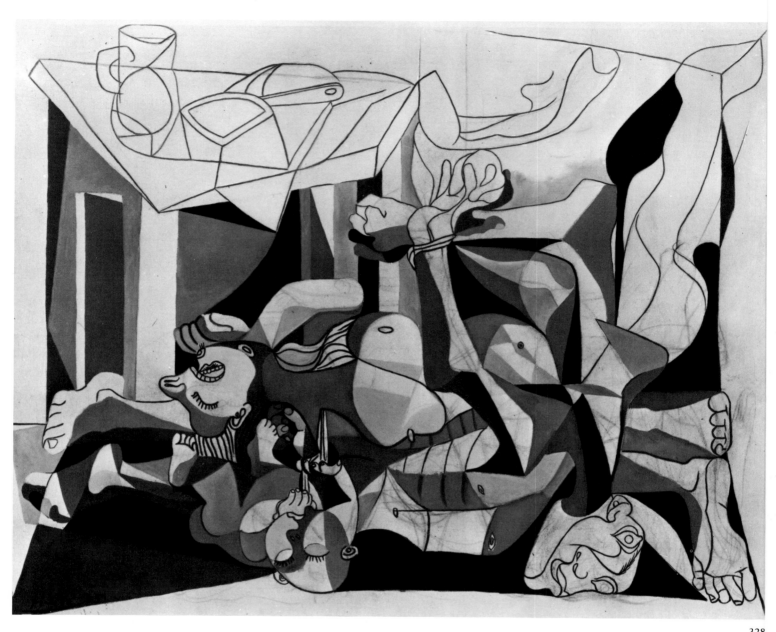

action; the *Bacchanal, Triumph of Pan* could be considered a pagan hymn to life.[6]
Picasso used the ingredients of the Poussin literally, but his men are more leeringly
drunk, the women fuller breasted, and the whole, because of his characteristic
distortions of the human body, more frenetic and tortured as if struggling against
the confinement of the Occupation. It is finally less liberated and less sensual than
the Poussin. But it is significant in showing Picasso's identification of such freedom
with the pagan and classical world.[7] (He painted himself as one of the quieter
figures—a youth solemnly bearing a basket of fruit.)

When he was almost sixty-five, in the summer of 1946, Picasso sought freedom
from the confinement of the city of Paris, with its war-time associations, by going
to the south of France. With him was Françoise Gilot. In February he had already
drawn her juxtaposed with Dora Maar, the mistress he was in the process of
rejecting and, as Leo Steinberg has pointed out,[8] changed her from the sleeping
figure to the seated one, conscious as Dora sleeps. As the drawings and prints

developed, Françoise and Dora were abstracted until Françoise with her long hair and full breasts became a plant.[9]

Picasso painted his first important portrait of Françoise after she had come to live in his Paris apartment on the rue des Grands Augustins in May 1946. As he worked on a fairly conventional pose, he remembered that earlier that spring Matisse had said he would like to paint Françoise with green hair.[10] From that point on the hair developed into a leaf form and from that resolved itself in a symbolic floral pattern. With her body reduced to a blue stalk, her breasts rounded and her hair flowing from her oval face, this *Femme-fleur* seems the essence of 330

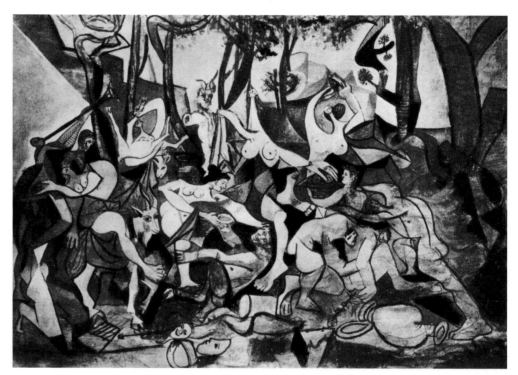

331

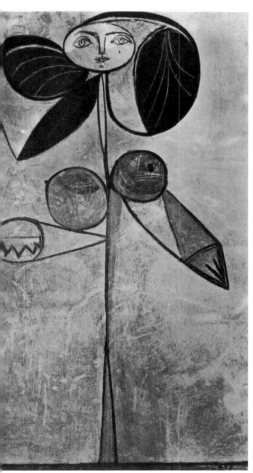

330

329

spring—tender, youthful, breaking into flower. She is also as remote as the goddess of the moon or as sad as Persephone. Françoise tells us that 'The insistent moon-shape of the head was particularly annoying to him. "I've never thought in terms of stellar zones before. Those are not my preferred structures. They're something from another kingdom. But I just don't have any control over it. An artist isn't as free as he sometimes appears."'[11] On another occasion he was concerned about the hands and, when he had achieved the final form, said, 'You see now, a woman holds the whole world—heaven and earth—in her hand.' Françoise added, 'I noticed often at that period that his pictorial decisions were made half for plastic reasons, half for symbolic ones. Or sometimes for plastic reasons that stemmed from symbolic ones, rather hidden, but accessible once you understood his humour.'[12]

Only in the thirties in his paintings of Marie-Thérèse Walter, nude and sleeping, 185
had Picasso imagined a human body becoming a plant or flower—but in those voluptuous paintings a hand or hair may become a leaf but the body remains most human flesh. (Their sexual preoccupation could not be more vividly expressed than by the aerial roots of the philodendron which appears in so many of these paintings.) Françoise did not suggest that kind of passive, hibernating, slowly germinating form of the plant world—but rather a flower, growing on an erect

but very slender stalk. Almost alone of Picasso's loves since Fernande Olivier forty years before she stands proudly in air and light.[13] Even when she becomes a leaf in a drawing or lithograph she is alert.

The stellar zones were there in this symbolic portrait. They may have expressed Picasso's own lack of a sense of a control over Françoise. He was also to lithograph her as the sun. Curiously, sun, moon and stars seldom appear in the many works of Picasso over a long career. As someone with a passing interest in astrology[14] it is possible, judging from his remark to Françoise, that he deliberately wanted to avoid the firmament; it may have been a reminder of his suspicion that man was

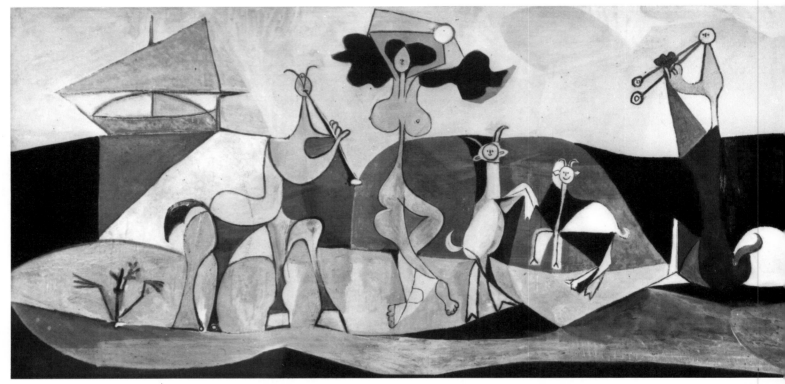

332

not absolutely free.

During that autumn after having moved south Picasso ended up painting joyously pagan pictures in the Musée Grimaldi in Antibes. Its curator, who had given him the key to the sixteenth-century castle so that he could use it as a studio, has written that Picasso told him, 'every time I come to Antibes . . . *this antiquity* seizes hold of me.'[15] In this fortress, with its magnificent views of the Mediterranean, Picasso painted Homeric hymns to life. The key painting at Antibes is the marvellously silly and unpretentious *Joie de Vivre*. Against a Mediterranean seascape far less confining than Poussin's wood, with a sailboat on the horizon at the left, a full-breasted young woman with long, wine-red hair—clearly Françoise—dances with a young centaur and faun while two of their elders play on their pipes. It is wonderfully abandoned. There are other quick linear paintings and crisp pencil drawings of the cheerful centaurs and fauns from this Mediterranean mythology. Picasso easily associated Françoise with the mythical figures with which he peopled Antibes—as young, gentle, graceful, gambolling with a centaur family, or rising out of the sea. At the same time he could identify himself with the uninhibited animal nature of the centaurs. When their first child was born he made a lithograph of the *Birth of the Last Centaur* to illustrate *Dos Conses* by his Catalan poet friend, Ramon Reventós.[16]

200

333

Picasso often painted and drew fauns at Antibes. More completely human than the centaur, a faun could be exceedingly endearing. Picasso used its form affectionately for some of his many portraits of his old friend and secretary, Jaime Sabartés. The horns make that gentle, bespectacled face slightly rakish. In the museum which Sabartés endowed with his own collection of his friend's work, the Picasso Museum in Barcelona, there is a large charcoal drawing which thirteen-year-old Picasso had carefully signed 'P. Ruiz, Coruña, 94.' It is a vigorous and enthusiastic study from a plaster cast of a faun. Picasso had apparently all his life admired the vitality in this fusion between the human and animal worlds that has neither the libidinousness of the centaur nor the brutality of the minotaur. And he was not deaf to the intoxicating music of the pipes of Pan.

Another more constant symbol in his work entered his life at Antibes. When he was painting, an owl was found with an injured claw which Picasso kept as a pet. It seems to have been an unfriendly bird[17] but did inspire a sequence of memorable and frequently appealing drawings, paintings, ceramics and pieces of sculpture. Picasso could have identified the owl with Athena, the goddess of wisdom, but if so, without any illusions. When he and Françoise had spent a little time earlier in the summer of 1946 at Ménerbes they used to walk in the evenings to see large owls swoop down on unwary rabbits and cats.[18] Six years later, in beginning to make drawings in the spring of 1952 for his large allegorical painting of *War,* Picasso first represented war as an owl spreading disease over an innocently dancing world.[19] As he formalized this figure and began to give it a human body it came close to an Egyptian Horus. In the final version the form of the owl disappeared but whatever fierceness the painted god of war possesses it owes to Picasso's understanding of this bird. The artist, who was nothing if not a predator himself, accepted the compliments of those who said he reminded them of an owl and actually cut out one drawing, replacing the eyes with photographs of his own. As his biographer and friend, Sir Roland Penrose, put it: 'Nothing unnatural seemed to have taken place except that the bird now possessed the vision of a man whose eyes could not only see but also understand.'[20]

The summer of 1947 at Antibes Picasso painted one large composition of Odysseus himself, bound to the mast of his boat as it sails away from the islands and the tempting song of the pink Sirens; his face reveals his wonder and his agony—his mouth sewn together like a star. And on the surface of the water are white lines—meandering, irregular—ending in white dots, rather as if they were linking up the firmament and confining his journey; presumably these indicate the predestined voyages of Odysseus. The fish of this sea also appear in some Antibes' still lifes.

The lines on the surface of the painting of Odysseus are hauntingly calligraphic. They do suggest both a voyage and the stars. Picasso almost linked them up in saying to the Musée Grimaldi's curator, Souchère, 'If all the ways I have been along were marked and joined up with a line, it might represent a minotaur.'[21] In designing the face of a faun for both a gouache and a plate[22] at this time, Picasso saw them as spirals or labyrinths, perhaps reminding us of the inevitability of its symbolism, which he had expressed to Françoise by saying that the myth of Theseus killing the minotaur in the labyrinth 'happened every Sunday.'[23] These formations were prefigured in the varied combinations of lines and dots he had made in 1924, which were eventually published with Balzac's *Le Chef-d'œuvre inconnu.*[24]

In human terms it is quite easy to interpret the meaning for Picasso of classical mythology in the works at Antibes as escape, freedom and a certain stylized and innocent hedonism. One thing is certain: he had forgotten the myth of Antaeus; the Minotaur was dead; and love was given freely without the violent physical

341

335

143

333

333
341
335
143

332 *La Joie de Vivre*, 1946.

333 *Sabartés as a faun*, 1946.

assaults of many of his classicistic works of the past. The very ebullience of the figures from Antibes is a result of their apparent weightlessness, their apparent indifference to gravity—quite unlike his solidly-rooted mythical beings from the twenties and thirties. The nearest he had ever come to the blissful paintings and drawings at Antibes had been his decorations in the summer of 1918 for the house of Mme Errazuriz at Biarritz.[25]

Although the details of these mythological works—which also include the ceramics he was moulding and painting at Vallauris—defy detailed iconographic analysis[26] they are part, as one would expect from the painting of Odysseus, of Picasso's fatalism and his almost mystical identification with the past. Françoise tells us he was superstitious,[27] that he behaved as if his destiny was determined by some unknown, unpredictable fate. Again and again through his long life he had been struck by some strong intuition of the past or the future—his own or another's. The day Picasso and Françoise had first made love he made his overtures by showing her the *Vollard Suite* he had etched in the 1930s. In looking at one of the prints he said, 'There you are. That's you. You see it, don't you? You know, I've always been haunted by a certain few faces and yours is one of them.'[28] And in coming to another he exclaimed, 'But of course, that's you again, that model. If I had to do your eyes right now, I'd do them just that way.'[29] It was not only that he had anticipated Françoise in works etched some twenty years before but that they were works in which, as Picasso explained, 'All this takes place on a hilly island in the Mediterranean. Like Crete.' Françoise wrote, 'Everyone was nude or nearly so and they seemed to be playing out a drama from Greek mythology.'[30] Picasso may in 1946 have been willing himself back into such a past with its implications of immortality, but the forms he chose were much more joyous and ecstatic than those of the *Vollard Suite*.

Picasso was not content only to paint hymns to life; the very act of creation became an expression of his own security, his own capacity to live. He painted. He drew. In the museum in Antibes alone he painted twenty-three works and made forty-four drawings in six months. Before he left Paris in the autumn of 1945 he had become interested once again in print-making and, in collaboration with Mourlot, was to make 179 lithographs from 2 November 1945 to 30 May 1949. And in the south of France he discovered the Communist, pottery-making town of Vallauris and moved there, reviving its industry by making or painting some 2000 pieces of ceramics in one year himself. Again the themes were often related to his absorption in Mediterranean mythology and occasionally gave evidence of his interest in the forms of antiquity.

This cheerful productivity, however, perhaps can be interpreted as superficial. Moreover, the paintings at Antibes were on the only wall board available after the war, a wall board not as stable as canvas would have been. On a visit to the museum about 1960 Françoise noticed that 'the blues had darkened and other surface painting had faded,' and that the drawings, which were exposed to the intense southern sunlight, were yellowing and in one case even foxing.[31] Similarly there was a problem with the ceramics because the clay of Vallauris was insufficiently washed and its imperfections would eventually cause it to crack.[32] Whether or not the inventive plates and vessels by Picasso survive, their permanence was clearly not his primary concern.

It is possible that to Picasso at this time the very act of creation as an affirmation of life may have been more important than the profundity or the survival of the work. He told Françoise, 'I have the impression that time is speeding on past me more and more rapidly It's the movement of painting that interests me, the dramatic movement from one effort to the next, even if those efforts are perhaps

334

334 *Vase with a Bacchante*, 1950.

335 *Ulysses and the Sirens*, 1947.

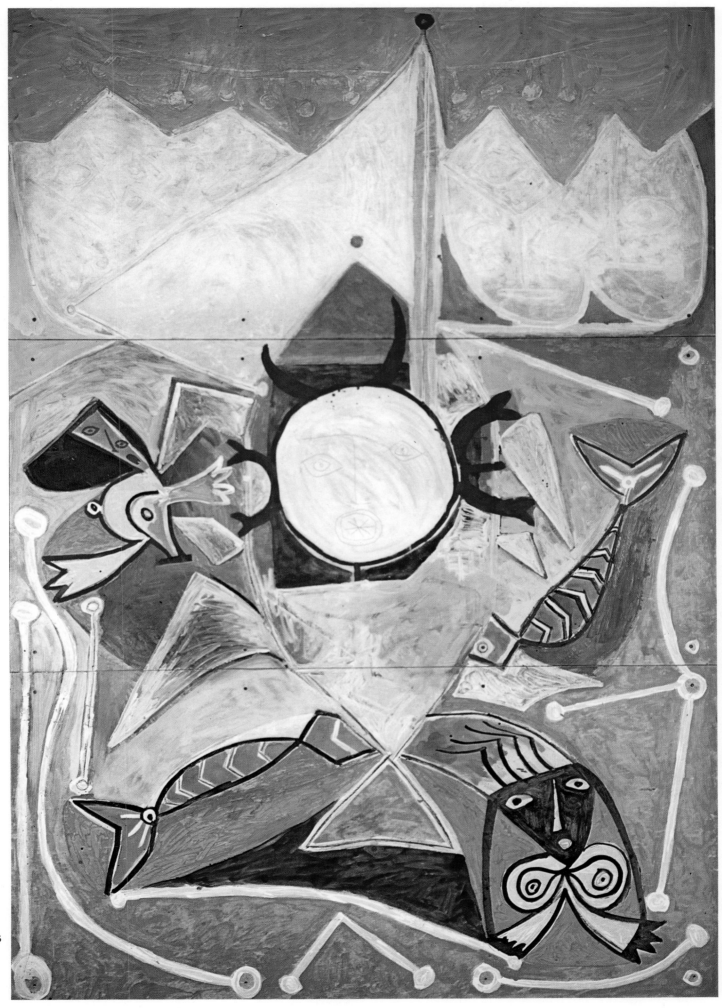

335

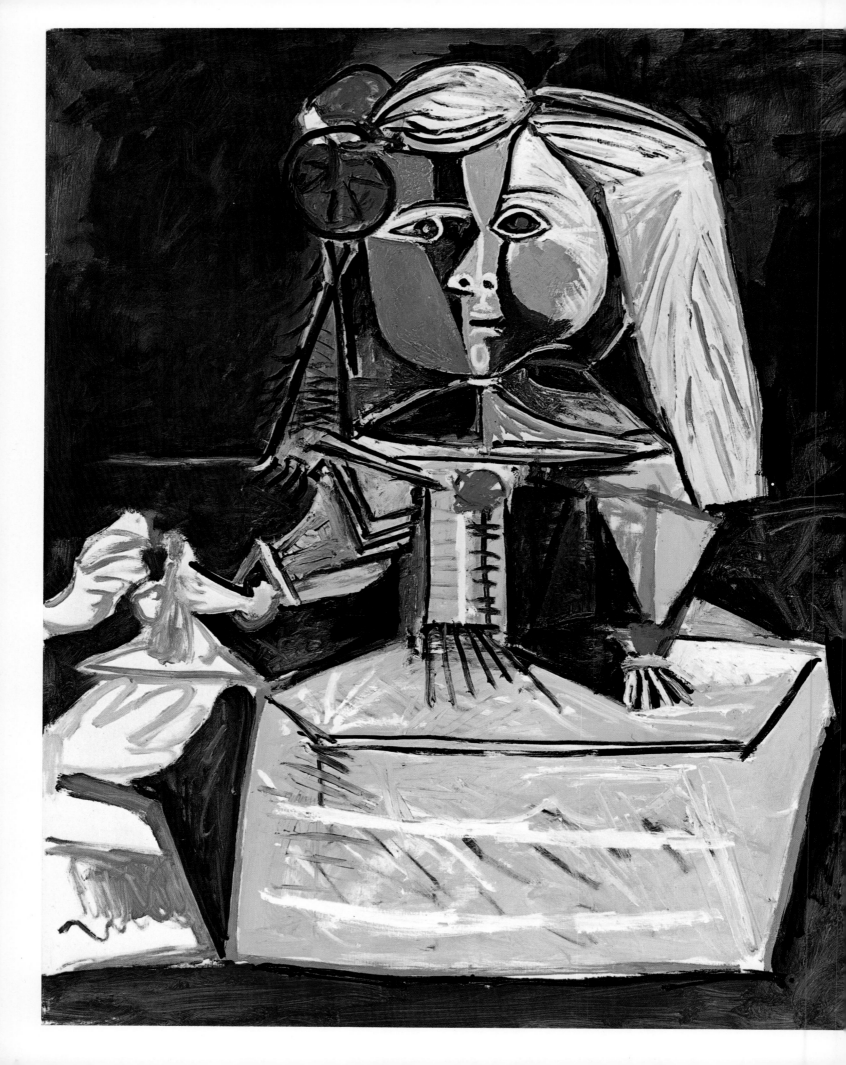

337

338

336 *The Infanta Margarita*, 14 September 1957.

337 *Kneeling Woman*, before 1951.

338 *Woman with Baby Carriage*, 1950.

not pushed to their ultimate end I have less and less time, and yet I have more and more to say.'[33] But over twenty years still remained.

Picasso was an artist of such consummate skill, so at ease with his medium—any medium—that he could clown with it, pinching the neck of a vase in wet clay to make it a dove, while saying, 'You see, to make a dove you must first wring its neck,'[34] or miming for the screen in the film, *Le Mystère Picasso*, made with Georges Clouzot in 1955. Life was full of humorous possibilities—a junk heap to be searched daily for the found objects he could transform, for example, into a woman with a baby carriage.[35] He would describe such actions as metaphors, a matter of fooling the mind rather than the eye.[36] With wit and clowning he savoured living. In this connection Françoise tells of the occasion when Picasso finally met Charles Chaplin in October 1952 and, although they could not speak each other's language, Picasso told of taking Chaplin up to his studio and after showing him some pictures 'giving him a bow and a flourish to let him know it was his turn. He went into the bathroom and gave me the most wonderful pantomime of a man washing and shaving'[37] Chaplin in his turn has written that Picasso, 'could pass for an acrobat or a clown more readily than a painter.'[38]

In this period when he nostalgically remembered himself as a youth in a lithograph of 1945,[39] Picasso must have sought a renewal of life in taking a young mistress who was twenty-five when he was sixty-five, and in having children by Françoise when he was sixty-six and sixty-eight. Certainly he was enchanted with the idea of fertility in the human and animal worlds. Many of his drawings at Antibes show the pleasure of mortals and centaurs in their offspring. He delighted in making a bronze of a pregnant goat from, among other things, a wicker basket, a palm frond, two pottery pitchers underneath the plaster—or on the other hand, a baboon with its young from toy cars and pottery. A little girl skipping in Vallauris inspired him to make a bronze based on found objects in the garbage heap[40] including a chocolate box and two actual shoes for one foot. He painted his own children lovingly while at the same time often showing their ruthless pleasure in their Christmas toys. He even made toys out of the face of the younger, his solemn daughter, Paloma.[41] In such ways the world of his work seemed young.

At the time of the Liberation Picasso officially became a Communist, explaining it as a logical step in his life[42] and done out of admiration for Communist active resistance in both Spain and France. He felt Communism offered the best hope for a happier, freer life. Although more of a painter than a politician he was committed enough, in spite of his dislike of travelling and speeches, to go to the Peace Congresses of 1948 (Poland), 1949 (France), 1950 (England) and 1951 (Rome). Penrose tells of Picasso at the conference in Sheffield in England being asked to speak and saying a few words in French, explaining how he had learned to paint doves from his father and ending: 'I stand for life against death; I stand for peace against war.'[43] The story of the doves was important because one of Picasso's doves, a lithograph of 1949, had become the symbol of the Peace Congresses and even of world Communism. Their numbers multiplied as Picasso drew other doves for other congresses.

Out of his political commitments grew three large paintings of 1951 and 1952. One was the *Massacre in Korea* in which robot-like soldiers line up, like the firing squads in Goya's *May 3, 1808* or Manet's *Execution of Maximilian*, to shoot poignantly innocent mothers and children. The work has never been considered a complete success. Indeed Hélène Parmelin in her book *Picasso Plain* tells of the time she and her husband, the painter Pignon, both Communists like Picasso, were going through some canvases in his studio the summer after he had first exhibited it.

338

256

255

339

340

We all three sat down in front of it, as we often did. And Picasso said that the history of this canvas was really quite incredible; and that he had never altogether understood it. Even if no one liked it, it still had something, had it not? Well then? . . . He said he would like to know the reasons why *Massacre en Corée* had been more or less boycotted.

There was of course no point in explaining to him what he already knew, or at least suspected.

It was evening. And I remember that the canvas suddenly looked its best, as sometimes happens. It was vigorous, grand and terrible. We had never before seen it as it was now, as little by little it was to become for many people who had shaken their heads at it . . .

Picasso looked pensively at his canvas.

'What a trade! Poor painters! They always wish to be understood, and they are analysed instead. They give the best of themselves in profusion and with the purest conviction—I am talking of the real creators—and their gift is weighed on the scales of politics and implications. They fight against war, and in painting; and war is declared on them. They paint the man with the machine gun, the massacring robot, the man with the repeating rifle, the man with the gun; and people tell them they cannot distinguish the uniform. They paint the massacre of the innocents; and they are told the innocents ought to look prettier than that.'[44]

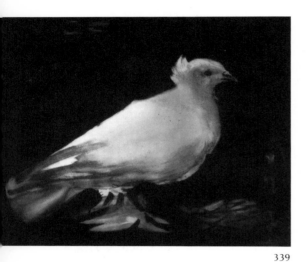

339

Picasso seems to have been more at ease the next year in painting two large allegorical works for the barrel-vaulted 'Temple of Peace,' a deconsecrated chapel in Vallauris.[45] For *War* he returned to antiquity. A nude Perseus stands at the left, with a dove firmly engraved over Medusa's opalescent head on his shield, lifting a staff which supports the scales of Justice. A vertical burst of light blue seems to protect him from the vision of the nightmare of war. The horned god of war, who in the original studies was an owl, wears translucent black wings ornamented with ominous skulls. He holds in his right hand a glowing red and white sword—a symbol of war since the bronze age—and in his left a shield from which flies a modern weapon—the insects or germs of biological warfare. His horses and the black shadows of the soldiers in the background threaten both learning (symbolized by the book) and fertility (symbolized by the corn). Imploring hands reach up between the horses and chariot. All this occurs against a largely abstracted space with a warning black cloud and fiery red ground. With the curvature of the painting over the barrel vault the shadows of the heads and weapons of the soldiers are more threatening and the head of Perseus more reassuring than they seem in reproduction.

Peace represents a topsy-turvy world in which nothing is quite as it seems. But it is not as liberated or irresponsible in form, in colour or in action as the *Joie de Vivre*. At the right there are three serious crouching figures—a woman nursing her infant, a man drawing, and another earnestly placing a vessel on some stones which must conceal a fire. Above, a glowing orange tree and a grapevine offer consolation. The group on the blue ground, which Hélène Parmelin saw as the sea,[46] are more irresponsible, although a young boy ploughs with a tame Pegasus. A faun sits on a shell and plays his pipes and a woman dances (or swims). The other woman puts her arm across her head in some desperation as she performs the incredible juggling act of the painting. On the finger of her right hand she supports a rod, on which a single full hour-glass balances a small boy who, with an owl on his head, juggles a glass bowl of birds against a cage of fish suspended by a string. Another, larger boy—apparently floating—supports the cage of fish. As the violently-coloured sun bursts into leaf, this cannot but seem an unpredictable

341

342

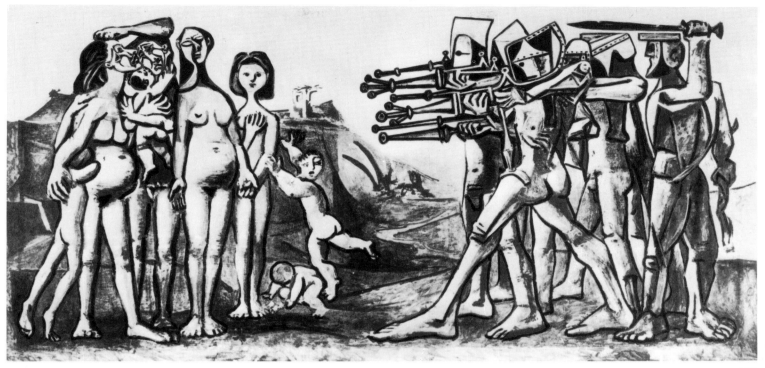

340

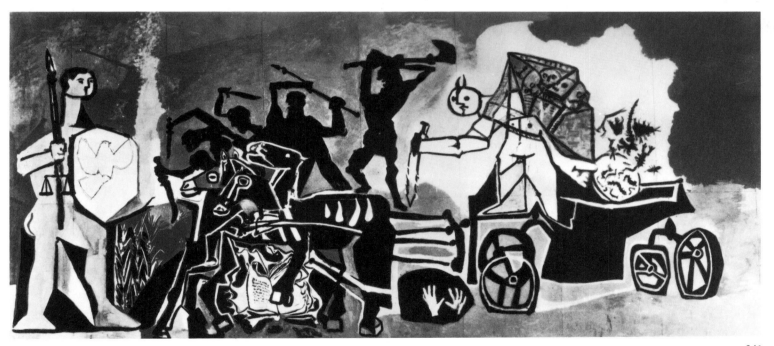

341

339 *Dove*, 1949.

340 *Massacre in Korea*, 1951.

341 *War*, 1952.

and clown-like vision of peace. John Berger, who in his *Success and Failure of Picasso* is by no means uncritical of Picasso's late works, says of *Peace*, 'the poetry of this painting is simple, fantastic, legendary, and, as it were, proverbial. It belongs to the tradition of folk stories and nursery rhymes It is a painting which, to make us imagine peace and happiness, encourages us to believe in innocence rather than experience.'[47] This was another way in which Picasso denied the effects of age.

207

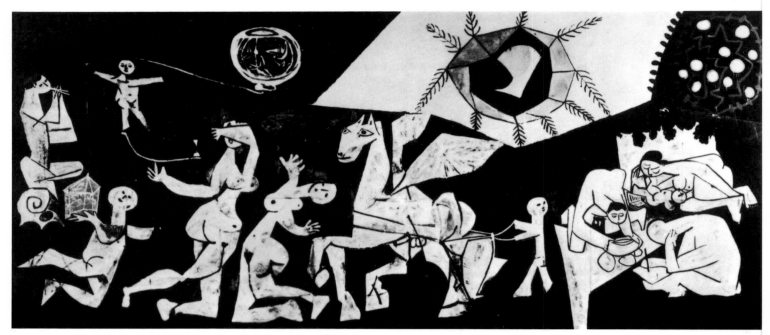

The fact that in *Peace* an hour-glass balances the small boy, the owl, the fish from the sea and the birds from the air is important. In working upon these paintings Picasso was conscious of the passing of time. When the panels were finished and shown to some friends in October 1952, Penrose tells us, 'On a table by the door stood an alarm clock and a calendar on which the date of his beginning was marked and two months mapped out in advance. To the astonishment of all . . . he had kept his programme to a day.'[48] He expressed his concern about time more poignantly to Kahnweiler: 'I am still fit enough to do anything I want, so I must finish the work for this chapel while I am still active, because to be wanting to work and not able would be a terrible thing.'[49] This must have been just before his seventy-first birthday.

Although Parmelin says expressively that Picasso 'cut the umbilical cord of *La Guerre et la Paix* at the very moment the first stranger eye lit on it,'[50] actually the theme and the composition did continue to haunt him. The two large paintings were finished in October 1952, were shown at the retrospective exhibition of his work in Milan that autumn and installed in the chapel at Vallauris in February 1954. It was on 4 December 1953 that *War* seems to have bothered him first. He made a new compositional study of greater immediacy and consistency than the painting. Perseus is now more active; the image of the head of Medusa under the dove on his shield has disappeared; and he is backed up by a pattern of lances that suggest Velázquez's *Surrender of Breda*. The opposing warriors are fiercer and their methods and weapons more varied. The pair of hands do not seem an isolated symbol but rise beseechingly from the earth between the wheels of the chariot. And finally a more vigorous war-like Mars seems based upon the griffins of Assyrian art rather than the owl or the Egyptian god Horus. In other drawings in a notebook Picasso began to play with the idea of Perseus triumphing over this griffin-like Mars, perhaps intending to work toward a composition for the end of the chapel at Vallauris. The dove on Perseus's shield, a symbol of much importance to Picasso, seemed to consume the hero and in one version, very much like the symbol for the Holy Ghost, fells a human warrior, not too unlike Picasso's images of himself. In the final version there is only the warrior protecting his eyes from an abstracted vision of peace.[51]

342 *Peace*, 1952.

Having eliminated *War* Picasso turned to *Peace*. He made drawings[52] of female nudes blissfully dancing in a ring, and, when he went on to at least three compositional studies of *Peace* on 16 December 1953, he incorporated them into one of his joyously abandoned drawings. There is a consistency now in the élan of the improbable juggling, the dancing and even the ploughing of a Pegasus who rears happily into the air. The three figures at the right, still serious, nevertheless seem to occupy the same universe in which the other more extroverted figures rejoice. Although different reasons are given for the delay of the opening of the Temple of Peace at Vallauris—the artist's disillusionment at its reception, or politics when it

345

343

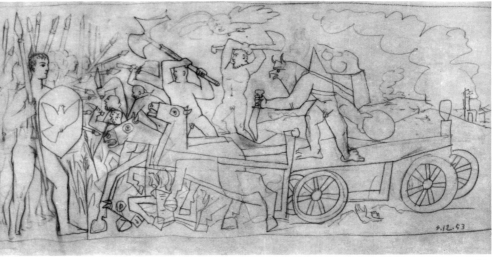

344

345

was exhibited at Milan—it is possible that having had further, more optimistic visions of both *War* and *Peace*, Picasso hesitated to exhibit the large paintings.

During these years of almost frenetic creativity—of keeping active in a Homeric way to keep alive—there was another factor in Picasso's life and that was his relationship with Françoise Gilot. Françoise has documented it with surprising frankness in her book *Life with Picasso*. But Picasso had been equally frank in describing the changes in their relationship through his art. Françoise probably quotes him correctly, saying, 'I paint the way some people write their autobiography.'[53] After his intoxication with Françoise and Antibes Picasso could at times be tender in recording her gracefulness—her neck long, her breasts and hips full—as he did in a bronze vase, or her gentleness as we find it in the pottery figure of her kneeling. But his attitude toward her changed as he found her only too mortal, particularly with the birth of the children he himself very much wanted. When he painted her with their baby son Claude he suggested her melancholy, but it was an approachable human melancholy, not that of a goddess. When she was pregnant the winter of 1948–49 he attacked her body savagely with lines,[54] distorting it so that the allusions now seemed to be animal rather than floral. In 1950 he made a sculpture of a pregnant woman as the visible form of his desire for a third child by Françoise.[55] That autumn he made a lithograph of her weeping. He also told her, 'You were a Venus when I met you. Now you're a Christ—and a Romanesque Christ, at that, with all the ribs sticking out to be counted. I hope you realize you don't interest me like that.'[56] His feelings fluctuated. He could, while illustrating *Ivanhoe* in 1951, the same year that he painted the *Massacre in Korea*, imagine Françoise leaning out of a fortified castle while her knight in armour deserts her.[57] In the year she finally left him, 1953, he painted

337

253

343 *Dove and Warrior*, 1953.

344 *War*, 1953.

345 *Peace*, 1953.

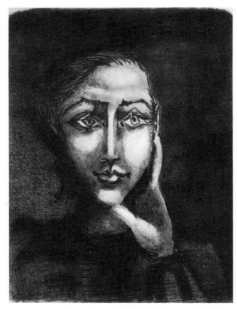

346

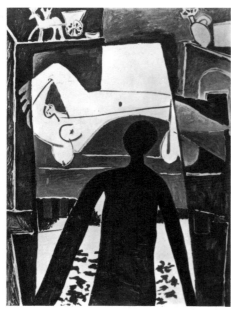

347

her in the most colourful savagery as a woman attacking a dog[58] and a little later as a tragic and dignified nude.[59] The ferocity of the image of Françoise with the dog could have been anticipated from some of Picasso's other works from this largely idyllic time. There is the fierceness of the *Cock and Knife* with the dead bird beside a bowl of blood, or the cat stalking a bird, or the cock looking at an empty, spiky cage.[60] Although suppressed, the violence of the years of *Guernica* can occasionally be found in the time in which he was working at Antibes and Vallauris. His paintings of Vallauris itself are often tortured—even if a night landscape[61] seems a dazzling echo of El Greco's *View of Toledo*.

The December after Françoise left Picasso he seems to have been reflective—perhaps in anticipation of the visit of their children for the Christmas holidays. It was at this time that he made new drawings of *War* and *Peace*. It was on 15 and 16 December that he took up the subject of the cat's killing and torturing a bird. And with great poignancy at the last of the month he made two paintings; he explained one to David Douglas Duncan: 'It was our bedroom. See my shadow? I'd just turned from the window—*now* do you see my shadow and the sunlight falling onto the bed and across the floor? See the toy cart on the dresser, and the little vase over the fireplace? They're from Sicily and still around the house.'[62] The nude figure seems to have been Françoise, and this painting a nostalgic memory of her former presence in the house.

Although Picasso found some distraction from Françoise's threatened and actual desertion in painting pretty young Sylvette David and very soon consolation with Jacqueline Roque, Françoise's departure in September 1953 did make him conscious of the process of ageing. Almost a year before Picasso had spoken to Françoise about Chaplin: 'The real tragedy lies in the fact that Chaplin can no longer assume the physical appearance of the clown because he's no longer slender, no longer young, and no longer has the face and expression of his "little man" but that of a man who's grown old Time has conquered him and turned him into another person.'[63] And so Picasso who was so sensitive to the passing of time that he introduced an hour-glass into his allegory of *Peace*, over the winter of 1953–54, examined the problem humorously and poignantly in a series of drawings that have been called the *Human Comedy*.[64] He contrasted old men and young women, real human beings and the masks they wear. It was as if he saw himself as a little, pot-bellied, wizened old man, continually seeking a girl as young and graceful as Françoise. There are moments of marvellous irony as when three tiny cupids, wearing grimacing elderly masks, attack a seated female nude as if they were dive-bombing wasps. There can be strong elements of melancholy when a small, obese painter gazes smilingly at a young model while ignoring the elderly body of the other model, his contemporary, who is also nude. It is nostalgic to find a young Harlequin, of the kind Picasso had painted some thirty years before, bowing diffidently behind the mask of the older painter. Picasso was sure as a draughtsman, ironic, but poignant as well.

The rueful drawings of the *Human Comedy* represented a break in Picasso's life and work. A new period began which was characterized by his mistress—and after March 1958 his wife—Jacqueline Roque. Jacqueline is indisputably beautiful, and in her beauty reminded Picasso of figures created by other artists throughout history. She seems to have provided a stability in Picasso's life; certainly he lived longer with her than with any other woman. From the flattering comments of the coterie around Picasso it is difficult to be certain of her character; but from the photographs taken by Duncan[65] it would seem to possess a certain gravity.

While painting Sylvette David in the spring of 1954 and transforming the pretty blonde with each version into a seated Egyptian, Picasso abruptly turned her into

346 *Françoise on a grey background*, 1950.

347 *The Artist's Bedroom*, 1953.

34

34

34

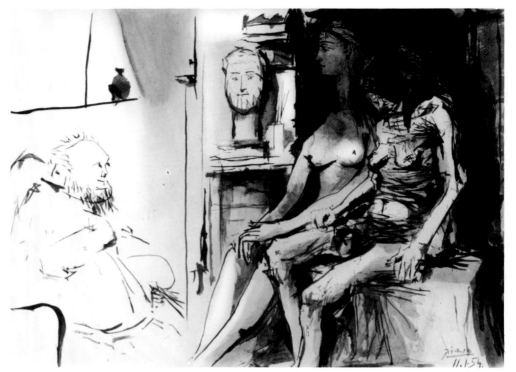

348

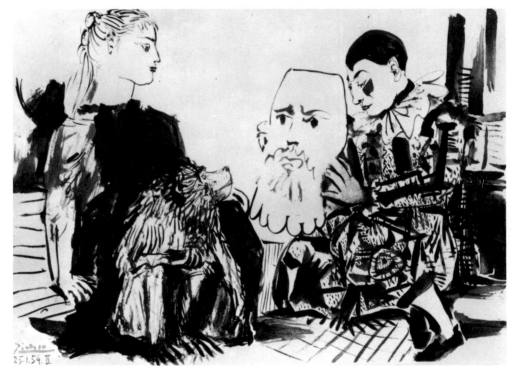

349

348 *Painter and Two Models*, 1954.

349 *Girl, Clown, Mask and Monkey*, 1954.

Jacqueline. That same day, he painted his most decorative portrait of his future wife—and undoubtedly the most famous—*Jacqueline with Roses*[66] in which she is a modern Nefertiti. Again and again he made drawings and paintings of the beautiful planes of her head with the smooth hair and dark eyes, exquisitely placed on a long and slender neck. The strength of those planes inspired him to record it in three dimensions; he used plywood, cut it into highly arbitrary forms and, around a piece of pipe which suggests her neck, produced several silhouettes of Jacqueline, which he made more explicit with paint.

Jacqueline reminded Picasso of women other than Nefertiti. In 1955 he drew her

350

351

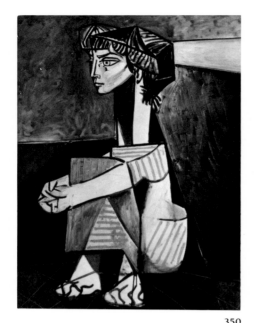

350

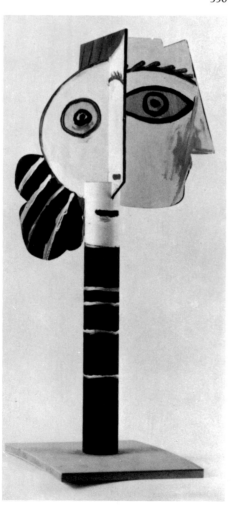

351

charmingly as Manet's *Lola de Valence*. Hélène Parmelin tells us of the episode which
led up to the drawing which involved her husband, as well as the Picassos.

> One summer's day at La Californie, Picasso announced a great piece of news:
> *Lola de Valence* had arrived in Nice . . . We could talk of nothing else but of the
> beautiful and magnificent *Lola de Valence*. Picasso and Pignon were in the
> studio. Manet was clearly the only painter in the world, and they discussed
> all his canvases. They talked about him for an hour. They turned the pages of
> a book in which there were reproductions of Manets, talking delightedly all the
> time. Only Cézanne and Van Gogh emerged triumphant from the arena. All the
> rest were tripe . . . We went off, all four of us, as delighted as if we were going
> to see the queen on Republic Day in Paris. We lauded the beauty of *Lola de
> Valence* all the twenty-five kilometres that separated Cannes from Nice, where
> she was. We found the Museum, full of Napoleonic relics and very pretty. We
> hurried up the steps. It would be splendid, Picasso said, if we saw her come to
> the top of the steps to receive us, as at a ball, with her mantilla and her fan,
> like an ambassador's wife . . . And with Manet on her arm.[67]

Jacqueline in her beauty suggested other paintings to Picasso—even of the *Femme
de Marjorque* he himself had painted half a century before.[68] He drew her riding
on a horse like a Velazquez, peering through veils like a Goya and with a white
ruff like a Holbein.[69]

Since Jacqueline is so ornamental it is not surprising that Picasso's work became
more unaffectedly decorative. It is particularly apparent in the series inspired by
two houses—La Californie at Cannes where they lived from 1955 and the chateau
at Vauvernargues (near Aix) into which they moved in 1958. With Françoise
Picasso had lived unpretentiously, even humbly, in a small and relatively primitive
house in sombre Vallauris. In moving to La Californie (which had a magnificent
view of the Gulf) he protested that this was not for its size or walled garden
and in spite of its Art Nouveau ornament. 'It's a horrible house,' he would say
affectionately, 'but it pleases me. And, after all, it's not really as horrible as all
that. Besides, I like it.'[70] And he must have particularly liked it when they moved
there, because in 1955 and 1956, and indeed even in 1957 and 1958, he painted
decorative paintings of its rooms, making the most of its elaborate windows and
other ornament, the pattern of bent-wood chairs against the white walls, the
inevitable piles of canvases and pieces of sculpture (in any room) and the glimpses
of palm trees and other foliage in his garden. And in many of these Studios[71] sits
the handsome figure of Jacqueline. When they bought the remote and romantic
château at Vauvernargues (since an apartment house had cut off their view from
La Californie) Picasso once more painted and drew this new house—seeing it as a
theatrical set or as a morbid and rich background which consumed human activity.[72]
In these works of 1959, handsome as they are, one does not find Jacqueline. But
Jacqueline herself was painted romantically; and on one of those canvases, Picasso
lettered 'Jacqueline de Vauvernargues.'[73] In 1973 she arranged to have Picasso
buried in the garden there.

A gravity we assume to be natural to Jacqueline permeates this period. This
gravitas was not, of course, as instinctive with Picasso. Although we could imagine
the pictorial Jacqueline, at least, ruling over Vauvernargues, the real Picasso
could only clown as 'King of La Californie.'[74] There is consequently a startling
contrast between the dignified pretensions of both houses, La Californie and
Vauvernargues, and the gypsy-like lives led in them.[75] Picasso, who only as re-
cently as the winter of 1953–54 had reminded himself of the differences between

352

the actual human being and the mask he wears in his drawings of the *Human Comedy,* was highly attuned to absurd contrasts between pretensions of dignity and reality. Although he could find both combined in Jacqueline he could be amused when they did not correspond; this may have been one of the reasons later for the inexhaustible attractions of Manet's improbable *Déjeuner sur l'Herbe.* In any case he was very conscious of human dignity—and manners—within this period.

It would be possible to make a pun and point out that another form of *gravitas,* a sense of mass and weight and the pull of gravity, is also found in these works. For example, in drawing a *Bacchanal* in 1955, Picasso made his figures heavier and 353 more rooted to the earth than in the 1946 *Joie de Vivre.* And their experiences and natures seem to be based on a lusty reality rather than upon an earlier fantasy. It may have been because he was satisfied with the reality of Jacqueline that Picasso's imagination rarely moved, as it had here, to classical mythology and, when it did, interpreted it in such earthy terms. Revealingly, his nudes are always mortal, if at times grotesque. One of the most pedestrian (and magnificent) is of a tragic Jacqueline seated with her shoes tossed on the floor, a carafe and glass on a cupboard (or refrigerator) beside her; the briefest of comparisons with his 1953 nude of Françoise makes it clear how far Picasso had withdrawn from a heroic conception of the universe.

It should be pointed out that there is one strange sequence in the work of Picasso after the appearance of Jacqueline which could seem a contradiction of the rest. These are the steps from the improvisations in the 1955 film, *Le mystère Picasso,* particularly in the painting of the beach at La Garoupe, to the 1956 group of sculptures known as *The Bathers,* to the 1958 Unesco Mural. From the film and the conscious naïveté of *The Bathers,* which are of bronze cast over roughly-carpentered 262 pieces of wood, one might assume that the work was something of a lark. On the other hand it is quite clear from many detailed studies[76] that Picasso took the sculpture very seriously and, from one drawing[77] of the circular-faced figure struggling to avoid drowning, that he saw the work as a grave commentary on

350 *Portrait of Jacqueline with her hands folded,* 1954.

351 *Head of a Woman (Jacqueline),* 1954.

352 *Jacqueline as Lola de Valence,* 1955.

353 *Bacchanal,* 1955.

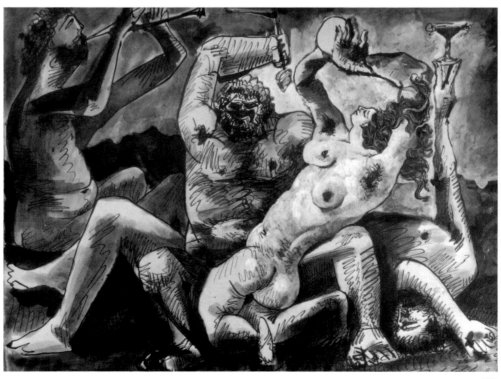

353

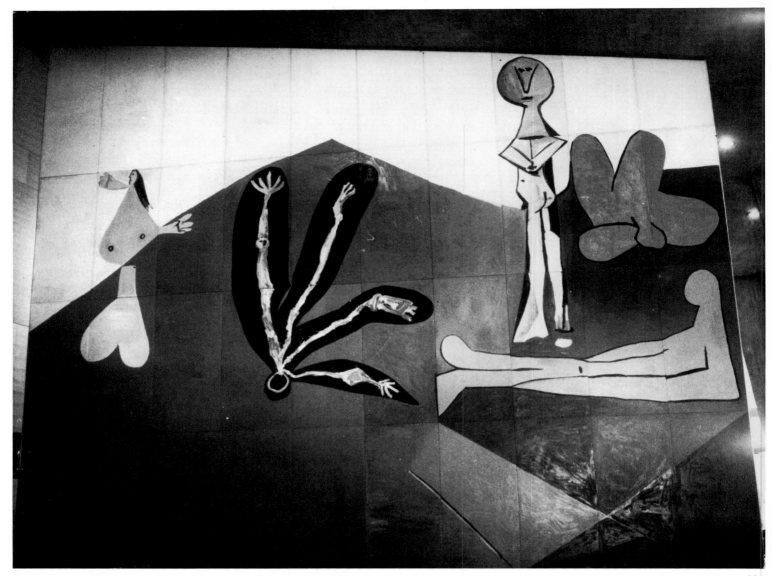

survival. The Unesco mural is even more pessimistic. On the right a primitive, helpless figure stands on the land—simple, pathetic, uninspired. Beneath him lounges a more relaxed male nude who seems ready at least to absorb the sun and air. Another amorphous shape seems to struggle to life. The white spot beneath the foot of the standing figure may represent an egg, an even more rudimentary stage of evolution. At the left a heart seems to pull a figure like Jacqueline into the sea. And a dessicated Icarus, already a smoky white skeleton, is falling into the water, a victim of *hubris* and imagination. It is a cynical and pessimistic mural to have painted for an organization with the hopes of UNESCO in the 1950s.

Picasso could be an exhibitionist about his skills. He would, for example, make many penetrating variations in pencil drawings of the head of Helena Rubinstein until he could still make her identifiable without drawing the features of her face. On the other hand it was said, 'Picasso is convinced that if he ever finished a portrait of Madame [Rubinstein] he will die before her.'[78] He could make brush and ink drawings like an oriental artist[79] and in one of them replace an insect on the stalk of a plant by a seemingly correct and inevitable bull. Duncan has photographed Picasso etching thirty-five prints of the bullfight he had painted from memory in three hours one afternoon.[80] The film by Clouzot gave him a magnificent opportunity to demonstrate his facility, ingenuity and capacity to improvise before the camera. But another possibility existed—one which grew out of his enthusiasm for earlier art. (If in fact there were any mythological figures

354 *UNESCO Mural*, 1957.

355 *Les Demoiselles des Bords de la Seine (after Courbet)*, 1950.

214

peopling his imagination at this time, they were artists and their subjects—like Manet and Lola de Valence who should have greeted him at the top of the staircase in the museum of Nice). He wanted to pit himself against the masters—to accept the challenges their works presented. In three series after a single canvas by three painters he characterized this period of his work. The three were the *Femmes d'Alger* by Delacroix, *Las Meninas* by Velazquez and *Déjeuner sur l'Herbe* by Manet.

Picasso had, of course, painted interpretations of other artist's work before. There was the version of Poussin's *Bacchanal* from the time of the Liberation of Paris in 1944. And in 1950 he had made two remarkably handsome translations— one after a portrait by El Greco of his son, the other after the *Demoiselles de la Seine* by Courbet. His El Greco could be interpreted as a bold visual analysis of the stresses and tensions the earlier painter had indicated more subtly. It is parti- cularly sensitive in its evocation of El Greco's painting of his son's hand. In the 423 palette of blacks, browns, ochre and white none of the drama of the original is lost; Picasso indeed said he wanted it to seem painted by the light of the moon.[81] His Courbet could be regarded as an even more brilliantly analytical tour de force, 355 more interesting in some ways because he was dealing with a painting which has traditionally been considered ambiguous. Picasso compressed the landscape so that, although his large canvas is as wide as the Courbet, it is not nearly as high— but in his painting of lush green foliage, liquid yellow water and brown leaves he seems to capture the feeling of Courbet's painting of a bank of the Seine. His figures share the restless inertia of the nineteenth-century painter's *Demoiselles*.

In 1954 his attraction to another work of art was far more compulsive and resulted in his making more than twenty variations on it between 13 December 1954 and 14 February 1955. Apparently he had always admired the *Femmes d'Alger* by Delacroix. Françoise tells us that, when he gave a group of his works to the Louvre and was permitted to see them next to the masters he most admired, among them was Delacroix. She wrote, 'He had often spoken to me of making his own version of *The Women of Algiers* and had taken me to the Louvre on an average of once a month to study it.' She also reports that when they had left, 'I asked him how he felt about the Delacroix. His eyes narrowed and he said, "That bastard. He's really good."'[82] Even before knowing Françoise, in January 1940 at Royan, he had made drawings in a notebook from the painting.[83] Another indication of his respect was in a literal drawing he made after a *Self-portrait* by Delacroix[84] in the summer before he made his variations on the *Femmes d'Alger*.

Picasso had another motive in analysing this work. Jacqueline, even to our un-

<div style="text-align:right">355</div>

prejudiced eyes, is uncannily like the young woman crouched to the right of Delacroix's painting. Once more a face which had haunted him had come to life. It is tempting to think that the resemblance drew him back to Paris with Jacqueline that winter to be near the Delacroix in the Louvre while he painted the variations on it. We are told, however, that 'Picasso . . . would in no circumstances look even at a reproduction of Delacroix's *Les Femmes d'Alger,* and carried them everywhere in his head.'[85] Since he seems to have combined the Louvre version with one in Montpellier this could be true.

Hélène Parmelin tells us that at this time the *Femmes d'Alger* were 'the absolute mistresses of the household.'[86] One motive for Picasso's absorption in them was the presence of Jacqueline in the painting. But another had undoubtedly been the fame of the work and the fame of the artist. That Picasso did not forget the artist is apparent from his drawing from Delacroix's self-portrait. Hélène Parmelin records that Picasso would say, 'I have a feeling that Delacroix, Giotto, Tintoretto, El Greco, and the rest, as well as all the modern painters, the good and the bad, the abstract and the non-abstract, are all standing behind me watching me at work' He said he spent his time wondering what Delacroix would say if he came in.[87] I suspect it had another appeal as a work fundamentally unlike Picasso's own. Here was an artist who depended upon subtle atmospheric handling of light and colour, even upon the translucency of his paint. By contrast Picasso's light is even and his paint opaque. Here was an artist too who conveyed sensuality through passivity and tranquility. Picasso's own sensuality was restless and active. And here was a work whose meaning was evasive and diffuse whereas Picasso has always been a forthright painter who hammered his meaning home. In short here was a great painting, a famous painting and one which, as the reverse of Picasso's own work, was a challenge to animate.

Picasso worked at it through at least fifteen paintings, three drawings and three etchings; he even produced two postscripts in drawings that March. All were exceedingly free variations on the Delacroix; in none of them did he come as close to the original as he had with El Greco's portrait or Courbet's *Demoiselles de la Seine.* From the first he interpreted the North African architecture by a keyhole arch that disappeared by merging into the headdress of the frontally seated figure at the left but appeared again as a reflection in the distance in the final version. His room was always handled decoratively and in the last canvas had become, instead of the shadowed unknown vastness of the Delacroix, a gayly striped tent-like structure. He changed his figures at will. The only one who seems constant is the maidservant in the background whose buttocks in action continued to attract him. From the first he moved Jacqueline with her hookah to the left; she becomes more formal in version after version until he made a grisaille painting of her alone which is particularly angular and abstracted. At the beginning there had been a sensuality in the softness of the contours of all the figures and in the whiteness of their flesh. It would have been typical of Picasso if the figure at the right had been Françoise. After two paintings in which she sleeps gently, there is a drawing in which Jacqueline at the left seems to disappear into a Surrealist abstraction dominated by the arch—but her highly recognizable profile is drawn at the right as if in reproach. After that the figure at the right is transformed; she becomes restless, her legs thrust up much in the manner of two drawings Picasso had made on 1 December 1954.[88] In some of the variations she has the features of Jacqueline. The other figure in the distance (or more probably in the reflection of a mirror) appears, disappears, changes places and form with Jacqueline and finally emerges in the last version.

The character of each of Picasso's *Femmes d'Alger* in spatial sense and in colour

356

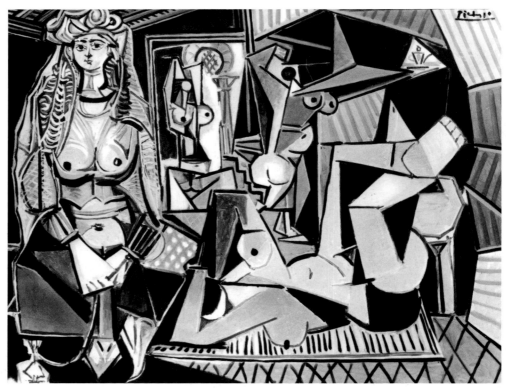

359

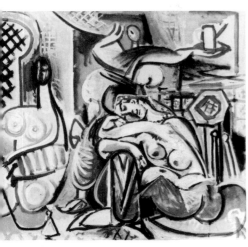

357

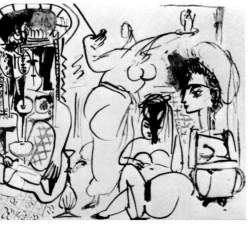

358

356 Eugène Delacroix, *Femmes d'Alger*, 1834.

357 *Femmes d'Alger*, 13 December 1954.

358 *Femmes d'Alger*, 21 December 1954.

359 *Femmes d'Alger*, 14 February 1955.

is surprisingly different. The final version seems to be the most assured and 359 triumphant—a strident, decorative treatment of the Delacroix. Only Jacqueline— bare-breasted, extravagantly coiffed—captures some of the mystery and melancholy of the original.

Picasso's *Femmes d'Alger* contained another surprise. This was its suggestion— at least in the last painting—of the exoticism and decorative quality of the work of Matisse. Penrose tells of visiting Picasso in his studio that February and seeing the canvases: 'My first sight of the Moorish interiors and the provocative poses of the nude girls reminded me of the odalisques of Matisse. "You are right," he said with a laugh, "when Matisse died he left his odalisques to me as a legacy, and this is my idea of the orient though I have never been there." '[89]

More than two years later, in the autumn of 1957—when he was seventy-six— Picasso holed up on the second floor of La Californie, which was usually uninhabited except for doves, and painted twenty variations upon *Las Meninas* by Velazquez. From all reports his concentration upon the work was obsessive. According to Mme Parmelin it was much worse than the period he had worked on the *Femmes d'Alger*:

. . . the colloquy with Delacroix, life in common with Delacroix, the introduction of Delacroix as a guest at meals, as a real or imaginary presence, and as a companion in painters' misery, never committed such ravages as did Velazquez on setting foot in La Californie. He upset everything. From the day the idea of *Las Meninas* raised its head, Picasso's healthy looks became ravaged. And the battle with or without, for and against, without and within Velazquez began. There was no more happiness in life, and yet complete happiness. No sooner had he left the pigeon-loft-studio than he began suffering from not being in it, and the whole of life and every evening were conditioned by it. But the next day, when the time came for work, he would go up to the studio as if mounting a scaffold.[90]

Picasso's compulsive interest in *Las Meninas* could be explained in terms similar

to those used to understand his absorption in the *Femmes d'Alger*. It is a monument in the history of painting (and one Picasso had probably admired on his first trip to Madrid at the age of fourteen, sixty-two years before).[91] It is by a great master. From Hélène Parmelin's report of life at La Californie when Picasso was painting his variations it is clear that he thought of Velazquez as well as about his painting. And *Las Meninas* itself contains a magnificent self-portrait of the painter before a large canvas. Like the *Femmes d'Alger, Las Meninas* is also a painting which masters the very subtle atmospheric handling of a large volume of space. And finally, like the other work, it is reserved—if indeed not ambiguous—in its meaning.

It should not be forgotten that Picasso was once the custodian of *Las Meninas*. In 1936 he was made by the Spanish Republican Government honorary director of the Prado at a time the works were being removed for their security. As he said, 'Alors, je suis directeur d'un musée vide',[92] but he followed the reports of the security arrangements with interest. When he was told of the arrival of the pictures in Valencia from Madrid and of their inspection, including the unrolling of *Las Meninas*, 'Picasso pousse un soupir, 'Comme j'aurais aimé cela! . . .'[93] In a clearly propagandist tract, to be issued when Spanish War posters were shown in New York to aid Spanish Democracy, he made a statement which may not be completely accurate but which shows his involvement with the republican side of the Spanish Civil War: 'Everyone is acquainted with the barbarous bombardment of the Prado Museum by rebel airplanes, and everyone also knows how militiamen succeeded in saving the art treasures at the risk of their lives . . . the world should know that the Spanish people have saved Spanish art. Many of the best works will shortly come to Paris, and the whole world will see who saves culture and who destroys it.'[94] The paintings did not go to Paris but to Geneva where Picasso saw them in the autumn of 1938. It must have been the last time he saw *Las Meninas* and he did so as honorary director of the Prado for the Spanish Republican Government.

Today, when it is so easy to see *Las Meninas* by Velazquez enshrined in the Prado one day and the versions by Picasso in the Picasso Museum in Barcelona the next, it becomes quite evident that the twentieth-century painter had no intention of meeting Velazquez on the seventeenth-century artist's terms. The first version of Picasso's series, which is by far the largest, seems surprisingly small and anxious after that voyage from Madrid. In no single canvas nor in the total sensation of the group is there that serenely coherent presence which Picasso must have felt as an adolescent when he first saw *Las Meninas* in the Prado.

On the other hand Picasso was curiously literal in his translation of the Velazquez. It is true that Penrose has pointed out that we are 'drawn into the royal apartments of the King of Spain' and invitingly suggests that Picasso intends to keep us there to show us 'a whole gallery of incongruous associations Into such surroundings anyone might stray. Don Quixote might appear, or El Greco, burying the Duke of Orgaz,[95] Goya could stroll in From the hooks in the ceiling to which the chandeliers are hitched at night, he will hang ham and sausages.'[96] But Don Quixote, El Greco and Goya do not appear. Picasso did not hang ham or sausages from the hooks in the ceiling. Penrose, knowing Picasso so well, might legitimately have expected what he calls 'disrespectful games,' but if they exist they do not take such a form. Velazquez's dog is replaced by Picasso's dachshund Lump. And since the position of the tiny jester at the right suggested to Picasso that he should be playing the piano, there is one painting of him doing so that could be considered apart from the series. But whereas with the *Femmes d'Alger* Picasso had refused to look at reproductions or to go to the Louvre, here he wanted to retain Velazquez's cast of characters intact.

The first and largest painting of the series is somewhat like a theatre set with the

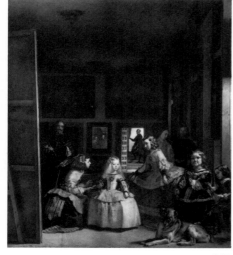

360

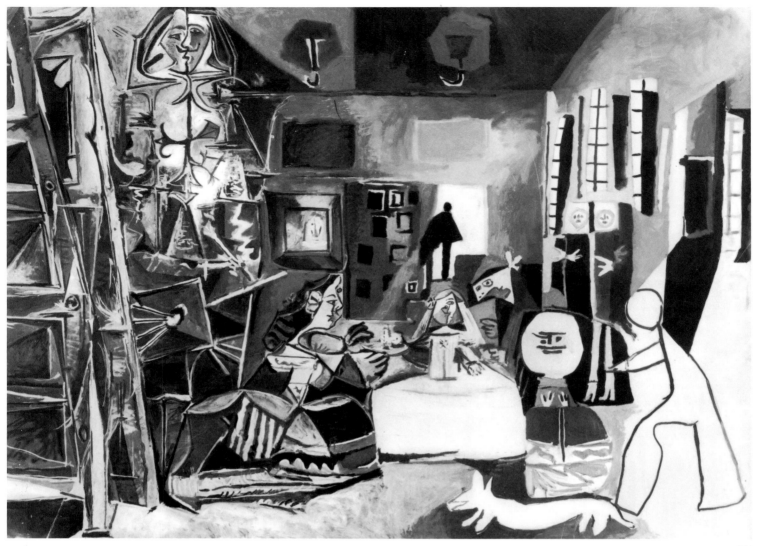

cast waiting for the hero or the villain—perhaps Don Quixote, El Greco or Goya—
to appear. Their positions are approximately those of the Velazquez. We can be
grateful to both Mme Parmelin and Sir Roland Penrose for pointing out that Picasso
was only too conscious of ambiguities in the original. As Penrose wrote:

> Velazquez' painting contains some very strange and subtle relationships between
> the painter, the model and the spectator. 'Look at it,' said Picasso recently when
> we were discussing *Las Meninas,* 'and try to find where each of these is actually
> situated.' Velazquez can be seen in the picture, whereas in reality he must be
> standing outside it, he is shown turning his back on the Infanta who at first
> glance we would expect to be his model. He faces a large canvas on which he
> seems to be at work but it has its back to us and we have no idea what he is
> painting. The only solution is that he is painting the king and queen, who are
> only to be seen by their reflection in the mirror at the far end of the room. This
> implies incidentally that if we can see them in the mirror they are not looking
> at Velazquez but at us. Velazquez therefore is not painting Las Meninas. The
> girls have gathered around him not to pose but to see his picture of the king
> and queen with us standing beside them.[97]

Although it has been suggested that the sequence of canvases in Picasso's *Las
Meninas* is similar to the planes in an Analytical Cubist canvas and therefore an
exploration of space, surprisingly he did nothing to clarify the spatial ambiguities

360 Diego Velazquez, *Las Meninas*, 1656.
361 *Las Meninas*, 17 August 1957.

219

of the Velazquez. There is great variety in the rooms he painted for this courtly cast (although in reality it is always the same room) and eccentric games with proportion but in no way does he change the fundamental frontality of the original painting—except perhaps in making it more frontal still. We do not approach *Las Meninas* at an angle which clarifies relationships or permits us to see what we could not see in the Velazquez.

On the basis of Picasso's professed Communism and the story of his life we would expect him to be, to use Penrose's adjective, somewhat 'disrespectful' before this painting by Velazquez which seems to justify the servility of the court—and even a painter—before one small princess, the Infanta Margarita. But it is quite apparent that besides understanding the eccentricities in Velazquez's handling of space, he saw other qualities in the painting with which he could sympathize and which he could clarify in his own work. A young critic and painter, John Anderson, has pointed out:

> The liberties in the Velazquez are considerable but are disguised. What is ostensibly intended as a royal portrait celebrating dynastic solidarity (King, Queen and Infanta) has by accident turned into a minor debacle exposing in unrehearsed form degrees of personal variance, social license, individual waywardness, and all the consequent uncertainty, insecurity and freedom from the old hieratic form implicit in such dangerous departures. In resorting to tricks whereby dogs, dwarfs, children and kneeling adults are unkindly confused, where royalty is reduced to eyes in a distant mirror, and perspective made to ridicule its own inevitable laws, Velázquez mocks all preconception; and by making himself a detached and omniscient presence affirms a profound and total cynicism.[98]

(Anderson might also have remarked on the significance of Velazquez's having given himself the features of a Hapsburg.)

Picasso's appreciation of Velazquez was mixed with some ambivalence. Mme Parmelin records one conversation when he was irritated and tired:

> If he were only a really intelligent painter—Or even the greatest among the great . . . But he's not that at all. He's just Velazquez, he said, with all that implies. Fine bits of painting and the rest which sinks the lot. It's neither El Greco or Goya.[99]

Among other painters Picasso really respected outside Spain were Rembrandt and Van Gogh, artists who were, like El Greco and Goya, deeply concerned with the expression of human situations. The very detachment of Velazquez, aside from his role even as a disillusioned sycophantic courtier, could irritate Picasso. But still he was an extremely subtle painter and a great Spanish figure. And clearly Picasso wanted to give the characters in Velazquez's most famous work a new life.

The first painting, which is in grisaille on a faintly pink ground, could be interpreted as the hypothesis to be proved in smaller, more concentrated paintings. It is more probably, however, the stage in which the characters are with the greatest formality introduced. There is the Infanta whose dress is delicately pink under the free strokes of grey and white which give it a silvery cast; she looks in one direction while accepting a pitcher of water in another from the attentively kneeling maid of honour, Maria Agustina Sarmiento. The other maid of honour, Isabel de Velasco, is fiercely painted as if we are warned we should automatically distrust her. Directly above the Infanta is the court chamberlain standing cockily in the doorway

361

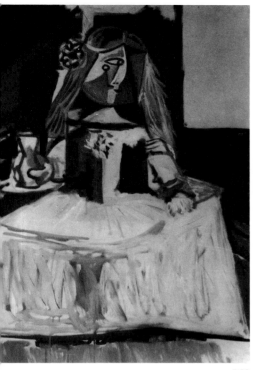

362

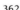

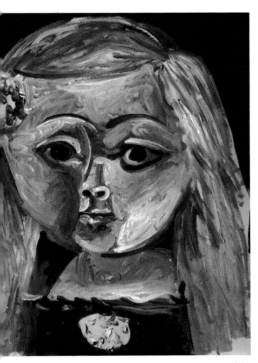

363

362 *The Infanta*, 21 August 1957.

363 *The Infanta*, 6 September, 1957.

with a swaggering cape; the line of his leg carries through the centre of the Infanta's body. To the right are two tutors in clerical garments who seem to have retreated into coffin-like forms although their hands flutter ineffectually. The smaller dwarfed jester at the right is only a white ghost—like the dachshund pup—but behind is the grotesque form of the female dwarf with the face of an angry Charley Brown (or as the Spanish charmingly call him, Carlino). Even more grotesque than the face of the dwarf are the reflections in the mirror of the King and Queen; Philip IV's bloated Hapsburg jaw and moustache are comically lampooned.

The leading character is, however, the artist. He has grown to meet the ceiling which has been lowered so that hooks are ominously near his neck. Basically the structure of his body seems reminiscent of Analytical Cubism, although his face is treated in a later manner with two profiles confronting each other to form one face and to emphasize the painter's surprised concern. The brush strokes are loose enough in his upper torso to suggest something vaporous like smoke. And the other strokes, in particular one like a bolt of lightening above his brush, indicate his inspiration. The touches of pink on the decoration of the cross of Santiago[100] he wears and on the edge of his canvas are like a caress.

In no other canvas in the series is the figure of Velazquez treated even this analytically—either as a painter or as a human being. Nor is he ever painted larger than the other members of the cast again. As a matter of fact he only appears three more times—in works of the total composition in which he is presumably needed to justify the enrichment of the paint. Otherwise his genius as a painter and his personal uncertainty have been explained.

Picasso went on to Maria Agustina, the kneeling lady-in-waiting he had painted sympathetically, and showed her convincingly with large, unhappy eyes and long, curling hair. But then the Infanta Margarita demanded his time. At first she was 362 handled as if she possessed all the hostility of a Lucy in *Peanuts*—suspicious, plotting. Picasso continued to paint her in small canvases of surprising technical variety, changing her dress from pink to lavender to yellow, trying her in two tiny compositions of the whole group (omitting the painter) with a relatively friendly dark dachshund pup. Finally she emerged as human and endearing, 363 painted with fluid green hair, soft pink skin and very black eyes. She had been transformed from a distrustful figure in the comic strips into a little girl who is the very essence of credulity—Alice in Wonderland. And when he painted her on 14 September against a gloomily dramatic background, he made her skin mauve, 336 her cheek an intense blue, the shadow at the left a bright green and ran a paler blue stroke through her face as if preparing this solemn little girl (with one red eye and one cream) for the fantasies possible within *Las Meninas*.

The next day the fantasy began. She herself became crankily transparent, but 364 her dog was a solid if curious green. Maria Agustina had swollen rather domineeringly like the White Queen in *Alice in Wonderland* whereas an angular Isabel de Velasco seemed distraught. In the background the tutors flutter helplessly while the chamberlain tries to enter a red door. The Infanta's parents are reduced to a hazy, pale green form like a heart in a very large mirror. Two days later Maria Agustina becomes more intense, more triangular and more helplessly demanding while the princess becomes smaller and even paler. That same day, Picasso painted a large composition in which the Infanta is reduced to a geometric, yellow form, 365 her dog curls up and her maids of honour swell to become terrifyingly large and attentive; as usual the tutors are ineffectual, and even the chamberlain has shrunk.

Another painting came the next day, a painting with heavier paint and a strong sense of the difference between light and shadow. As a result the artist is present if 366 only modestly at the left. The Infanta has emerged and stands like a formal doll with

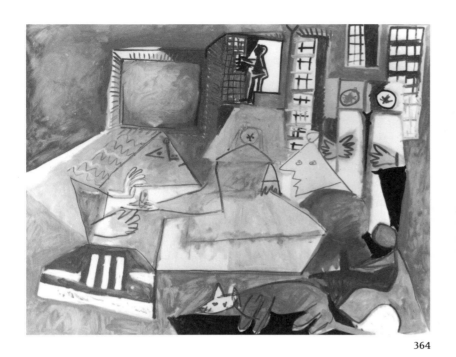

364

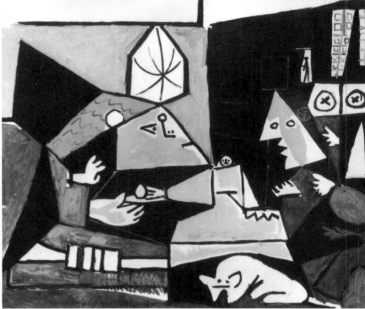

365

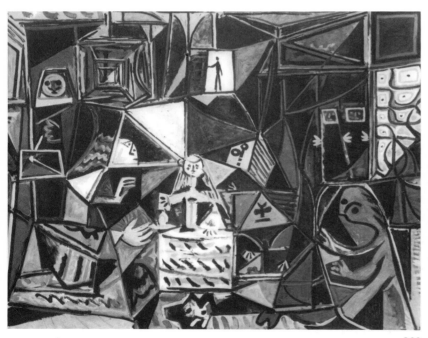

366

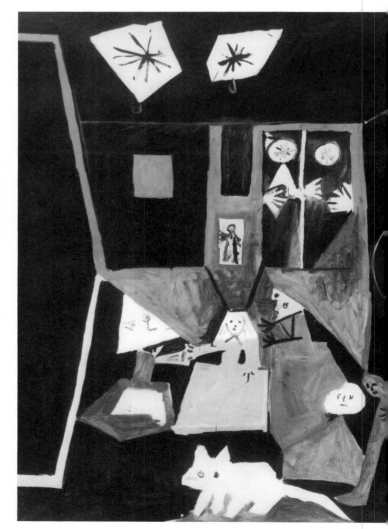

367

364 *Las Meninas*, 15 September 1957.

365 *Las Meninas*, 17 September 1957.

366 *Las Meninas*, 18 September 1957.

367 *Las Meninas*, 19 September 1957.

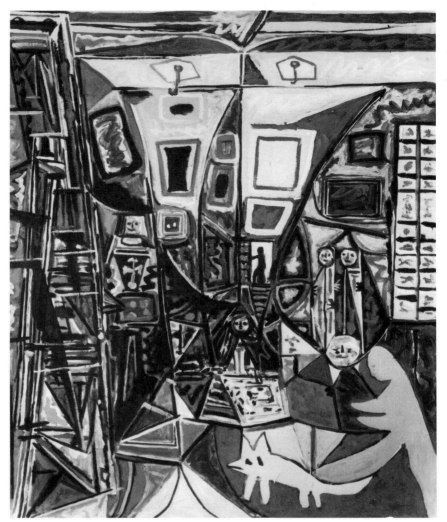

368

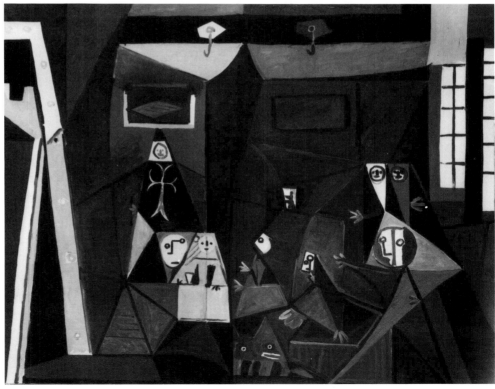

368 *Las Meninas*, 2 October 1957.
369 *Las Meninas*, 3 October 1957.

369

223

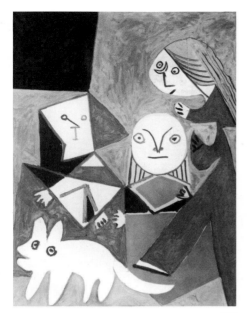

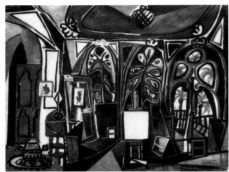

370

371

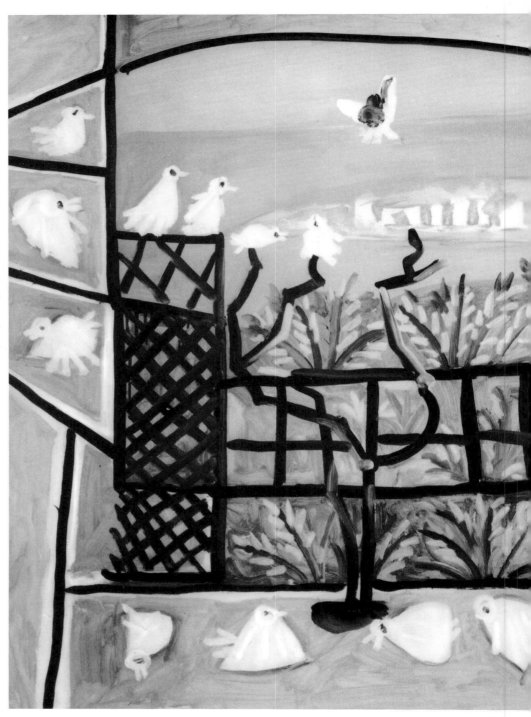

372

her arms outstretched to show her yellow dress. She seems to be surrounded by a kite-like aura which takes in the heads and the hands of the ladies-in-waiting and the irritated, triangular face of the dwarf. Mirrors within mirrors cannot seem to produce the faces of her parents. The black tutors are somewhat livelier with red features and a blue border around their square heads and their bodies. And the jester has become very red and strange as if he were becoming a toy animal himself.

Only the next day Picasso painted another work in which the painter disappears (for after all it is only thinly and crudely painted), and all the figures seem reduced before the spectacular black, red and white setting, as funereal as the royal tombs of the Escorial; the tutors even seem to be constructed in its wall. The chamberlain is diabolic. 'Carlino' emerges once again in the guise of the dwarf looking out the corner of his eyes at the dog which appears to have become a white cat. Picasso waited twelve days before painting the next version which is the same

size but consumes the figures and their characters in a pyrotechnically brilliant painting of the room. The artist, of course, appears once again. And the final full composition was painted on 3 October in which all, including the painter, are brought together into a sober, rich and dignified interior. It is difficult to identify the grey animal—perhaps an iguana?—into which the dog has been transformed. The cast now seems divided and at war with the space. At the right the jester (resisting with a red diagonal), the dwarf, Isabel de Velasco, the tutors and the traitorous grey dog seem funnelled toward the chamberlain standing in the opened door; it is as if he had triumphed over them. At the left in a solemn triangle stand the yellow-clad Infanta, the good lady-in-waiting and the protective symbol of the artist; directly above them is a diamond-shaped reflection of the King and Queen.

In all these variations upon the total composition of *Las Meninas* the character of the space is an important element. It has been pointed out that Picasso's almost claustrophobic fear of any confinement in his paintings after the Second World War, which makes the works at Antibes seem particularly free, disappeared with his *Femmes d'Alger* for whom he painted brilliant and exotic interiors.[101] And Picasso went on to the paintings of La Californie in which, admittedly, any sense of confinement is always relieved by views through the elaborate windows into the park beyond. In these cases his approach to space was still decorative. But with *Las Meninas* it suddenly has the expressive power of his wartime paintings. The degree to which Picasso himself felt confined by the ominous spaces he was creating can be seen in the number of times he sought escape in painting the pigeons at his windows overlooking the intensely blue Mediterranean.

Picasso continued to paint the ladies-in-waiting and, as they seemed too frightened, he relieved the game with the silly painting of the jester at the piano, and the even sillier head of the jester himself. Next came six paintings of the same size in an abbreviated comic book style studying groups of characters from *Las Meninas* in their total absorption upon the dog—even when he does not appear in the painting. Finally there was a small compositional study and six tiny postscripts of the ladies-in-waiting.

What was Picasso doing? Both Penrose and Anderson have written of parody which is defined as 'making ridiculous by imitation,' but actually the Velazquez remains remarkably unscathed. Penrose also remarks that the series 'cannot fail to bring a smile.'[102] In actuality there are many serious people standing before it in Barcelona but, if they were less inhibited, Penrose would be right. Anderson writes about his 'translating the old world, Velazquez's reality, into the artificial mock reality of the doll's house. This doll's house is an image of perfect freedom. In it Picasso, unbound by laws of gravity or representation, can mime the human condition and the complex of relationships and paradoxically at the same time emulate the intense dramatic unity of the Velazquez, still satisfying his intellect with the knowledge that it is all a masque, pure conceit.'[103]

Anderson's analysis of the situation is perceptive; Picasso was even freer than he would be with a doll's house, quite unconfined by any laws of gravity or proportion. He could even commit those absurdities with proportion like a mirror which used to hang in Jacqueline's 'Salon' at La Californie: 'a trick mirror like those in the Musée Grévin, in which one could see oneself as long as a day of fasting, flattened, atrocious, and as one was; or tall as a boot, fat, hideous, and as one was.'[104]

Whenever anyone has recorded Picasso's explanation of one of his paintings it has been surprisingly literal. And I feel there is something equally literal in this Velazquez series. Against the background of his long admiration for comic strips[105] he has made a series with a dramatic development. Each work in itself has a strong narrative element, much of it funny, some of it sentimental, occasionally terror-

368

369

371

372

370

struck. He was doing what he had described to Françoise, 'I want to draw the mind in a direction it's not used to and wake it up.'[106] It is as if he had taken the characters of Velazquez's *Las Meninas*, kept them in that room, and put them through the trials of *Alice in Wonderland*.[107] Instead of capturing the sense of mystery of the Velazquez, he gives us a series of puzzles to solve.

In August 1959 Picasso turned to the third of his series—based on Manet's *Déjeuner sur l'Herbe*. Although this time even more paintings and drawings were to result from his preoccupation there is no evidence that either the artist or the work that inspired it was such an obsession. From the episode concerned with *Lola de Valence* we know Picasso admired Manet as a painter: he had even parodied his *Olympia* in 1901.[108] And indeed only a few years before he had made almost factual drawings[109] based on the *Déjeuner* itself. This painting, like the *Femmes d'Alger* and *Las Meninas*, was famous—famous for its tonality and famous also, significantly, for its ambiguity. Picasso approached it with an irreverence which was closer to his attitude toward the Delacroix than the Velazquez—using it to stimulate his own fantasies.

Douglas Cooper in introducing the publication of the *Déjeuner* series[110] points out that the variations which Picasso drew or painted between August 1959 and August 1961 fall into four phases—the first a Country Outing (August 1959 and February and July 1960), the second a Baignade (June and July 1961), the third a Nocturnal Excursion (July and August 1961) and the fourth, limited to drawings, a Classical Ideal (August 1961). Picasso actually continued with the theme beyond Cooper's publication. In all of them there is (borrowed from the Manet) a pastoral landscape which is rare for Picasso, a self-possessed and normally indifferent nude woman, and the man with the cane at the right—*'le grand Causeur'* as Cooper describes him[111]—endlessly talking.

In the first of the paintings of the country outings—on 27 February 1960— Picasso gave the figures a beautifully green glade and an intense blue pool in which the bending female nude stands. It was a landscape far from the open seascapes of his paintings at Antibes—protected, cave-like, mysterious and very green. Except for the large imploring hand of the *Causeur* at the right the male figures are insignificant, particularly before the soft pink flesh of the model at the left—as appetizingly painted as the four pieces of fruit spread out temptingly on the white napkin before her. It is revealing to compare her with the first seated nude in the series on the *Femmes d'Alger* who is partly dressed in blue stripes of paint, whose flesh is a remote if luminous white and whose small, dark head rises from a long neck. The 'Manet' nude is less articulated and less dignified—more earthy and more humanly adorable. Picasso took the cast of this charade through many variations of this country outing, moving through one large painting in which Jacqueline is found as the exotic model at the left sitting with supreme self-confidence. If she is compared with Jacqueline in the final version of the *Femmes d'Alger* we realize the degree to which she is participating in a good-natured spoof. The work is richly decorative—repainted on 20 August—to provide an ornamental background worthy of the queenly Jacqueline.

The series of *Bathers*, produced some eighteen months later, are largely light-hearted drawings and sketches related to many earlier studies Picasso had made of the nude. They form the end of a series of paintings of some seriousness in which indolent figures, whose nudity suggests antiquity, are painted with a faint suggestion of the *Bathers* of Cézanne.[112]

In moving into what Cooper called the Nocturnal Excursions in July 1961 the works reach what he rightly describes as a 'nightmarish intensity,'[113] and the transformations of the character are extreme. The bather in the background still con-

tinues to bend or stoop—sometimes picking a flower—indifferent to the man at the right who continues to talk. Although in some of the drawings and paintings his hat and beard could be interpreted as deriving from Manet's figure, they are treated so formally and severely by Picasso that this figure appears rabbinical— even a seer from the Middle East. Nothing could be further removed from the fullness, freedom and voluptuousness of the bather's body, even as she pulls her chemise across one breast, than the tight, fancifully-clothed figure of the man with the intent and even ecstatic gaze. But she remains unconcerned as he talks. As Cooper says, the *Causeur* seems 'a figure in Greek tragedy delivering himself of a recital of fateful tidings. Indeed there is something sinister about the *Causeur* throughout this small group of paintings, for either his eyes are mysteriously lit up, or a beam of light falls on his skull, or he appears to be opaque, while most of his body is kept in darkness.'[114]

This dialogue continues although usually with the model at the left. In a series of paintings she becomes Jacqueline and he Picasso. In the fantastic, unreal light of the night-time glade one shrinks while the other expands—both apparently victims of a supernatural force. Cooper writes, 'In general the effect of these pictures is alarming. Something supernatural and uncanny is in the air.'[115] The *Causeur* shrinks in the final oil to an appropriate green shadow while, across the bather who has now turned the pool into a fountain, sits the figure of Jacqueline, predatorily in command.

Picasso with a pencil continued to play with the *Déjeuner*—but finally as a classical

373 373

375

374

376

373 Déjeuner sur l'Herbe, 4 July 1961.

4.7.61.II

373

374

375

376

idyll which begins with Jacqueline, reclining and turbaned like Ingres' *odalisques,* and a young Picasso, classically nude, as a shepherd at the right. Again he mocks himself and his love in these witty drawings which recall the *Human Comedy.*

Although it is quite clear that Cooper is justified in pointing out in relation to the *Déjeuner* series that 'Picasso will take things apart to see how they are made, loves probing mysteries, and takes a special pleasure in pushing on beyond the point at which some other man stopped,'[116] in this interest in the Manet there is a great deal of good-natured play—some perhaps slightly in parody of the original but much of it arising out of interpreting the human situation which the Manet suggests. As Cooper also points out, Picasso 'maintains a dramatic intensity of which there is no suggestion in the Manet,'[117] but most of it is a gentle domestic comedy. Only in the haunted paintings of the Noctural Excursion is there a suggestion of something more melodramatic. With the *Déjeuner* series Picasso clearly reached a new phase in his work in which an interest in human situations had triumphed over his interest in art.

In writing of this period, which with the move in 1961 to Mougins came to an end, any critic almost inevitably refers to masques, tableaux, stages and the theatre. Picasso's characters assumed, sometimes seriously, sometimes mockingly, the costumes of painted figures of the past. And we are made conscious of the difference between the person and the highly mannered role he was playing. It is interesting in this connection that whereas in the period with Françoise, Picasso's closest poet friend was Paul Eluard, who was also a Communist and died in 1952, at this time the 'court poet' was Jean Cocteau who had been the first to interest Picasso in the theatre and in 1915 had come to invite him to work for Diaghilev dressed in the costume of a harlequin.[118] If, in the period with Françoise, Picasso had been concerned with highly poetic metaphors, here he had been using mannered similes. As Picasso's dealer and old friend, Daniel Kahnweiler, had predicted,[119] the painter and his wife soon found the romantic château at Vauvernargues too gloomy and, in spite of its associations with the countryside of Cézanne, too remote from the sea and the activity of the Côte d'Azur. Consequently they bought another house, the Mas Notre Dame de Vie, at Mougins above Cannes. Whereas La Californie and Vauvernargues had been photographed, painted and thoroughly publicized, the Mas Notre Dame de Vie has remained obscure. We know from Mme Parmelin that it has large gardens with olive trees, cypresses, pepper trees, geraniums and begonias and that it is not so vast that the sounds of the activities of neighbours cannot be heard.[120] Picasso had a studio built for himself with large windows— but its appearance remained a private affair. In fact Notre Dame de Vie seems to have represented a period in which Picasso had turned in on himself, on his own resources and in particular on his own life.

After 1961 Picasso rarely stretched out to the work of other artists. There were exceptions, however, in the year 1963. One was with David's *The Sabine Women,*[121] a painting which had had some influence on *Guernica* in 1937. The David is not the atmospheric, subtle, ambiguous kind of painting that had interested Picasso in the fifties; indeed it is as theatrical as any of Picasso's own transpositions of Delacroix, Velazquez or Manet. In the strongest of his versions, Picasso eliminated most of David's figures, forced the composition into a vertical, and concentrated on the meaningless conflict and the helplessness of the mother and child. This canvas has a greater immediacy than his *Massacre in Korea* and *War,* painted over a decade before, but also greater pessimism in the inevitability of the pressures of the hoof of the mindless horse and the golden leg of the foot-soldier. This very pessimism about conflict may have represented a spiritual change in Picasso who had, at least in the time with Françoise, claimed to be ruthless about struggle being

377

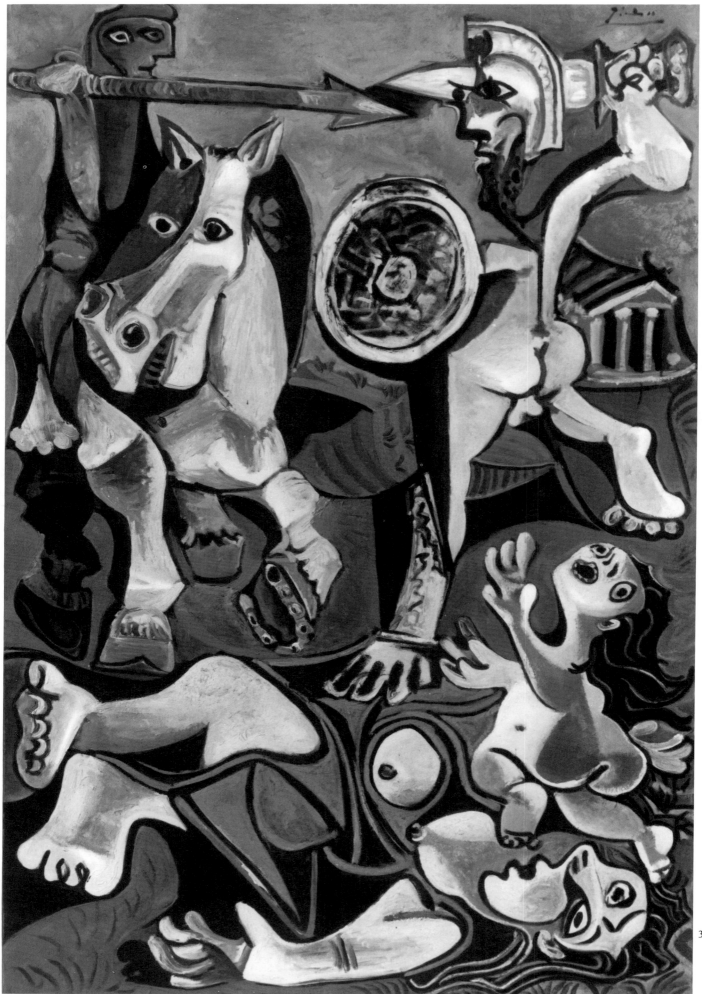

377

378

fundamental to life.[122] The degree of outraged compassion shown the dead mother and imploring child represented a new sympathy for the helpless in the work of Picasso who two years before had reached eighty.

Another 'copy' was only a series of small drawings after the work of an artist Picasso had always revered—Rembrandt. Rembrandt's homely face and forthright expression often appears in Picasso's drawings of the period[123]—haunting his work as it had done in the *Vollard Suite* in the thirties. But this time it was not the man himself but his late, moving painting of *Bathsheba* in the Louvre which had inspired Picasso to make drawings of Jacqueline as a radiant and mature Bathsheba. Nevertheless in one richly-coloured crayon version beside her is a small, crouched adoring figure with an absurd hat—Rembrandt in the guise of David. Like *The Sabine Women* this drawing is a work of compassion—but in this case for both beauty and age, tinged with gentle humour.

This new gentleness could be found before the move to Notre Dame de Vie in drawings Picasso made of the life around the bullfight[124]—almost a new *Human Comedy* in 1959. If compared with the *Human Comedy* of 1953–54 these drawings seem more romantic—in costume, subject and the richness of the washes of the black ink—and less caustic about the contrasts between youth and age. Picasso was far tenderer now toward human frailties. This new romanticism can also be detected in drawings he made the same year[125] of a Spanish legend of the Crucifixion taking place in a bull-ring and the figure of Christ sweeping his loin-cloth before the bull as if it were a cape. In one of the drawings Jacqueline is shown as a

419

378

316

377 *The Rape of the Sabines*, 1963.
378 *Bathsheba*, 1963.

tearful Mater Dolorosa.

Within the protected garden of Notre Dame de Vie Picasso redrew his life in metaphoric terms. He showed himself, for example, as a small, dark, curly-haired boy eating watermelon and sticking out his penis arrogantly at an inquisitive cock.[126] (In this last-decade Picasso used genitalia with a frankness that is unusual in the visual arts in the West but always with expressiveness and often with humour.) He drew his young *alter ego* being crowned with laurel[127] and standing between a lean, angular, bearded man (somewhat like the man with the lamb he would become) and a nude woman who wears two strings of beads and eyelashes that are patently artificial;[128] perhaps she represents the possible prostitution of the world. Picasso went on to the small boy's fascination with a circus rider[129] or his jealousy when his mother embraces a younger child.[130] The boy grows and learns to play the pipes or a flute which he does joyously for a mature nude.[131] The idea of the dark-eyed youth blowing on a reed suggests Picasso's great painting of 1923, *The Pipes of Pan,* in which the artist's familiar features are found in the standing figure at the left. But the earlier work (painted forty-three years before) is formal and hieratic whereas the musician in these late drawings abandons himself uninhibitedly to his playing.

In several drawings Picasso brought together the boy with the watermelon (crowned), the flutist and, as a stage of maturity, the figure he had evolved during the war for a free-standing bronze, the *Man with a Lamb.* As Picasso had worked through series of studies almost a quarter of a century before for this large piece of sculpture he had often drawn his own features. Consequently this image was, like the *Pipes of Pan,* a highly personal document.[132] In these later drawings of 1968, this ungainly figure remains dignified and obsessed but like the flutist somewhat less totemic than his antecedents although he carries the lamb in a more traditional way than he had in the bronze. Since Picasso loved animals, it is possible that the thought of the sacrifice of the wriggling lamb could explain the man's serious expression. In any case as he moves purposefully forward with his staff he represents a mature contribution to life itself as he confronts two earlier stages in the

379

380

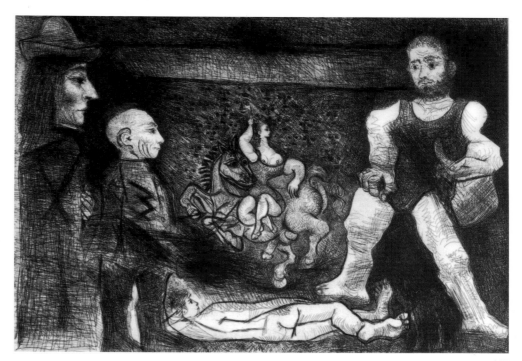

growth of man—indulgence and precocity and the more active giving of pleasure.

We are never apt to forget Picasso's extraordinary versatility, inventiveness and control of the forms of art, but we may not give him sufficient credit for his narrative imagination. Nevertheless—like Albrecht Dürer—he has enriched our world with vivid, expressive and enduring visual symbols. Often they are essentially autobiographical—the result of the nature of the exploration of his own life— but sometimes they are the result of a genuine fantasy. The intensity of his narrative imagination is apparent in that extraordinary tour de force of the 347 etchings he produced in 203 days in 1968.[133] In this relentless and often erotic[134] series the cast of characters is astronomical—circus bare-back riders, acrobats, weight-lifters, clowns, male and female charioteers, a woman with a lamb, Cupid, Harlequin, the owl, the musketeers to whom we will return, Rembrandt, the smoker, the dove, the gullible young painter, the *Femmes d'Alger* and other ladies of a harem, a sphinx, the artist and his model, the young voyeur, a lecherous faun, Greek warriors, a friar, three ladies at the fountain, a Punch and Judy show, two combative cocks, a lady with her duenna tempting a customer, the boy genius, a Surrealist piece of sculpture, films, the wheel, a tyre, a carriage, sexual acrobatics, a ladder, his own parody of Manet's *Olympia* as black, the wilds of Spain, Sabine warriors, a Sabine flutist, a female warrior with a shield, the watermelon-eater, the countryside of the *Déjeuner sur l'Herbe,* an abduction, a duel, a boy playing pipes, dancers, Jacqueline occasionally and himself frequently, children and finally lovers against a landscape painted in aquatint as if it had been a *cliché verre* by Corot. All this is introduced by an etching on which he actually worked for 381 three days. In it a small, dessicated, bald Picasso, whose profile is unmistakable and who wears the zigzag mark of genius on his sleeve, stands before a wizard with the profile of Cocteau who had died four years earlier, looking over the long body of a dreaming youth at an energetic but melancholy giant, who has been interpreted as that other side of Picasso's creative personality—the sculptor.[135] A voluptuous woman rides on an excited horse while from the finely-etched web of the darks in the background stare countless eyes.

These 347 etchings seem an excursion into an ebullient imagination in which ideas or feelings, as always for Picasso, assume concrete form. They are full of humour. Particularly enchanting are the aquatints of a seductive Spanish nude, 380 her wizened duenna and the man in the romantic cloak whom they tempt.

379 *Nude and Cavalier,* 1968.

380 *Prostitute, Procuress and Clients,* 1968.

381 *Figures and Bare-back Rider,* 1968.

In this last decade Picasso has explored the nature of human relationships. He even made one drawing of himself as young and nude shaking hands with himself—identical except that he is bald.[136] These explorations often grew out of his own past. But he was quite capable in 1962 of studying in drawings, prints and tiles the solidarity of bourgeois families whose members, in particular an old man visibly shrunken beside his plump and fussily dressed wife, an aesthetic youth with long hair and poignant eyes, and a young woman with an elegantly long neck, bear no resemblance whatsoever to his own family in Barcelona in the 1890s. The drawings,[137] which show a tenderness for the members of the family and even for the social unit they represent, seem to have been executed to fill a surprising lacuna in nineteenth-century art. At the same time that he was working on these daguerreotype-inspired family portraits, Picasso could ridicule any of its members' pretensions by drawing a seated, completely covered woman smiling politely at a perplexed male who is entirely nude.[138]

One relationship which concerned him was with the past he had not known, which he symbolizes by costumed invaders into his world—the 'musketeers' who wear the beards, ruffs and doublets of the seventeenth century. Whether or not they are literally Dumas's heroes, Picasso etched and drew them in a series of adventures—many of them amatory. No matter how indiscreet their situation becomes they never lose their dignity and very rarely their clothes.[139] In one drawing a baby boy—presumably as usual Picasso—stands transfixed as he grasps the sword of a musketeer;[140] their gallantry seems an important stimulus to the growth of his imagination. From expressive and compassionate wash drawings of their heads[141] it is clear that Picasso saw the Cyrano or the Quixote in each of them.

One world Picasso entered often in fantasy was the circus—a world which had appealed to him periodically but never with quite the same humour it did now. The bare-back rider was a particularly tempting figure, not only for Picasso remembered as a child but for Picasso as a dwarfed, clown-like adult. In 1967 he made one wide brush drawing which is called *The Circus* but in some ways seems a child's bad dream. At the left a man holds a large, ritualistic sword which the eyes of the two men in the crowd nearest him follow anxiously. Seated children are more concerned about a gigantic cock[142] which the knife seems to menace. A vigorous back-back rider, painted like a harlot, sits on an unconvincing donkey and stretches out an enormous arm under a tier of the crowd which contains a shadowed head like a young, melodramatic Picasso as well as the seventeenth-

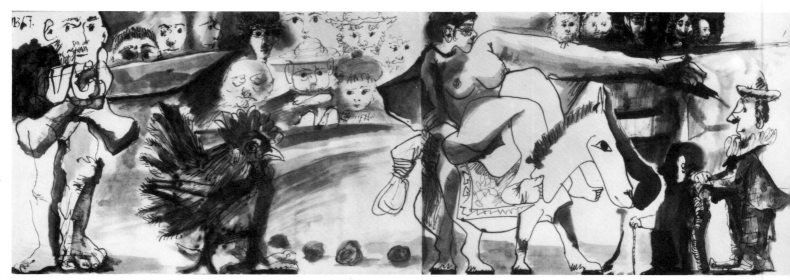

382

234

century face of a musketeer. But this arm reaches out protectively toward two small clowns—the smallest and frailest like an elderly Picasso, the other only idiotically pushing him on. In the disconnected world of the circus there was still an important sense of camaraderie.

Two related figures also reappear in his works—Punchinello and Harlequin—Punchinello more helpless and dependent than before, Harlequin more vigorous.[143] At some moments he becomes, as he had often been, an *alter ego* for Picasso himself, as when he grasps the hand of a dramatic, nude Jacqueline.[144] He also even occasionally performs tricks, as when he turns the whole world, including a sleeping nude, into a dazzling vortex of flowers.[145]

But the real magician remained the artist. And Picasso examined him frequently, and not always autobiographically. In 1962 and 1963 he often painted an artist—varying his features and his costumes but generally making his silhouette endearingly clumsy—seating him sometimes against a landscape but usually before a model in a studio.[146] We are told Picasso always referred to him as *'le pauvre'*;[147] and although his awkwardness seems the antithesis of Picasso's own agility and grace, even in his eighties, *'le pauvre'* invites the compassion of Picasso's caricatures of himself as small and clown-like or Rembrandt's admissions of his own plain body and face. There is a greater range in the appearances of these artists than there was between Rembrandt and Picasso, but they always seem on the verge of madness, as if occupied by some alien spirit; only occasionally does this appear integrated into the inspiration of pure genius.

Rembrandt appeared once again in 1963 as a heroic younger man, based on the Dresden self-portrait by Rembrandt seated with his wife Saskia on his knees. Characteristically for Picasso the original he chose to interpret is a bewildering painting, Rembrandt dressed as a swaggering, smiling cavalier with his modest wife on his lap, painted in a sumptuous setting; but sedate Saskia does not normally invite anyone to undress her mentally, and there is no indication whatsoever in the work that the painted Rembrandt was a painter. In the Picasso, although the frontal view of Rembrandt's bearded Jove-like head might suggest his satisfaction with a glass of wine and 'Saskia-Jacqueline' on his knee, the stronger profile and the outstretched hand with the pointing finger are conspicuous indications that, in spite of their distractions, the artist—unlike the seventeenth-century Rembrandt—can only concentrate upon his easel.[148] This theme of the mesmerized painter continued as Picasso in 1964 painted the haunted and often tragic artist with a serenely unselfconscious model.[149] At this point the painting of the artist's face was often reduced to rudimentary and stingy strokes of black paint with two more generous and healing strokes of colour. The painter remained brooding, haunted, and disturbingly intense.

When in 1964 Spitzer, a Berlin publisher, sent Picasso a package of reproductions of one of his own paintings of an artist, he proceeded to make variations of it[150]—painting curly-haired painters, bearded painters, clean-shaven painters, painters with square hats, painters with flattened fedoras—some young, some old—but all working with manic intensity on their canvases, all surprised by the results. At the same time he was making drawings of the heads of other people with equal fervour.[151] One series was of a man, often smoking (Picasso himself seems to have been an incessant smoker). In drawings of this man Picasso combined particularly brilliant calligraphic motives of different colours to suggest a distraught human being. From this series there is also a deeply melancholy portrait of Jacqueline. But the difference is that these other works do not contain a canvas or a sheet of paper, which seems to provide a resolution—or at least an excuse—for the excitement of the painter.

There is also that magic moment of Pygmalion's when the man-made figure

384
403

388

385

386

383

384

382 *The Circus*, 1967.

383 *The Musketeers*, 1967.

384 *Pierrot and Harlequin*, 1970.

385 386

comes to life. In many of the drawings of the 1970s the painted and actual model are drawn as if they were one—and often as if the model in the painting was becoming alive with each stroke.[152] Picasso drew these artists with a certain amused detachment—some chinless boys, some Rembrandtesque, bearded, balding, bent old men, others like a suave and vigorous young Picasso. There is always an affinity between the characterization of the artist, the work he is painting and the style of Picasso's drawing. Picasso never ceased to speculate in his work about the variety of men who are drawn to painting, about their essential confraternity, about the magic that possesses them, and about the unpredictability of the results.

With the artist there is usually that ancient symbol of sexuality—the female nude. Often she—a model—seems narcissistically indifferent to the artist and only rarely actually provocative. But essentially the artist, like Picasso's Rembrandt with Saskia, concentrates upon recording sensuality rather than responding to it more directly. In the seventies the forms of the models are as varied as those of the artists and the style of Picasso's drawings. But in general Picasso's female bodies in the last decade became more yielding, their figures smaller, their contours undetermined, as if their virtues are in their passivity, their softness, the way their skin reflects light, rather than in the energy of youth. In the particularly beautiful and intense paintings of 1964 of the relationship of the artist to the model (or perhaps the painted model), the female nudes were suggested as luminous flesh by the barest strokes of pink and green on white.[153] These are so gently convincing that we could understand Picasso's having said at this time, 'What a good fortune it would have been to have been an Impressionist. I would have been a painter in the innocence of painting.'[154] To some degree one must assume that these quiet nudes were the consequence of Picasso's own contentment with his gentle, mellowing wife.

Picasso did not always separate his artist and model with an easel. Even when an easel existed he was conscious of the sexual provocation, which the contrast between the painter's dress and the model's nudity often emphasized. Again and

385 *The Painter at Work*, 1964.

386 *The Smoker*, 1964.

387 *Le Déjeuner sur l'Herbe*, 1960.

388 *Rembrandt and Saskia*, 1963.

236

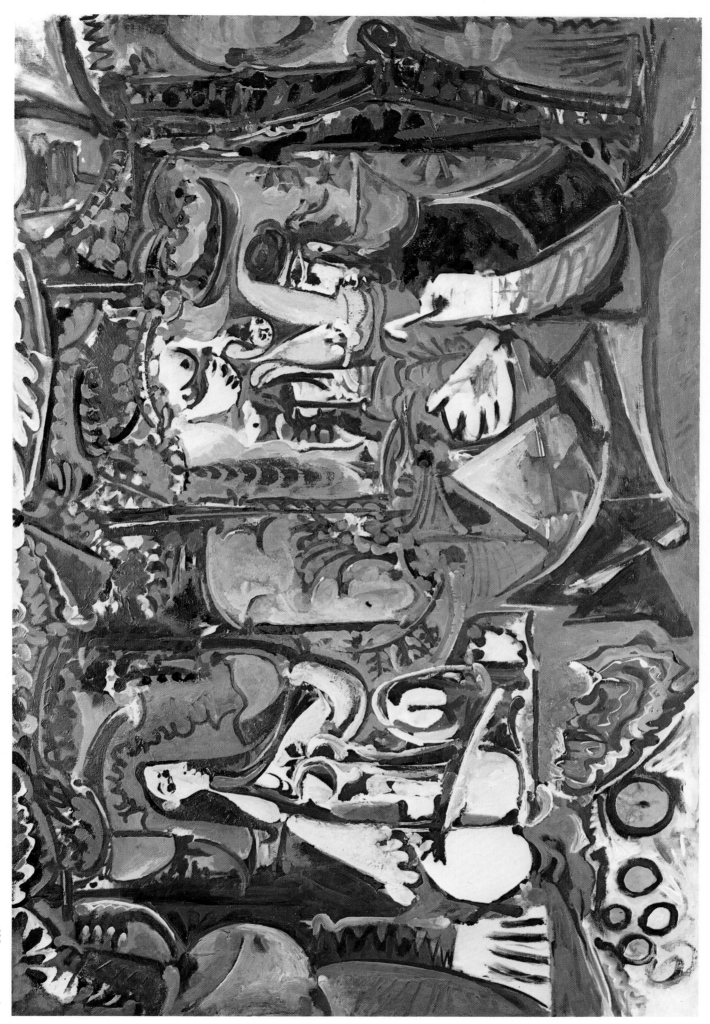

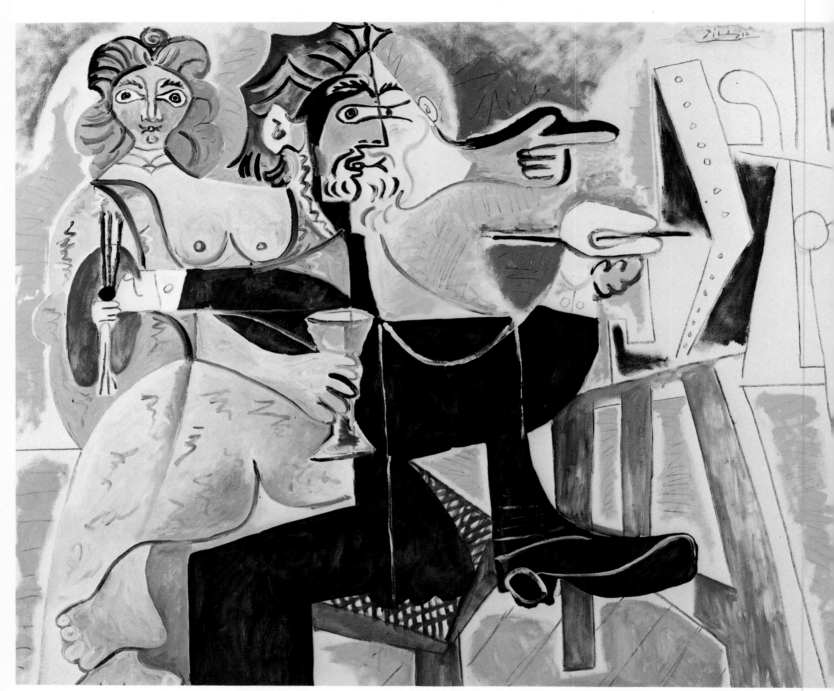

388

again genitals are painted without any embarrassment, the models' often visible as they stretch their legs apart. Picasso drew nude women lying around in luxuriant relaxation as if they were in a harem or, as Mme Parmelin would put it, playing at being *Femmes d'Alger*. These lazy nudes were often drawn on Sundays, a day Picasso tried to avoid working; in one of these Sunday drawings an indolent and voluptuous Salome contemplates the head of John the Baptist.[155] When the painter ceases to paint, and the easel disappears, he is only a man—sometimes with Picasso's features—as he kisses, is kissed, is tempted, or copulates. Scenes of courtship or flirtation are rare but they do exist, and, with more poignancy than in the *Human Comedy*, often between an old man and a young woman.[156] In the past thirty years Picasso's sensuality and his humour seemed to have increased.

389

390

392

And yet one day, despite the bravado of the days of his Elysian escape with Françoise, the spirit Jacqueline gave him later to challenge the masters of the past, and the cheek of the final years in which he equated creativity and copulation,[157] Picasso died. That inventiveness, that battle against facility, that clowning humour (so full of pathos) were now forever contained. The creative drive his struggle against death had represented was stilled. That sense of the fertility of a highly individual human genius working among us, which gave so much heart to the French during the Occupation, was lost. The act itself, which was so sublimely courageous, was over. Now we are left with the results—the works of an artist who had begun as an unusually precocious youth and who died three-quarters of a century later planning next summer's exhibition at Avignon.

It has been conventional to deprecate Picasso's works of the last thirty years. We were admittedly dazzled by the quantity of paintings, drawings, works of sculpture and ceramics he continued to make—even more by their variety than by their actual numbers. The 347 subjects he etched in little more than six months when he was eighty-seven would be considered a perfectly satisfactory—if improbable—life work by a fifteenth-century artist. But at the same time we were often disturbed by this productivity as if it were too obsessively an end in itself. With John Berger[158] we worried that it was too superficial. Instead of magnificent, synthetic, profound masterpieces based upon a life's experiences, such as those left us by the painters of the past we felt Picasso could equal—Michelangelo, Titian, Rembrandt—we feared Picasso was failing us in his unwillingness to probe deeply enough, to face the meaning of his own life except symbolically, to sustain his interest and his energies to paint single masterpieces comparable to theirs. In short, many of us were afraid, with Berger, that he was fighting the wisdom of age.

It is not uncommon to point out how removed Picasso seemed from the twentieth-century. The First World War did not touch his work. Only the Spanish Civil War made even the evils of war of immediate concern to him. But apart from war most of the problems of our society—mechanization, poverty, illness—have not been reflected in his painting since the Rose Period. Although it is not the place to discuss Cubism here it is even possible that it has been falsely interpreted as an intuition of the changing concept of the physical world as a result of Quantum physics and should be seen instead as a summing up of the Newtonian approach to the universe. Picasso was undoubtedly more influenced by Freud[159] and by Surrealism than he was willing to admit; but he tried to remain aloof from the Surrealist movement in the arts which fundamentally he feared. For some of the same reasons he disliked Abstract Expressionism.[160] In short he tried to work as a giant in isolation—even geographically—from the main issues of this century.

Curiously, in his late works he may have found himself being drawn closer—if perhaps equally reluctantly—to the attitudes of his time. His very anti-heroicism (his work had become increasingly mundane since 1945), his unconcerned sexual

frankness (liberated by Freud), his conviction that the sensations of youth are the most precious and should be prolonged,[161] even his struggle against age are the predominant values of this past decade. Although undoubtedly he had the status of a hero himself, he fought as keenly as a young artist in his twenties against the concept of a masterpiece—a heroic work of art. With other artists producing multiples, series or perishable environments he shared a pessimism about the future of his work and perhaps about the world; he was actually increasingly willing to have his own work duplicated. Even in his impersonal and sentimental compassion he was very much attune with the year, 1971, in which he became ninety.

Picasso's creative life was so incredibly long that we can only admire the will that sustained it. But because of its very length we may have to admit that, whereas he began in the Belle Epoque, he ended in a period when many of the Abstract Expressionists were dead, when Dubuffet was a grand old man with an exhibition at the Guggenheim, when Pop Art seemed *déjà-vu*, Minimal Art had become classic, and Conceptual Art and Super-Realism seemed the fashions of the day. When the work of his last thirty years is finally analysed with complete critical detachment—unconscious of that genius who until so recently was still working—surely it will be measured against the time in which he was living and to which, in spite of his curiously hermetic existence in the South of France, he was responding. With great tenacity—and admittedly even greater egocentricity—Picasso said a great deal about the world in which he died.

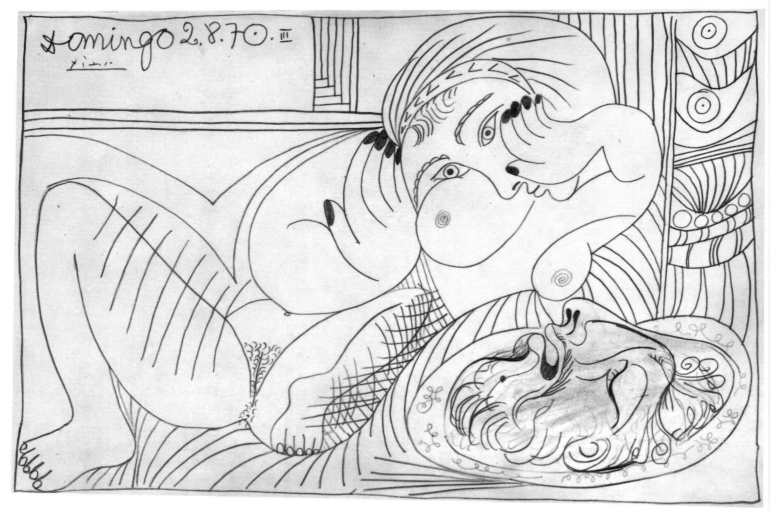

389

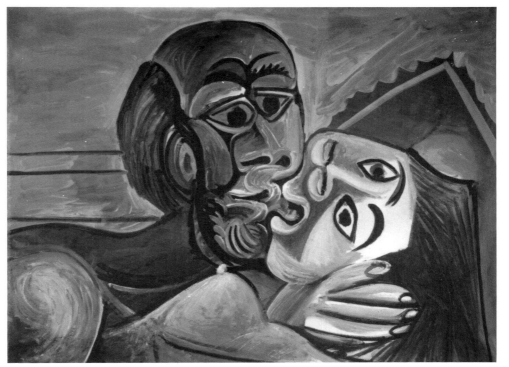

390

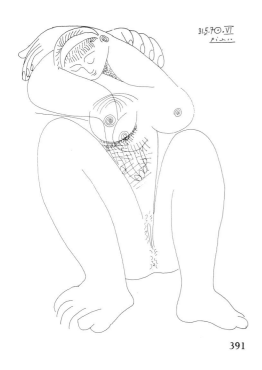

391

392

389 *Salome*, 1970.

390 *The Kiss*, 1969.

391 *Woman Sleeping*, 1970.

392 *Nude Woman and a Man*, 1969.

393

The Artist and his Model

Michel Leiris

394

394

393 *The Studio at 'La Californie'*, 1955.

394 *Sebastian Junyent Painting*, 1900.

More than one commentator has already remarked on the important rôle auto-biographical content played in the art of Picasso. His private life constantly showed through his work, either directly as, for example, in the portraits and in many figures, or in a highly allusive manner, and where one would least expect it, when, for example, the title of a song which happened to have a precise emotional relevance for the painter was inscribed in a still life. At the same time, as some of the most important works of this marvellously inventive man prove, his was an art which did not turn its back on public events outside the limits of his own acts and achievements in which he felt himself directly involved: these, the dreadful vicissitudes of our times, sometimes took precedence over his personal pre-occupations, and inspired Picasso to produce, not only *Guernica* (1937), the *Massacre in Korea* (1951) and some other major paintings, but also a two-part composition where Hope and Fear are balanced against one another; this huge ensemble, in a deconsecrated chapel in Vallauris, transformed since 1954 into the sanctuary of another kind of religion, illustrates the all too strident horrors of War, the longed-for delights of Peace and the Brotherhood of Man, which one is allowed to think will one day unite the people of all races.

Picasso never believed in the barren doctrine of 'art for art's sake', yet although he never neglected the outside world, and despite his full involvement in his own personal adventure, he treated the subject of art—in the sense of the practice of art—over and over again and in many different ways. However, one can hardly be surprised that he should so often have chosen to represent the silent dialogue between the painter and his model and other scenes based on the life of the artist in his studio, when one considers that, although not expressly a confession, nearly all his painting related to what was closest to him, to what he liked and knew best: the people, the familiar objects, even the animals of his immediate circle. Once one admits this, surely it is natural that he should have become obsessed with the activity which was the pivot of his life from his earliest years—I mean the practice of his art—as if with a privileged theme. This theme became gradually elevated almost to the realms of myth, and its hero is a painter—any painter, and not only the painter who signed himself 'Picasso'.

The subject of the artist at work first appears in the youthful drawing in the Picasso Museum in Barcelona depicting an artist in front of a painting which is placed on an easel; the Indian ink portrait, done in 1900, of the painter Sebastian Junyent at work, standing and seen from the back; and also the more ambitious works of 1903, the studies for *La Vie* and *La Vie* itself. In *La Vie* two easel paintings form part of the composition and echo the main subject of the painting which is the group formed by a nude man and woman, who seem to have been surprised in the intimacy of their studio (as later the saltimbanques will be surprised in the privacy of their shelter); to this group of a man and woman Picasso later added a woman and a child, the symbol of maternity. After these early works Picasso abandoned the

394

6

theme of the artist at work for a long time, but it was to reappear later on, and by way of numerous reincarnations was to be asserted with so much insistence that, however strong one's scruples may be against leaving the realm of aesthetics to risk oneself in the realm of psychology, one is forced to conclude that it corresponded to something very deep in Picasso.

The theme of the artist and his model made its entry into Picasso's art with a dozen etchings executed in 1927. By this time he was thoroughly experienced and had been much admired for many years, although his fame had not then reached the world-wide proportions it enjoys today. Related to this theme was the notion of the artist as a worker, and the theme of his perhaps paradoxical output which might or might not have originated directly in a human being. In these works the theme of the artist and his model becomes explicit, whereas in the earlier ones (apart from *La Vie* in which the nude couple appear in a place which must be a studio) only the painter himself or the pictures were shown—in other words, either a man painting was depicted or the painted objects. In the 1927 engravings, scenarios appeared that Picasso was to use time and time again in future years—not, of course, without modifications and additions, although he would always concentrate above all on the extraordinary potentiality for varied treatment that these settings possessed. In fact one could go so far as to say that this theme became for Picasso the foundation of much more than an ordinary 'series', and that, despite the great diversity of works springing from it, it has ultimately attained the generality of a pictorial genre with infinitely renewable contents—the genre of 'painter and model', just as one speaks of the genre of 'still life' or 'landscape'.

These etchings, all published by Ambroise Vollard, which initiated what was to

395 *Man Watching a Sleeping Woman*, 1904.

396 *The Studio*, 1927.

397 *Painter and Knitting Model*, 1927.

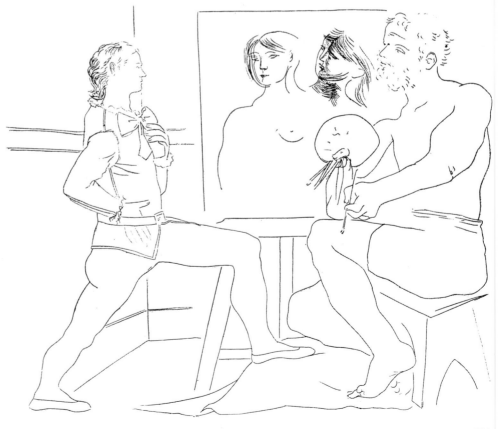

396

244

become so fruitful a production, were for the most part intended as illustrations for a book by Honoré de Balzac, *Le Chef-d'œuvre inconnu*. As is well known, the hero of this story is a man bent implacably on the pursuit of the ideal in the art of painting figures, yet also determined not to sacrifice any of their living reality; his search leads him, after heroic persistence, to make of the work an incomprehensible jumble of colours from which only a naked foot emerges, magnificently beautiful and alive. Surely it was inevitable that such a subject should attract Picasso. For many years Picasso himself had defied comprehension; not like the hero of Balzac's novel, a kind of blundering Pygmalion, but because he wanted to represent people and things in new ways, and because he responded to the creative rather than the imitative character of painting. All these engravings, supposedly based on the story, are of great classical purity—as if Picasso had adopted Balzac's aesthetic point of view but retained, as far as the subject matter is concerned, only the almost complete illegibility of the 'masterpiece', which to Balzac was the fruit of an aberration and the sign of failure. For all but one of the etchings have no precise connection with the text (indeed no connection at all, as for instance, in the case of the engraving representing a bull charging a horse), and when they do rejoin the text, they rejoin it only in the very generalized and superficial sense of the theme of the artist in his studio, usually accompanied by his model. Nevertheless, one should not interpret either Picasso's disregard for a close illustration of Balzac's book, or his choice of a style totally different from what might seem necessary, as the results of indifference, but instead as the signs of the extreme liberty which the originator of Cubism never ceased to manifest. And moreover, there remains one exception to this, which proves that Picasso has in no way misunderstood the implications of the subject—the engraving in which one sees a painter standing in front of his model who knits away like any respectable middle-class girl, while he works at a canvas which is hardly more than a jumble of lines, contrasting with the realistic fashion in which the knitting model is presented. This engraving seems to be in close contact with the idea suggested, at least to the modern reader, by the book (and after all, Balzac has confined himself to the particular case of a painter, who certainly has a genius but whose maniacal perfectionism results in a complete

397

399

failure of communication)—the idea of the occasionally enormous breach which can develop between the version of reality which the artist gives and which is clear to him, and the version of reality which the rest of the world sees, or rather, does not see. More than once Picasso would return to this idea (which he pushed to the point of farce in some of the drawings of 1953 and 1954 reproduced in number 29–30 of the *Verve Suite*, where groups of very different people are united in a studio examining with great respect a picture which they obviously don't understand at all), and he would also deliberately play on the theme of this breach between the version accessible to everyone and the version so personal that it is inevitably confusing. Thus, Picasso contrasted the still relatively photographic reproduction of a motif and its much more free representation in the same work, as if the two were equally valid. A good example of this can be found in a work of 1929, *Woman and Mirror*, where the reflection in the mirror of a very distorted, monstrous-looking figure shows a thoroughly classical profile, making one think that, under these circumstances, it is the reflection which constitutes reality—a paradox reminiscent of *The Painter and his Model* of 1928 where the almost naturalistic profile the painter has traced on his canvas is contrasted with two living people, both altered almost beyond recognition.

In the engravings of 1933 from the series known as the *Vollard Suite*, sculptors of antiquity instead of painters make their appearance. (There had already been precedents for these sculptors in several plates of *Le Chef-d'œuvre inconnu*, and they too had been escorted by their models.) They are shown either working or resting in front of groups of figures, or in front of other works which they have created and which in their style usually evoke Ancient Greece, but sometimes also a particular sculpture by Picasso which has classical characteristics. Forming semi-mythological scenes, these sculptors and their companions are joined, in defiance of chronology, by one bull-fighting scene (which, however, cannot be associated exactly with any historical period because it simply represents the bull charging a horse which has no harness). In this series, the theme of the gulf between

398

159

399

398

398 *Visit to the Studio*, 1954.

399 *The Sculptor Resting*, 1933.

400 *Painter and Model*, 1970.

401 *Painter and Model*, 1963.

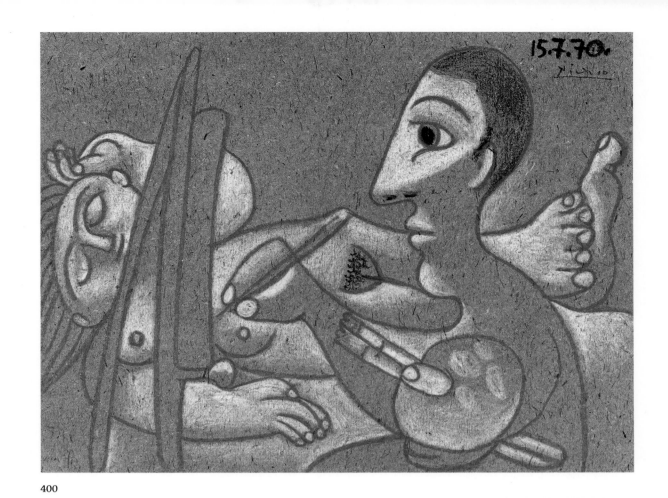

401 400

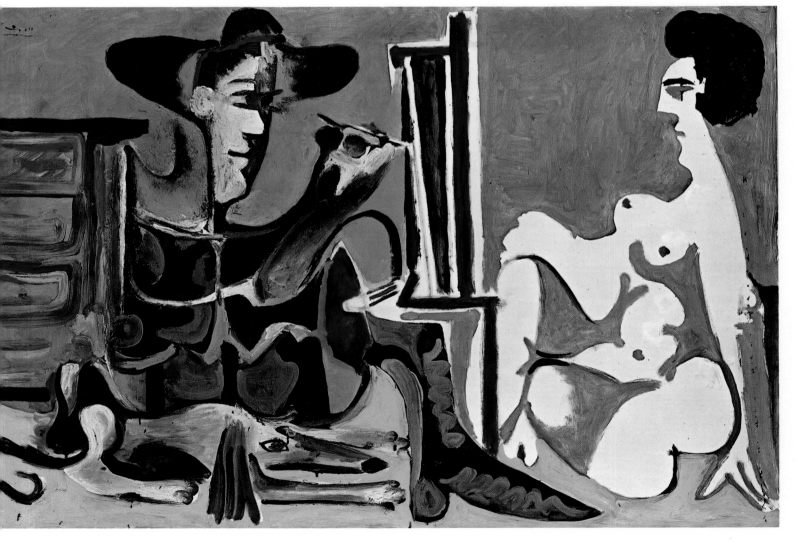

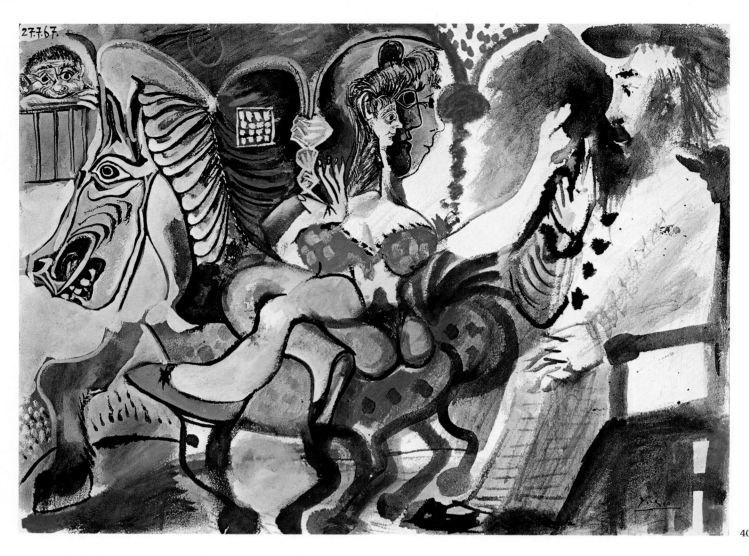

402

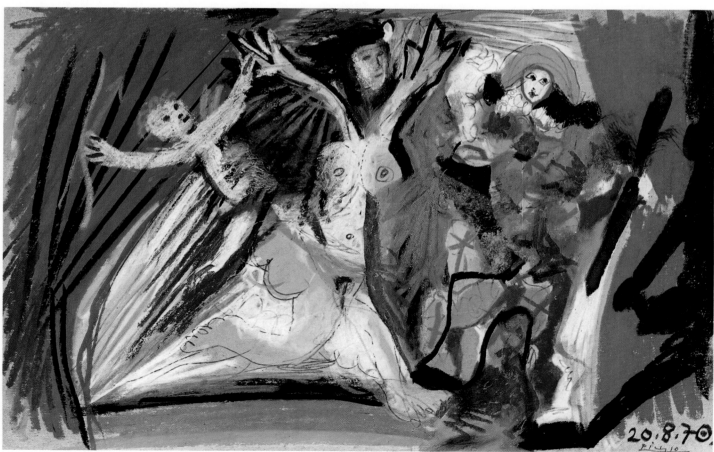

403

reality and works created by man is not abandoned, and one sees, for instance, a nude model beside a highly unnaturalistic statue which seems to be her own strangely altered image. 189

Moreover, if one can judge by the abundance of works which Picasso devoted to this theme, what seemed to interest him most is the confrontation of painter and model—considered as a confrontation: an abstraction made from the perhaps disconcerting result which this contact between the artist and reality can have.

In the paintings and graphics where the painter is shown working in front of his model, one notices that the results of this work done from life are, in fact, only rarely visible: the canvas in most cases is shown in profile, so that one cannot see 400 what is being drawn on this kind of screen dividing the artist and his model, and 401 thus their confrontation—at last offered in its pure state—seems to form the only subject of the picture. On the other hand, this confrontation to which the scene is usually reduced seems to have been for Picasso an imaginary creation, since he himself hardly ever worked directly from the subject and, at least during his later years used to lay his canvas flat down and not in the vertical position obviously imposed by an easel. This, then, was not something which actually happened in his own studio and which he could reproduce in a more or less disguised manner, but something which is traditionally reputed to happen in a painter's studio, and which Picasso offered as an epitome of his profession.

Another characteristic worth mentioning is this: although in the pictures of this type painted during recent years the model is almost always none other than Jacqueline (easily recognisable to anyone who knows her beautiful face, which is usually hardly indicated at all, yet not deliberately distorted, and suggested with the barest means), the painter on the other hand is only rarely identifiable as Picasso, and then only in the vaguest way. Often the interior setting is clearly localised, for in many works the painter and his model are placed in a studio which, thanks to details of architecture, sculptures on pedestals or objects fixed to walls, is immediately and definitely recognisable as the main room on the ground floor of La Californie, the villa which Picasso lived in when he painted these pictures. Yet 393 despite all this anecdotal precision of décor, the confrontation of the painter (who is only a painter) and his model (even though she is the one Picasso represented so often) appears to be much less a 'slice of life', which over and above its intrinsic quality would have value as a document on the author of the work, than a symbolic and somewhat dramatized representation of the activity of every practising painter or sculptor.

A painter before his canvas (sometimes flanked by a connoisseur or a colleague); a painter seriously working, looking at his model and sometimes being observed by her; a painter inactive in his studio, with the model by his side; a painter working with a group of models; a painter and his model installed out of doors; a painter with his brush pointing at the model; a painter painting on the actual body of the model (after the fashion for decorating women's skin in this way); a model usually nude or half-nude, but sometimes dressed or in disguise (for a fancy-dress ball, a theatrical performance or the reconstruction of some historical scene); a model sleeping while the painter works; a model supremely beautiful or, on the other hand, lined with age—just as painters of all types are represented, young or old, 404 inspired, authoritative or meticulous, of today, or several centuries ago, or of an unspecified antiquity. Men, women, and even monkeys wield palette and brush 405 or camera; and all these works, painted, drawn, or engraved, composing a vast 276 gallery so diverse that one begins to think that Picasso—not neglecting any of the possibilities the subject offers, but showing a marvellously varied series of artists

404

405

249

in action or repose, or simply all alone and equipped with their tools—had made himself the author of a sort of pictorial encyclopaedia, so exhaustive that anyone who consulted it would be able to say: 'This is what being a painter is all about'.

What indeed is a painter—living or dead, obscure or famous, academic or revolutionary (at least, if he belongs among the so-called 'figurative' artists, once the only category, and still now the most numerous)? Isn't he essentially someone whose hand in one way or another fixes on the canvas the elements supplied to him by his eyesight, either immediately or at some later time? If it is true to say that painting is supremely a visual art, one does not mean it simply in the sense that painting produces objects intended to be seen, but also in the sense that before the painter makes anything—even the least naturalistic representation possible—he must *have seen* with the greatest acuteness, he must have been, in the widest sense of the term, a kind of seer or visionary; not someone prey to hallucinations, but someone who will seize on things which escape others and will work from material amassed in this way, either using it as the basis for a direct transcription, or integrating it, an amalgamation of selected memories of what his eye has assimilated, into a composition which does not tally with the original facts, but which instead arises almost entirely from the imagination. One is, therefore, not being too sweeping if one suggests that when an artist treats the subject of the painter and his model— and as Picasso did, under varying forms but always in what one might call rough drafts of the central subject—he is in fact summarising, in vivid illustrations, the game in which every figurative artist is involved: for at the source of his work there is always a model or models, living beings or objects which offer themselves to his watching eyes in the manner of the professional model, whose job is to be observed, and whose naked body has formed the subject among subjects over the centuries—the Nude.

Picasso's eye never seemed to rest. It was an eye curious about everything, scrutinising everything, at the same time so attentive, so active, so penetrating. No one whose eye has met his eye could be surprised that the act of looking at what the outside presents assumed for Picasso an importance much greater than one would expect from an artist whose chief quality seems at first to be the discovery of form, rather than scrupulous observation. This is confirmed especially by the clear resemblance to the sitter he is able to give to even the least literal portrait, by the truth of many figures, which one assumes have been drawn from life, but which are in fact imaginary, and by works, minor works perhaps, which testify to a striking capacity to catch the immediately expressive detail. One could cite a number of fairly important paintings of which one could even say that the eye has played a more significant role than the hand, and that the hand has only intervened to give shape to what the eye had revealed. Then there are the sculptures which are really no more than assemblages, cast in bronze but created out of odds and ends, none of which have lost their identity, but all of which have been brought to blend into the unity of the whole, sculptures where visual puns have come into play during the process of creation: a child's toy car metamorphosed into the top of an ape's head, a fork into a bird's foot, the handle bars and saddle of a bicycle into a bull's head—these are only some examples of methods of creation which consist in exploiting, almost without the use of hands, equivalents which only an extraordinarily sharp eye would be able to establish. *To have known how to see in that way:* this was the stroke of genius. The most extreme example of this type was not a work which ever achieved anything of the permanence of a work of art, or even resulted in anything durable, but involved a use of the hands as simple and as rapid as Picasso's initial look must have been: the ephemeral *Venus*, wittily

406

contrived out of a gas-ring which one day Picasso had thought of standing upright.

If this is true, then surely Picasso was giving a kind of metaphorical translation of what he thought the most crucial moment when he put the painter face to face with his model and showed him looking at her? Taking Picasso's work as a whole, one does not have to research for long before one realizes that the action—almost the absence of action—of looking is one of the most frequent themes. A man contemplating a sleeping woman; a woman looking at herself in a mirror (which she holds herself or someone else, facing her, holds for her); a man sizing up or admiring a prostitute (a creature from a different sphere to him) whom a procuress presents to him (a theme which occurs from the earliest works); David watching Bethsheba washing herself (an engraving inspired by a painting by Cranach); a picador in a tavern relishing the spectacle of a woman dancing as if possessed by a devil; the painter himself appearing on his own canvas, especially in certain works of 1954, as if Picasso wanted to strip away the façade of convention and to suggest that the man who paints pictures is by definition a witness or *voyeur*, or to show that, caught in his own trap, the painter himself only exists in terms of his paintings. Sometimes people interpose a mask between themselves and those who are looking at them (occasionally, following the Spanish custom, a mask of a stuffed or artificial bull's head), and sometimes they unmask themselves: in these cases the emphasis is on the pretence which transforms the man looked at into something he is not and allows him to escape the other person's stare. They are examples of the games of truth versus falsehood that Picasso so often indulged in, not only in the engravings drawn spontaneously, almost automatically, and thus when he was at the mercy of his fancy, but also in some paintings; games which in their varied twists and turns express the element of doubt ever present in the world of appearances to which we are bound so tightly, and also the degree to which sight can mislead us: for instance, the reflection which could be taken for the original, the face uncovered versus the face masked, the natural object versus what art makes it (or *vice versa*), the model shown half as she really is and half as she appears drawn

395
48
407
380
406
426
409

407

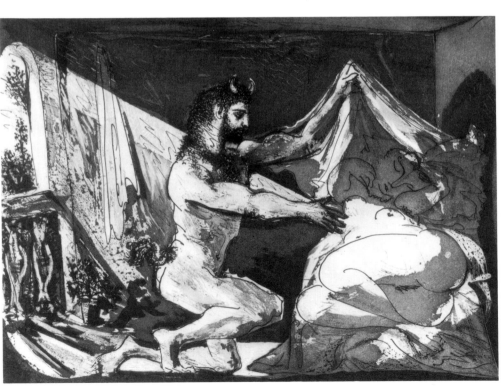

408

406 *David and Bathsheba*, 1947.

407 *Nude with a Mirror*, 1967.

408 *Faun Unveiling a Woman*, 1936.

on the canvas, as if there was no difference between the actual body and its pictorial representation. All these are so many proofs of the quite special interest which Picasso, himself a tireless observer, brought to bear on the most elementary method of communication with other people and things—the all-embracing look. Even in Picasso's plays one finds instances of this fascination with the confusions of sight, for example in the introduction of the game of hide-and-seek in *The Four Little Girls,* where time and again, after she has hidden herself, one of the four girls cries out the traditional words 'Ready!' In *Désir attrapé par la queue* there is a scene when after everyone has jumped into a bath full of soap suds, three men, leering and grinning, say to the Tart, the attractive *habituée* of the hero's *studio artistique,* 'I can see you!', and the same play finishes up with a scene in which all the characters mockingly point their fingers at one another, after covering up their eyes.

Confrontations, meetings, mutual discoveries are the basic themes of many compositions involving two or more characters between whom nothing is happening, except that they are looking at each other (for example, the woman and the rider in a drawing dated 26 June 1968, who exchange looks which Picasso has represented as lines coming out of their eyes). Elsewhere, in circus scenes, for instance, and in other carnival-like or quasi-mythological scenes, his real concern is with a spectacle, on one side the actors and on the other the spectators or acolytes, so that here the watching is one-sided, not reciprocal; and because a spectacle is involved and because a spectacle is made precisely to be looked at, the act of looking

411
402
410

thus assumes special importance. After all, isn't the legendary *Judgement of Paris* 412
(which Picasso dealt with in a large Indian ink drawing begun 31 March and finished
7 April 1951), simply one spectator looking at three women—a story whose
essence is a look and the three offerings dedicated to this look?

Not counting the fearful confrontation of the shooters and the shot in the
Massacre in Korea where, if there is an exchange of looks, it remains a secondary 340
element, the most dramatic and eloquent of the scenes whose main point is the
open defiance of two beings watching one another is certainly the extraordinary
Minotauromachia of 1935: while a woman with a bull fighter's costume, which is 301
half-torn so that it reveals her naked bosom, is lying inanimate on a wounded
horse, the monster advances towards a little girl who is carrying a bouquet of
flowers and a lighted candle; a frightened man hanging on to a ladder watches this
meeting over his shoulder, but two women who only have eyes for a pair of doves
resting on a window-sill seem not to notice it. The closed eyelids of the woman on
the horse, the fearsome glare of the monster, the gaze of the man escaping, the
lowered eyes of the two women engrossed in the doves, even the light held by the
unmoving child who seems to oppose quietly the advance of the half-man, half-
beast close to her—all these elements refer expressly to *sight* (to see or not to see,
to illuminate in order to reveal) in a composition dominated by an astounding
apparition, the Minotaur, his right arm held palm open as if to sweep everything
aside. This composition, a bullfight with all the grandeur of an ancient myth,

409 *Game with a Bull's Mask*, 1954.

410 *The Rehearsal*, 1954.

411

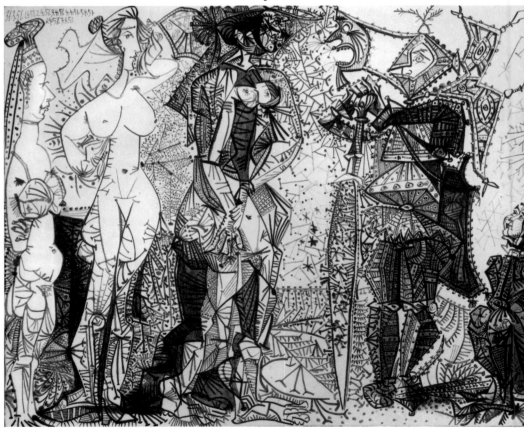

411 *Woman and Cavalier*, 1968.

412 *The Judgement of Paris*, 1951.

412

evokes for the spectator the idea of a tragic unveiling which the artist wished to build up to gradually by means of images that, rationally speaking, remain enigmatic.

The theme of the look and the rôle of the eye as a creative agent (which can replace the hand on occasion) are both very important in Picasso's work; yet it would be a gross misunderstanding of the wild exuberance of his genius to interpret the works on the subject of the painter and his model exclusively in those terms, and as if they were a deliberate and reasoned illustration of them. A man painting and a woman who poses for him form a couple, and the model therefore has a dual

413

414

function: she is both a subject and a woman. And this idea of a painter observing the nakedness of the model easily becomes associated with the idea of sex, an ambiguity that Picasso does not hesitate to exploit, as for instance is shown by some etchings based on a subject treated by Ingres, in which one sees Raphael 422 placing the carnal possession of La Fornarina higher than his pictorial possession of her, at least for the moment. The distance between the look which scrutinizes and the look which covets is so difficult to measure that it would be arbitrary to separate the two into watertight compartments. And there is no disturbance of continuity between scenes where Picasso shows a painter (with the tools that identify him) standing in front of the model (who has no distinguishing paraphernalia and is therefore simply a woman), between scenes concerned essentially with the artist's job, and those where, far from partnering her in a purely aesthetic undertaking, a man makes love to a woman who is often, after all, stripped of everything that could distinguish her from a model. Without any disruption, then, Picasso adds to the gallery of painters and models an astonishingly varied gallery of men and women, the protagonists of an erotic comedy which has many aspects, and which Picasso readily invests with the appearance of a simple masquerade illustrating the kind of play-acting that goes on between lovers, as well as the comedy of errors, to which the intrigues of seduction so often lead. The actors in this comedy sometimes push the use of the accessories they flaunt to the extreme limits of ambiguity, which is both enchanting or farcical: a winged cupid, 414

413 *The Masks*, 1954.

414 *L'Amour Masqué*, 1954.

255

for instance, hides his face behind a grotesque mask, or two lovers wear masks, one male and the other female, but each holds the mask appropriate to the other sex, both showing evident enjoyment in this exchange of roles as if they were participating in a light love comedy or some Shakespearian entertainment. In drawings and engravings of this type, the spirit of some *Midsummer Night's Dream* runs free. Such a spirit has no real parallel in the paintings, although they too have their share of humour and irony.

Indeed Picasso spent his life in trying out every means of translating reality into plastic terms or of making figures real. This is the result of his taste for experiment and invention: more important than the actual representation is the way it was arrived at; and in this sense, one can say that for Picasso the real subject of his work was always the work still to be done. It is conceivable that he could have tried out so many different ways of representing things without trying humour too, without experimenting each time to see what effect humour might produce?

Moreover, it is reasonable to suggest—and one would hardly be stretching a point—that after all his different 'periods' (illustrated usually with such abundance that one is tempted to compare them to a series of civilizations succeeding one another within him, and each one attested by characteristic masterpieces) Picasso may possibly have arrived at a period of indifference to periods. In his last years every means from the newest to the most traditional, from the most surprising to the most ordinary, seemed to him suitable for treating the old themes which surged up again. Retrospective by then, his sharp gaze was focused on his own work which he returned to, never repeating himself, in much the same way as he had previously turned to the work of other artists: so, for example, *Les Femmes d'Alger* (which can, after all, be considered as a group of models posing for Orientalist painters), *Le Déjeuner sur l'Herbe* (an artist's spree away from the studio) and *Las Meninas* (Velazquez in the midst of his royal models). This retrospection, allied with a certain degree of criticism, must surely, by definition, have involved irony?

415

The opinion, once quite widespread, that Picasso with his often baffling and revolutionary discoveries took a malicious pleasure in dumbfounding the public, is thankfully no longer held, at least by anyone with the slightest knowledge of the development of modern art or by anyone who knows simply that Picasso is the author of the famous *Dove* and *L'homme à l'agneau*. But there is a big difference between mocking people and having a sense of humour. To say that Picasso is not mocking, as the philistines have believed for much too long, is not to say that joking is absent from his work. It could be said, in fact, that one of the truly indisputable achievements of this man, in whom some have seen a practical joker, others a charlatan, and others still a kind of devil, is the introduction of comedy into great art, when so frequently the sublime is also the dull.

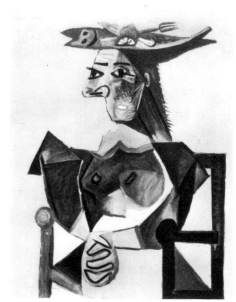

In a drawing of 1911 Picasso included a palette which bore the inscription 'Picasso, Artiste Peintre, 11, Bd. de Clichy, Paris', a humorous kind of signature he was to use again some thirty-five years later on one of the canvases assembled in an exhibition held in his honour in the Salon d'Automne just after the Liberation of Paris (an exhibition which, of course, did not fail to enrage some people). In this canvas a small boy appeared wearing a sailor's beret on which 'Picasso', masquerading as the name of a ship, was written in large printed letters. Equally comic, yet simultaneously of resounding grandeur, is the imposing figure dated 16 April 1965 of a kind of monumental goddess in classical draperies, who hitches up her clothing in order to empty her bladder into the sea, a frothing mass which one is tempted to believe she has created herself. Then a handsome and serious female portrait of 1943 shows the model crowned with a hat—pictorially a still life, made of a fish, a knife, a fork and half a lemon (a restaurant-hat instead of the

416

41

35

38

36

33

41

41

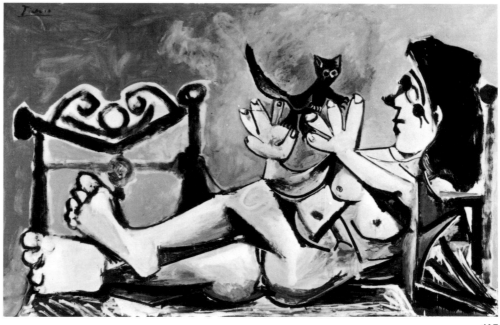

417

garden-hats which were fashionable at that time). Again, in a series of works derived from David's *Rape of the Sabines* a ridiculously anachronistic detail finds a place, both there for its own sake and as a part of the tumultuous confusion implicit in the subject: a young girl has fallen off her bicycle just as, if she had been a Sabine, she might have fallen off an overturned chariot. Finally, Picasso, the first to be amused by the inherent contrast between the earthy themes of these works and the noble treatment given to them, did not hesitate to release the element of absurdity in a similar contrast when he privately described as 'genre paintings' canvases which he painted some years later on a theme worthy of the magazine *La Vie Parisienne*—a naked woman playing with a kitten. So many foolish things 417 have been said by those who thought Picasso was an artist who delighted in insulting beauty, that it is necessary to emphasize that such works—and the list of them could be augmented—are too noble in appearance to be considered simply in terms of caricature. All one must admit is that over the years Picasso's genius developed such richness that, without lowering himself, he could indulge what in anyone else would probably be an insignificant quirk, but in him was the sign, if any were needed, of the sovereign ease which confirmed the authenticity of his genius.

Was this merely letting his natural sense of humour have its head? Irony at the expense of a profession he has practised almost since childhood and whose ins and outs he knew only too well? A reaction against the ponderousness so often a part of genius? Several theories could be proposed simultaneously to explain this undeniable fact: that as his fame increased the comic vein in Picasso's work became more obvious. This tendency is especially visible in his manner of treating the theme of the painter and his model in the last twenty years, so different from the time of *Le Chef-d'œuvre inconnu* and the *Vollard Suite*.

Treated in a classical spirit which leaves no room for particularization, these two series of engravings show painters or sculptors and their models, sometimes in an abstracted Graeco-Roman antiquity, sometimes deprived of any references enabling one to assign them any specific status. For this whole earlier period, it seems that the subject was treated under its universal and timeless aspect: the artist by the side of or looking at his model—the man whose job has always been (anyway in the framework of western civilisation) to represent this human being more or less faithfully as she is. Perhaps what Picasso has expressed is the true essence of every figurative artist's activity, an activity which forms one of the

415 *The Butterfly Hunter*, 1938.

416 *Seated Woman in a Hat*, 1943.

417 *Woman with a Kitten*, 1964.

principal means of contact between man and nature (here represented by a woman's body), and which, seen in its general perspective and without characterizing the protagonists, escapes historic time and place.

If it is imprudent to establish a correlation between the evolution of his art and particular events in the artist's life, it is at least permissible to indicate certain coincidences. For in fact one does notice the appearance of a new manner of treating the theme of the artist and his model in the series of drawings of 1953–54, collected as the *Verve Suite*, which corresponds chronologically to a period of crisis in Picasso's private life. It is as if, feeling himself just as vulnerable as any ordinary man, despite his genius and his fame, Picasso abandoned the figure of the generalized artist—the anonymous hero of a kind of myth about the birth of images—in order to concentrate only on particular painters, who would not be turned into supermen as a result of their art. Now Picasso individualized and differentiated these characters, noting the mannerisms of each of his reincarnations in so incisive a way that he sometimes came close to caricature. That, perhaps, was the way he worked. But if this hypothesis is correct, and if one looks at the situation in this light, isn't one writing rather journalistically about a process of revaluation which, after all, had no need of an external catalyst to trigger it off, since one of Picasso's fundamental qualities was always to set off constantly on some new track, and never to rest on his earlier achievements? Whatever we may think, this series of drawings in which many old themes were taken up again, half poetically, half comically, and with some degree of detachment, implicitly evokes the idea of one of those returns into oneself which one falls back upon when difficult circumstances demand it. Of all subjects, the painter and his model could least hope to escape the ambiguous revaluation—tender as well as caustic—that Picasso had set in motion. He did not stop at referring to his own personal 'folklore', redoing everything in different ways; he also invented new dramas, which turned on the confrontation of the actors of both sexes—a confrontation which was often reduced to a paradoxical meeting between creatures of very different kinds.

418

Whether or not a precise event in his life was the cause, a satirical or at least anecdotal attitude tended to replace the one which, until then, had created a kind of mythology out of the subject of the artist and his model. Picasso was not debasing for the sake of it, but was watching the spectacle mercilessly and not without amusement. Painters are shown as they really are, with models who are not necessarily beauties. Once stripped of the romantic halo which we are only too ready to accord to any artist, why should painters be any different from other people? Like the members of any profession, their chances are not equal, they can be ridiculous, just as they can be conventional, need not even be eccentric, and like everyone, grow old. Picasso shows them of all types and of all ages, and he makes us observe one of them grow old, a man with a short beard and a head completely bald except for a few hairs, to whom Picasso returned in a second drawing made on the same day (5 February 1967) as if to someone he had not seen for some time and who, in the interval, had visibly increased his waistline and his self-importance.

420

421

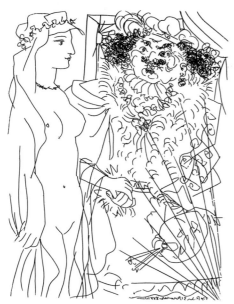

419

In Picasso's representations of the painter and his model one can observe the development of an irony which often turns the subject into comedy; and one cannot miss the scent of irony in certain of the first works he had devoted to this theme, such as the painter with his jumble of lines facing the knitting girl, or the model considering a statue in which she seems to be straining to recognize a woman's body. However, despite this growing irony, especially obvious in the drawings and engravings, one finds many canvases dating from recent years and treating the same or connected themes which cannot be considered comical. This is the case, not only with most of the variously sized canvases depicting the painter and his

258

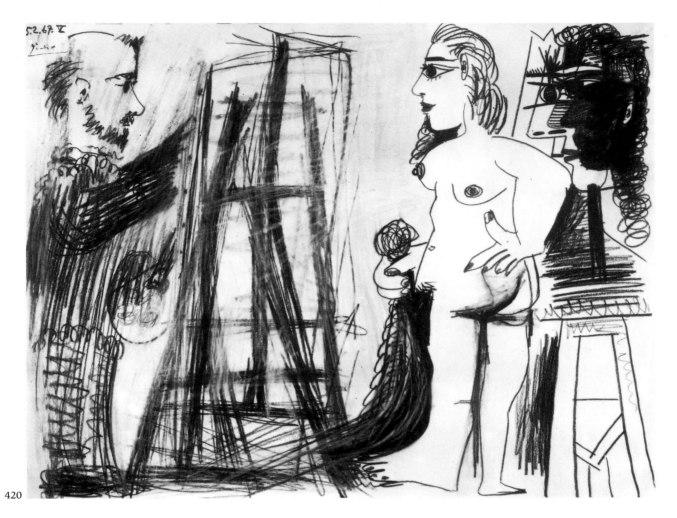

420

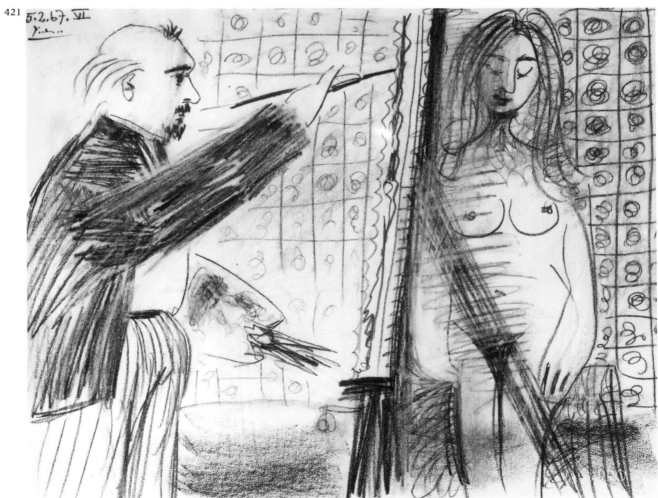

421

model, but also with the sumptuous Studios, and with the extraordinary imaginary portraits of painters of centuries gone by. This theme was announced in the five etchings of Rembrandt done in 1934, and is found again in the 1950 *Portrait of a Painter after El Greco,* before it reached its full expression in the stunning and explosive works representing artists of earlier times, almost all alive, as it happens, in the seventeenth century, who are given the same truculent appearance as the musketeers Picasso painted at the same period.

Doubtless, it was not without irony that Picasso, the revolutionary, approached his colleagues of the great classical periods, as if he wished to state that they were all in the same boat together, and that throughout time, despite the succession of people and the variations of style, painters are always painters and painting is always painting. It is an irony which seems to contain no mockery of his predecessors, but which echoes the ambiguity common to all the arts: the grandeur and the ridiculousness in the perpetuity of painting, for painting is endowed both with a kind of eternity, since it has existed since time immemorial and does not seem to be dying out now, and yet with routine, which is inescapable, for the painter is simply a wielder of brushes, whether or not he wears a ruff and a periwig, whether he is Rembrandt, Velazquez, Picasso or anybody else from the guild of picture-makers.

If Picasso's works often carry the visible seal of irony and if he was already deep in irony (directed against himself as well as others) when he chose as his subject either the painter (who is none other than an *alter ego,* whatever the ostensible century), or the work of the painter assisted by his model, it seems that this irony resulted not so much from a mocking attitude to life as from a kind of mental hygiene, and that it rested not on a desire to disparage, but rather on the need to pursue—to sift, to examine pitilessly, to detach himself from—the very thing that he thought most important. Not to delude himself; not to be duped by the things he loved; to know that art—which some, placing it too high, see as a sacrament, and others, placing it too low, as a craft—can only be valuably practised as a manic obsession or a game—a great and glorious game, it is true, which can be played to the utmost limit, as is shown—in painting—by Van Gogh's madness and shorn ear.

Many of Picasso's important sayings about his art have been reported. Really one should say his *arts,* for his works were both various in style and in means of expression: painting, sculpture, ceramics, and the different kinds of graphic art, each pursued relentlessly as if he had determined to experiment with everything, including architecture (as several pictures show where minute people are placed beside figures which thus appear to be monuments erected out of doors), and had also wanted to push the possibilities of each technique to the absolute limits. Yet Picasso, unlike his contemporaries Braque, Gris and Leger, and other more recent artists, never tried to *theorize* about his art. Although there is plenty of verbal proof that he often reflected profoundly on the activity which occupied him for so many years, it was a capricious kind of thinking that shied away from philosophical or didactic pretentiousness and was expressed—ironically—in witticisms. This irony was perceptible in his conversation as well as in his work; and supported by his inveterate impulse to dispute his own progress with himself, it prevented him from settling down and forced him to renew himself constantly. Indeed, without this irony, would Picasso have invented all these types of painting which, although each is unquestionably stamped with his personality, are so numerous and so various that one could be forgiven for thinking that they issued, not from one man, but from this chequered mass of painters he represented at work or during their leisure moments? With reference to his art, this irony indicates the degree of detachment that Picasso maintained from his profession, which he looked

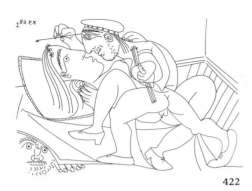

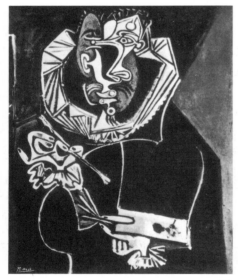

422 *Raphael and La Fornarina,* 1968.

423 *Portrait of a Painter after El Greco,* 1950.

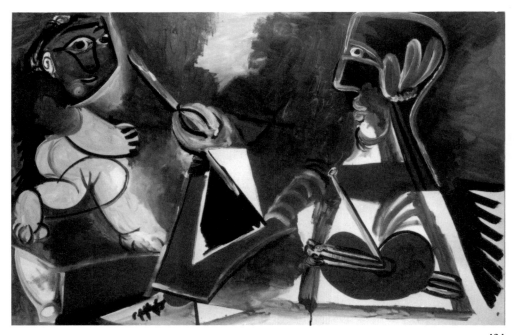

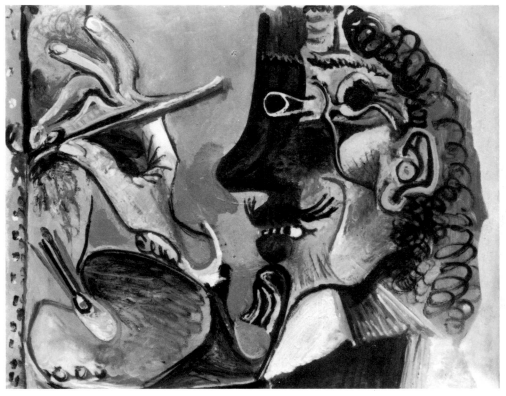

at objectively from all angles, and which he subjected, at the very moment of creation, to a brand of self-criticism that did not hold him back but spurred him on. And yet, paradoxically, this irony also expresses Picasso's passionate commitment to his profession, which he valued at its proper rate (for he realized that it is simply a human industry) but to which he tended increasingly to devote all his time.

Quite rightly one speaks of the 'heroic years' when referring to the first period of Cubism—years when a group of artists initiated a revolution which, although limited to the realm of the plastic arts, upset many accepted notions and magnificently prepared the way for ventures which called everything in question—first

424 *Classical Painter*, 1969.

425 *Seventeenth-Century Painter*, 1967.

261

Dada and Surrealism, then more recent movements. Without trying to create a scandal, the Cubists excited surprise and condemnation because the breach was huge between artists who, like the Impressionists, had striven to paint what they saw immediately around them and the Cubists themselves, who did not avoid using what they had seen but had determined on a quite different aim, and did not seek to reproduce exactly, without destroying natural appearances, a unique and datable vision as the Impressionists had done. Today it is difficult to think without emotion of this period, now more than fifty years old, which was lived through by painters who pursued their search, despite derision and hard material conditions—a search which would have seemed as crazily unreasonable to Balzac as the quest of the principal character *Le Chef-d'œuvre inconnu*. Picasso was one of those painters, and although his achievements were considerable since youth onwards, one can see that his spirit of discovery was never blunted. At the end, despite wealth and glory, he still knew how to remain an artist who observes and strives as doggedly as if he still had everything to learn.

426

Picasso did not make art a religion, and he often made *The Painter and his Model,* for instance, a receptacle for his irony; but this does not mean at all that he rejected the myth of the artist as of only marginal interest—a European myth whose origins go back to Romanticism, and which expresses a denial of the ways and customs of our bourgeois society. Quite the contrary, it seems that being an outsider of this type was one of the guiding forces of his life. In his work he has, in fact, without any satirical intention, accorded a privileged place to the most typical outsiders of all, those whose art is not acknowledged as one of the 'fine arts': the saltimbanques, the Harlequins of the *Commedia dell'Arte*, circus people (clowns, acrobats, or riders), the musicians no one will hear in a concert hall, as well as the bullfighters—who may frequently be stars today, but originally were such wretched creatures that when the matador who had laboured so brilliantly was given the dead bull's ear, it meant that his victim's body belonged to him, and he could sell it as butcher's meat. Remaining a romantic in the midst of the machine age, Picasso painted several portraits of Jacqueline in Turkish costume, just as any member of the *coterie* of the Rue du Doyenné might have done for his mistress—his Cydalise, his Lorry or his Victorine—in Nerval's descriptions in the first part of *Les Petits Châteaux de Bohème*.

The son of a painter, Picasso liked to tell how one day when he was still very young, his father, José Ruiz Blasco, ceremoniously handed to him his palette and brushes, just as the older matador used to hand his sword and red flag to the novice he was solemnly investing according to the correct procedure for succession. No pretentious intellectual but a working artist—this is what Picasso remained by some miracle, as if, a bohemian to his death, he had come from a family just as unconventional as the strolling players or the matadors of the old days.

427

426 *Dancer and Picador*, 1960.

427 *Portrait of Jacqueline in Turkish Costume*, 1955.

Notes on the chapters

Zervos, followed by a Roman number, refers to Christian Zervos's catalogue raisonné: *Pablo Picasso: Oeuvres*, Paris 1932– (twenty-three volumes to date).

1. Themes of Love and Death in Picasso's Early Work *Theodore Reff*

1. There are two important exceptions, both inaccessible to most English readers: J. Runnqvist, *Minotauros, en Studie i Förhallandet Mellan Iconografi och Form i Picassos Konst, 1900-1937*, Stockholm, 1959; and P. Palme, 'La Vie: Ett Dödsmotiv hos den Unge Picasso', *Paletten*, I, 1967, pp. 22–35.

2. F. Fagus, 'Peintres espagnols', *Revue Blanche*, 1 September 1902; quoted in P. Daix and G. Boudaille, *Picasso, The Blue and Rose Periods*, Greenwich, Conn., 1966, under no. VI.17.

3. Zervos, VI, 77, 79; XXI, 44; I, 2; XXI, 49, respectively. Cf. also J.-E. Cirlot, *Picasso, Birth of a Genius*, London, 1972, figs. 57–60, another religious subject and the studies for it.

4. Zervos, VI, 186; cf. VI, 180, 182, 184; XXL, 61, 63: and Cirlot, *Picasso*, figs. 174, 176.

5. Zervos, VI, 390; XXII, 6.

6. A. Blunt and P. Pool, *Picasso, The Formative Years*, Greenwich, Conn., 1962, caption of ill. 109–110: T. Reff, review of same in *Art Bulletin*, 48, 1966, p. 266.

7. Blunt and Pool, *Picasso*, caption of ill. 105–110.

8. J. Sabartès, *Picasso, An Intimate Portrait*, trans. A. Flores, New York, 1948, p. 77.

9. J. Palau I Fabre, '1900: A Friend of His Youth', *Homage to Picasso*, ed. G. di San Lazarro, New York, 1971, pp. 3–4. Cf. A. Cirici-Pellicer, *El Arte modernista catalan*, Barcelona, 1951, pp. 418–424 on Casagemas' work.

10. Zervos, VI, 132, 219, 240, 241; XXI, 116.

11. X. de Salas, 'Some Notes on a Letter of Picasso', *Burlington Magazine*, 102, 1960, p. 484. Cf. Sabartès, *Picasso*, p. 48.

12. Below, pp. 46–47; translated from J. Pla, *Vida de Manolo, contada per ell mateix*, Barcelona, 1953 (first ed., 1927), pp. 104–107 by my colleague Steven Ketly. Only Per Palme, in 'La Vie', pp. 28, 31, seems to have drawn on it.

13. The sequence of events given by de Salas is inaccurate, since it is known that they spent New Year's together in Málaga and then parted, Picasso going to Madrid, Casagemas returning to Barcelona for about six weeks and then to Paris in mid-February. Cf. J. Palau I Fabre, *Picasso en Cataluña*, Barcelona, 1966, pp. 74, 84; Cirlot, *Picasso*, p. 108; and Manolo's memoir.

14. Cf. notes 88, 90, below.

15. Published in Daix and Boudaille, *Picasso*, p. 338. Cf. P. Daix, 'La Période bleue de Picasso et le suicide de Casagemas', *Gazette des Beaux-Arts*, 69, 1967, pp. 239–246.

16. Palau I Fabre, 'A Friend of His Youth', p. 5.

17. Pla, *Vida de Manolo*, p. 106.

18. Quoted in Daix and Boudaille, *Picasso*, under no. V.45.

19. Pla, *Vida de Manolo*, p. 106.

20. The latter is Zervos, XXI, 179; reproduced in colour in Daix and Boudaille, *Picasso*, p. 192.

21. Zervos, IX, 239, 240. Cf. R. Arnheim, *Picasso's Guernica, The Genesis of a Painting*, Berkeley and Los Angeles, 1962, pp. 40–41, 46–47, etc.; and A. H. Barr, Jr., *Picasso, Fifty Years of His Art*, New York, 1946, p. 193.

22. Cf., for example, J.-B. de la Faille, *The Works of Vincent van Gogh*, New York, 1970, nos. F604, F499. Seventy-one works by van Gogh were shown at the Bernheim-Jeune gallery in Paris in March 1901, but it is not known whether these two were among them.

23. On Picasso's interest in him at this time, cf. Blunt and Pool, *Picasso*, caption of ill. 74–80.

24. A. Cirici-Pellicer, *Picasso avant Picasso*, trans. M. de Floris and V. Gasol, Geneva, 1950, p. 68.

25. De Salas, 'Letter of Picasso', p. 484. Cf. H. E. Wethey, *El Greco and His School*, Princeton, 1962, figs. 99, 100.

26. Blunt and Pool, *Picasso*, caption of ill. 99–104. Three more studies are published in Cirlot, *Picasso*, figs. 213, 214, 261: the first two show the Entombment type of composition; the third, showing a nude woman standing behind the deceased, is related to the other type.

27. Palau I Fabre, 'A Friend of His Youth', p. 11.

28. Sabartès, *Picasso*, p. 70.

29. According to Palme, 'La Vie', pp. 31–32, blue, grey, and green tones already predominate in *The Mourners*. Cf. also the comments on *Casagemas in His Coffin*, p. 16, above.

30. It was published recently as *El Entierro del Conde de Orgaz*, Barcelona, 1970. On Picasso's early interest in El Greco, cf. de Salas, 'Letter of Picasso', p. 484.

31. Cirlot, *Picasso*, fig. 159; cf. also the oil sketch, fig. 150.

32. M. Sanchez-Camargo, *La Muerte y la pintura española*, Madrid, 1954, pp. 331–336, with ill.; also pp. 187–191, 303–306 for other examples. According to Palau I Fabre, 'A Friend of His Youth', p. 11, Picasso's composition more closely resembles another El Greco, the so-called *Dream of Philip II* in the Escorial; cf. Wethey, *El Greco*, figs. 65, 66.

33. On this point, cf. Runnqvist, *Minotauros*, p. 13.

34. According to Blunt and Pool, *Picasso*, p. 15, the two nudes stand for sacred love; but if this would better explain their nudity, it would not account for their gestures or marginal positions. According to Palme, 'La Vie', p. 32, the embracing couple consists of two sisters, rather than a man and woman; but closer observation shows this to be incorrect.

35. Letter to Max Jacob, 1902; quoted in R. Penrose, *Picasso, His Life and Work*, London, 1958, pp. 85–86.

36. Palme, 'La Vie', p. 28. Palme's further suggestion, that the younger woman is identical with the younger one in *La Vie*, is unconvincing.

37. Cf., in this order, Daix and Boudaille, *Picasso*, nos. A.14, D.VII.6, D.VII.4, D.VII.22, and Cirlot, *Picasso*, figs. 270, 267 (incorrectly identified as a study for *La Vie*).

38. F. Gilot and C. Lake, *Life with Picasso*, New York, 1964, p. 84.

39. Blunt and Pool, *Picasso*, p. 15.

40. M. Omer, 'Picasso's Horse: Its Iconography', *Print Collector's Newsletter*, 2, 1971, p. 74. Palme's suggestion in 'La Vie', p. 32, that the horse is a 'wingless Pegasus' seems unconvincing, despite Picasso's later interest in the Pegasus motive; for that, cf. Arnheim, *Picasso's Guernica*, pp. 40–41.

41. On this and other examples of the white horse in religion and mythology, cf. J. Chevalier *et al.*, *Dictionnaire des symboles*, Paris, 1969, s.v. 'Cheval'.

42. Cf. R. Kaufmann, 'Picasso's Crucifixion of 1930', *Burlington Magazine*, 111, 1969, pp. 553–561.

43. Cf. R. Alley, *Picasso: The Three Dancers* (Charlton Lecture on Art), University of Newcastle upon Tyne, 1967 (publ. 1970), pp. 11–16.

44. De Salas, 'Letter of Picasso', p. 484. Palau I Fabre, 'A Friend of His Youth', p. 12.

45. Zervos, I, 143.

46. Cf. M. Praz, *The Romantic Agony*, trans. A. Davidson, New York, 1956, pp. 291–305, with many literary examples as well.

47. G. Apollinaire, *Oeuvres poétiques*, ed. M. Adéma and M. Décaudin, Paris, 1959, pp. 86, 1055–1056. Cf. also the description in Sabartès, *Picasso*, p. 94 of a mural Picasso painted in his apartment in 1903.

48. Pla, *Vida de Manolo*, p. 104.

49. On this point, cf. Palau I Fabre, 'A Friend of His Youth', p. 12.

50. Although *La Vie* is usually dated 1903, since one of the preparatory studies is inscribed 2 May 1903 (Daix and Boudaille, *Picasso*, no. D.IX.5), Picasso has told Palau I Fabre that it was painted in a studio he inhabited in 1904; cf. *Picasso en Cataluña*, p. 120.

51. Compare Picasso's reaction to the suicide of the painter Wiegels in 1908 and his recollection of it in painting *Guernica* thirty years later; note 137, below.

52. Daix and Boudaille, *Picasso*, p. 60 and no. D.IX.5. A stylistic connection with Gauguin is also drawn in G. H. Hamilton, *Painting and Sculpture in Europe, 1880 to 1940*, Baltimore, 1967, p. 89.

53. F. Cachin, *Gauguin*, Paris, 1968, p. 323. For *Ia Orana Maria*, cf. G. Wildenstein, *Gauguin*, Paris, 1964, no. 428.

54. On this point, cf. Runnqvist, *Minotauros*, p. 14.

55. Palau I Fabre, in 'A Friend of His Youth', p. 11, hints that Picasso introduced the mother and child into *The Mourners* for the same reason, but later was unwilling to acknowledge this.

56. Cf. Palau I Fabre, *Picasso en Cataluña*, p. 120.

57. Cirici-Pellicer, *Picasso*, p. 52. The comparison is made in Blunt and Pool, *Picasso*, caption of ill. 115–119.

58. Cf. notes 131, 133, below.

59. Compare the related pictures, Zervos, I, 162; VI, 550; those of a proletarian couple embracing, I, 24, 25; and those of a prostitute and client embracing, I, 26; VI, 320. Together, they span the range of attitudes toward love in Picasso's early work.

60. Blunt and Pool, *Picasso*, p. 21 and caption of ill. 46. Although the latter (dated 1894, not 1902 or 1899 as stated there) would not have been known to Picasso when he painted *La Vie*, he may have seen the etched and lithographed variants. Cf. Palme, 'La Vie', p. 27; and W. Timm, *The Graphic Art of Edvard Munch*, Greenwich, Conn., 1969, pls. 22, 23.

61. Palme, 'La Vie', p. 28.

62. Cf. C. Gottlieb, 'Picasso's *Girl Before a Mirror*', *Journal of Aesthetics and Art Criticism*, 24, 1966, pp. 509–518.

63. According to Palme, 'La Vie', pp. 24, 28, this connection is already drawn in Runnqvist's *Minotauros*, but I have been unable to find it there.

64. H. W. Singer, *Max Klingers Radierungen, Stiche und Steindrucke*, Berlin, 1909, no. 233. For the other versions cited, cf. T. Reff, 'Cézanne and Hercules', *Art Bulletin*, 48, 1966, p. 36.

65. E. Guldan, *Eva und Maria, Eine Antithese als Bildmotiv*, Graz and Cologne, 1966, pp. 213–214 and pl. 131; cf. also p. 222 and pl. 158.

66. Wildenstein, *Gauguin*, no. 628; cf. nos. 389, 390. J. H. Langaard and R. Revold, *Edvard Munch*, trans. M. Bullock, New York, 1964, pl. 25; cf. also pl. 16 and the *Adam and Eve* of 1908 in the Oslo Municipal Collections.

67. Zervos, VI, 176. Its significance was first observed by Runnqvist, in *Minotauros*, p. 14.

68. Zervos, VI, 438, the sketch at the lower right.

69. Timm, *Edvard Munch*, pls. 35, 75, respectively. On this connection, cf. Palme, 'La Vie', p. 27.

70. De la Faille, *Van Gogh*, no. F1655, of which only three exempla are listed. The comparison is made in Blunt and Pool, *Picasso*, caption of ill. 115–119; in Hamilton, *Painting and Sculpture*, p. 89; and in Palme, 'La Vie', p. 27. The latter also refers to Munch's lithograph *Ashes* and his woodcut *Melancholy*, for which cf. Timm, *Edvard Munch*, pl. 76 and fig. 14, respectively. A more convincing example visually in his etching *Old Woman on a Bench*; *ibid.*, pl. 87.

71. F. Antal, *Fuseli Studies*, London, 1956, pp. 92–94 and pl. 34. C. de Tolnay, *Michelangelo*, Princeton, 1943–60, III, figs. 279–285. According to officials of the Cleveland Museum of Art, X-ray photographs of this area of *La Vie* have never been made.

72. Cf., in this order, Cirlot, *Picasso*, figs. 269, 266, and Daix and Boudaille, *Picasso*, nos. D.IX.4, D.IX.5. Incorrectly identified as additional studies are Cirlot, figs. 262, 267.

73. Runnqvist, *Minotauros*, p. 14. Zervos, XXII, 117, dates this drawing 1904, but Daix and Boudaille, *Picasso*, no. D.IX.24, observe correctly that it may be earlier.

74. J. Palau I Fabre, *Picasso per Picasso*, Barcelona, 1970, pp. 90–91.

75. Gilot and Lake, *Life with Picasso*, p. 350.

76. Presumably painted in Barcelona before Picasso returned to Paris in the spring of 1904, this portrait was reproduced in *Forma*, I, 1904, p. 374.

77. Zervos, I, 57, 92, 79, respectively.

78. Zervos, I, 135; VI, 482; I, 232; VI, 798; XXII, 188, respectively.

79. Zervos, XXII, 121; I, 208; I, 197, respectively. The woman in *The Tragedy* seems to be based on Feuerbach's painting *By the Sea*; cf. H. Uhde-Bernays, *Feuerbach, Des Meisters Gemälde*, Stuttgart and Berlin, 1913, p. 146.

80. Zervos, XXII, 159; I, 186.

81. V. Pandolfi, *La Commedia dell'arte*, Florence, 1957–61, V, p. 410. Its location is given as the Museo Correr in Venice, but the latter's catalogue does not mention it.

82. C. Goldoni, *Commedie*, Venice, 1934, IV, pp. 171ff. (*La Femmine puntigliose*, Act III), pp. 305ff. (*L'Amante militare*, Act III). J. Byam Shaw, *The Drawings of Domenico Tiepolo*, London, 1962, pl. 96 (*The Last Illness of Punchinello*). Champfleury [J. Husson], *Souvenirs des funambules*, Paris, 1859, pp. 7–13 (*Pierrot valet de la mort*), pp. 61–73 (*Pierrot pendu*). I owe this information to Dr. David Allen, Baltimore.

83. A. G. Lehmann, 'Pierrot and Fin de Siècle', *Romantic Mythologies*, ed. I. Fletcher, London, 1967, pp. 209–223. E. Welsford, *The Fool, His Social and Literary History*, New York, 1935, pp. 307–308 on Willette.

84. H. Macfall, *Aubrey Beardsley*, London, 1928, pp. 89–91. On its relation to *The Death of Harlequin*, cf. Blunt and Pool, *Picasso*, caption of ill. 134–138; however, it was not 'an illustration to Ernest Dowson's play *The Pierrot of the Minute*', nor was it 'reproduced in *Joventut*', though it was published a second time in *The Later Work of Aubrey Beardsley*, London, 1900, pl. 126, and A. de Riquer did discuss it at length in *Joventut*, I, 1900, p. 10.

85. Zervos, XXII, 334. Roughly translated, the note reads: 'the lady who holds her hand on the pillow—it wouldn't be bad if she raised a handkerchief which were placed above the face [heart?] of the dead man.' Other preliminary studies are Zervos, XXII, 335, 337.

86. Zervos, VIII, 287, a study for the stage curtain for a production of Romain Rolland's *Quatorze Juillet*. On its place in the Minotaur cycle, cf. Runnqvist, *Minotauros*, p. 134, p. 173, note 16. There was, however, a postscript, a drawing dated 2 December 1937, in which the dying Minotaur figures for the last time; cf. R. Penrose, 'Beauty and the

Monster', this volume, p. 178.

87. Zervos, XXII, 337. However, according to Daix and Boudaille, *Picasso*, no. XII.27, the painting was bought from Picasso in 1905–06.

88. Public Education Association, New York, *Picasso, An American Tribute*, 25 April–12 May 1962, works of 1895–1909, no. 16.

89. M. G. Dortu, *Toulouse-Lautrec et son oeuvre*, New York, 1971, II, no. 429; cf. also II, no. 399; III, no. 516.

90. Gilot and Lake, *Life with Picasso*, p. 82.

91. Sabartès, *Picasso*, p. 74; cf. also p. 76: 'Germaine would take care of sending Pichot along' to paint murals at the Café Zut. This is also the opinion of Alley, *Picasso*, p. 17.

92. G. Stein, *The Autobiography of Alice B. Toklas*, New York, 1933, pp. 29–30, 33.

93. A. B. Toklas, *What is Remembered*, New York, 1963, p. 29; cf. the further remarks on Germaine Pichot, p. 35.

94. Daix and Boudaille, *Picasso*, no. VII.8. Cf. also the photograph of her in 1900, reproduced in Palau I Fabre, 'A Friend of His Youth', p. 12.

95. Palme, 'La Vie', p. 28. Among the other examples he cites is the watercolour, Zervos, I, 95.

96. Published in Palau I Fabre, 'A Friend of His Youth', p. 12.

97. This would, at least, account for his frequent portrayal of her at the time, as well as his presence at her side in the studies for *La Vie* and in *At the Lapin Agile*. It would also account for his later visit with Françoise Gilot and his still later willingness to identify her in the early works.

98. Cf. Alley, *Picasso*, pp. 5–6, 17 on this figure and its resemblance to Germaine, also pp. 13–14 on Picasso's close friendship with the Pichots. Dr. Alley informs me that he would now give even more emphasis to this reading of the picture.

99. R. Füglister, 'Wer aber sind Sie, sag mir, die Fahrenden? Hinweise zum Motiv der fahrenden Komödianten, Gaukler und Jahrmarktartisten in der französischen Kunst zur Zeit Daumiers', *Bulletin Annuel de la Fondation Suisse, Université de Paris, Cité Universitaire*, 12, 1963, pp. 25–54.

100. G. Apollinaire, 'Les Jeunes: Picasso peintre', *La Plume*, 15 May 1905; his *Chroniques d'art*, ed. L.-C. Breunig, Paris, 1960, p. 31.

101. Timm, *Edvard Munch*, pl. 23; cf. also the drypoint *Woman*, pl. 22, and the lithograph *Jealousy*, pl. 55.

102. Zervos, XXII, 163, 158; B. Geiser, *Picasso, peintre-graveur*, Berne, 1933–, I, no. 13.

103. A. Salmon, *Souvenirs sans fin*, Paris, 1955–61, II, pp. 328–329. F. Carco, *L'Ami des peintres*, Paris, 1953, p. 208. Compare Max Jacob's version of the story, referring discreetly to 'an artist's family', in H. Fabureau, *Max Jacob, son oeuvre*, Paris, 1935, pp. 28–29.

104. Brassaï, *Picasso and Company*, trans. F. Price, New York, 1966, p. 196.

105. L. Stein, *Appreciation: Painting, Poetry, and Prose*, New York, 1947, p. 169. As William Rubin observes, *Picasso in the Museum of Modern Art*, New York, 1972, p. 33, monkeys and other animals are 'virtual members of the *saltimbanques*' families' in the Rose Period.

106. Zervos, I, 57. Cf. H. W. Janson, *Apes and Ape Lore in the Middle Ages and the Renaissance*, London, 1952, chap. VII.

107. Blunt and Pool, *Picasso*, caption of ill. 130–131. Cf. Janson, *Apes and Ape Lore*, p. 151 on the Dürer, also p. 161, note 25 on copies and variants of it.

108. Cf. Ermitage Impérial, *Catalogue de la galerie des tableaux*, St. Petersburg, 1891, I, p. 137 for prints and photographs of the Raphael available by that date.

109. Janson, *Apes and Ape Lore*, pp. 275, 335; cf. also pp. 341ff. on nineteenth-century attitudes.

110. Cf. note 100, above.

111. Information kindly communicated by Mr Hugo Perls, the dealer in question, who recalls giving it this title in 1927.

112. Zervos, XXII, 142. Roughly translated, the note reads: 'The harlequin black, blue, and rose, perhaps yellow instead of rose. The lady blue and white. A negro [cancelled word] a platter of fruit dressed in vermillion red and green. Carmine red. A green floor [or background] wouldn't seem bad to me.'

113. Zervos, XXII, 143, 144, 147, 151, 152, 481, 482; cf. also VI, 925.

114. R. Lothar, *Arlequin roi*, trans. R. de Machiels, Paris, 1903. Cf. the reviews in *Mercure de France*, 44, 1902, p. 526; *Revue Blanche*, 29, 1902, pp. 315–316; *Joventut*, 4, 1903, pp. 440–442; *ibid.*, 6, 1905, pp. 656–657.

115. G. Apollinaire, *Le Théâtre italien*, Paris, 1910, pp. 32–34.

116. Welsford, *The Fool*, pp. 305–308.

117. Gilot and Lake, *Life with Picasso*, p. 350. Cf. R. Gomez de la Serna, *Le Cirque*, trans. A. Falgairolle, Paris, 1927 (first ed., 1917), p. 27; and W. Willeford, *The Fool and His Scepter*, Evanston, Ill., 1969, pp. 188–191.

118. On this point, cf. P. von Blanckenhagen, 'Rilke und ''La Famille des Saltimbanques'' von Picasso', *Das Kunstwerk*, 5, no. 4, 1951, pp. 43–44.

119. Compare especially the lithograph *Dans la Coulisse, Deux Danseuses*; L. Delteil, *Edgar Degas (Le Peintre-graveur illustré*, IX), Paris, 1919, no. 59.

120. Zervos, I, 205. On its relation to the other works, cf. Blunt and Pool, *Picasso*, caption of ill. 157–160; and Penrose, *Picasso*, pp. 110–111. On the presence of Apol-

linaire and others of their circle in the *Family of Saltimbanques*, cf. T. Reff, 'Harlequins, Saltimbanques, Clowns, and Fools', *Artforum*, 10, no. 2, October 1971, pp. 42–43.

120a. Cf. the description in George Sand, *Un Hiver à Majorque*, Paris, n.d. (first ed. 1841), p. 124.

121. Cf. the remarks in Runnqvist, *Minotauros*, p. 14, and in D. E. Schneider, 'The Painting of Pablo Picasso: A Psychoanalytic Study', *College Art Journal*, 7, 1947–48, pp. 92, 95, on Columbine's role in this composition.

122. Appropriately, Hamlet himself has been compared with Harlequin and with the fool generally. Cf. Willeford, *The Fool and His Scepter*, pp. 192–200; and A. Nicoll, *The World of Harlequin*, Cambridge, 1963, pp. 1–8.

123. Gilot and Lake, *Life with Picasso*, p. 82.

124. G.-A. Aurier, *Oeuvres posthumes*, Paris, 1893, p. 407. On the others, cf. H. P. Bailey, *Hamlet in France*, Geneva, 1964, pp. 137–160.

125. Serge, *Histoire du cirque*, Paris, 1947, p. 183. On Picasso's acquaintance with Antonet, cf. F. Olivier, *Picasso et ses amis*, Paris, 1933, p. 155.

126. Daix and Boudaille, *Picasso*, pp. 87–104, from which the quotations are taken, is the most detailed discussion of this period.

127. Zervos, VI, 720.

128. Penrose, *Picasso*, pp. 117–118. On its specific sources, cf. P. Pool, 'Picasso's Neo-Classicism: First Period, 1905–6', *Apollo*, 81, 1965, pp. 122–127.

129. Zervos, I, 349, 350. These may reflect the influence of Rouault, who exhibited similar subjects in 1904–06; cf. R. Courthion, *Georges Rouault*, New York, 1961, p. 377, note 23; p. 378, note 34; p. 379, notes 65, 68.

130. D.-H. Kahnweiler, 'Huit entretiens avec Picasso', *Le Point*, 42, October 1952, p. 24, reporting a conversation of December 1933. Cf. also Barr, *Picasso*, p. 57, reporting a conversation of 1939.

131. L. Steinberg, 'The Philosophical Brothel', *Art News*, 71, no. 5, September 1972, pp. 20–29, and no. 6, October 1972, pp. 38–47, figs. 3, 30–34.

132. *Ibid.*, especially fig. 30; on this point, cf. p. 39, quoting an observation by William Rubin.

133. *Ibid.*, pp. 38–39. However, Steinberg's conclusion that the picture can no longer be understood in *memento mori* terms overlooks precisely those iconographic parallels in Picasso's work which are discussed here.

134. Zervos, II, 444; cf. also II, 443, and the interpretation of it in R. Rosenblum, *Cubism and Twentieth-Century Art*, New York, 1960, pp. 94–96.

135. J. Golding, *Cubism: A History and an Analysis*, London, 1959, pp. 49–51. Cf. also T. Reff, 'Cézanne, Flaubert, St. Anthony, and the Queen of Sheba', *Art Bulletin*, 44, 1962, p. 125 and note 111.

136. Zervos, II, 61. Although usually dated to the fall of 1907, the *Still Life with a Skull* is stylistically closer to works of 1908; cf. especially Zervos, II, 68, 102–107. On the traditional *vanitas* type, cf. I. Bergström, *Dutch Still Life Painting in the Seventeenth Century*, chap. IV, London, 1956.

137. Penrose, *Picasso*, pp. 133, 141, 203. Cf. Olivier, *Picasso*, pp. 87, 145. According to Salmon, *Souvenirs*, II, pp. 23–25, Wiegels' funeral occurred at the same time as Zola's burial in the Pantheon, hence in early June 1908.

138. Not in Zervos. Cf. Grand Palais, Paris, *Hommage à Pablo Picasso*, November 1966–February 1967, no. 197.

139. Stockholm, Nationalmuseum, Inv. N.M.B. 1246; bought from the Swedish artist Georg Pauli in 1930; exhibited at the Moderna Museet, Stockholm, in 1963–64, and at the Louisiana, Humlebaek, in 1968, according to information kindly furnished by Gunhild Osterman, Chief Librarian of the Nationalmuseum.

140. Notice by L. Descaves in J.-K. Huysmans, *Oeuvres complètes*, Paris, 1928–29, V, pp. 129–133; interestingly, this *Tentation* was to be illustrated by Degas.

141. Adrian, *Histoire illustré des cirques parisiens d'hier et d'aujourd'hui*, Bourg-la-Reine, 1957, p. 100. J. Garnier, *Forains d'hier et d'aujourd'hui*, Orléans, 1968, pp. 198–199, 211–212. H. Frichet, *Le Cirque et les forains*, Tours, 1898, p. 117.

142. Zervos, IV, 331, 332. Cf. also the discussion of sources in Rubin *Picasso*, pp. 112–114, which however insists that 'the monk is totally unanticipated in prior work' by Picasso.

143. L. Venturi, *Cézanne, son art, son oeuvre*, Paris, 1936, no. 688; cf. also nos. 684, 686, etc.

144. Zervos, II, 145; cf. II, 138, 149. In the same year, however, Picasso also painted a *Harlequin's Family* and a *Carnival in the Bistrot* in which Harlequin figures; cf. Zervos, II, 120, 62; VI, 1065–1067, 1073, 1074.

145. Zervos, II, 277, 333; the former is also called *The Accordeonist*.

146. Cf. note 12, above. Some of the details, such as Casagemas' address, are obviously incorrect.

147. José Espronceda, a Spanish poet of the Romantic era, who was much influenced by Byron.

148. A writer of Anarchist convictions and member of the Quatre Gats circle.

149. The proprietor of the Quatre Gats café in Barcelona.

2. Picasso and the Typography of Cubism *Robert Rosenblum*

This article is a considerably revised and amplified version of a lecture, 'The Typography of Cubism', first given at a meeting of the College Art Association of America in Los Angeles, 28 January 1965, and subsequently repeated in many universities and museums in the United States and England. The idea that the choice of words in Cubist art could involve intentional puns and jokes seems to have been largely a product of the growingly non-formalist interpretation of Cubism common to the 1960s. In my own *Cubism and Twentieth-Century Art*, New York, 1960, I made several such suggestions (e.g., pp. 64, 72, 96, 121). Other examples were offered in Harriet Janis and Rudi Blesh, *Collage: Personalities, Concepts, Techniques*, Philadelphia, 1962, pp. 18ff., although most of these—from the reference to upside-down nickelodeon slides in Picasso's first *papier collé* (1908; Zervos II, 66), where the words AU LOUVRE are inverted, to the pun on 'du Louvre' in the Spanish word fragment DILUV (Zervos, II, 348)—may strike one as somewhat far-fetched. Subsequent studies of Cubism have tended to be increasingly open to these possibilities. See, e.g., Edward Fry, *Cubism*, New York, 1966, pp. 29, 31; Nicholas Wadley, *Cubism*, London, 1970, pp. 80–82; as well as the catalogue entries by George Downing and Daniel Robbins on Gris and Picasso in *The Herbert and Nanette Rothschild Collection*, Providence, Rhode Island School of Design, 1966. Recently, I have been able to consult an unpublished Master of Arts thesis at Columbia University, which deals with a major theme of my own essay: J. Charlat Murray, *Picasso's Use of Newspaper Clippings in His Early Collages*, 1967. Inevitably, many of the examples and interpretations coincide with those in my lecture and in the present essay, although the range of allusions in Miss Murray's readings of Cubist words tends to be more speculative than mine. I have tried to acknowledge, in notes, the new material in her thesis that I have found relevant to my own arguments. After my own article was completed in 1971, I was able to share its specific contents and general ideas with William Rubin during the preparation of his admirable catalogue, *Picasso in the Collection of the Museum of Modern Art*, New York, 1972. In his analyses of the use of words in specific works by Picasso, he has been kind enough to acknowledge his debts to this article and astute enough to make many fresh observations of his own.

1. The most lucid analysis of Cubist words and collage elements from a purely formal viewpoint is Clement Greenberg, 'The Pasted-Paper Revolution', *Art News*, LXVII, 1958, pp. 46–49.

2. For a conspicuous example, see Zervos, *Picasso*, II, 348, where the Barcelona newspaper, *El Diluvio*, is clearly dated 31 March 1913, but the catalogue caption dates the work 'printemps 1912'. I have discussed this and other dating problems related to the newspaper clippings in Rosenblum, 'Picasso and the Coronation of Alexander III: A Note on the Dating of Some *Papiers Collés*', *Burlington Magazine*, CXIII, October 1971, pp. 604–606.

3. Zervos, II, 406.

4. Zervos, II, 765.

5. Zervos, II, 729; III, 118, 142, 293.

6. Zervos, II, 339.

7. Zervos, II, 335. This issue of *Le Figaro* is, exceptionally, an old one, dated 28 May 1883. For more on Picasso's use of this old newspaper, see Rosenblum, *op. cit.*

8. Zervos, II, 348.

9. Zervos, II, 461. Another collage that uses *Lacerba* is not included in Zervos. It is, however, illustrated in H. Wescher, *Die Collage*, Cologne, 1968, pl. 16.

10. Braque and Gris, incidentally, considerably enlarged Picasso's repertory of newspapers by including *Le Courrier*, *Le Petit Éclaireur*, *L'Écho d'Alger*, *Le Réveil*, *Le Matin*, *Gil Blas*, etc.

11. The only exception I have found to this rule is Zervos, VI, 1239, a small watercolour there dated 1914 or 1915.

12. The *calligrammes* and other poem-images by Apollinaire are now most conveniently anthologized in Michel Décaudin, ed., *Oeuvres complètes de Guillaume Apollinaire*, Paris, 1966, vol. 3.

13. See, for example, Jacob's puns on the phrase 'les ménages déménagent', discussed in Jean Rousselot, *Max Jacob au sérieux* [Rodez], 1958, pp. 170ff. More on this is included in Gerald Kamber, *Max Jacob and the Poetics of Cubism*, Baltimore, 1971.

14. See the catalogue, *An Exhibition . . . of the Works of Man Ray*, London, Institute of Contemporary Arts, 1959, unpaginated.

15. For the question of the date of this work, see Rosenblum, *op. cit.*, p. 604.

16. On the dating of this first collage, see *ibid.*, note 9. It should be added that, although this work is considered to inaugurate the collage period of Cubism, Picasso had earlier, in 1908, used a piece of pasted paper on a drawing (Zervos, II, 66).

17. The skull was an important motif in the first conception of the *Demoiselles d'Avignon*, where a figure holding a skull was seen entering a brothel (Zervos, II, 19), but it was then eliminated. It recurs however in two still lifes of 1907 (Zervos, II, 49, 50).

18. The point is already made in Rosenblum, *Cubism and Twentieth-Century Art*, p. 96; repeated in N. Wadley, *op. cit.*, p. 80.

19. Mallarmé's poem was first published in *Cosmopolis*, May 1897, pp. 417–28; and then re-published separately (Paris, 1914) at the peak of the Cubist artistic and literary movement.

20. A die is found, for example, in Zervos, II, 469, 490, 501, 512, 525, 789, 830, 832–838, 840, 847, 852.

21. The tradition of using poster announcements in Cubist art would seem to begin

with Braque's *The Portuguese* of spring 1911, with its stencilled letters (GRAN)D BAL, and Picasso's *Still Life on a Piano* (Zervos, II, 728), which also uses a stencilled poster fragment CORT(OT), presumably announcing a concert by that pianist. For the problem of the date of the Picasso, see below, note 61.

22. See also Rosenblum, 'Picasso at the Philadelphia Museum of Art', *Bulletin, Philadelphia Museum of Art*, January–March, 1967, p. 183.

23. Mondrian's use of this advertisement and its precedent in Picasso's work are discussed in Robert P. Welsh, *Piet Mondrian, 1872–1944*, The Art Gallery of Toronto, 1966, pp. 144, 146. Douglas Cooper (*The Cubist Epoch*, London, 1970, p. 106) has also suggested that the spelling KUB may have influenced the Parisian tendency to refer to 'le Cubisme' as 'Der Kubismus', i.e. something foreign and German.

24. See Pierre Cabanne, *L'Épopée du Cubisme*, Paris, 1963, pp. 147–148.

25. As pointed out in John Richardson, ed., *Picasso; an American Tribute*, New York, The Public Education Association, 1962, 'Cubism', no. 7.

26. The other two are Zervos, II, 312, 734. Zervos dates the latter of these winter 1911–12, but its similarity to the other two and, above all, to the rope-framed first collage (Zervos, II, 294) suggests that they must all date from the same time, spring 1912.

27. The connection between the aeronautics slogan and Picasso's comments on his and Braque's interest in the making of aeroplanes as analogous to the making of Cubist constructions (as well as Picasso's reference to Braque as 'mon cher Vilbure') was first made by Roland Penrose (*Picasso; His Life and Work*, London, 1958, p. 161). It is repeated in Cooper, *op. cit.*, p. 59.

It should be added that the aeronautics motif was aggrandized in the Cubist mileu by La Fresnaye's *Conquest of the Air* (1913) and Delaunay's *Homage to Blériot* (1914), and that, in at least one case, a watercolour still life of 1915, with an aeroplane viewed through a window, Picasso was to refer more literally to aviation. (Illustrated in J. Richardson, *ed. cit.*, 'Cubism', no. 24.)

28. The newspaper clipping comes from *Le Journal*, 3 December 1912, p. 5.

29. In other paintings by Gris, both of 1912, two other facets and syllable combinations of a DUBONNET matchholder are seen: (a) DU (illustrated in D.-H. Kahnweiler, *Juan Gris, His Life and Work* (rev. ed.), New York, 1969, p. 23) and (b) DUBON (illustrated in James Thrall Soby, *Juan Gris*, New York, 1958, p. 17). It should be added that a modern advertisement for DUBONNET uses a comparable series of puns (DU, DU BON, DUBONNET) and may have existed, in a similar form, earlier in the century. If so, it would offer yet another case of the confluence of commercial imagery and Cubist art.

Marcoussis, too, included verbal fragments of the alcohol brand names found on matchholders, as in *Le Pyrogène 'Quinquina'* (1912) and *Le Pyrogène 'Byrrh'* (1914), illustrated in Jean Lafranchis, *Marcoussis, sa vie, son oeuvre*, Paris, 1961, p. 22, pl. 30.

30. Zervos, II, 366, 372.

31. Zervos, II, 413.

32. Zervos, II, 772.

33. Zervos, II, 786.

34. I believe the first writer to pinpoint this reference was Maurice Jardot, in his exemplary catalogue, *Picasso*, Paris, Musée des Arts Décoratifs, 1955, no. 26.

35. Zervos, II, 244. It is there dated 'printemps 1911', although its style has suggested to later chroniclers of Cubism a somewhat later date, i.e., winter 1911–12.

36. See also Rosenblum, *Cubism and Twentieth-Century Art*, pp. 64ff.

37. Contrary to what Stravinsky thought, the song was copyright by its composer, Émile Spencer, to whom royalties on performances of *Petrouchka* then had to be paid. For further details, see Eric Walter White, *Stravinsky, the Composer and His Works*, Berkeley and Los Angeles, 1966, p. 162, note 10.

38. '. . . et je l'aime beaucoup et je l'écrirai sur mes tableaux.' (Quoted by M. Jardot, *op. cit.*, no. 30, and often repeated by subsequent writers.) For further comments on 'Eva' see R. Penrose, *op. cit.*, pp. 169–170. Gertrude Stein also discloses the identity of 'Ma jolie' in reference to the inscription in a still life of spring 1912 (Zervos, II, 321). (*The Autobiography of Alice B. Toklas*, New York, 1933, p. 136.)

39. Zervos, II, 352, 364.

40. The frequency of this phrase is even greater than the nine examples cited by Jardot (*op. cit.*, no. 26). It is found in Zervos, II, 244, 306, 321, 341, 351, 445, 446, 503, 505, 525, 526, 527.

41. The collage was often dated 1913, although research in a periodical room would have disclosed that the newspaper clipping from *Le Matin* is dated 12 May 1914.

42. Published in London by Elkin Matthews.

43. That this particular clipping might be relevant to the imagery of the work was first suggested briefly by Lawrence Alloway ('Against Picasso', *Art International*, IV, no. 8, 25 October 1960, p. 46, note).

44. The newspaper clipping comes from an account in *Le Journal*, 3 May 1914, of the explosion of the dirigible 'L'Adjutant-Réau' near Verdun.

45. A related example here would be his use of the upper half of a clipping about a 'train volant', whose aerial wires are just visible and contribute to the Cubist sense of a new airborne realm in tune with the twentieth century. On this collage, see the exhibition catalogue, *The Herbert and Nannette Rothschild Collection . . . op. cit.*, no. 60 and unpaginated notes on Gris.

46. See also Rosenblum, *Cubism and Twentieth-Century Art*, p. 121.

47. The clipping is taken from *Le Matin*, 26 April 1914. The text reads: 'Un des lions de la Place de la Condorde en janvier 1889, à l'époque de la lutte électorale entre Jacques et le Général Boulanger. Le même (à droite) photographié hier. Le pittoresque y a perdu, mais l'esthétique et la propreté y ont certainement gagné.'

48. The irony of this clipping in a collage context has also been commented on briefly by E. Fry, *op. cit.*, p. 31; and Nicholas Wadley, *op. cit.*, p. 81.

49. The masked emblem of Fantômas is even included in a Gris still life of 1915 (illustrated in Kahnweiler, *op. cit.*, p. 261). Kahnweiler, in fact, comments on Gris's fascination with this fictional detective (*ibid.*, p. 49). For further references to the importance of Fantômas in the Cubist mileu, see J. Charlat Murray, *op. cit.*, p. 54.

50. The full article, of which Gris provides only a provocative fragment, can be read in *Le Matin*, 3 February 1914. Bertillon, incidentally, died only ten days later (13 February), a fact which might have made the inclusion of this article in Gris's *papier collé* all the more topical.

51. A brief reference to the general relevance of this headline, 'On ne truquera plus . . .', to Cubism is also made by Wadley, *ibid.*

52. I believe this joke was first pointed out in print by Thomas Hess ('Paste Mixed with Paint', *Art News*, XLVII, October 1948, p. 25, caption).

53. For a succinct and informative discussion of the problem of Picasso's signatures during the Cubist period, see Maurice Jardot's 'Note sur les signatures de Picasso et les titres de ses tableaux' in the indispensable catalogue, *Picasso*, Paris, Musée des Arts Décoratifs, 1955, in the unpaginated section 'Documents'. The question of signatures in Cubist art was raised earlier by Kahnweiler (*op. cit.*, pp. 124–125).

54. Zervos dates it winter 1911–12, but in view of its similarity to such other oval still lifes as Picasso's first collage (Zervos, II, 294), also misdated by Zervos winter 1911–12, and now generally dated no earlier than May 1912 (see above, note 16), it is probably to be advanced in time. The address on the painting, however—11 Bd. de Clichy—provides a *terminus ante quem*, since Picasso left that address on his return from Sorgues in October 1912.

55. An idea similar to this painting of a letter may be found earlier in a drawing of 1911 which inscribes a palette with: PICASSO, ARTISTE PEINTRE, 11 BD. DE CLICHY, PARIS (Zervos, VI, 1134). See also the painted letter in Marcoussis' *Nature morte à l'échiquier* (1912), illustrated in J. Lafranchis, *op. cit.*, p. 23.

56. The other Spanish word fragments include: (PUBLI)CIDAD, DON, and BARCE (LONA). For other Spanish allusions in Picasso's Cubist works, see Zervos, II, 319 (with the inscription ENTR(ÉE) AUX ARÈN(ES)); 362 (the so-called *Aficionado*, with its reference to the bullfight periodical, *Le Torero*, and to Nîmes, a city whose arena is still used for bullfights); and 348 (with the clipping from the Barcelona newspaper, *El Diluvio*). For more on Picasso and Spain during the Cubist years, see the sections on Céret in Josep Palau i Fabre, *Picasso en Catalūa*, Barcelona, 1966, pp. 160ff.

Gris, too, may have wished to suggest obliquely his Spanish identity, not only by the inclusion in his still lifes of such alcohols as Jerez de la Frontera and Anis del Mono, but by such overtly Spanish subjects as the *Torero* of 1913, illustrated in Kahnweiler, *op. cit.*, p. 47.

57. For other related works, with mock frame and name plate, see Zervos, II, 478, 500, 552. Picasso also signed, in his natural handwriting, the illusionistic borders around many still lifes of 1917–19 (e.g. Zervos, III, 102, 121, 140, 367; VI, 1411, 1432).

58. See also Rosenblum, *Cubism . . .*, p. 98, where a parallel in Duchamp's work is indicated. It should be added that Braque used a *trompe l'oeil* name plate in other works, the earliest of which seems to be the *Still Life, Sorgues*, dated, without explanation, 1912/14 in the exhibition catalogue, *The Herbert and Nannette Rothschild Collection*, no. 18. Perhaps the mock frame, with the name plate, postdates by two years the picture within it. For a later example by Braque, see *Still Life with Fruit Dish and Guitar* (1917), illustrated in John Richardson, *Georges Braque* (Penguin Modern Painters), 1959, pl. 14.

59. The Museo Picasso, Barcelona, contains dozens of examples of these calligraphic variations on the theme of the artist's own signature, beginning with the elegant inscriptions on the pages of his schoolboy's Latin grammar books of 1891–92 and continuing with countless typographical inventions and imitations that even include replicas of his artist-father's signature.

60. The date of 1914 is Zervos's, although the many overlapping transparencies and chiaroscuro effects suggest that the date may be more convincingly located in 1913.

61. Presumably, the first example of the use of stencilled letters in Picasso's work is Zervos, II, 728, with the inscription CORT (for the pianist Cortot?). Zervos dates this winter 1910–11, but Jardot contends, to my eye correctly, that on stylistic grounds, it must be no earlier than spring 1911 (*op. cit.*, no. 23). Such a dating raises the question already posed by Rosalind Krauss in her review of the exhibition, 'The Cubist Epoch' (*Artforum*, IX, February 1971, p. 35), of whether Braque's use of stencilled letters in *The Portuguese* precedes (as is generally claimed) or follows Picasso's.

Picasso's use of a stencilled signature was also taken up by Diego Rivera, who stencilled his initials on paintings in 1914, and by Jacques Villon, who, as late as 1924 (*The Jockey*), stencilled his entire name on a painting. The inclusion of stencilled letters in paintings was most recently revived with the greatest invention by Jasper Johns.

62. The refinements of the situation are explained in such a standard French etiquette book as La Baronne Staffe, *Règles du Savoir-Vivre dans la Société Moderne* (15th ed.), Paris, 1890, p. 224: '. . . la corne signifie qu'on est venu en personne et, dans ce cas elle équivaut à une visite, qui doit être rendue comme si elle avait été reçue.'

63. In the *Sintesi circolare di oggetti*, reproduced and discussed in Marianne W. Martin, *Futurist Art and Theory, 1909–1915*, Oxford, 1968, fig. 192 and pp. 192–193. (For a more legible reproduction, in colour, see H. Wescher, *op. cit.*, p. 67.) The inscription on the calling card reads: C. D. Carrà, Pittore Futurista, Milano. Prof. Martin suggests that the tilting of the card and wine glass against the siphon allude to a bout of drunkenness. In any case, the intersection of the plane of the siphon and the upper right-hand corner of the calling card creates the effect of a dog-eared card.

64. The incident is recounted in G. Stein, *The Autobiography of Alice B. Toklas*, New York, 1933, p. 136, a reference kindly called to my attention by Miss Margaret Potter.

65. For further comments on this painting and its title, see *Four Americans in Paris; the Collection of Gertrude Stein and Her Family*, New York, The Museum of Modern Art, 1970, p. 171. This painting, incidentally, is misidentified in Jaime Sabartès, *Picasso; documents iconographiques*, Geneva, 1954, fig. 194 and pp. 329–330, as the work Picasso executed on a wall of the villa *Les Clochettes* at Sorgues and then had transferred to canvas. This wall-decoration, which a M. Couturier remembered as containing a mandolin, a musical score inscribed 'Ma Jolie', and a bottle of Pernod, is to be identified rather with Zervos, II, 351.

66. The story is told in Edward Burns, ed., *Gertrude Stein on Picasso*, New York, 1970, in the unpaginated catalogue.

67. For another complex example in Picasso's work of this kind of double identity, see Zervos, *Picasso*, II, 493, a curious quartet of still lifes (1914), of which the two on the left are by Picasso and the two on the right by Derain. But in the still life with playing cards in the lower left-hand corner, Picasso has painted a stamped letter addressed by hand to André Derain. This suggestion of Derain's signature is all the more paradoxical since it occurs in the painting executed by Picasso rather than in the adjacent painting, executed by Derain.

68. See Zervos, II, 454, 457, 787. There are other signatures of this year that stand more ambiguously between the cursive script and Picasso's usual signature (e.g. Zervos, II, 469, 530), as if the natural and the artificial were being combined.

69. As in the italic signature on *The Musician* (1917–18), illustrated in J. Richardson, *op. cit.*, pl. 13.

70. In Severini's *Portrait of Paul Fort*, the calling card of the poet, Fort, is pasted onto the canvas, and its italic type is imitated by Severini in the inscription in the lower right-hand corner. The work is illustrated in the catalogue, *Collagen*, Zurich, Kunstgewerbe Museum, 1968, p. 79, where it is misdated 1913, despite the date of December 1914 printed on one of the collage elements, the periodical *Poèmes de France*.

71. On this drawing, see also R. Rosenblum, 'Picasso at the Philadelphia Museum . . .', p. 183.

72. The story is recorded in an interview of Kahnweiler by Hélène Parmelin in *Picasso; oeuvres des Musées de Leningrad et de Moscou et de quelques collections parisiennes*, Paris, 1955, p. 20. I am grateful to Miss Margaret Potter for this and the following reference.

73. See Gertrude Stein, *The Autobiography of Alice B. Toklas*, New York, 1933, p. 195. The context suggests that this took place in the winter of 1914–15, although the picture in question is dated 1913–14 by Zervos. Since Férat had known Picasso in Paris since 1910, the Russian lesson may well have taken place somewhat earlier than implied by Stein's narrative.

74. The other letters and numbers (which offer a contrast in terms of the use of numbers and the Latin alphabet) are less easily read. The FRA refers perhaps to a price (francs), the 9½ to the time (i.e. 9½ heures).

75. This is fully as true of Gris, who, in a still life of 1915, even imitated the complex typographical variety on the labels of both a bottle of Bass and a package of Quaker Oats (illustrated in J. Soby, *op. cit.*, p. 51), thereby providing a kind of Cubist prophecy of Andy Warhol's paintings of Campbell's soup cans.

76. A package of Job cigarette papers also turns up in a still life of 1916, not included in Zervos, but illustrated in J. Richardson, *ed. cit.*, 'Cubism', no. 27.

It has been suggested by J. Charlat Murray (*op. cit.*, p. 26) that the references to JOB in Picasso's still lifes are also puns on Max Jacob's name.

77. For a useful survey of these French posters, see the exhibition catalogue, *Cent Ans d'Affiches: 'La Belle Époque'*, Paris, Bibliothèque des Arts Décoratifs, 1964.

78. See Soby, *op. cit.*, pp. 11–12. Gris' illustrations for José Santos Chocano's *Alma América—Poemas Indo-Españoles* (Madrid, 1906) and the Parisian humorous journal *L'Assiette au Beurre* (to which he contributed from 1908 to 1910) offer a surprisingly large repertory of proto-Cubist ideas, ranging from flattening, geometric stylizations of figure drawing and eccentric perspective schemes to complex interplays of words and images.

79. Some of the newspaper illustrations of the young Cubists are discussed in Jean Adhémar, 'Les journaux amusants et les premiers peintres cubistes', *L'Oeil*, no. 4, 15 April 1955, pp. 40–42.

80. See, for example, his illustrations for the Madrid periodical, *Arte Joven* (31 March 1901), most conveniently reproduced in Anthony Blunt and Phoebe Pool, *Picasso,*
the Formative Years; a Study of His Sources, London, 1962, fig. 57. Here, as elsewhere, words and images are interwoven, including even the repetition of the title, *Arte Joven*, on the paper the woman is reading.

81. See Joseph K. Foster, *The Posters of Picasso*, New York, 1964.

82. This menu-card was published for the first time in Blunt and Pool, *op. cit.*, and discussed in the caption for figs. 1–9.

83. The former still life with a chicken (Zervos, II, 347) is dated by Zervos 1912, a date repeated in D. Duncan, *op. cit.*, p. 206. Nevertheless, the easy legibility of this still life, as well as its stylistic and thematic closeness to 534 (dated by Zervos 1914), suggest that it, too, should be dated 1914 rather than 1912.

For an earlier, less legible example of such a restaurant still life, see Zervos, II, 308 (1911–12), where a 'pigeon aux petits pois' is presented against the inscription CAFE. For a later, more legible one, see Zervos, II, 430 (1913), where a *papier collé* roast chicken (duck? goose?) is set against a drawn menu, wine glass, bottle, and knife.

84. This enumeration of urban printed matter comes from the following lines in Apollinaire's *Zone*:
Tu lis les prospectus les catalogues les affiches qui chantent tout haut
Voilà la poésie ce matin et pour la prose il y a les journaux
Il y a les livraisons à 25 centimes pleines d'aventures policières . . .
Les inscriptions des enseignes et des murailles
Les plaques les avis à la façon des perroquets criaillent . . .

85. The realization that many formal and iconographic aspects of Cubism may be in good part inspired by commercial imagery seems to have been very slow in coming to historians and critics of the movement, but the advent of Pop Art in the early 1960s may have opened the possibility of such interpretations. For some preliminary comments in this direction, see N. Wadley, *op. cit.*, pp. 69ff.

3. Picasso and Surrealism
John Golding

1. This was the first of a series of articles by Breton which came out in book form (with further additions) as *Le Surréalisme et la Peinture*, Paris, 1928. The word Surrealism is for the most part not capitalized in the original documents. For the sake of continuity a capital letter will be used throughout this essay.

2. A. Breton, Pablo Picasso, *Combat*, Paris, November 6, 1961. The original French reads '. . . sur le plan onirique et imaginatif'.

3. W. S. Rubin, *Dada and Surrealist Art*, New York, 1968, p. 279. The phrase was originally Breton's.

4. *Documents*, no. 2, Paris, 1930.

5. Quoted by Brassai, *Picasso and Co.*, London, 1967, p. 28.

6. Brassai, *op. cit.*, p. 27, says that the works by Picasso at the first Surrealist exhibition were lent by collectors without his knowledge. Sir Roland Penrose in *Picasso, His Life and Work*, London, 1958, p. 229, says Picasso agreed to have his work shown and this seems more likely.

7. For the problems involved in an exact dating of the *Three Dancers* see R. Alley, *The Three Dancers* (Charlton Lectures on Art), Newcastle upon Tyne, 1967.

8. *Magazine of Art*, New York, 1937, pp. 236–239. Graham, Russian by birth and American by naturalization, spent much time in Paris and moved in Surrealist circles.

9. For a fuller analysis of the *Three Dancers* see the Tate Gallery *Report, 1964–65*, pp. 7–12. The passages on the *Three Dancers* were written by Lawrence Gowing and my own analysis and understanding of the picture are much indebted to him.

10. R. Alley, *op. cit.*, p. 11.

11. Picasso told Francoise Gilot that a friend of his youth had committed suicide for love of Germaine Pichot. Casagemas had shot himself after first trying to kill a young woman with whom he was obsessed. In the police files her first name is given as Laure, but it seems likely that it was the same woman. See F. Gilot and Carlton Lake, *Life with Picasso*, London, 1965, p. 75, and G. Daix and P. Boudaille, *Picasso 1900–1906*, Neuchatel, 1966, p. 338.

12. 'Picasso etudié par le Docteur Jung', *Cahiers d'Art*, 7th year, nos. 8–10, Paris, 1932, p. 352. Jung's article, printed here in a somewhat abbreviated form was originally commissioned by the *Neue Zurcher Zeitung* on the occasion of the Picasso exhibition held at the Zurich Kunsthaus.

13. For the influence of Negro art on Picasso's art in the Synthetic Cubist phase see J. Golding, *Cubism, 1907–14*, 2nd ed., London, 1968, pp. 123–125.

14. E. Nesfield, *The Primitive Sources of Surrealism*, unpublished M.A. Report submitted to the Courtauld Institute of Art, London University, 1970, pp. 23–24. This essay is heavily indebted to Miss Nesfield's researches for many of the comparisons between Picasso's work and primitive sources.

15. L. Gowing, *op. cit.*, pp. 10–11.

16. *What is Surrealism?*, London, 1936 (Eng. translation by David Gascoyne), p. 25. Original French edition, *Qu'est que c'est le Surréalisme?*, Brussels, 1934.

17. *Combat*, Paris, 6 November 1961. Breton sees affinities with Surrealism in 'some of (Picasso's) work of 1923–24, a number of works of 1928–30, the metal constructions of 1933, the semi-automatic poems of 1935 and up till *Le Désir attrapé par la queue* of 1943'. But he gives pre-eminence to the pre-war constructions.

18. Breton refers to this painting in his 1925 article. Eluard mentions it in 'Je Parle de ce qui Est Bien', *Cahiers d'Art*, nos. 7–10, Paris, 1935. The canvas was also shown at

the International Surrealist Exhibition at the New Burlington Galleries, London, 1936.

19. Tériade, who was steeped in the movement's aesthetic, writes: 'D'autre part, elle (l'écriture) relie l'aesthétique surréaliste au langage primitif, à ce langage par signes dont on connaît de si éttonnantes schématisations . . .'. *Cahiers d'Art*, 5th year, no. 2, Paris, 1930, p. 74.

20. The attitude of the Surrealists to *Mercure* and its place in Picasso's work at the time is discussed by Peter Ibsen in *Interactions between Miro and Picasso: 1924–1932*, unpublished M.A. report, submitted to the Courtauld Institute of Art, London University, 1970, pp. 8–9.

21. *Picasso*, Paris, 1938, p. 37.

22. See P. Waldberg, *Max Ernst*, Paris, 1958, p. 25 and p. 150.

23. Zervos in *Cahiers d'Art*, Paris, July 1926, quotes Picasso as having said: 'J'ai assez donné à mon tour d'en prendre aux autres'; Picasso appears to have been referring to his relations with his younger colleagues.

24. *Le Surréalisme et la Peinture, suivi de Genèse et Perspective Artistique du Surréalisme et de Fragments Inédits*, New York, 1945. (This is an expanded version of the 1928 book.)

25. Miro's enthusiasm for neolithic art is discussed at some length in R. Doepel's *Aspects of Joan Miro's Stylistic Development*, unpublished M.A. report, submitted to the Courtauld Institute of Art, London University, 1967.

26. Charts of Easter Island hieroglyphs were printed in *Cahiers d'Art*, nos. 2–3, 1929. Zervos, its editor, was a friend of Picasso and the Surrealists, and when articles and reproductions of different art forms appear in his periodical (and in other Surrealist or Surrealist-biased magazines such as *Documents* and *Minotaure*) it was often as a result of the painters' and writers' enthusiasm for them.

27. The first work in which Picasso appears to have made deliberate play of reversing the axes of the features (as opposed to tilting them slightly as he was doing in the years before 1914) is the *Harlequin* of 1924, Zervos, V, 328.

28. R. Rosenblum, 'Picasso and the Anatomy of Eroticism', from *Studies in Erotic Art* (edited by T. Bowie and C. Christensen), New York, 1970, p. 341. This present essay owes a great deal to Professor Rosenblum's pioneering study.

29. Preface to an exhibition of Oceanic art held at the Galerie Andrée Olive, Paris, 1948. Reprinted in *La Clé des Champs*, Paris (?), 1953.

30. See in particular the *Embracing Couple* of this year, Zervos, *Picasso*, V, 460, (catalogued by Zervos as *Femme Assise*).

31. See Zervos, VIII, 57–59. *Minotaure*, no. 7, 2nd year, Paris, 1935, published an article with illustrations of the praying mantis.

32. Other works, in particular Zervos, V, 115, seem to make specific reference to predatory marine forms.

33. Rubin, *op. cit.*, reproduces both works, thus underlining their affinities with Surrealism.

34. Authorized statement by Picasso published in the catalogue of the 1955 exhibition held at the Musée des Arts Decoratifs, Paris, 1955. The statement appears between nos. 40 and 41 of the catalogue.

35. J. Richardson, *Pablo Picasso*, London, 1964, p. 60.

36. *Cahiers d'Art*, 10th year, Paris, 1935, nos. 7–10.

37. Rosenblum, *op. cit.*, p. 348.

38. In 'Fragments of a Lecture given at Madrid at the Residencia de Estudiantes', published in *La Revolution Surréaliste*, no. 4, Paris, 1925.

39. See Nesfield, *op. cit.*, p. 29.

40. Rubin, *op. cit.*, p. 284.

41. In its 2nd issue of 1929, *Documents* published an article on *L'Apocalypse de Saint-Sever* by Georges Bataille, with five illustrations including one of the Flood. The strong, somewhat crude colour of Picasso's *Crucifixion* suggests that Picasso might even have seen the original. Both Bataille and Tériade, whom Picasso was seeing at the time, had contacts with the Bibliothèque Nationale.

42. R. Kaufmann, 'Picasso's Crucifixion of 1930', *The Burlington Magazine*, September 1969, pp. 553–561.

43. Miro's painting was reproduced in *La Revolution Surréaliste*, October 1926. Picasso's first studies for the *Crucifixion* were executed before February–March 1927 when they were reproduced as recent drawings in *Cahiers d'Art*, no. 2. Rubin, *op. cit.*, p. 283, suggests that *An Anatomy* comes out of Giacometti's *Objects Mobiles et Muets*.

44. In the section on Dali in *What is Surrealism?*, p. 27, Breton writes, 'Dali is like a man who hesitates between talent and genius or as one might once have said, between vice and virtue'.

4. The Sculpture of Picasso *Alan Bowness*

1. Translated from Brassai, *Conversations avec Picasso*, Paris, 1964, p. 80 (hereafter referred to as *Brassai Conversations*). Alfred Barr (*Picasso*, Museum of Modern Art, New York, 1946, p. 38) says that Vollard cast the bronzes in 1905.

2. Many of the dates in the first (and fundamental) book on Picasso's sculpture are demonstrably slightly inaccurate and perhaps best regarded as approximations. This is Daniel-Henry Kahnweiler, *Les Sculptures de Picasso*, Paris, 1948, with photographs by Brassai (hereafter referred to as Kahnweiler/Brassai).

3. E.g. Zervos, I, 160.

4. Zervos, I, 168, 172 and 187 respectively.

5. Compare for example the exactly contemporary portraits of the Duchesse de Choiseul.

6. Zervos, I, 301 and 293.

7. Zervos, I, 313, perhaps painted in Paris; and I, 325. The earliest study of this subject is the gouache, Zervos, I, 259, presumably late 1905. The drawing for the sculpture is Zervos, I, 341.

8. For a recent discussion of this point, see John Golding, *Cubism*, London, 1969, pp. 55–57. We should however bear in mind that Picasso himself (and D.-H. Kahnweiler following him) has always maintained that negro influence came only *after* 1910, and that the savage appearance of pre-1910 work is largely due to Gauguin.

9. Zervos, II*, 67.

10. Zervos, II*, 165, 167–172 and 197.

11. Roland Penrose, *The Sculpture of Picasso*, Museum of Modern Art, New York, 1967, p. 19.

12. *Picasso sculpteur*, Cahiers d'Art XI, Paris, 1936, pp. 189–191; the English translation is taken from the catalogue of the Gonzalez exhibition, Museum of Modern Art, New York, 1956, pp. 43–44. Other Picasso sculptures of this Cubist period are a terracotta *Head* and a plaster *Apple* (Zervos, IIGG, 717 and 718).

13. Zervos II**, 531; cf. also II**, 457.

14. Françoise Gilot and Carlton Lake, *Life with Picasso*, London, 1965, p. 23 (hereafter referred to as Gilot). Clearly remarks from such books of recorded conversations must be treated with caution.

15. Zervos, IV, 332 and 322; both of 1921.

16. Zervos, V, 141.

17. Zervos, V, 451.

18. Zervos, V, 426.

19. E.g. Zervos, VII, 252, 272–274, 290 and 306. The story of the Apollinaire monument reaches a sad conclusion in the mid 1940s, when Picasso gave the city of Paris a sculptured head of Dora Maar (originally made in 1941) to serve as a memorial sculpture. The work can be seen in the garden of the Rue de l'Abbaye, behind the church of St. Germain-des-Près. For a somewhat sour account of the affair see Gilot, pp. 298–300.

20. Cahiers d'Art IV, Paris, 1929, pp. 341–354. The sculpture *Metamorphosis* was first reproduced in Cahiers d'Art III, Paris, 1928, p. 289.

21. Zervos, VII, 206. This drawing in turn has very obvious precursors in the ink drawings from a sketchbook dated 20 March 1928 (Zervos, VII, 145–169), which in turn link up with the *Chef-d'oeuvre inconnu* drawings.

22. The precise date, October 1928, is given in Cahiers d'Art IV (January 1929), where the work was illustrated for the first time (p. 6). The sculpture is sometimes dated 1929 or even 1930, but this is clearly a mistake.

23. Kahnweiler/Brassai, plate 20.

24. Zervos, VII, 142; the sculpture referred to is also reproduced in Cahiers d'Art IV (January 1929) p. 11.

25. *Picasso dans son élément*, Minotaure I, Paris, 1933, pp. 9–29.

26. Catalogue of the Gonzalez exhibition, Museum of Modern Art, New York, 1956. In fairness to Mr Ritchie, an excellent guide to modern sculpture, one should note that he could have had only a very approximate idea of the relative chronology of the two artists in the crucial 1928–32 period.

27. The quotations are from Roberta Gonzalez's article on her father in *Arts*, New York, February 1956.

28. It is in fact dated 1930 in the catalogue of the 1932 Petit exhibition, where it was exhibited as no 229 *Sculpture*.

29. Certain of Gonzalez's sculptures are now pushed back in time and given a starting date of 1927 (v. catalogue of the 1970 Tate Gallery exhibition, where for example *The Harlequin* is dated 1927–29, and the *Rabbit* head 1927–30: the 1956 New York catalogue dated them respectively simply 1929 and 1930). But nothing was exhibited or illustrated before 1930, and I do not know of any evidence to support these early starting dates which seem designed to suggest a priority vis-à-vis Picasso which I personally do not believe existed.

30. E.g. Gonzalez's *Large Standing Figure* of 1934 and Picasso's half life-size *Woman* of 1929–30 (at the latest).

31. Commenting during the war on Brassai's photographs of his sculpture of this period, Picasso said: 'They were much more beautiful in plaster . . . At first I didn't want to have them cast in bronze.' Sabartes however apparently persuaded him that plaster was perishable, and that the work should be cast in bronze (*Brassai Conversations*, p. 65). This was unquestionably the correct decision, but bronze casts of iron pieces are sometimes of dubious aesthetic value, I feel.

32. Zervos, VII, 346. The picture also appears to be the starting point for the etching series of 1933, see below.

33. Two of the monumental heads were shown in plaster outside the Spanish Pavilion at the 1937 Paris World's Fair; they re-appeared at the 1944 Salon d'Automne. It is perhaps worth noting that the same Parisian bronze caster, Valsuani, made both Matisse's heads of Jeannette and Picasso's Boisgeloup heads.

34. There are many examples in Kahnweiler/Brassai, some of them in plaster. Brassai's

photograph of the Boisgeloup studio also shows a large plaster version of the *Woman Running* subject, which is plainly an important work.

35. *Brassai Conversations*, p. 67. See also Gilot, p. 297.

36. 'Il faudrait pouvoir prendre un bout de bois et que ce soit un oiseau'—a remark made to Michel Leiris, and quoted in Kahnweiler/Brassai, n.p. Picasso of course has made other remarks in the same vein.

37. The date is uncertain, and the work may have been made in 1941 or 1942. Kahnweiler/Brassai, plate 162, gives 1943; Alfred Barr (*Cubism*, p. 238) dates it 1941—these are perhaps dates of casting and making respectively. The usual date of 1944 is certainly wrong: Françoise Gilot saw the *Flayed Head*, already cast in bronze, when she first visited Picasso's apartment in the Rue des Grands Augustins in May 1943 (Gilot, p. 17).

38. E.g. Kahnweiler/Brassai, plate 139.

39. Kahnweiler/Brassai, plate 117.

40. Kahnweiler/Brassai, plate 192, with a detail, plate 191, wrongly labelled.

41. Gilot, pp. 289–290.

42. Two afternoons according to Gilot, p. 290; a single day according to Kahnweiler/Brassai, n.p. Curiously enough, the *L'homme à l'agneau* has always been dated 1944, but this is manifestly wrong. Picasso showed it to Brassai, and said that he had made it in February, when the photographer visited him for the first time during the Occupation. This was certainly in the summer of 1943 (v. *Brassai Conversations*, p. 66). Brassai returned to photograph the sculpture on 30 November 1943 (*op. cit.*, p. 115). The work was still in plaster, and one of the lamb's legs accidentally fell off when it was being moved—the photographs taken are presumably plates 193–194—in Kahnweiler/Brassai. Françoise Gilot confirms the 1943 dating: she saw the *L'homme à l'agneau* when she first visited Picasso's studio in May 1943 (Gilot, p. 17). Three bronze casts of the work were made in 1949 or 1950. Picasso gave one to the town of Vallauris, where it was inaugurated on 6 August 1950 (Gilot, p. 289). A second is in Philadelphia; the third he kept. Despite Picasso's statement to Brassai that he made the work in February, the existence of the group of drawings dated March 1943 makes me wonder whether March was not the actual month of construction—though they may have been done after the sculpture, as others certainly were.

43. Picasso joined the party in 1944 at the time of the liberation of Paris (Penrose, *Picasso*, London, 1958, p. 315). But he had been moving in this direction for some time, encouraged by his friends Luis Aragon, a long-standing member, and Paul Eluard, who joined the Communist Party in 1942. The fact that Picasso helped hide Laurent Casanova, a leading Communist, during the Nazi occupation, probably accelerated his political conversion (v. Gilot, pp. 54–55).

44. For a fuller account of the constituents of the Vallauris sculptures, and the way in which they were made see Gilot, pp. 293–298.

45. Kahnweiler/Brassai, n.p.

5. Beauty and the Monster *Roland Penrose*

1. H. Read, *The Origins of Form in Art*, London, 1965, p. 39.

2. This painting has been given several different titles and dates in addition to that which I have given it here. Breton in *Le Surréalisme et la Peinture* calls it *La Femme en Chemise* and dates it 1914. Eluard in *A Pablo Picasso* gives it the same title as Breton but dates it 1915. In the Arts Council catalogue of 1960 it is entered as *Woman in an Armchair*, dated autumn 1913, and in the Grand Palais *Hommage à Pablo Picasso* catalogue as '*Femme en Chemise dans un fauteuil*, Paris automne 1913. Signature, lieu et date au dos: Picasso Paris 1913.'

3. The same influence may be seen in the drawings of monumental bathers of the summer of 1927. See Zervos, VII, 84–109.

4. Another painting in which Picasso appears as Harlequin is the *Family of Saltimbanques*, 1905, National Gallery, Washington D.C.

5. Verve, *Suite of 180 drawings of Picasso*, 1954, vol. VIII, nos. 29–30.

6. A. Jarry, *The Ubu Plays*, New York, 1969.

7. Zervos, *Catalan Art*, London, 1937.

8. Zervos, V, 178.

9. *Suite Vollard*, Paris and London, 1965.

10. Zervos, VIII, 336, 337.

11. Zervos, IX, 12–57.

12. R. Kaufmann, 'Picasso's *Crucifixion* of 1930', *Burlington Magazine*, 111, September 1969.

13. R. Kaufmann, *ibid.*

14. Georges Bataille published in 1930 in a special number of *Documents—Hommage à Picasso* an article entitled 'Soleil Pourri' which has an important bearing on the iconography of the *Crucifixion* and *Guernica*. See extracts translated in Penrose, *Picasso, His Life and Work*, London, 1972, p. 273.

15. Zervos, VII, 29.

16. R. Kaufmann, *ibid.*

17. Zervos, VIII, 49–56.

18. Zervos, XVIII, 333, 334 and 336–359.

19. Twelfth-century Catalan sculptures of Christ with the right hand detached from the cross, suggesting a preliminary movement towards the deposition, are found in the eastern Pyrenees (see Juan Ainaud, 'La Sculpture Polychrome Catalan', *L'Oeil* no. 4, 15 April 1955) but in Picasso's version Christ is not dead, he is alive and active.

20. G. Apollinaire, *Les Peintres Cubistes*.

21. Verve, *ibid.*

6. The Last Thirty Years *Jean Sutherland Boggs*

1. The plays: *Quatre Petites Filles*, 1952; *The Four Little Girls*, London, 1970; *El entierro del Conde de Orgaz*, Barcelona, 1969; the films: Paul Haesaerts, *Visite chez Picasso*, 1950 and Georges Clouzot, *Le mystère Picasso*, 1955.

2. R. Alberti, *Picasso en Avignon*, Paris, 1971.

3. Compare with the article by Penrose who quotes Picasso saying, 'Like all Spaniards I am a realist' and also later discusses Picasso's fascination with death.

4. Zervos, XIV, 76, The Museum of Modern Art, New York.

5. Zervos, XIII, 36, Yale University Gallery.

6. D. Cooper, *Picasso: Les Déjeuners*, Paris, 1962, pp. 27–28, discusses its significance.

7. Compare with the article by Golding on the yearning of Surrealists for a primitive world, and on classicism as the antithesis of Surrealism.

8. Leo Steinberg, 'Sleep Watchers,' *Life*, vol. LXV, no. 26, 27 December 1968, p. 115.

9. Françoise Gilot and Carlton Lake, *Life with Picasso*, New York, 1964, p. 92.

10. *Ibid.*, pp. 99, 117.

11. *Ibid.*, p. 122.

12. *Ibid.*, p. 118.

13. He may have painted her standing earlier: see Zervos, XIII, 305, 27 January 1944. Her body seems prefigured, at least, in 1944: see Zervos, XIII, 271, 272, 306–312, 320–322, 324, 325.

14. Gilot, p. 129.

15. D. de la Souchère, *Picasso in Antibes*, trans. by W. J. Straihan, London, 1960, pp. 55–56.

16. A. Horodisch, *Picasso as a Book Artist*, London, 1962, p. 66.

17. Gilot, pp. 144–145; Roland Penrose, *Picasso, His Life and Work*, London, 1958, p. 322.

18. Gilot, p. 128.

19. See C. Roy, *Picasso: La Guerre et la Paix*, Paris, 1954.

20. Penrose, p. 322; Picasso also used the owl in the watermark based on Gongora's name for the book he illustrated in 1948; see Horodisch, *op. cit.*, p. 70.

21. Souchère, *op. cit.*, p. 54.

22. *Ibid.*, no. 33, plate 10, 16 October 1946: no. 127, plate 59, 27 October 1947.

23. Gilot, p. 50.

24. Zervos, V, 276–327; compare with article by Golding.

25. Zervos, III, 226–230; Philippe Julian, 'The Lady from Chile,' *Apollo*, April 1969, pp. 264–267.

26. Cooper, p. 28, sees them as derived from Picasso's copy of Poussin's *Bacchanal: Triumph of Pan*.

27. Gilot, p. 230.

28. *Ibid.*, p. 49.

29. *Ibid.*, p. 51.

30. *Ibid.*, p. 49.

31. *Ibid.*, p. 135. From the author's visit to the museum in Antibes the summer of 1971 this might seem exaggerated but the point of Picasso's indifference to material survival of his works still stands.

32. *Ibid.*, p. 187.

33. *Ibid.*, pp. 123–124.

34. Penrose, p. 325.

35. Gilot, pp. 317–322.

36. Gilot, p. 321; compare with article by Golding on Picasso and metaphors.

37. *Ibid.*, p. 350.

38. C. Chaplin, *My Autobiography*, London, 1966, p. 464.

39. F. Mourlot, *Picasso Lithographe*, vol. I, Monte-Carlo, 1949, no. 8.

40. Gilot, pp. 318–319; H. Parmelin, *Picasso Plain*, translated by Humphrey Hare, London, 1963, pp. 42–43.

41. 'Picasso à Vallauris', *Verve*, nos. 25–26 (1951).

42. Gilot, p. 63.

43. Penrose, p. 329.

44. Parmelin, pp. 193–194.

45. Roy, *op. cit.*, illustrates preparatory studies as well as finished works; Pierre Dufour, *Picasso 1950–1968*, Geneva, 1969, p. 37 reproduces paintings *in situ* in colour.

46. Parmelin, p. 52.

47. J. Berger, *Success and Failure of Picasso*, London, 1965, pp. 115–116.

48. Penrose, p. 336.

49. A. Vallentin, *Picasso*, Paris, 1957, p. 408.

50. Parmelin, p. 52. These drawings were used to illustrate Paul Eluard, *Le Visage de la Paix*, Paris, 1951; see Horodisch, *op. cit.*, p. 82, B16.

51. The drawings for the end of the chapel as we now see it were made in June 1958: see Zervos, XVIII, 253–256, 259.

52. See M. Jardot, *Pablo Picasso Drawings*, New York, 1959, p. 135, for illustration of such a drawing dated 6 December 1953.

53. Gilot, p. 123.

54. Zervos, XV, 115, 127, 130, 132, 133, 146, 147.

55. Gilot, p. 320.

56. *Ibid.*, p. 337 which would seem to contradict Picasso's statement to Penrose, quoted in his article in this volume.

57. Mourlot, *op. cit.*, vol. III, no. 201; in relation to this Vallentin, *op. cit.*, p. 406 quotes Kahnweiler, 'Je soupçonne aussi un peu une série d'images illustrant *Ivanhoé* qui paraît dans *l'Humanité*, en ce moment, de l'y avoir fait penser.'

58. Zervos, XV, 245, 10 February 1953, the artist; Zervos, XV, 246, 8 March 1953, Galerie Rosengart, Lucerne.

59. Zervos, XV, 292, St Louis Art Museum.

60. Zervos, XV, 41, 42, 154; Zervos, XVI, 36–52, 54, 55, 58, 59.

61. Zervos, XVI, 166, private collection.

62. David Douglas Duncan, *Picasso's Picassos*, New York, 1961, p. 183.

63. Gilot, p. 351.

64. *Verve*, nos. 29–30, 1954 or Michel Leiris and Rebecca West, *Picasso's Private Drawings*, New York, 1954.

65. David Douglas Duncan, *The Private World of Pablo Picasso*, New York, 1958.

66. Zervos, XVI, 325.

67. Parmelin, pp. 120–121.

68. Zervos, XVI, 334, 15 October 1954.

69. Zervos, XVIII, 367; Zervos, XIX, 330; Zervos, XX, 219.

70. Parmelin, p. 101.

71. For an analysis of this material see John Richardson, 'Picasso's *Ateliers* and other recent works,' *Burlington Magazine*, vol. XLIX, no. 651, June 1957, pp. 183–193.

72. Zervos, XVIII, 332, 375–403.

73. Zervos, XVIII, 452.

74. Parmelin dedicates her book to the King of La Californie and writes a story about the king.

75. Parmelin gives the best account of life in both houses. See Chaplin, *op. cit.*, for his reaction to the Paris apartment.

76. Zervos, XVII, 159–169, 171–174, 181–200, 348, 350, 409, 410, 412, 415–418.

77. Zervos, XVII, 172, 16 September 1956.

78. P. O'Higgins, *Madame, an Intimate Biography of Helena Rubinstein*, New York, 1972, p. 283; for drawings see Zervos, XVI, 410, 415, 508, 517.

79. Zervos, XVII, 123–146, 17–24 June 1956.

80. Duncan, *op. cit.*, pp. 82–83, 94–103.

81. *Cooper*, p. 28; Zervos, XV, 165, 22 February 1950, collection Angela Rosengart, Lucerne.

82. Gilot, p. 203.

83. Zervos, X, 204–208.

84. Zervos, XVI, 320.

85. Parmelin, p. 77.

86. *Ibid.*, p. 78.

87. *Ibid.*, p. 77.

88. Zervos, XVI, 338–341, 1 December 1954.

89. Penrose, pp. 351–352.

90. Parmelin, pp. 229–231.

91. On his second trip to Madrid he had written on 3 November 1897 of his enthusiasm for Velazquez; see Xavier de Salas, 'Some Notes on a Letter of Picasso,' *Burlington Magazine*, no. 692, 102, p. 483. That winter he painted a copy of a portrait of Philip IV by Velazquez; his copy is in the Picasso Museum, Barcelona.

92. Vallentin, p. 316.

93. *Ibid.*

94. Alfred H. Barr, Jr., *Picasso: Fifty Years of his Art*, New York, 1946, p. 264.

95. Picasso wrote and published in Spanish a play, *El entierro del Conde de Orgaz*, published in Barcelona in 1969.

96. Penrose, p. 372.

97. *Ibid.*, pp. 371–372.

98. J. Anderson, 'Faustus/Velázquez/Picasso', *Artscanada*, no. 106, March 1967, p. 19.

99. Parmelin, p. 232.

100. G. Kubler and M. Soria, *Art and Architecture in Spain and Portugal*, London, 1959, p. 269, point out that this decoration was added to the Velazquez on the king's order after his death.

101. Cooper, p. 30.

102. Penrose, pp. 373–374.

103. J. Anderson, *op. cit.*, p. 21.

104. Parmelin, p. 166.

105. G. Stein, *The Autobiography of Alice B. Toklas*, London, 1966, p. 28.

106. Gilot, p. 60.

107. Roy, *op. cit.*, in discussing *War and Peace* makes more than one reference (pp. 34, 109) to *Alice au pays des merveilles*.

108. Zervos, VI, 343.

109. Zervos, XVI, 316–319.

110. Cooper, p. 34.

111. *Ibid.*, p. 12.

112. See Parmelin, p. 30, for evidence of his interest in Cézanne's *Bathers*.

113. Cooper, p. 21.

114. *Ibid.*, p. 23.

115. *Ibid.*, p. 22.

116. *Ibid.*, p. 11.

117. *Ibid.*, p. 14.

118. F. Steegmuller, *Cocteau*, London, 1970, p. 138.

119. M. Jardot, Picasso: *Peintures (Vauvernargues 1959–61)*, Galerie Louise Leiris, Paris, 1962.

120. H. Parmelin, *Picasso: Notre Dame de Vie*, Paris, 1966, pp. 9–10.

121. H. Parmelin, *Picasso: Le Peintre et son Modèle*, Paris, 1965, pp. 47–70, discusses the evolution of the work.

122. Gilot, p. 101.

123. For example, Saidenberg Gallery, *Picasso 1967–70*, New York, 1970, no. 18, 26 May 1969.

124. Zervos, XIX, 1–7, 46–53, 195, 303–359.

125. A. Blunt, *Guernica*, New York, 1969, pp. 57–58; Zervos, XVIII, 333, 334, 336–359.

126. R. Char and C. Feld, *Picasso: Dessins 27.3.66–15.3.68*, Paris, 1969, no. 29, 23 December 1966.

127. Char and Feld, no. 54, 31 December 1966.

128. *Ibid.*, no. 55, 1 January 1967.

129. *Ibid.*, no. 241, 24 July 1967.

130. *Ibid.*, no. 140, 7 March 1967.

131. *Ibid.*, no. 64, 3 January 1967.

132. For a discussion of the possible meaning of this work; see P. M. Laporte, 'The Man with the Lamb', *Art Journal*, vol. XXI, spring 1962, pp. 144–150.

133. A. and P. Crommelynck, *Picasso: 347 gravures*, Galerie Louise Leiris, Paris, 1968, or *Picasso 347*, New York, 1970.

134. For a discussion of the eroticism of the series see G. Schiff, 'Picasso's Suite 347, or Painting as an Act of Love', *Woman as Sex Object*, Art News Annual XXXVIII, pp. 239–253, ed. by T. B. Hess and L. Nochlin, New York, 1972; L. Steinberg, 'A Working Equation or—Picasso in the Homestretch', *Print Collector's Newsletter*, vol. III, pp. 102–105, February–March 1973.

135. P. Dufour, *Picasso 1950–1968*, Geneva, 1969, p. 118.

136. Char and Feld, no. 157, 15 March 1967.

137. H. Parmelin, *Picasso: Notre Dame de Vie*, Paris, 1966, pp. 56–63.

138. *Ibid.*, p. 62.

139. Crommelynck, *op. cit.*, nos. 121, 174.

140. Char and Feld, no. 45, 29 December 1966.

141. *Ibid.*, nos. 111–119, 9–12 February 1967.

142. For a discussion of the cock as a symbol of masculinity in Picasso's work see Willard E. Misfeldt, 'The Theme of the Cock in Picasso's Oeuvre,' *Art Journal*, vol. XXVIII, winter 1969, pp. 146–154.

143. Galerie Louise Leiris, *Picasso: Dessins en noir et en couleurs 15 décembre 1969–12 janvier 1971*, Paris, 1971, nos. 1–5, 50–62, 68–71, 148–149, 160–166, 171–194.

144. *Ibid.*, no. 62, 17 June 1970.

145. *Ibid.*, no. 71, 21 June 1970.

146. H. Parmelin, *Le Peintre et son modèle*, Paris, 1965.

147. H. Parmelin, *Notre-Dame-de-Vie*, Paris, 1966, p. 134.

148. There may be echoes of the influence of the paintings by Ingres of Raphael and his mistress, La Fornarina, which Schiff, *op. cit.*, and Steinberg, *op. cit.*, have considered as possibly influencing part of Picasso's *Suite 347*; Steinberg, p. 103, wrote of the Ingres that, 'The message is about the claims of erotic attachment as against the vocation of art.'

149. Parmelin, *op. cit.*, pp. 138–153.

150. *Ibid.*, pp. 129–137.

151. *Ibid.*, pp. 110–127.

152. Leiris, *op. cit.*, nos. 76–143.

152. Parmelin. *op. cit.*, pp. 138–153.

154. *Ibid.*, p. 180.

155. Leiris, *op. cit.*, no. 146.

156. *Ibid.*, nos. 8, 10–12; Crommelynck, *op. cit.*, nos. 49, 72; Char and Feld, *op. cit.*, no. 19.

157. Steinberg, *op. cit.*, p. 104, put it: 'Picasso's point is that he is not doing two things but one—performing the act of painting as a making of love, as if love and creation were twin phases of a single cycle, perpetually generating each other and most accurately defined when telescoped into one.'

158. Berger, *op. cit.*

159. Gilot, pp. 159, 160, 255.

160. *Ibid.*, pp. 269–270.

161. K. Gallwitz, *Picasso at 90: The Late Work*, New York, 1971, p. 19, put it: 'Picasso worships and imitates youth as fervently as he rebels against it.'

Select Bibliography

Catalogue

The standard catalogue of Picasso's work, edited by Christian Zervos, with each item illustrated, has been published at intervals by Editions 'Cahiers d'Art', Paris, and now numbers twenty-three volumes (1932–71).

Monographs and General Studies

Maurice Raynal, *Picasso*, Paris 1922. — Jean Cocteau, *Picasso*, Paris 1923. — Pierre Reverdy, *Picasso*, Paris 1924. — Waldemar George, *Picasso*, Rome 1924. — Wilhelm Uhde, *Picasso et la tradition française*, Paris 1928. — André Level, *Picasso*, Paris 1928. — Christian Zervos, *Picasso*, Milan 1932. — Fernande Olivier, *Picasso et ses amis*, Paris 1933. — Jaime Sabartès, *Picasso*, Milan 1937. — Jean Cassou, *Picasso*, Paris 1937. — Gertrude Stein, *Picasso*, London 1938 and New York 1939. — Robert Melville, *Picasso, Master of the Phantom*, London 1939. — Jean Cassou, *Picasso*, Paris and New York 1940. — Robert Desnos, *Picasso: seize peintures 1939–1943*, Paris 1943. — W. S. Lieberman, *Picasso and the Ballet*, New York 1946. — Alfred H. Barr, Jr., *Picasso, Fifty Years of his Art*, New York 1946; reprinted 1967. — Sidney and Harriet Janis, *Picasso: The Recent Years, 1939–1946*, New York 1946. — Jaime Sabartès, *Picasso, Portraits et Souvenirs*, Paris 1946. — Paul Eluard, *A Pablo Picasso*, Geneva and Paris 1947. — Tristan Tzara, *Pablo Picasso*, Geneva 1948. — Jacques Lassaigne, *Picasso*, Paris 1949. — Roland Penrose, *Homage to Picasso*, London 1951. — Maurice Gieure, *Initiation à l'œuvre de Picasso*, Paris 1951. — Tristan Tzara, *Picasso et la poésie*, Rome 1953. — Claude Roy, *Picasso, La Guerre et La Paix*, Paris 1954. — Franco Russoli, *Pablo Picasso*, Milan and Paris 1954. — Jaime Sabartès, *Picasso, Documents iconographiques*, Geneva 1954. — Wilhelm Boeck and Jaime Sabartès, *Picasso*, London and New York 1955. — Frank Elgar and Robert Maillard, *Picasso*, Paris and London 1955. — Vercors, D. H. Kahnweiler and Hélène Parmelin, *Picasso, Œuvres des musées de Leningrad et de Moscou*, Paris 1955. — Maurice Jardot, *Picasso 1900–1955*, Paris 1955. — Pierre Descargues, *Picasso*, Paris 1956. — Roland Penrose, *Portrait of Picasso*, London 1956, New York 1957; revised edition 1972. — Antonina Vallentin, *Picasso*, Paris 1957, New York and London 1963. — Roland Penrose, *Picasso, His Life and Work*, London and New York 1958. — D. D. Duncan, *The Private World of Pablo Picasso*, New York and London 1958. — Jaime Sabartès, *Picasso, Les Ménines*, Paris 1958. — Hélène Parmelin, *Picasso sur la place*, Paris 1959. — L. Gunther, *Picasso: A Pictorial Biography*, New York 1959. — L. G. Buchheim, *Picasso*, London 1959. — Jacques Prévert, *Portraits de Picasso*, Milan 1959. — Gaston Diehl, *Picasso*, Paris 1960. — Dor de la Souchère, *Picasso à Antibes*, Paris 1960. — D. D. Duncan, *Picasso's Picassos*, London 1961 and New York 1963. — Rudolf Arnheim, *Picasso's Guernica, The Genesis of a Painting*, Los Angeles and London 1962. — Douglas Cooper, *Picasso, Les Déjeuners*, New York and London 1963. — Françoise Gilot and Carlton Lake, *Life with Picasso*, New York and London 1964. — Brassaï, *Conversations avec Picasso*, Paris 1964; *Picasso and Company*, New York and London 1966. — Pierre Daix, *Picasso*, Paris 1964, New York and London 1965. — Hans L. C. Jaffé, *Picasso*, New York and London 1964. — Hélène Parmelin, *Les Dames de Mougins*, Paris 1964. — John Berger, *Success and Failure of Picasso*, London 1965. — Hélène Parmelin, *Le peintre et son modèle*, Paris 1965. — Edward Quinn and Roland Penrose, *Picasso at Work*, London and New York 1965. — Hélène Parmelin, *Notre-Dame-de-Vie*, Paris 1966. — Lael Wertenbaker, *The World of Picasso*, New York 1967. — Douglas Cooper, *Picasso: Theatre*, London and New York 1968. — Anthony Blunt, *Picasso's Guernica*, Oxford 1969. — Pierre Dufour, *Picasso 1950–1968*, Geneva 1969. — André Fermigier, *Picasso*, Paris 1969. — Klaus Gallwitz, *Picasso at 90, The Later Work*, New York and London 1971. — Rafael Alberti, *Picasso en Avignon*, Paris 1971. — Jean Leymarie, *Picasso, The Artist of the Century*, Geneva 1971 and London 1972.

The Early Work

Alexandre Cirici-Pellicer, *Picasso antes de Picasso*, Barcelona 1946; revised in French, *Picasso avant Picasso*, Geneva 1950. — Denys Sutton, *Picasso, peintures, époques bleue et rose*, Paris 1948. — W. S. Lieberman, *Picasso: Blue and Rose Periods*, New York 1952. — Frank Elgar, *Picasso, époques bleue et rose*, Paris 1956. — Anthony Blunt and Phoebe Pool, *Picasso, The Formative Years, A Study of his Sources*, London and New York 1962. — Jaime Sabartès, *Picasso, Les Bleus de Barcelone*, Paris 1963. — Georges Boudaille, *Picasso, première époque, 1881–1906*, Paris 1964. — Pierre Daix and Georges Boudaille, *Picasso 1900–1906*, Neuchâtel and Paris 1966; *Picasso: The Blue and Rose Periods. A Catalogue Raisonné, 1900–1906*, London and New York 1966. — Josep Palau I Fabre, *Picasso en Cataluña*, Barcelona 1966. — Juan Eduardo Cirlot, *Picasso, Birth of a Genius*, with catalogue, Barcelona and London 1972.

Cubism

Albert Gleizes and Jean Metzinger, *Du cubisme*, Paris 1912. — Guillaume Apollinaire, *Les peintres cubistes*, Paris 1913 and 1965; *The Cubist Painters*, New York 1944. — D. H. Kahnweiler, *Der Weg zum Kubismus*, Munich 1920 and Stuttgart 1958; *The Rise of Cubism*, New York 1949. — Alfred H. Barr, Jr., *Cubism and Abstract Art*, New York 1936. — Ramón Gómez de la Serna, *Completa y verdica historia de Picasso y el cubismo*, Turin 1945. — Christopher Gray, *Cubist Aesthetic Theories*, Baltimore 1953. — *Le cubisme*, exhibition catalogue, Musée d'Art Moderne, Paris, January–April 1953. — François Fosca, *Bilan du cubisme*, Paris 1956. — Guy Habasque, *Cubism*, Geneva 1959 (editions in English, French and German). — John Golding, *Cubism*, London and New York 1959, new edition 1969. — Guillaume Apollinaire, *Chroniques d'Art 1902–1918*, edited by L. C. Breunig, Paris 1960. — Robert Rosenblum, *Cubism and Twentieth-Century Art*, New York and London 1960–1961. — Pierre Cabanne, *L'Epopée du cubisme*, Paris 1963. — Edward F. Fry, *Cubism*, London and New York 1966. — Jean Paulhan, *La peinture cubiste*, Paris 1970. — Douglas Cooper, *The Cubist Epoch*, London and New York 1971. — P. W. Schwartz, *Cubism*, New York 1971.

Graphic Work

Bernhard Geiser, *Picasso, peintre-graveur, Catalogue illustré de l'œuvre gravé et lithographie, 1899–1931*, Bern 1933; reprinted 1955. — Fernand Mourlot, *Picasso lithographe*, Vols. I to V, Monte Carlo 1949, 1950, 1956, 1965, 1970. — *Picasso, L'œuvre gravé*, exhibition catalogue, Bibliothèque Nationale, Paris 1955. — Hans Bolliger, *Picasso, Vollard Suite*, London 1956. — *Picasso: Fifty Years of his Graphic Art*, exhibition catalogue, Arts Council, London 1956. — Abraham Horodisch, *Picasso as a Book Artist*, New York and London 1962. — Bernhard Geiser and Hans Bolliger, *Picasso: His Graphic Work*, Vol. 1, 1899–1955, London 1966. — Kurt Leonhard, *Picasso: His Graphic Work*, Vol. 2, 1955–1965, London 1967. — Aldo and Piero Crommelynck, *Picasso: 347 Gravures*, Paris 1968. — Bernhard Geiser, *Picasso, peintre-graveur, Catalogue illustré de l'œuvre gravé et des monotypes, 1932–1934*, Bern 1968. — Georges Bloch, *Picasso, Catalogue de l'œuvre gravé et lithographié, 1904–1967*, Vol. 1, Bern 1968. — Georges Bloch, *Picasso,*

Catalogue de l'œuvre gravé et lithographié, 1966–1969, Vol. 2, Bern 1971.

Sculpture

Julio Gonzalez, 'Picasso sculpteur', *Cahiers d'Art*, II, No. 6–7, Paris 1936. — Enrico Prampolini, *Picasso scultore*, Rome 1943. — D. H. Kahnweiler, *Les Sculptures de Picasso*, Paris 1948 (photographs by Brassaï); *The Sculptures of Picasso*, London 1949. — G. C. Argan, *Scultura di Picasso*, Venice 1953. — Roland Penrose, *The Sculpture of Picasso*, New York 1967. — Werner Spies, *Picasso Sculpture*, with complete catalogue, New York and London 1972.

Drawings

Waldemar George, *Picasso, Dessins*, Paris 1926. — Christian Zervos, *Dessins de Picasso, 1892–1948*, Paris 1949. — Jean Bouret, *Picasso, Dessins*, Paris 1950. — Paul Eluard, *Picasso, Dessins*, Paris 1952. — *Verve*, VIII, No. 29–30, Paris 1954 (special issue devoted to a series of 180 drawings). — D. H. Kahnweiler, *Picasso: Dessins 1903–1907*, Paris 1954. — *Picasso, Dessins, Gouaches, Aquarelles 1898–1957*, exhibition catalogue, Musée Réattu, Arles 1957. — Douglas Cooper, *Picasso, Carnet catalan*, Paris 1958. — Georges Boudaille, *Pablo Picasso, Carnet de La Californie*, Paris 1959. — Maurice Jardot, *Picasso, Dessins*, Paris 1959. — A. Millier, *The Drawings of Picasso*, Los Angeles 1961. — John Richardson, *Picasso, Watercolours and Gouaches*, London 1964. — Jean Leymarie, *Picasso Drawings*, Geneva 1967. — Charles Feld, preface by René Char, *Picasso Dessins 27.3.66–15.3.68*, Paris 1969.

For the principal books illustrated by Picasso we recommend the bibliography in Jean Leymarie's *Picasso, The Artist of the Century*.

Magazine Articles and Special Issues

Max Jacob, 'Souvenirs sur Picasso', *Cahiers d'Art*, Paris 1927. — *Documents*, No. 3, Paris 1930. — *Cahiers d'Art*, 7, No. 3–5, Paris 1932. — C. G. Jung, 'Picasso', *Neue Zürcher Zeitung*, No. 13, Zurich 1932. — *Cahiers d'Art*, 10, No. 7–10, Paris 1935. — *Gaceta de Arte*, Tenerife 1936. — *Cahiers d'Art*, 12, No. 4–5, Paris 1937 (on *Guernica*). — *Cahiers d'Art*, 13, No. 3–10, Paris 1938. — J. J. Sweeney, 'Picasso and Iberian Sculpture', *Art Bulletin*, 23, No. 3, New York 1941. — *Verve*, V, No. 19–20, Paris 1948 (Picasso at Antibes). — *Cahiers d'Art*, 23, No. 1, Paris 1948 (drawings, ceramics and the Antibes Museum). — Christian Zervos, 'Œuvres et images·inédites de la jeunesse de Picasso', *Cahiers d'Art*, 2, Paris 1950. — *Verve*, VII, No. 25–26, Paris 1951 (Picasso at Vallauris). — R. Bernier, 'Barcelone, 48 Paseo de Gracia', *L'Œil*, No. 4, Paris 1955. — John Richardson, 'Picasso's Ateliers and Other Recent Works', *Burlington Magazine*, XCIX, London, June 1957. — John Golding, 'The Demoiselles d'Avignon', *Burlington Magazine*, C, London, May 1958. — Phoebe Pool, 'Sources and Background of Picasso's Art', *Burlington Magazine*, CI, London, May 1959. — *Du*, Zurich, October 1961 (80th birthday number). — *La Nouvelle Critique*, No. 30, Paris, November 1961. — G. C. Argan, 'Picasso, il simbolo e il mito', *España libre*, 1965. — Jean Sutherland Boggs, 'Picasso and the Theatre at Toulouse', *Burlington Magazine*, London, January 1966. — Anthony Blunt, 'Picasso's Classical Period (1917–1925)', *Burlington Magazine*, London, April 1968. — Ruth Kaufmann, 'Picasso's *Crucifixion* of 1930; *Burlington Magazine*, London, September 1969. — Robert Rosenblum, 'Picasso and the Coronation of Alexander III: A Note on the Dating of some *Papiers Collés*', *Burlington Magazine*, London, October 1971.

List of illustrations

An asterisk preceding a number indicates that the illustration is reproduced in colour.

Frontispiece: *Heads of Sculptor and Model and Statue of a Striding Youth*, 1933.
Etching, $14\frac{1}{2} \times 11\frac{3}{4}$ (36.7 × 29.8). Vollard Suite No. 70.

1 *Triptych (Satyr, faun and centaur)*, 1946.
Oil on fibreboard, $98\frac{3}{8} \times 141\frac{1}{2}$ (250 × 360). Musée Grimaldi, Antibes.

2 *Watermelon Eater, Flutist and Man with Lamb*, 1967.
Coloured pencil, $19\frac{5}{8} \times 25\frac{1}{2}$ (50 × 65). Private Collection.

3 *Study of a Cast*, 1895.
Charcoal on paper, $24\frac{5}{8} \times 18\frac{5}{8}$ (63 × 47.5). Museo Picasso, Barcelona.

4 Cranach the Younger, *Portrait of a Woman*, 1564.
Oil on canvas, $32\frac{1}{2} \times 25\frac{1}{8}$ (83 × 64). Kunsthistorisches Museum, Vienna.

5 *Bust of a Woman after Cranach*, 1958.
Coloured linocut, $25\frac{1}{2} \times 21$ (65 × 53.5).

6 *La Vie*, 1903–4.
Oil on canvas, $77\frac{1}{2} \times 50$ (197 × 127.3). Cleveland Museum of Art, Gift of Hanna Fund, 1945.

7 *Courtesan with Jewelled Collar*, 1901.
Oil on canvas, $25\frac{3}{4} \times 21\frac{1}{2}$ (65.3 × 54.5). Los Angeles County Museum of Art, Collection of Mr and Mrs George Gard de Sylva.

8 *Girl in Prayer*, 1898–9.
Conté crayon on paper, $6\frac{3}{4} \times 9$ (17 × 23). Owned by the artist.

9 *At the Café de la Rotonde*, 1901.
Oil on canvas, $18\frac{1}{2} \times 32\frac{1}{2}$ (47 × 82.5). Collection Mr and Mrs David Lloyd Kreeger, Washington, DC.

10 *Portrait of Casagemas Dead*, 1901.
Oil on cardboard, $20\frac{1}{2} \times 13\frac{3}{8}$ (52 × 34). Owned by the artist.

11 *Carlos Casagemas, Full-Face and in Profile*, 1901.
Charcoal on paper, $5\frac{1}{8} \times 8\frac{1}{4}$ (13 × 21). Collection J A Samaranch, Barcelona.

12 *The Death of Casagemas*, 1901.
Oil on wood, $10\frac{5}{8} \times 13$ (26.9 × 34.8). Owned by the artist.

13 Study for *The Mourners*, 1901.
Chinese ink on paper, $15\frac{3}{4} \times 22$ (40 × 56). Collection Walter P Chrysler, Jr, New York.

14 *The Mourners*, 1901.
Oil on canvas, $39\frac{3}{8} \times 35\frac{1}{2}$ (100 × 90.2). Knoedler Gallery, New York.

15 Study for *The Mourners*, 1901.
Pencil on paper, $16\frac{1}{2} \times 11\frac{1}{2}$ (41.8 × 29.3). Present location unknown.

16 El Greco, *The Burial of the Count of Orgaz*, 1586–8.
Oil on canvas, $189 \times 141\frac{1}{2}$ (480 × 360). Church of Santo Tomé, Toledo.

17 *The Two Sisters*, 1902.
Oil on canvas, $59\frac{7}{8} \times 39\frac{3}{8}$ (152 × 100). Hermitage Museum, Leningrad.

18 *Nude Man with Hands Crossed*, 1902–3.
Ink and crayon on paper, $5\frac{1}{2} \times 3\frac{1}{2}$ (14 × 9). Collection Junyer Vidal, Barcelona.

19 *Crucifixion*, 1903.
Pencil on paper, $12\frac{5}{8} \times 8\frac{5}{8}$ (32 × 22). Owned by the artist.

20 Paul Gauguin, *Ia Orana Maria*, 1891.
Oil on canvas, $44\frac{3}{4} \times 34\frac{1}{2}$ (113 × 89). Metropolitan Museum of Art, Bequest of Samuel A Lewisohn, 1951.

21 *The Embrace*, 1903.
Pastel on paper, $38\frac{5}{8} \times 22\frac{5}{8}$ (98 × 57). Musée de l'Orangerie des Tuileries, Paris, Collection Jean Walter-Paul Guillaume.

22 *La Vie*, 1903–4, as No. 6.

23 Max Klinger, *Genius (The Artist)*, 1900–3.
Etching, $17\frac{5}{8} \times 13\frac{5}{8}$ (44.9 × 34.5). Albertina, Vienna.

24 *Woman with a Crow*, 1904.
Gouache and pastel on paper, $25\frac{5}{8} \times 19\frac{1}{2}$ (65 × 49.5). Toledo Museum of Art, Ohio, Gift of Edward Drummond Libbey, 1936.

25 Flemish School, *Eve and Mary*, 1634.
Engraving, from Pedro de Bivero, *Sacrum Oratorium piarum imaginum Immaculatae Mariae*, Antwerp.

26 *Nude Woman (Eve)*, 1902.
Pencil on paper, $15 \times 10\frac{5}{8}$ (38.2 × 26.5). Present location unknown.

27 *The Couple*, 1902–3.
Ink and coloured crayons on paper, $3\frac{1}{8} \times 4\frac{5}{8}$ (8 × 12). Private collection, Paris.

28 Study for *La Vie*, 1903.
Conté crayon on paper, $9 \times 7\frac{1}{2}$ (23 × 18). Museo Picasso, Barcelona.

29 *Standing Male Nude*, 1903–4.
Ink on paper, $13\frac{1}{2} \times 10\frac{1}{2}$ (34.3 × 26.6). Fogg Art Museum, Harvard University, Bequest of Meta and Paul J Sachs.

30 Study for *La Vie*, 1903.
Pencil on paper, $10\frac{1}{2} \times 7\frac{3}{4}$ (26.7 × 19.7). Collection Sir Roland Penrose, London.

31 Study for *La Vie*, 1903.
Pen on paper, $6\frac{1}{8} \times 4\frac{3}{8}$ (15.7 × 11). Present location unknown.

* 32 *The Burial of Casagemas (Evocation)*, 1901.
Oil on canvas, $59 \times 35\frac{3}{8}$ (150 × 90). Musée d'Art Moderne de la Ville de Paris.

* 33 *At the Lapin Agile*, 1905.
Oil on canvas, $39 \times 39\frac{1}{2}$ (99 × 100.3). Collection Mrs Charles S Payson, New York.

34 Sebastian Junyent, *Portrait of Picasso*, 1904.
Oil on canvas, reproduced in *Forma*, 1, 1904.

35 *The Seizure*, 1904.
Ink and gouache on cardboard, dimensions unknown. Private Collection, Paris.

36 *Street Urchins*, 1904.
Coloured crayons on paper, $14\frac{1}{8} \times 10\frac{3}{8}$ (36 × 26.5). Collection Mrs H Thannhauser, reproduced by courtesy of Thannhauser Foundation, Inc.

37 *Two Acrobats with a Dog*, 1905.
Gouache on cardboard, $41\frac{1}{2} \times 29\frac{1}{2}$ (105.5 × 75). Collection Mr and Mrs William A M Burden, New York.

38 Aubrey Beardsley, *The Death of Pierrot*, 1896.
Ink on paper, reproduced in *The Savoy*, No. 6.

39 *The Death of Harlequin*, 1905–6.
Gouache on cardboard, $26 \times 36\frac{1}{2}$ (65 × 95). Collection Mr Paul Mellon, Upperville, Virginia.

40 Study for *The Death of Harlequin*, 1905–6.
Chinese ink on paper, $6\frac{1}{8} \times 9\frac{1}{2}$ (15.5 × 24). Owned by the artist.

41 Henri de Toulouse-Lautrec, *A Corner of the Moulin de la Galette*, 1892.
Oil on canvas, 40×39 (101.6 × 99). National Gallery of Art, Washington, DC, Chester Dale Collection.

42 *The Two Saltimbanques*, 1901.
Oil on canvas, $28\frac{3}{4} \times 23\frac{5}{8}$ (73 × 60). Pushkin Museum, Moscow.

43 *Woman with a Shawl (Germaine Pichot)*, 1902.
Oil on canvas, 18⅛ × 16 (46 × 40.8). Collection Mrs Harris Jonas, New York.

44 Edvard Munch, detail of *Woman (The Sphinx)*, 1899.
Lithograph, 18⅛ × 23⅜ (46 × 59.4). The William B and Evelyn A Jaffe Collection, Museum of Modern Art, New York.

45 Carlos Casagemas, *At the Café*, 1900.
Ink on paper, dimensions unknown. Private Collection, Barcelona.

46 *The Harlequin's Family*, 1905.
India ink and gouache on paper, 22⅞ × 17⅛ (58 × 43.5). Collection Mr and Mrs Julian C Eisenstein, Washington, DC.

47 *The Mother's Toilet*, 1905.
Etching, 9¼ × 6⅞ (23.5 × 17.6). Museum of Modern Art, New York.

* 48 *La Toilette*, 1906.
Oil on canvas, 59½ × 39 (151 × 99). Albright-Knox Art Gallery, Buffalo, New York.

* 49 *St Anthony and Harlequin*, 1908.
Watercolour on paper, 23⅜ × 18⅛ (62 × 48). Moderna Museet, Stockholm.

50 *The Acrobat's Family with a Monkey*, 1905.
Gouache, watercolour, pastel and India ink on cardboard, 41 × 29½ (104 × 75). Konstmuseum, Goteborg.

51 Raphael, *Holy Family with the Beardless St Joseph*, 1505.
Oil on canvas, 29⅛ × 22⅜ (74 × 57). Hermitage Museum, Leningrad.

52 *The Wedding of Pierrette*, 1904–5.
Oil on canvas, 37⅜ × 57⅛ (95 × 145). Present location unknown.

53 Study for *The Wedding of Pierrette*, 1904–5.
Conté crayon on paper, 9⅞ × 13 (25 × 33). Owned by the artist.

54 *Salome*, 1905.
Drypoint, 15¾ × 13¾ (40 × 34.8).

55 *Family of Saltimbanques*, 1905.
Oil on canvas, 83¾ × 90⅜ (212.8 × 229.6). National Gallery of Art, Washington, DC, Chester Dale Collection.

56 *Woman of Majorca*, 1905.
Gouache on cardboard, 26⅜ × 20⅛ (67 × 51). Pushkin Museum, Moscow.

57 *Planche de Dessins* (with Max Jacob), 1905.
Drypoint, 11½ × 9⅞ (29.2 × 25).

58 *The Two Brothers*, 1906.
Oil on canvas, 55⅞ × 38⅛ (142 × 97). Rodolphe Staechlin Foundation, on loan to the Kunstmuseum, Basel.

59 Study for *Les Demoiselles d'Avignon*, 1906–7.
Charcoal and pastel on paper, 18½ × 24⅝ (47 × 62.5). Kunstmuseum, Basel.

60 *Three Nudes*, 1906.
Oil on canvas, 9⅞ × 11½ (25 × 30). © 1973 by The Barnes Foundation, Merion, Pennsylvania.

61 Paul Cézanne, *The Temptation of St Anthony*, 1869–70.
Oil on canvas, 21¼ × 28¼ (54 × 73). Foundation Collection, E G Bührle, Zurich.

62 *Still Life with a Skull*, 1908.
Oil on canvas, 45 × 34⅝ (116 × 89). Hermitage Museum, Leningrad.

63 Paul Cézanne, *The Smoker*, c 1895.
Oil on canvas, 36¼ × 28¾ (92 × 73). Pushkin Museum, Moscow.

64 *Harlequin Leaning on his Elbow*, 1909.
Oil on canvas, 35⅞ × 28 (91.2 × 71.2). Collection Enrico Donati, New York.

65 *Composition (Harlequin and Nude)*, 1908.
Pencil and watercolour on wood block, 7⅜ × 10⅛ (18.9 × 25.7). Present location unknown.

66 *Bottle of Suze*, 1913.
Collage with charcoal, 25⅝ × 19⅝ (65 × 50). Washington University Gallery of Art, St Louis.

67 *Bottle of Vieux Marc, Glass, Newspaper*, spring 1913.
Collage with charcoal, 24⅝ × 18½ (62.5 × 47). Musée National d'Art Moderne, Paris.

68 *The Card Player*, winter 1913–14.
Oil on canvas, 39⅜ × 31⅞ (100 × 81). Lillie P Bliss Bequest, Museum of Modern Art, New York.

69 Juan Gris, *The Saucepan*, 1919.

Destroyed by fire in 1944.

70 *Still Life with Skull*, 1913.
Oil on canvas, 17⅛ × 24 (43.5 × 61). Collection Jean Masurel, Roubaix.

71 *Student with Newspaper*, 1913–14.
Oil on canvas. Private Collection, Paris.

72 *Bottle and Newspaper on Table*, 1912.
Collage with charcoal, 24¾ × 18⅞ (63 × 48). Musée National d'Art Moderne, Paris.

73 *Man with Guitar*, 1913.
Oil on canvas, 12¼ × 9¼ (31 × 23.5). Walter Chrysler Collection, New York.

74 *Study for a Manager's costume in 'Parade'*, 1917.
Pencil on paper. Present location unknown.

75 *Guitar and Bottle*, 1913.
Charcoal and pencil on paper, 12¼ × 15¾ (31 × 40). The A E Gallatin Collection, Philadelphia Museum of Art.

76 *Landscape with Poster*, summer 1912.
Oil on canvas, 18⅛ × 24 (46 × 61). Present location unknown.

77 *Still Life with Bouillon Cube*, spring 1912.
Oil on canvas, 10⅝ × 8¼ (27 × 21). Present location unknown.

78 Piet Mondrian, *Paris Buildings (Rue du Départ)*, 1912–13.
Pencil on paper, 9¼ × 6⅛ (23.6 × 15.5). Courtesy Sidney Janis Gallery, New York.

79 Piet Mondrian, *Oval Composition*, 1913–14.
Oil on canvas, 44½ × 33¾ (113 × 84.5). Loan S B Slijper, Collection Gemeentemuseum, The Hague.

80 *Still Life ('Notre Avenir est dans l'Air')*, spring 1912.
Oil on canvas, 5½ × 8⅝ (14 × 22). E and A Silberman Galleries, New York.

81 *Café Table*, summer 1912.
Ink on paper, 5⅛ × 3⅜ (13 × 8.5). Owned by the artist.

82 *The Old Port at Marseilles*, summer 1912.
Ink on paper, 5⅛ × 3⅜ (13 × 8.5). Owned by the artist.

83 *Bottle and Glass on Table*, winter 1912–13.
Collage with charcoal, 21⅝ × 18⅛ (55 × 46). Formerly Collection J J Sweeney, New York.

84 *Pipe, Glass, Bottle of Rum*, 1914.
Collage with pencil and gouache on cardboard, 15¼ × 20¾ (38.7 × 52.7). Museum of Modern Art, New York, Gift of Mr and Mrs D Saidenberg.

85 *Still Life with Bottle of Bass*, 1912. Oil on canvas. Private Collection.

86 Juan Gris, *Still Life*, 1916.
Oil on wood, 20½ × 13 (52.1 × 33). Collection Mr and Mrs Bernard Reis, New York.

87 Juan Gris, *The Check Tablecloth*, 1915.
Oil on canvas, 45¾ × 35 (116.2 × 88.9). Collection Dr W Loeffler, Zurich.

88 Juan Gris, *The Siphon*, 1917.
Conté crayon on paper, 18¾ × 12½ (47.6 × 31.8). The A E Gallatin Collection, Philadelphia Museum of Art.

89 *Woman with Guitar ('Ma Jolie')*, winter 1911–12.
Oil on canvas, 39⅜ × 25⅝ (100 × 65). Museum of Modern Art, New York.

90 *The Violin ('Jolie Eva')*, 1912.
Oil on canvas 23⅝ × 31⅞ (60 × 81). Staatsgalerie, Stuttgart.

91 *Still Life ('The Architect's Table')*, 1912.
Oil on canvas, 28¾ × 23⅝ (73 × 60). Collection Mr and Mrs William Paley, New York.

92 Max Weber, *Avoirdupois*, 1915.
Oil on canvas, 21 × 18 (53.3 × 45.7). Mabel G Siemonn Fund, Baltimore Museum of Art.

93 Juan Gris, *The Package of Coffee*, 1914.
Collage with charcoal and oil on canvas, 25½ × 18½ (64.8 × 47). Museum, Ulm.

94 Juan Gris, *The Violin ('Auprès de ma blonde')*, 1913.
Oil on canvas, 36¼ × 23¾ (91 × 59.1). The A E Gallatin Collection, Philadelphia Museum of Art.

95 Detail of *Bottle and Glass*, 1913.

96 *Bottle and Glass*, 1913.
Collage with charcoal, 24⅝ × 18½ (62.5 × 47). D and J de Menil Collection, Houston, Texas.

97 Juan Gris, *Still Life ('The Table')*, 1914.
Oil and paper on canvas, $17\frac{1}{2} \times 23\frac{1}{2}$ (44.5 × 59.7). The A E Gallatin Collection,
Philadelphia Museum of Art.

98 Detail of Gris' *Still Life ('The Table')*, 1914.

99 *Still Life with Siphon, Glass, Violin*, 1912–13.
Collage with charcoal, $18\frac{1}{2} \times 24\frac{5}{8}$ (47 × 62.5). Moderna Museet, Stockholm.

100 Juan Gris, *Still Life (Glasses and Newspaper)*, 1914.
Collage with oil and charcoal on canvas, 24×15 (61 × 38.1). Given by Joseph
Brumner to Smith College Museum of Art, Northampton, Mass.

101 Juan Gris, *The Tea Cups*, 1914.
Collage, charcoal and oil on canvas, $36\frac{1}{4} \times 25$ (92.1 × 65.1).
Kunstsammlung Nordrhein-Westfalen, Düsseldorf.

102 Detail of Gris' *The Tea Cups*, 1914.

103 Juan Gris, *Figure Seated in a Café*, 1914.
Oil and paper on canvas, $39 \times 28\frac{1}{4}$ (99.1 × 71.8). Collection Mr and Mrs
Leigh B Block, Chicago.

104 Detail from Gris' *Figure Seated in a Café*, 1914.

105 Juan Gris, *Breakfast*, 1914.
Collage, crayon and oil on canvas, $31\frac{7}{8} \times 23\frac{1}{2}$ (81 × 59.7). Lillie P Bliss Bequest,
Museum of Modern Art, New York.

106 *The Letter*, spring 1912.
Oil on canvas, $6\frac{1}{4} \times 8\frac{5}{8}$ (16 × 22). Present location unknown.

107 *Spanish Still Life*, 1912.
Oil on canvas, 18×13 (46 × 33). Private collection, France.

108 *Still Life with Pipe*, 1914.
Oil and charcoal on canvas, $19\frac{5}{8} \times 25\frac{5}{8}$ (50 × 65). Houston Museum of Art, Texas.

109 *Still Life*, 1918.
Oil on canvas, $10\frac{5}{8} \times 11\frac{3}{4}$ (27 × 30). Private Collection, New York.

110 Diego Rivera, *Still Life with Carafe*, 1914.
Collage with ink and charcoal on canvas, $14 \times 7\frac{3}{8}$ (35.5 × 18.8).
Collection Jacques Dubourg, Paris.

111 Georges Braque, *Music*, 1914.
Oil on canvas, $36 \times 23\frac{1}{2}$ (91.4 × 59.7). The Phillips Collection, Washington, DC.

112 Juan Gris, *Still Life with Plaque*, 1917.
Oil on canvas, $31\frac{7}{8} \times 25\frac{3}{4}$ (81 × 65.4). Kunstmuseum, Basel.

113 *Sketch of Hermen Anglada*, 1900.
Ink on paper, $5\frac{1}{4} \times 3\frac{5}{8}$ (13.5 × 9.3). Museo Picasso, Barcelona.

114 *Various sketches*, 1898.
Ink on paper, $12\frac{3}{8} \times 8\frac{5}{8}$ (31.5 × 22). Museo Picasso, Barcelona.

115 *Still Life with Bottle of Bass*, 1914.
Oil on canvas. Present location unknown.

* 116 *Still Life with Chair Caning*, spring 1912.
Oil, oilcloth and paper on canvas with rope surround, $10\frac{5}{8} \times 13\frac{3}{4}$ (27 × 34.9).
Owned by the artist.

* 117 *Still Life ('Au Bon Marché')*, winter 1912–13.
Oil and paper on canvas, $9\frac{1}{4} \times 12\frac{1}{4}$ (23.5 × 31). Collection Mrs Michael Newbury,
Chicago.

* 118 *Restaurant Still Life*, 1914.
Oil on canvas. Hermitage Museum, Leningrad.

* 119 *Still Life with Grapes and Pear*, 1914.
Oil on canvas, $18\frac{1}{2} \times 24\frac{5}{8}$ (47 × 62.5). Collection Mr and Mrs David Lloyd Kreeger,
Washington, DC.

120 *Still Life: Bottle of Bass, Glass, Package of Tobacco, and Calling Card
('André Level')*, winter 1913–14.
Collage with charcoal. Present location unknown.

121 *Still Life with Calling Card*, 1914.
Collage with oil and charcoal on canvas, $5\frac{1}{2} \times 8\frac{1}{2}$ (14 × 21.6). Collection Mrs Gilbert
W Chapman, New York.

122 *Still Life: Newspaper, Glass and Pipe*, 1914.
Watercolour and charcoal, $7\frac{1}{2} \times 11$ (19 × 28). Present location unknown.

123 *Still Life: Bottle, Playing Cards and Glass*, 1914.
Oil on canvas, $12\frac{3}{8} \times 16\frac{7}{8}$ (31.5 × 42.9). The A E Gallatin Collection,

Philadelphia Museum of Art.

124 *Woman with Guitar*, 1913–14.
Oil on canvas, $45\frac{5}{8} \times 18\frac{7}{8}$ (115.9 × 47.9). Collection Mr and Mrs David Rockefeller,
New York.

125 *Plat del Día (Menu Card from Els Quatre Gats)*, 1897.
Ink on paper. Collection John Hunt, Dublin.

126 *Still Life with Fan (L'Indépendant)*, 1911.
Oil on canvas, $24 \times 19\frac{5}{8}$ (61 × 50). Collection Mr and Mrs Henry Clifford, Pa.

127 Jane Atché, *Poster for Job Cigarette Paper*.
Bibliothèque des Arts Décoratifs, Paris.

128 *Restaurant Still Life*, 1912.
Oil on canvas, $14\frac{1}{8} \times 17\frac{1}{4}$ (36 × 44). Owned by the artist.

129 *Three Dancers*, 1925.
Oil on canvas, $84 \times 56\frac{1}{4}$ (215 × 140). Tate Gallery, London.

* 130 *Les Demoiselles d'Avignon*, 1907.
Oil on canvas, 96×92 (244 × 233). Museum of Modern Art, New York.

* 131 *Woman in an Armchair,(La Femme en Chemise)*, 1913.
Oil on canvas, $58\frac{1}{4} \times 39$ (148 × 99). Collection Mr and Mrs Victor W Ganz, New York.

132 *Three Musicians*, 1921.
Oil on canvas, $79 \times 87\frac{3}{4}$ (200.7 × 222.9). Mrs Simon Guggenheim Fund,
Museum of Modern Art, New York.

133 African(?) mask, belonging to Picasso.

134 Eskimo mask from Lower Yukon, Alaska, 19th century.

135 *Crucifixion (after Grünewald)*, 1930–2.
Ink on paper, $13\frac{5}{8} \times 19\frac{7}{8}$ (34.5 × 50.5). Present location unknown.

136 Donatello, the 'Weeping Maenad at the Cross' from San Lorenzo pulpit,
c 1460–70. Florence.

137 Mathis Grünewald, *Crucifixion* (Isenheim Altar), 1505–15.
Colmar.

138 *Man with a Hat*, 1912–13.
Collage with charcoal and ink, $24\frac{1}{2} \times 18\frac{1}{4}$ (62.2 × 46.4). Museum of Modern Art,
New York.

139 *Violin on a Table*, 1912–13.
Collage with crayon, $24\frac{5}{8} \times 18\frac{1}{4}$ (62.5 × 46.5). D and J de Menil Collection, Houston.

140 *Bottle and Glass*, 1913.
Collage with charcoal, $23\frac{3}{4} \times 18\frac{3}{4}$ (60.5 × 45). Kunstsammlung Nordrheim-
Westfalen, Dusseldorf.

141 *Nude with Guitar Player*, 1914.
Pencil on paper. Owned by the artist.

142 *Sketch for the night scene of the ballet 'Mercure'*, 1924.
Pencil on paper.

143 *Drawing*, 1924.
Ink on paper, subsequently reproduced by wood engraving in *Le Chef-d'oeuvre
inconnu* (Vollard) 1931.

144 *L'Atelier de la Modiste*, 1926.
Oil on canvas, 68×101 (172 × 256). Musée National d'Art Moderne, Paris.

145 *The Painter and his Model*, 1926.
Oil on canvas, 68×101 (172 × 256). Owned by the artist.

146 Max Ernst, *One Night of Love*, 1927.
Oil on canvas, $64 \times 51\frac{1}{4}$ (162.5 × 130). Private collection, Paris.

147 Chart of tracings of neolithic motifs.

148 Joan Miro, *Drawing*, 1944.

149 Joan Miro, *Drawing*, 1929.

150 *Woman in an Armchair*, 1927.
Oil on canvas, $51\frac{3}{8} \times 38\frac{1}{4}$ (130.5 × 97.2). Owned by the artist.

151 Easter Island hieroglyphs representing men.

152 *Acrobat*, 1930.
Oil on canvas, $63\frac{3}{4} \times 51\frac{1}{8}$ (160 × 130). Owned by the artist.

153 Neolithic rock painting from the Baghdi valley, Algeria.

154 *Artist and Model*, 1927.

Oil on canvas, $84\frac{1}{4} \times 78\frac{3}{4}$ (214 × 200). Private collection.

155 René Magritte, *The Rape*, 1934.
Oil on canvas, $28\frac{1}{2} \times 21$ (72.4 × 53.3). Collection George Melly, London.

156 *Woman Sleeping in a Chair*, 1927.
Oil on canvas, $36\frac{1}{4} \times 28\frac{3}{4}$ (92 × 73). Collection Betty Barman, Brussels.

157 Marcel Duchamp, *The Bride*, 1912.
Oil on canvas, $35\frac{1}{4} \times 21\frac{3}{4}$ (89 × 54). The Louise and Walter Arensberg Collection, Philadelphia Museum of Art.

158 *Study for a Monument (Woman's Head)*, 1929.
Oil on canvas, $25\frac{5}{8} \times 21\frac{1}{4}$ (65 × 54). Present location unknown.

159 *Artist and Model*, 1928.
Oil on canvas, $51\frac{5}{8} \times 66\frac{7}{8}$ (131 × 162.5). The Sidney and Harriet Janis Collection, Gift to the Museum of Modern Art, New York.

160 Wooden dance shield from New Guinea.

161 Wooden figure from the Sepic valley, New Guinea.
Collection, Pennsylvania University.

162 *Head (Blue Bone)*, 1929. Gift of the Dexter M Ferry Jr Trustee Corporation of Detroit, Baltimore Museum of Art.

163 *Woman's Head*, 1932.
Bronze, $27\frac{1}{2} \times 16\frac{1}{8} \times 14\frac{1}{8}$ (70 × 41 × 36). Owned by the artist.

164 Wooden figure from the Sepic valley, New Guinea.
Collection Matta.

165 *Study for a Crucifixion*, 1929.
Pencil on paper. Owned by the artist.

166 Detail of painted wooden figures from Tibet.
Musée Guimet, Paris.

167 *Figures by the Sea (The Kiss)*, 1931.
Oil on canvas, $51\frac{5}{8} \times 76\frac{3}{4}$ (130 × 195). Owned by the artist.

168 *Bather*, 1927.
Crayon on paper. Owned by the artist.

169 *Bather*, 1927.
Crayon on paper. Owned by the artist.

170-71 *An Anatomy*, 1932.
Pencil on paper, reproduced in *Minotaure*, No. 1, 1933.

172 *Drawing*, 1928.
Pen and ink on paper. Owned by the artist.

173 *Drawing*, 1928.
Pen and ink on paper. Owned by the artist.

174 *Nudes (Copulating Couple)*, 1933.
Pen and ink on paper, $13\frac{3}{8} \times 19\frac{7}{8}$ (34.5 × 50.5). Present location unknown.

175 *Seated Bather*, 1930.
Oil on canvas, $61\frac{1}{4} \times 51$ (163.5 × 130). Mrs Simon Guggenheim Fund, Museum of Modern Art, New York.

176 *Figure and Profile*, 1927–8.
Oil on canvas, $25\frac{5}{8} \times 25\frac{1}{4}$ (65 × 64). Present location unknown.

177 *Bust of a Woman*, 1929.
Oil on canvas, $25\frac{5}{8} \times 19\frac{5}{8}$ (72.5 × 50). Collection Mr and Mrs Ralph F Colin, New York.

178 *The Open Window*, 1929.
Oil on canvas, $51\frac{1}{4} \times 63\frac{3}{4}$ (130.2 × 161.9). Collection Mrs Mollie Bostwick, Chicago.

179 *The Painter*, 1930.
Oil on wood, $19\frac{3}{4} \times 25\frac{5}{8}$ (50.2 × 65.1). Collection Dr and Mrs Abraham Melamed, Milwaukee.

180 *Minotaure*, 1933.
Pen and ink on paper, $15\frac{1}{2} \times 19\frac{1}{2}$ (39 × 50). Present location unknown.

181 *Composition*, 1933.
Crayon and ink on paper, $15\frac{1}{2} \times 19\frac{1}{2}$ (39 × 50). Present location unknown.

182 *The Mirror*, 12 March 1932.
Oil on canvas, $51\frac{1}{4} \times 38\frac{1}{4}$ (130 × 97). Gustav Stern Foundation Inc., New York.

183 *Lespugue Venus*. leptolithic.
Mammoth ivory, 5.75 high (14.6). Musée de l'Homme, Paris.

184 *Girl in Front of a Mirror*, 14 March 1932.
Oil on canvas, $63\frac{3}{4} \times 51\frac{1}{4}$ (162 × 130). Museum of Modern Art, New York.

185 *The Painter*, 1934.
Oil on canvas, $39\frac{1}{4} \times 32$ (99.7 × 81.3). Present location unknown.

* 186 *Bather with a Ball*, 1932.
Oil on canvas, $57\frac{1}{2} \times 45\frac{1}{8}$ (146 × 114.5). Collection Mr and Mrs Victor W Ganz, New York.

* 187 *Reclining Nude*, July 1932.
Oil on canvas, $40 \times 36\frac{1}{2}$ (101.6 × 92.7). Collection Mr and Mrs Peter A Rubel, New York.

188 *Hal Saflieni Venus*, Hypogeum in Paola, Malta.

189 *Model and Fantastic Sculpture*, 1933.
Etching, $10\frac{1}{2} \times 7\frac{1}{2}$ (26.8 × 19.3). Vollard Suite No. 74.

190 *The Flood*, from the commentary on the Apocalypse of Beatus of Liebana, 11th century. $14\frac{1}{2} \times 11$ (37 × 28). Bibliothèque Nationale, Paris.

191 Aborigine cave painting from Oenpelli, Arnhemland.

192 *Crucifixion*, 1930.
Oil on wood, 20×26 (51 × 66). Owned by the artist.

193 *Study for a Crucifixion*, 1930–31.
Pencil on paper. Owned by the artist.

194 *Study for a Crucifixion*, 1930–31.
Pencil on paper. Owned by the artist.

195 Joan Miro, *Harlequin's Carnival*, 1924–25.
Oil on canvas, $26 \times 36\frac{5}{8}$ (66 × 93). Albright Knox Art Gallery, Buffalo, New York.

196 *The Dream and Lie of Franco*, January–June 1937.
Etching and aquatint, $12\frac{3}{8} \times 15\frac{5}{8}$ (31.4 × 39.7). Collection Sir Roland Penrose.

197 *Guernica*, May–June 1937.
Oil on canvas, 138×308 (350.5 × 782.3). On extended loan to the Museum of Modern Art, New York, from the artist.

198 *Seated Woman*, 1901 (?).
Bronze, $5\frac{1}{2} \times 3\frac{1}{8} \times 2\frac{3}{4}$ (14 × 8 × 7). Owned by the artist.

* 199 *Woman Combing her Hair*, 1906.
Bronze, height $16\frac{1}{2}$ (42). Reproduced by courtesy of the Hanover Gallery, London.

* 200 *Glass of Absinth*, 1914.
Bronze, height $8\frac{5}{8}$ (22). Museum of Modern Art, New York, gift of Mrs Bertram Smith

* 201 *Still Life*, 1914.
Painted wood and cloth, $10 \times 18\frac{7}{8} \times 4$ (25.5 × 48 × 10). Tate Gallery, London.

* 202 *Guitar*, 1914.
Painted sheet metal, $37\frac{3}{8} \times 26 \times 7\frac{1}{2}$ (95 × 66 × 19). Owned by the artist.

203 *Head of a Picador with a Broken Nose*, 1903.
Bronze, $7\frac{1}{4} \times 5\frac{1}{8} \times 4\frac{3}{8}$ (18.5 × 13 × 11). Owned by the artist.

204 *Blind Singer*, 1903.
Bronze, $5\frac{1}{8} \times 2\frac{3}{4} \times 3\frac{1}{8}$ (13 × 7 × 8). Owned by the artist.

205 *Head of a Woman (Alice Derain)*, 1905.
Bronze, $10\frac{5}{8} \times 10\frac{5}{8} \times 5\frac{1}{2}$ (27 × 27 × 14). Owned by the artist.

206 *Harlequin (Jester)*, 1905.
Bronze, $15\frac{3}{4} \times 13\frac{3}{4}$ (40 × 35). Owned by the artist.

207 *Figurine*, 1907.
Wood, $8\frac{5}{8} \times 2\frac{3}{8} \times 2\frac{3}{8}$ (22 × 6 × 6). Private Collection.

208 *Figure*, 1907.
Wood, $32\frac{1}{4} \times 9\frac{1}{2} \times 8\frac{1}{2}$ (82 × 24 × 21.5). Owned by the artist.

209 *Head of a Woman (Fernande)*, late 1905.
Bronze, $13\frac{3}{8} \times 9\frac{7}{8} \times 10\frac{1}{2}$ (34 × 25 × 26.5). Owned by the artist.

210 *Woman's Mask*, 1908.
Terracotta, $7\frac{1}{2} \times 6\frac{1}{4}$ (19 × 16). Musée National d'Art Moderne, Paris.

211 *Woman in Green*, 1909.
Oil on canvas, $38\frac{7}{8} \times 31\frac{1}{2}$ (99 × 80). Stedelijk Van Abbemuseum, Eindhoven.

212 *Head of a Woman (Fernande)*, 1909.
Bronze, height $16\frac{1}{2}$ (42). Collection Max Rayne, London.

213 *Violin*, 1913.
Cardboard and painted paper, 20 × 11¾ (51 × 30). Owned by the artist.

214 *Guitar*, 1913.
Sheet metal and wire, 30¾ × 13¾ × 7¼ (78 × 35 × 18.5). Owned by the artist.

215 *Glass, Pipe and Playing Card*, 1914.
Wood and metal, diameter 13⅜ (34). Owned by the artist.

216 *Glass and Dice*, 1914.
Wood, 9¼ × 8⅝ (23.5 × 22). Owned by the artist.

217 *Musical Instrument*, 1914.
Painted wood, 23⅝ × 14⅜ × 8⅝ (60 × 36 × 22). Owned by the artist.

218 *Violin and Bottle on a Table*, 1915–16(?).
Wood, string and tacks, 18½ × 16½ × 7½ (47 × 42 × 19). Owned by the artist.

219 *The New York Manager*, 1917.
Cloth and cardboard, height 10 (3.05). Present location unknown.

220 *Packet of Tobacco*, 1921(?).
Painted sheet metal, 5⅝ × 18⅞ (17 × 48). Owned by the artist.

221 *Pipes of Pan*, 1923.
Oil on canvas, 80½ × 68⅝ (204.5 × 174). Owned by the artist.

222 *Construction in Wire*, 1928.
Metal, 19⅝ × 16⅛ × 6¾ (50 × 41 × 17). Owned by the artist.

223 *Head*, 1930–31.
Bronze (after original in iron), 33 × 15¾ × 14¼ (84 × 40 × 36). Owned by the artist.

224 *Woman's Head*, 1930–31.
Iron, 39⅜ × 14½ × 24 (100 × 37 × 61). Owned by the artist.

225 *Woman in the Garden*, 1929–30.
Bronze (after original in iron), 82¾ × 46 × 32¼ (210 × 117 × 82). Owned by the artist.

226 *Construction with Glove*, 1930.
Cardboard, plaster and wood on canvas, covered with sand, 10⅝ × 14 (27 × 35.5). Owned by the artist.

227-8 *Group of Women*, 1931.
Wood, height up to 21⅞ (55.5). Owned by the artist.

229 *The Sculptor*, 1931.
Oil on plywood, 50¾ × 38½ (130 × 98). Private collection.

230 *Woman's Head*, early 1932.
Bronze, 19¾ × 12⅜ × 10⅝ (50 × 31 × 27). Owned by the artist.

231 *Bust of a Woman*, 1932.
Bronze, 30¾ × 18⅛ × 18⅞ (78 × 46 × 48). Owned by the artist.

232 *Head of a Woman*, 1932.
33½ × 14½ × 17⅞ (85 × 37 × 45.5). Owned by the artist.

233 *Head of a Woman*, 1932.
Bronze, 50⅜ × 22⅞ × 26 (128 × 58 × 66). Owned by the artist.

234 *Bust of a Woman*, 1932.
Bronze, 25⅛ × 12⅛ × 15 (64 × 31 × 38). Owned by the artist.

235 *Standing Woman*, 1932.
Bronze, 27⅞ × 12⅝ × 15¾ (71 × 32 × 40). Owned by the artist.

236 *Woman with Raised Arms*, 1932.
Bronze, 13 × 5½ × 5½ (33 × 14 × 14). Owned by the artist.

237 *Reclining Woman*, 1932.
Bronze, 9½ × 27½ × 11¾ (24 × 70 × 30). Owned by the artist.

238 *Woman with Leaves*, 1934.
Bronze, 15 × 7⅞ × 10⅝ (38 × 20 × 27). Owned by the artist.

239 *Running Woman*, 1940(?).
Bronze, 20½ × 12⅝ × 5½ (52 × 32 × 14). Owned by the artist.

240 *Cock*, 1932.
Bronze, 26 × 24 × 13 (66 × 61 × 33). Tate Gallery, London.

241 *Cat*, 1944.
Bronze, 14⅛ × 21⅝ × 6⅞ (36 × 55 × 17.5). Owned by the artist.

242 *Bull's Head*, 1943.
Bronze, 16½ × 16⅛ × 5⅞ (42 × 41 × 15). Owned by the artist.

243 *Death's Head (Flayed Head)*, 1943(?).
Bronze, 11⅜ × 8⅝ × 10¼ (29 × 22 × 26). Owned by the artist.

244 *L'homme à l'agneau (Man with a Lamb)*, February–March 1943.
Bronze, 86½ × 30¾ × 28⅝ (220 × 78 × 72). Owned by the artist.

245 *Flowering Watering Can*, 1943–44.
Bronze, 33 × 17¾ × 15¾ (84 × 43 × 40). Owned by the artist.

246 *Woman with the Apple*, 1943.
Bronze, 71⅞ × 30¾ × 28 (180 × 78 × 71). Owned by the artist.

247 *Standing Figure*, 1944.
Bronze, 60¼ × 19⅝ × 7⅜ (154 × 50 × 19). Owned by the artist.

248 *La Taulière*, 1943–44.
Bronze, 67¾ × 17 × 11¾ (172 × 43 × 30). Owned by the artist.

* 249 *La Statuaire*, 1925.
Oil on canvas, 51¼ × 38 (131 × 97). Collection Mr and Mrs Daniel Saidenberg, New York.

* 250 *Maquette for Chicago Civic Centre*, 1946.
Welded steel, 41¼ × 27½ × 19 (105 × 70 × 48). Art Institute, Chicago.

251 *Standing Figurine*, 1945.
Bronze, height 11 (27.9). Reproduced by courtesy of the Hanover Gallery, London.

252 *Angry Owl*, 1953.
Bronze, 10⅝ × 8⅝ × 11 (27 × 22 × 28). Owned by the artist.

253 *Pregnant Woman*, 1950 (second version).
Bronze, 43¼ × 11¼ × 13⅜ (110 × 30 × 34). Owned by the artist.

254 *Female Form*, 1948.
Bronze, 37¾ × 10¼ × 7⅞ (96 × 26 × 20). Owned by the artist.

255 *Little Girl Skipping*, 1950.
Bronze, 60¼ × 25⅝ × 24⅜ (153 × 65 × 62). Owned by the artist.

256 *Goat*, 1950.
Bronze, 47⅝ × 28¾ × 55 (121 × 73 × 140). Owned by the artist.

257 *Flowers in a Vase*, 1953.
Bronze, 28¾ × 19¼ × 16½ (73 × 49 × 42). Owned by the artist.

258 *Bunch of Flowers*, 1953.
Bronze, 23⅝ × 19⅝ × 15⅜ (60 × 50 × 39). Owned by the artist.

259 *L'Espagnole*, 1961.
Metal, 21 × 15 (53.3 × 38). Owned by the artist.

260 *Sylvette*, 1954.
Metal, cut out, folded and painted, 24⅜ × 17¾. Owned by the artist.

261 *Woman's Head*, 1962.
Metal, cut out and folded, 20½ × 10⅞ × 7 (52 × 15 × 18). Owned by the artist.

262 *Bathers*, 1956, as exhibited in Battersea Park, London, 1960.
Bronze, height up to 104 (264). Owned by the artist.

263 *Dance with Banderillas*, 1954.
Lithograph, 20 × 26 (48 × 64).

264 *Nude in an Armchair*, 1929.
Oil on canvas, 76¾ × 51⅛ (195 × 130). Owned by the artist.

265 *Ape and Young*, 1952.
Bronze, height 21⅝ (55). Collection Norman Granz, London.

* 266 *Self Portrait and Monster*, 1929.
Oil on canvas, 29 × 24 (73 × 61). Private Collection.

* 267 *Portrait of Dora Maar*, 1937.
Oil on canvas, 36¼ × 25½ (92 × 65). Owned by the artist.

268 *Monster*, 1935.
Ink on paper, 7½ × 10⅜ (19 × 26.4). Private Collection.

269 *The Race*, 1922.
Tempera on wood, 12⅞ × 16¼ (32.5 × 41.5). Owned by the artist.

270 *Girl with a Mandolin*, 1910.
Oil on canvas, 39½ × 29 (100 × 73). Collection Nelson Rockefeller, New York.

271 *Man Beating his Wife*, 1903.
Ink and coloured crayon on paper. Private Collection.

272 *Man with his Skull Torn by a Raven*, 1903.
Ink on paper, 5½ × 3½ (14 × 9). Private Collection, Barcelona.

273 *Bullfight*, 1901.
Pen on paper. Collection Junyer Vidal, Barcelona.

274 *Dying Horse*, 1917.
Charcoal on canvas, $31\frac{1}{2} \times 63\frac{3}{4}$ (80.2 × 163.3). Museo Picasso, Barcelona.

275 *Cat and Bird*, 1939.
Oil on canvas, $38 \times 50\frac{3}{4}$ (97 × 129). Collection Mr and Mrs Victor W Ganz, New York.

276 *Ape and Model*, 1954.
Ink on paper, Verve Suite, $9\frac{1}{2} \times 12\frac{5}{8}$ (24 × 32.3). Verve Suite.

277 Detail from *The Dream and Lie of Franco (I)*, 1937.
Engraving, $12 \times 16\frac{1}{2}$ (31 × 42). Collection Sir Roland Penrose.

278 Detail of signature from *The Dream and Lie of Franco (I)*, 1937.

279 Detail of *La Courtisane*, 1901.
Oil on wood, $5\frac{1}{2} \times 7\frac{7}{8}$ (14 × 20). Private Collection.

280 *Charity*, 1903.
Ink and coloured pastel on paper, $10\frac{1}{2} \times 14\frac{1}{2}$ (26.7 × 36.8).
Private Collection.

281 *Pere Ubu*, 1937.
Ink on paper. Private Collection.

282 *Sketch of Casagemas (with the artist)*, 1898.
Ink and aquatint. Private Collection.

283 *Cartoon of Apollinaire as Pope*, 1905(?).
Ink on paper. Private Collection.

284 *Portrait of Hélène Parmelin against a green background*, 1952.
Oil on plywood, $57\frac{7}{8} \times 45\frac{1}{4}$ (147 × 115). Private Collection.

285 *Portrait of Hélène Parmelin*, 1952.
Oil on plywood, $58\frac{5}{8} \times 39$ (150 × 100). Collection Edouard Pignon, Paris.

286 *Bullfight*, 1901. Oil on board, $19\frac{1}{2} \times 25\frac{1}{2}$ (49.5 × 64.7). Collection Stavros Niarchos, St Moritz.

287 *The Sculptor's Studio*, 1933.
Etching, $7\frac{5}{8} \times 10\frac{1}{2}$ (19.3 × 26.7). Vollard Suite No 64.

288 *Minotaur Carousing*, 1933.
Etching, $11\frac{5}{8} \times 14\frac{3}{8}$ (29.7 × 36.6). Vollard Suite No 85.

289 *Minotaur Asleep*, 1932.
Etching, $7\frac{5}{8} \times 10\frac{1}{2}$ (19.4 × 26.8). Vollard Suite No 86.

290 *Minotaur Raping Girl*, 1933.
Ink on paper, $18\frac{1}{2} \times 24\frac{1}{4}$ (47 × 62). Collection Henry Kleeman.

291 *Centaur and Woman*, 1920.
Pencil on paper, $7\frac{7}{8} \times 10\frac{1}{2}$ (20 × 26.7). Collection Gilbert Seldes.

292 *The Rape*, 1933.
Ink on paper, $18\frac{1}{2} \times 24\frac{1}{4}$ (47 × 62). Private Collection.

293 *Head of a Minotaur*, 1933.
Charcoal on paper, $13\frac{3}{8} \times 19\frac{7}{8}$ (34 × 50.5). Private Collection.

294 *Death of a Minotaur*, 1933.
Etching, $7\frac{5}{8} \times 10\frac{1}{2}$ (19.6 × 26.8). Vollard Suite No 90.

295 *Minotaur and Sleeping Girl*, 1933.
Drypoint, $11\frac{7}{8} \times 14\frac{1}{2}$ (30 × 37). Vollard Suite No 93.

296 *Blind Man's Meal*, 1903.
Oil on canvas, $37\frac{1}{2} \times 37\frac{1}{4}$ (95 × 94.5). Gift of Mr and Mrs Ira Haupt, 1950, Metropolitan Museum, New York.

297 *Blind Minotaur*, 1934.
Aquatint, $9\frac{5}{8} \times 13\frac{5}{8}$ (24.7 × 34.7). Vollard Suite No 97.

298 *Minotaur Moves House*, 1936.
Ink on paper, $19\frac{5}{8} \times 25\frac{5}{8}$ (50 × 65).

299 *Minotaur Watching Woman*, 1936.
Ink, charcoal and flower petals on paper, $13\frac{3}{8} \times 20\frac{1}{4}$ (34.2 × 51.5).

300 *Minotaur Carrying a Dying Horse*, 1936.
Ink and wash on paper, $20 \times 25\frac{3}{4}$ (50.8 × 65.5).

301 *Minotauromachia*, 1936.
Etching, $19\frac{3}{4} \times 27\frac{5}{8}$ (50.2 × 70.3).

302 *End of a Monster*, 1937.
Pencil on paper, $15\frac{1}{8} \times 22\frac{1}{4}$ (38.4 × 56.5). Collection Sir Roland Penrose.

303 Picasso on the beach at Golfe Juan, 1937. Photograph by Dora Maar.

304 Picasso with a bull mask, 1950.
Photograph by Edward Quinn.

305 *Composition (Death of Marat)*, 1934.
Lead pencil, $15\frac{3}{4} \times 19\frac{5}{8}$ (40 × 50). Private Collection.

306 *Kasbec*, 1940.
Lead pencil on squared paper, $6\frac{3}{8} \times 8\frac{5}{8}$ (16.3 × 22.2). Owned by the artist.

307 *Dora Maar with a Monster*, 1937.
Ink and coloured crayon on paper, $6\frac{5}{8} \times 11\frac{1}{8}$ (17 × 25.5). Owned by the artist.

308 *Dora Maar as a Bird*, 1941.
Lead pencil and ink on paper, $12\frac{1}{8} \times 9\frac{3}{8}$ (31 × 24). Owned by the artist.

309 *Head of a Woman*, 1943.
Oil on canvas, $36\frac{1}{4} \times 28\frac{3}{4}$ (92 × 73). Private Collection, France.

310 *Woman with Dead Child*, 1937.
Oil on canvas, $51\frac{1}{4} \times 76\frac{3}{4}$ (130.3 × 195). On extended loan by the artist to the Museum of Modern Art, New York.

311 *Study for a Crucifixion*, detail, 1929.
Pencil on paper. Owned by the artist.

312 *Study for a Crucifixion*, 1929.
Pencil on paper, $13\frac{1}{2} \times 19\frac{3}{4}$ (34.5 × 50.5). Owned by the artist.

313 *'Le Crayon Qui Parle'*, 1936.
Ink and pasted paper, $13\frac{1}{4} \times 20$ (33.6 × 50.8). Owned by the artist.

314 *Study for a Crucifixion*, 1938.
Ink on paper. Owned by the artist.

315 *Crucifixion sketch*, 1959.
Ink on paper. Owned by the artist.

316 *Crucifixion sketch*, 1959.
Ink on paper. Owned by the artist.

317 *Skull in a Chair*, 1940.
Ink on paper. Owned by the artist.

318 *Still Life with Bull's Skull*, 1958.
Oil on canvas, $63\frac{3}{8} \times 50\frac{3}{4}$ (162 × 130). Private Collection.

319 *Four Girls with Chimera*, 1934.
Etching, $9\frac{1}{4} \times 11\frac{5}{8}$ (23.8 × 29.8). Vollard Suite No 13.

320 *First Steps*, 1943.
Oil on canvas, $51\frac{1}{4} \times 38\frac{1}{4}$ (130 × 97). Yale University Art Gallery, Gift of Stephen C Clark.

321 *Horse and Bull*, 1935.
Lead pencil on paper, $15\frac{5}{8} \times 19\frac{5}{8}$ (40 × 50). Owned by the artist.

322 *Two Nudes on the Beach*, 1938.
Ink and gouache on wood, $8\frac{5}{8} \times 10\frac{5}{8}$ (22 × 27). Present location unknown.

323 *Nude Composition*, 1934.
Ink on paper. Private Collection.

* 324 *Crucifixion*, 1930.
Oil on wood, 20×26 (51 × 66). Owned by the artist.

* 325 *Woman Dressing her Hair*, 1940.
Oil on canvas, $51\frac{1}{4} \times 38\frac{5}{8}$ (130 × 97). Collection Mrs Bertram Smith, New York.

326 *Drop Curtain design for 'Le Quatorze Juillet'*, 1936.
Ink and gouache on paper, $17\frac{5}{8} \times 21\frac{1}{8}$ (45 × 54).

327 *The Sailor*, 1943.
Oil on canvas, $51\frac{1}{8} \times 31\frac{7}{8}$ (130 × 81). Collection Mr and Mrs Victor W Ganz, New York.

328 *The Charnel House*, 1944–45.
Oil on canvas, $78\frac{5}{8} \times 98\frac{1}{2}$ (200 × 250). Museum of Modern Art, New York.

329 Nicolas Poussin, *Bacchanal: The Triumph of Pan*, 1635.
Oil on canvas, $54\frac{3}{4} \times 61\frac{3}{4}$ (139.1 × 154.9). Basildon Settled Picture Collection.

330 *La Femme-fleur (Françoise Gilot)*, 1946.
$57\frac{1}{2} \times 34\frac{1}{2}$ (146 × 89). Collection Mrs Jonas Salk.

331 *Bacchanal after Poussin*, 1944.
Watercolour and gouache on paper, 12×16 (30.5 × 40.5). Owned by the artist.

332 *La Joie de Vivre*, 1946.
Oil on fibreboard, 47×98 (120 × 250). Musée Grimaldi, Antibes.

333 *Sabartés as a faun*, 14 October 1946.
Enamel paint on paper, 26¾ × 20⅜ (67 × 51.8). Private collection.

334 *Vase with a Bacchante*, 1950.
Ceramic, 28⅜ × 13⅜ (72 × 34). Owned by the artist.

* 335 *Ulysses and the Sirens*, 1947.
Oil on fibreboard, 180 × 120 (457.2 × 304.8), Musée Grimaldi, Antibes.

* 336 *The Infanta Margarita*, 14 September 1957.
Oil on canvas, 39⅜ × 31⅞ (100 × 81). Museo Picasso, Barcelona.

337 *Kneeling Woman*, before 1951.
Ceramic, 11½ × 6⅝ × 5⅞ (29 × 17 × 15). Owned by the artist.

338 *Woman with Baby Carriage*, 1950.
Bronze after found objects, 80 × 24 × 57 (203 × 60 × 145). Owned by the artist.

339 *Dove*, 1949.
Lithograph, 21½ × 28 (54.5 × 70.0).

340 *Massacre in Korea*, 1951.
Oil on plywood, 43 × 78¾ (110 × 200). Owned by the artist.

341 *War*, 1952.
Oil on fibreboard, 188 × 398 (470 × 1020). Temple of Peace, Vallauris.

342 *Peace*, 1952.
Oil on fibreboard, 188 × 398 (470 × 1020). Temple of Peace, Vallauris.

343 *Dove and Warrior*, 1953.
Ink on paper, 10¾ × 13⅝ (27 × 34).

344 *Peace*, 1953.
Ink on paper, 19⅞ × 25¾ (50.6 × 65.6). Owned by the artist.

345 *War*, 1953.
Lead pencil on paper, 17⅛ × 27¼ (44.8 × 68.2). Owned by the artist.

346 *Françoise on a grey background*, 1950.
Lithograph, 25⅛ × 19 (63 × 48).

347 *The Artist's Bedroom*, 1953.
Oil on canvas, 51 × 38¼ (130.1 × 97.1). Owned by the artist.

348 *Painter and Two Models*, 1954.
Ink and wash on paper, 9⅜ × 12½ (24 × 32). Verve Suite.

349 *Girl, Clown, Mask and Monkey*, 1954.
Ink and wash on paper, 9⅜ × 12½ (24 × 32). Verve Suite.

350 *Portrait of Jacqueline with her hands folded*, 1954.
Oil on canvas 45⅜ × 34½ (116 × 89).

351 *Head of Woman (Jacqueline)*, 1954.
Wood cut and painted, 31⅛ × 11 × 13¾ (80 × 28 × 35). Owned by the artist.

352 *Jacqueline as Lola de Valence*, 1955.
Ink on paper, 12½ × 10¼ (32 × 26). Owned by the artist.

353 *Bacchanal*, 1955.
Chinese ink and gouache on paper, 19¾ × 26⅜ (50.7 × 65.8). Private Collection.

354 *UNESCO Mural*, 1957.
Enamel paint on fibreboard, 315 × 394 (800 × 1000). Conference Hall, UNESCO, Paris.

355 *Les Demoiselles des Bords de la Seine* after Courbet, 1950.
Oil on canvas, 39⅝ × 79¼ (100.5 × 201). Basle Museum.

356 Eugène Delacroix, *Femmes d'Alger*, 1834.
71 × 90⅜ (180 × 229). Musée du Louvre, Paris.

357 *Femmes d'Alger*, 13 December 1954.
Oil on canvas 24 × 28¾ (60 × 73). Collection Dr Herschel Carey Walker, New York.

358 *Femmes d'Alger*, 21 December 1954.
Chinese ink on paper, 13¾ × 17¼ (34.8 × 43.7). Owned by the artist.

359 *Femmes d'Alger*, 14 February 1955.
Oil on canvas, 44⅞ × 57⅛ (114 × 146). Collection Mr and Mrs Victor W Ganz, New York.

360 Diego Velázquez, *Las Meninas*, 1656.
54¾ × 109 (138 × 276). The Prado, Madrid.

361 *Las Meninas*, 17 August 1957.
76⅜ × 102 (194 × 260). Museo Picasso, Barcelona.

362 *The Infanta*, 21 August 1957.
39⅜ × 31⅞ (100 × 81). Museo Picasso, Barcelona.

363 *The Infanta*, 6 September 1957.
18⅛ × 15 (46 × 38). Museo Picasso, Barcelona.

364 *Las Meninas*, 15 September 1957.
47 × 63⅜ (120 × 161). Museo Picasso, Barcelona.

365 *Las Meninas*, 17 September 1957.
47 × 63⅜ (120 × 161). Museo Picasso, Barcelona.

366 *Las Meninas*, 18 September 1957.
51 × 63⅜ (129 × 161). Museo Picasso, Barcelona.

367 *Las Meninas*, 19 September 1957.
63⅜ × 51 (161 × 129). Museo Picasso, Barcelona.

368 *Las Meninas*, 2 October 1957.
63⅜ × 51 (161 × 129). Museo Picasso, Barcelona.

369 *Las Meninas*, 3 October 1957.
51 × 63⅜ (129 × 161). Museo Picasso, Barcelona.

370 *Group from Las Meninas*, 24 October 1957.
51 × 37⅞ (129 × 96). Museo Picasso, Barcelona.

371 *The Studio*, 1955.
Oil on canvas, 34½ × 45 (89 × 116). Private Collection.

372 *Pigeons at La Califórnie*, 1957.
39⅜ × 31½ (100 × 80). Museo Picasso, Barcelona.

373 *Déjeuner sur l'Herbe*, 4 July 1961.
Pencil on paper 10¾ × 14¾ (27 × 37). Galerie Louise Leiris, Paris.

374 *Déjeuner sur l'Herbe*, 19 August 1961.
Oil on canvas. 26 × 31⅞ (65 × 81). Galerie Louise Leiris, Paris.

375 *Déjeuner sur l'Herbe*, 30 July 1961.
Oil on canvas, 51 × 38⅛ (130 × 97). Galerie Louise Leiris, Paris.

376 *Déjeuner sur l'Herbe*, 22 August 1961.
Pencil on paper, 10¾ × 14¾ (27 × 37). Galerie Louise Leiris, Paris.

377 *The Rape of the Sabines*, 1963.
Oil on canvas, 77 × 51 (195.5 × 130). Museum of Fine Arts, Boston.

378 *Bathsheba*, 1963.
Coloured pencils on paper, 10⅝ × 14⅞ (26.9 × 37.3). Owned by the artist.

379 *Nude and Cavalier*, 1968.
Aquatint, 12⅜ × 15¾ (31.5 × 40). No 339 from *347 Gravures*.

380 *Prostitute, Procuress and Clients*, 1968.
Aquatint, 12⅜ × 16⅜ (31.5 × 41.5). No 114 from *347 Gravures*.

381 *Figures and Bare-back Rider*, 1968.
Etchings, 22¼ × 28⅛ (56.5 × 71.5). No 1 from *347 Gravures*.

382 *The Circus*, 1967.
Wash on paper, 19⅜ × 59 (49.5 × 150.4). Galerie Louise Leiris, Paris.

383 *The Musketeers*, 1967.
Ink and wash on paper, 19⅛ × 29⅝ (49 × 75.5). Galerie Louise Leiris, Paris.

384 *Pierrot and Harlequin*, 1970.
Pencil on paper, 26 × 19⅝ (65 × 50). Galerie Louise Leiris, Paris.

385 *The Painter at Work*, 1964.
Gouache and Chinese ink over a lithographic print, 38⅜ × 29⅛ (97.5 × 74). Galerie Louise Leiris, Paris.

386 *The Smoker*, 1964.
Pastel on paper, 26 × 19⅝ (65 × 50). Galerie Louise Leiris, Paris.

* 387 *Le Déjeuner sur l'Herbe*, 3 March/20 August 1960.
Oil on canvas, 45 × 57½ (114 × 146). Collection Heinz Berggruen, Paris.

* 388 *Rembrandt and Saskia*, 1963.
Oil on canvas, 51¼ × 64 (130.2 × 162.6). Private Collection.

389 *Salome*, 1970.
Pencil on paper, 13½ × 26 (33.7 × 50). Galerie Louise Leiris, Paris.

390 *The Kiss*, 1969.
Oil on canvas, 38⅛ × 51 (97 × 130). Galerie Louise Leiris, Paris.

391 *Woman Sleeping*, 1970.
Ink on paper, 12⅛ × 9 (30.8 × 22.8).

392 *Nude Woman and a Man*, 1969.
Blue pencil on paper, $17\frac{1}{8} \times 21\frac{1}{4}$ (43.5 × 54). Galerie Louise Leiris, Paris.

393 *The Studio at 'La Californie'*, 1955.
Oil on canvas, $31\frac{7}{8} \times 25\frac{5}{8}$ (81 × 65). Owned by the artist.

394 *Sebastian Junyent Painting*, 1900.
Ink on paper, $8\frac{1}{4} \times 5\acute{e}$ (21 × 13.4). Private Collection.

395 *Man Watching a Sleeping Nude*, 1904.
Watercolour and ink on paper, $14\frac{1}{2} \times 10\frac{5}{8}$ (37 × 27). Collection Raoul Pelleguer.

396 *The Studio*, 1927.
Etching, $13\frac{3}{4} \times 15\frac{5}{8}$ (34.8 × 39.7).

397 *Painter and Knitting Model*, 1927.
Etching, $7\frac{1}{2} \times 11$ (19 × 28). Plate IV of Balzac's *Le Chef-d'oeuvre inconnu*.

398 *Visit to the Studio*, 1954.
Ink on paper, $9\frac{1}{2} \times 12\frac{5}{8}$ (24 × 32). Verve Suite.

399 *The Sculptor Resting*, 1933.
Etching, $7\frac{1}{2} \times 10\frac{1}{2}$ (19.3 × 26.8). Vollard Suite No 55.

* 400 *Painter and Model*, 1970.
Coloured pencil and chalk on cardboard, $8\frac{5}{8} \times 11\frac{1}{8}$ (21.8 × 28.2). Private Collection.

* 401 *Painter and Model*, 1963.
Oil on canvas, $51\frac{1}{8} \times 76\frac{3}{4}$ (130 × 195). Private Collection.

* 402 *Circus Scene*, 1967.
Ink and gouache on paper, $22\frac{1}{4} \times 29\frac{1}{2}$ (56.5 × 75). Private Collection.

* 403 *Harlequin, Woman and Cupid*, 1970.
Coloured crayons on cardboard, $8\frac{7}{8} \times 13\frac{3}{4}$ (22.5 × 35). Private Collection.

404 *Painter and Model*, 1954.
Ink on paper, $9\frac{1}{2} \times 12\frac{5}{8}$ (24 × 32). Verve Suite.

405 *Model Painting*, 1967.
Etching. $13\frac{3}{4} \times 11\frac{3}{4}$ (35 × 30).

406 *David and Bathsheba*, 1947.
Lithograph, $25\frac{1}{8} \times 19\frac{1}{4}$ (64 × 49).

407 *Nude with a Mirror*, 1967.
Ink and gouache on paper, $22\frac{1}{4} \times 29\frac{1}{2}$ (56.5 × 75). Galerie Louise Leiris, Paris.

408 *Faun Unveiling a Woman*, 1936.
Lithograph, $12\frac{1}{2} \times 16\frac{1}{2}$ (32 × 42). Galerie Beyeler, Basle.

409 *Game with a Bull's Mask*, 1954.
Lithograph, $18\frac{5}{8} \times 25\frac{1}{8}$ (47.5 × 64).

410 *The Rehearsal*, 1954.
Lithograph, $19\frac{1}{2} \times 25\frac{5}{8}$ (49.5 × 65).

411 *Woman and Cavalier*, 1968.
Aquatint and drypoint, $9\frac{7}{8} \times 12\frac{3}{4}$ (25 × 32.5). No. 191 of *347 Gravures*.

412 *The Judgement of Paris*, 1951.
Ink on paper, $20\frac{1}{8} \times 25\frac{7}{8}$ (51 × 65.8). Private Collection.

413 *The Masks*, 1954.
Ink on paper, $9\frac{1}{2} \times 12\frac{5}{8}$ (24 × 32). Verve Suite.

414 *L'Amour Masqué*, 1954.
Ink on paper, $12\frac{5}{8} \times 10\frac{1}{8}$ (32 × 26). Verve Suite.

415 *The Butterfly Hunter*, 1938.
Oil on canvas. Owned by the artist.

416 *Seated Woman in a Hat*, 1943.
Oil on canvas, $39 \times 31\frac{7}{8}$ (100 × 81). Private Collection.

417 *Woman with a Kitten*, 1964.
Oil on canvas, $51\frac{1}{8} \times 75\frac{5}{8}$ (130 × 195). Galerie Louise Leiris, Paris.

418 *Model Undressing*, 1953.
Wash on paper $7\frac{1}{2} \times 11$ (24 × 18). Verve Suite.

419 *Rembrandt and a Veiled Woman*, 1934.
Etching, $10\frac{7}{8} \times 7\frac{3}{4}$ (27.8 × 19.8).

420 *Painter at Work*, 5 February 1967.
Coloured pencils on paper, $19\frac{5}{8} \times 25\frac{5}{8}$ (50 × 65). Galerie Louise Leiris, Paris.

421 *Painter and Model*, 5 February 1967.
Coloured pencils on paper, $20\frac{3}{8} \times 25\frac{1}{8}$ (52 × 64). Galerie Louise Leiris, Paris.

422 *Raphael and La Fornarina*, 1968.
Etching, $9\frac{7}{8} \times 12\frac{3}{4}$ (25 × 32.5). No 316 of *347 Gravures*.

423 *Portrait of a Painter after El Greco*, 1950.
Oil on plywood, $39\frac{1}{4} \times 31\frac{3}{4}$ (100 × 81). Collection Angela Rosengart, Lucerne.

424 *Classical Painter*, 1969.
Oil on canvas, $50\frac{3}{4} \times 76$ (130 × 193). Galerie Louise Leiris, Paris.

425 *Seventeenth-Century Painter*, 1967.
Oil on canvas, $31\frac{3}{4} \times 39\frac{1}{4}$ (81 × 100). Galerie Louise Leiris, Paris.

426 *Dancer and Picador*, 1960.
Wash on paper, $20\frac{1}{8} \times 25\frac{7}{8}$ (51.5 × 66). Galerie Louise Leiris, Paris.

427 *Portrait of Jacqueline in Turkish Costume*, 1955.
Oil on canvas, $39\frac{1}{4} \times 31\frac{3}{4}$ (100 × 81). Owned by Madame Picasso.

Index

283